D1273892

THE DRAWINGS AT WINDSOR CASTLE
GENERAL EDITOR: A. F. BLUNT

GERMAN DRAWINGS
BY EDMUND SCHILLING

ITALIAN AND FRENCH DRAWINGS: SUPPLEMENTS
BY ANTHONY BLUNT

PHAIDON

THE GERMAN DRAWINGS

IN THE COLLECTION OF

HER MAJESTY THE QUEEN

AT WINDSOR CASTLE

BY

EDMUND SCHILLING

AND SUPPLEMENTS TO THE CATALOGUES
OF ITALIAN AND FRENCH DRAWINGS

WITH A HISTORY OF
THE ROYAL COLLECTION OF DRAWINGS

BY

ANTHONY BLUNT

SURVEYOR OF THE QUEEN'S PICTURES

PHAIDON · LONDON AND NEW YORK

ALL RIGHTS RESERVED BY PHAIDON PRESS LTD · 5 CROMWELL PLACE · LONDON SW7

PHAIDON PUBLISHERS INC · NEW YORK
DISTRIBUTORS IN THE UNITED STATES: PRAEGER PUBLISHERS INC
III FOURTH AVENUE · NEW YORK · N.Y. 10003
LIBRARY OF CONGRESS CATALOG CARD NUMBER: 73–111053

ISBN 0-7148 1446 6

MADE IN GREAT BRITAIN
PRINTED BY R. & R. CLARK LTD · EDINBURGH

CONTENTS

FOREWORD

THE present volume is of necessity different in character from all previous members of the series. It includes one section dealing with the German drawings, which is separate and self-contained and has been prepared by Dr. E. Schilling. The remainder of the volume is devoted to those Italian and French drawings which, for one reason or another, have not been catalogued in previous volumes, except those by Guercino which are to be catalogued by Mr. Denis Mahon. These include drawings of the later Florentine, Neapolitan, Lombard and other schools, which have not been covered, and in addition a number of drawings which have been identified since the publication of the volumes in which they would naturally have appeared.

Finally the catalogue includes addenda and corrigenda to the entries in previous volumes. These are based on reviews, on independent articles, and very often on verbal or written communications from individual scholars, particularly the authors of previous volumes. I hope that these have all been properly acknowledged, and I should like to express my gratitude to all those who have contributed to the catalogue in this way. I am painfully aware of the fact that these addenda and corrigenda cannot be complete and that I may well have missed important published contributions.

It is necessary to define which categories of drawings have been included in this volume and which have been left out. To some extent arbitrary decisions have had to be made, because in a collection such as this, which has grown up over many centuries, neat pigeon-holing is often impossible.

I have aimed at including all figure drawings by Italian or French artists that have not already been dealt with, except those dating from the nineteenth century which will be covered in the volume dealing with Victorian drawings, but in other fields it has been necessary to make a selection. As regards architectural drawings, those dating from the sixteenth century have been excluded as well as the important series by Carlo Fontana, since a catalogue of the latter is in the press and one of the former is planned. I have on the other hand included the architectural drawings which do not fall into these categories and which consist primarily of Italian drawings of the seventeenth and eighteenth centuries. I have also included the large number of sixteenth-century decorative, as opposed to strictly architectural drawings, that is to say those which represent designs for ceiling or wall decorations and those for work in silver or glass. These present complicated problems and will need further study, but they are of such importance that it seemed worth while to bring their existence to the notice of scholars, even if at this stage the cataloguing has, of necessity, been somewhat schematic.

A further problem is presented by the drawings after the antique. I have aimed at including those which clearly date from the sixteenth century, but in the case of the seventeenth century I have had to be more cautious. I have listed a few which I feel can be ascribed with some degree of certainty to artists such as Pietro da Cortona or Romanelli, whose other drawings have been catalogued in previous volumes, and I have attempted to state the problems which arise over Pietro Testa's drawings after the antique, though a solution of them must await the completion of the work begun by Sheila Rinehart, who is also cataloguing the vast quantity of unattributed drawings of this kind dating from the seventeenth century.

The Royal Library contains other drawings by Italian artists, notably five volumes of geological studies from the collection of Cassiano dal Pozzo. These are primarily interesting from a scientific

point of view, though two volumes of them are by a draughtsman who was clearly a competent artist in his own right and who uses a style not remote from that of Grimaldi. The scientific importance of this series has been discussed in an article by C. E. N. Bromehead in the *Quarterly Journal of the Geological Society* (CIII, 1947, pp. 65 ff.). The other volumes of scientific drawings belonging to Pozzo which came to the Royal collection from Cardinal Albani were unfortunately sold and broken up in the early 1920's.

In the preparation of this volume I have incurred many debts, but most particularly to Miss Scott-Elliot, who for more than fifteen years looked after the Royal Collection of drawings. It is a great sadness to all who worked in the Library at Windsor that she should have retired just at the moment that this volume went to press, but, in spite of her other occupations, she was able to check the typescript, and prepare the concordance and indexes. I should like to take this opportunity of expressing to her the gratitude of all those authors who have been concerned with the preparation of the volumes in this series for her unfailing help.

I must also once again thank Miss Elsa Scheerer, who has typed the whole manuscript – most parts of it two or three times – patiently deciphering my handwriting and correcting slips and inconsistencies.

The problem of numbering the items in this volume is complex because of the different types of entry involved. Numbers have only been given to drawings which either have not appeared in previous volumes or are here given new attributions, whereas drawings about which the entries contain additional information or attributions proposed by other writers but rejected by the original authors are referred to by their old numbers (e.g. 'Kurz, no. 179'). This system means that drawings which here receive new attributions will have two numbers, their old one and the new one in this volume, which will be referred to as 'Blunt, Misc.'

<div align="right">A. F. B.</div>

THE HISTORY OF THE ROYAL COLLECTION
OF DRAWINGS

A GOOD DEAL has been written about the history of the Royal Collection of Drawings in previous volumes of this series, but the story has never been told as a whole and it may be convenient to summarize the available evidence in a single account and to add what new information has become available since the earlier volumes appeared.

The only group of drawings at Windsor which can be traced back to the sixteenth century in the Collection is the series of portraits by Holbein. Their history is immensely complicated and has been examined in detail by Sir Karl Parker in his volume devoted to them, so it will be enough here to give a summary of it. A book containing the portraits was recorded in the possession of Edward VI at his accession and had very probably belonged to his father, Henry VIII. It passed to Henry Fitzalan, Earl of Arundel, and at his death in 1580 to his son-in-law, Lord Lumley. When the latter died in 1609, it was probably acquired by Henry, Prince of Wales, and on his death in 1612 passed to his younger brother, Charles. At some date between 1627 and 1630, after Charles had become King, he gave the drawings to Lord Pembroke in exchange for Raphael's painting of *St. George*, which had been sent to Henry VII by the Duke of Urbino, when he received the Order of the Garter. Lord Pembroke almost immediately gave the book to his father-in-law, Thomas Howard, Earl of Arundel, the great collector, and it was acquired for the Crown after his death by Charles II, who is recorded as owning it in 1675. It does not seem to have aroused much interest till it was 'discovered' by Queen Caroline in 1727 in a bureau at Kensington, which contained the Royal Collection of Drawings, including some of those belonging to Charles I.[1]

The list of drawings in the bureau, made about 1735, has frequently been published and discussed, but it is of such importance that it must be reprinted in any account of the Royal Collection of Drawings:

'A List of the Books of Drawings and Prints in the Buroe in His Majestys Great Closset at Kensington' (B.M. Add. 20, 101, fol. 28).

No. 1. Drawings by Polidore, Julio Romano, Raphaell, Zuccaro, Daniell de Volterra, P. Ligorio, Jerom, Anniball Carraccio, Taddio, L. Cangiagio, J. Pantormo, Penis, Jognon di Vincenza, Barth. Passeroto, J. Salviati, P. Farrinato, B. Bandinelli,

No. 2. by Defferent hands,

No. 3ˣ. by Hans Holben, those framed & hang at Richmond

No. 4. by Paolo Farinato,

No. 5ˣ. Prints by Hollar, Deliverd to her Majty Augst 1735 & by her Lent to Lady Burlington Since put in Volumes & laid in yᵉ Library at Kensington,

No. 6. Drawings by Leonardi de Vinci,

No. 7. by the Best hands,

No. 8. Prince Charle's Book with a few Drawings,

No. 9. Drawings by Julio Romano, M. Angello, Raphaell,

No. 10. by Polydor, P. Veronese, Guido Rene, Titian,

No. 11. by Defferent hands,

No. 12. Prints of the Revelations of St John by Albert Durer,

No. 13. Drawings by Leonardi di Vinci.

No. 14. A Book of Mathamaticall papers,

No. 15ˣ. A Book with some Indian Pictures,

1. B.M. Add. 20, 101, ff. 28, 29.

(1)

No. 16. A Cover with one Drawing by Cherubim Alberti,
No. 17. Drawings by Severall Hands,
No. 18. by Severell hands,
No. 19ˣ. A Little Book of Heads Drawn on Vellum,
No. 20. Another of Defferent Figures,
No. 21ˣ. Another by Parmesano,
No. 22. Another by the same hand,
No. 23. Another by the same hand,
 Seven Drawings Rolled together, of the Cartoons after Raphael
 A Drawing in a frame and Glass
 ˣ Five heads in Black frames unfinished by Cowper
 A tin Box with A Drawing the Triumphs of Trajan
 ˣ These Mark'd with a Cross were deliver'd for her Majtys use in ye year 1728.

This list, combined with the entries in Van der Doort's inventory, provides the most important information about the drawings owned by King Charles I and the later sovereigns of the Stuart dynasty.[2]

Certain items, such as the copy by Isaac Oliver after one of Holbein's prints of the *Dance of Death* or the 'limnings' by Peter Oliver after Italian paintings in the King's Collection, are clearly identifiable in the inventory, but there are other entries which refer to volumes of drawings and which are more difficult to interpret. The relevant passages read as follows:

[p. 125] 42 Item one Booke with .49. Pictures by the life don in dry Cullors of the Cheifest Nobility and famous men at that tyme in ffraunce where at the end some .5 drawings which said .49. pictures by the life and the 5 drawings Comes in all togeither .54[1]

[p. 126] 47 Item a painted Booke in quarto in browne Leather wth your Mats Armes upon it when you were Prince Conteyning sev'all Accons and postures invented by Michaell Angello Bonorotto.

 49 Item a Booke in larg folio in white vellam wherein some .8. little drawings of Horatio Jentellesco[3]
 Item a very greate Booke in folio of Prints. being of severall Antiquities of statues and Roman buildings

[p. 145] 7 Item in an 8: square black ebbone frame in a round guilded ring upon white vellam drawn by Vorst wth a penn An our Lady hugging Christ on her lapp St John wth foulding hands by.

 8 Item upon blew paper drawn in black and white a head of Christ Crowned wth thornes thought to bee a Coppy after Alberdure very Curiously done set in a black frame wth a shiver,[4]

[p. 153] 21 Item in a little Booke wherein .6. drawings upon blew Papper wch were don for patterns for the great Seale wherein 2 more very Curiously don by Haskins alsoe for patterns[5]

 22. Item more a little drawing wth a Penn in a black frame Marcus Courchus liping in the fiery Pitt at Roome sett in a black ebbone frame

 23. Item a drawing in little of Prince Henry where hee is playing wth a lance beeing side faced in a black frame with a shiver[6]

 24. Item another drawing wth a penn upon white vellam yor Mats owne Picture on horsback
 [? at grin]

2. *Abraham van der Doort's catalogue of the collection of Charles I*, ed. O. Millar, *Walpole Society*, XXXVII, 1960, pp. 125 f., 145, 153 f.
3. Orazio Gentileschi. A note in the margin says that the drawings were given to the King by the artist. Two drawings survive at Windsor which may be by Gentileschi (Blunt and Cooke, Nos. 1006, 1007), but they would hardly be described as 'little'.
4. A note in the margin says that this drawing was given to the King by his jeweller, Heriott.
5. A note in the margin says that the first six were by Francis Cleyn. 'Haskins' is presumably John Hoskins.
6. A note in the margin says this drawing was given to the King by Van der Doort.

25. Item under a glasse being larg that hath bin a lookeing glasse a larg drawing upon vellam conteyning manie little figures beeing kinde of a part of a Citty[7]

p. 154 [1] Item. 5 Litle Cartouns *opan* [? *pasport*] of prospective done by Stanewick to Serve for. Pattrons *tu mak behind bij som pitturs bij te lijff* [8]

The individual drawings mentioned in this list cannot now be identified and none of the books has survived intact in the Royal Collection, but the volume containing portraits of the French nobility probably included the twelve coloured chalk portraits still at Windsor, one after François Clouet, the others traditionally ascribed to one of the Dumonstier family but more probably by François Quesnel.[9] According to a note by Van der Doort, this book of drawings was bought by the King from the Duc de Liancourt, who was Envoy to the Court of St. James and from whom the King obtained Leonardo's painting of *St. John*, giving in exchange Holbein's *Portrait of Erasmus* and a *Holy Family* by Titian.

The contents of one other volume in Charles I's collection may have survived in the Royal Collection, though not in their original form. Among the books listed by Van der Doort one, containing 'Accons and postures' by Michelangelo, is specifically mentioned as having belonged to Charles before his accession and as bearing his arms as Prince of Wales. This is almost certainly the book mentioned in the inventory of 1735 as 'Prince Charle's book with a few Drawings'.[10] A note in the Ashmolean manuscript of Van der Doort's inventory states that the book consisted of 'printts', but it is quite possible that it included 'a few drawings' as is stated in the 1735 inventory.[11]

It is, moreover, possible to identify with a reasonable degree of probability one drawing from this volume. Among the originals by Michelangelo at Windsor is a study for a *Pietà* (Popham and Wilde, No. 433), bearing the eight-pointed star, which is almost certainly the mark of Nicolas Lanière (or Lanier; 1588–1666), who played a considerable part at the Court of James I and Charles I as a musician and was an important agent in acquiring works of art for the latter. It is therefore at least possible that this drawing was bought by Charles I through Lanière. The fact that it was included in a volume made up when he was Prince of Wales raises a problem, since Lanière's activity in the field of collecting is generally associated with the period after Charles' accession, but two explanations are possible. Lanière may in fact have been active as a collector before 1625; or, alternatively, the drawing may have been bought later and inserted in a volume containing engravings after compositions by the same master.

There is in any case strong evidence to show that Charles I owned a number of drawings which are not identifiable in Van der Doort's inventory. There are, for instance, two drawings at Windsor connected with Raphael's *Miraculous Draught of Fishes* (Popham and Wilde, Nos. 808, 850), one of which has the Lanière star. They are listed in an inventory of George III's drawings made by John Chamberlaine in about 1800 (called Inventory A) with the following comment for No. 808: 'This drawing was found in an Old Bureau at Kensington which contained part of the Collection of King

7. A note says this is 'don by Juliano the Italian', and apparently came from Venice.
8. A note in the margin states that they were bought from the artist.
9. Cf. A. Blunt, *French Drawings*, Nos. 2, 9–19.
10. 'Prince Charles' must refer to the later Charles I, since Charles II was only 18 at the death of his father and at that time certainly not a collector of drawings.
11. Cf. O. Millar, *loc. cit.*, p. 125 note 1. A further link between Van der Doort's inventory and the 1735 list is formed by an entry in the former:

 54 Item another Booke in quarto in white vellam Conteyning the usage of the Mathematicall instruments of silver in a square dowble Case which my Lord Denby gave to your Maty.

(cf. O. Millar, *loc. cit.*, p. 126), which is probably the same as item 14 in the Bureau list.

Charles ye first where also was preserved the Volume of Leonardo da Vinci', and for No. 850: 'A copy of the above (i.e. No. 808) once held for an Original. This is the same Collection'. These two drawings may well have been included in item 9 of the inventory of books in the Bureau: 'Drawings by Julio Romano, M. Angello, Raphaell'.[12]

Finally it is worth noticing that Malvasia names 'Carlo Stuart' as one of the collectors who owned drawings by the Carracci.[13] This is to some extent confirmed by the existence, at Windsor, of a drawing by Lodovico Carracci bearing the mark of Nicolas Lanière.[14]

The Lanière star can help towards the identification of yet other drawings as having probably formed part of the collection of Charles I. It occurs on some thirty-four sixteenth-century Italian drawings at Windsor, and of these a surprising number can be connected, either through their present attributions or through the names which they bore in the eighteenth century, with artists whose works are listed among the contents of the Bureau. In addition to those connected with the names of Michelangelo and Raphael already discussed, there are drawings bearing the Lanière star attributed to Lodovico Carracci (Wittkower, No. 6), Giulio Romano (Popham and Wilde, Nos. 361, 387), Parmigianino (*ibid.*, No. 575), Passerotti (*ibid.*, No. 663), Giuseppe Porta (Salviati; *ibid.*, No. 753), Antonio Vicentino, called Tognone (*ibid.*, No. 965),[15] Veronese (*ibid.*, No. 1067), and Taddeo Zuccaro,[16] all of whose names occur in items 1, 9 or 10 of the Bureau list. In addition there is a whole volume attributed to Paolo Farinati, by whom there is one drawing at Windsor with the Lanière mark, and this volume may also have contained others now ascribed to Palma Giovane, three of which also have the star. Finally, two drawings – one now ascribed to Alessandro Allori (Popham and Wilde, No. 59), the other to the School of Fontainebleau (*ibid.*, No. 1104) – have on the *verso* the word *Jerom*, a name which also occurs among the artists represented in volume I of the Bureau.

It must, of course, be borne in mind that the Bureau at Kensington contained drawings acquired by sovereigns later than Charles I, and that drawings bearing the mark of Nicolas Lanière might have been bought by, say, Charles II, but the evidence seems to point fairly clearly towards the conclusion that Charles I owned at least a small collection of drawings, including some of considerable importance.

Of the other books listed as being in the Bureau at Kensington much the most important are those containing the drawings of Leonardo da Vinci. One of these was the famous volume put together by the sculptor Ottavio Leoni from the drawings bequeathed by Leonardo to his pupil Francesco Melzi. It later belonged to Lord Arundel, who presumably took it abroad during the Civil War. It is still uncertain how and when the drawings came into the Royal Collection, but the fact that they formed part of it in 1690 is established by a note in the diary of Constantine Huygens, who states that he was summoned to Kensington Palace on January 21st of that year by Queen Mary to see them.[17] The most probable hypothesis is that they were acquired by Charles II, either while he was

12. The author of the list seems to have been well informed about the history of the drawings in the Bureau, since he was clearly aware that the Leonardo drawings had not belonged to Charles I ('where *also* was preserved the volume of Leonardo da Vinci').
 One other original drawing by Raphael, the study for *Poetry* in the Stanza della Segnatura (Popham and Wilde, No. 792), and one school drawing of *Hope* (*ibid.*, No. 815) are also stated in Inventory A to come from Kensington, though there is no means of knowing when they were bought.

13. *Felsina Pittrice*, Bologna, 1678, I, p. 478. The author may be referring either to Charles I or Charles II.

14. Wittkower, No. 6.

15. This drawing bears the five-pointed star believed to be the mark of Nicolas Lanière's younger brother.

16. A full list of sixteenth-century Italian drawings at Windsor bearing the Lanière star is given in Popham and Wilde, p. 379.

17. On this occasion Huyghens records that he saw four or five books of drawings. Later in the year he was again summoned by the Queen to put the drawings in order, and he noted that a number had been stolen. It was said that Lely had taken some and replaced them with copies made by himself or members of his studio.

in exile or through the agency of Lely after his recovery of the throne, but there is no documentary evidence to prove this.[18]

The Bureau also contained four volumes of drawings attributed to Parmigianino which can be traced later in George III's Inventory A, and three of which survive, though broken up, in the Royal Collection today. Their history has been discussed by Mr. Popham,[19] who concludes that one of them contained a series of drawings by a northern hand, one a group of copies after Parmigianino, probably by Wallerant Vaillant, whose name appeared on the book together with the date 1655. The others are presumably among the originals and copies still at Windsor. Reveley in his *Notices illustrative of the Drawings and Sketches . . .*, London, 1820, p. 43, states that all four volumes belonged to Charles I. In the case of one which belonged to Vaillant in 1655 this is clearly incorrect, but it may well be that some of the others did in fact belong to the King, since one drawing (Popham and Wilde, No. 575) bears the Lanière star.

One of the volumes has on the fly-leaf a note of the price in a hand which is generally accepted as that of William Gibson (1644–1702), who, in addition to being a miniaturist much employed at the Court, was also a great collector of drawings and probably sold many to Charles II. Gibson's price mark is to be found on some twenty other Italian drawings at Windsor, including works attributed to Pisanello (Popham and Wilde, No. 26, attributed by Gibson to Leonardo), Niccolò dell'Abbate (*ibid.*, No. 49), Fra Bartolomeo (*ibid.*, No. 108), Daniele da Volterra (*ibid.*, No. 263, attributed to Michelangelo), Farinati (*ibid.*, Nos. 289, 293, 317), Giulio Romano (*ibid.*, No. 380), Pirro Ligorio (*ibid.*, No. 395), Michelangelo (*ibid.*, Nos. 434, 445, 449, 455, 462, the two last copies), Passarotti (*ibid.*, Nos. 658, 660, 661), Polidoro da Caravaggio (*ibid.*, No. 718), Raphael (*ibid.*, No. 829, apparently attributed by Gibson to Giulio Romano), Francesco Salviati (*ibid.*, No. 894), Sicciolante da Sermoneta (*ibid.*, No. 928, ascribed to Michelangelo), Perino del Vaga (*ibid.*, No. 981), and a drawing now without attribution, but called by Gibson Giulio Romano (*ibid.*, No. 1197). These drawings were probably bought by Charles II and may have been added to those mentioned above as probably owned by his father to form volumes 1, 4, 9 and 10 in the Bureau.

An even more important influence on Charles II as a collector was Sir Peter Lely. Lely was an avid collector of drawings – as well as paintings – and it is more than likely that, if the Leonardos were acquired by Charles II after the Restoration, it was through his agency. His mark appears on a certain number of drawings at Windsor by Farinati (Popham and Wilde, No. 287), Giulio Romano (*ibid.*, Nos. 352, 357; the latter a copy), and Pordenone (*ibid.*, No. 744), and it is quite possible that the King bought them from him, though most of his drawings were sold after his death and passed into many different collections. There are, for instance, at Windsor two which bear his mark, but which certainly did not come directly from his collection: one, now attributed to Poccetti (*ibid.*, No. 685), also has the mark of Jan Zoomer (1641–1724), and the other, ascribed to Rafaello da Montelupo (*ibid.*, No. 787), later belonged to the elder Richardson and was bought by Queen Victoria from the Mayor Collection in 1874.

One group of drawings listed in the inventory of the Bureau at Kensington can be firmly identified as being acquired by Charles II. Evelyn in his *Sculptura* published in 1662, refers to '*eight or ten drawings* by the pen of Francis and John Cleyn (two hopeful, but now deceased brothers) after

18. The most recent account of the history of the Leonardo drawings is that of Lord Clark in the second edition of his catalogue of the drawings (pp. ix ff.). Unaccountably Lord Clark does not mention the fact that the drawings are listed in the inventory of 1735 and states that there is no record of them between the passage in Huyghens' diary and their 'rediscovery' by Dalton in the reign of George III.

19. Popham and Wilde, p. 277. It is not quite clear why Mr. Popham identifies item No. 20 as containing drawings by Parmigiano, whose name is first mentioned in connection with No. 21.

those great cartoons of Raphael, containing the stories of *The acts of the apostles*, where, in a fraternal emulation, they have done such work, as was never yet exceded by mortal men, either of the former or present age; and worthy they are of the honour which his Majesty has done their memories, by having purchased these excellent things out of Germany, whither they had been transported, or, at least, intended'.[20] Mr. Francis Watson, who first called attention to this passage, identified the drawings as those on loan to the Ashmolean Museum but belonging to Wadham College, Oxford, to which they were bequeathed by John Griffiths, a former Warden, who had bought them in London in about 1853.[21] It is not known how or when they left the Royal Collection, but they are recorded there in 1787, when Dalton refers to them in an article in the *Gentleman's Magazine* [22] and they are listed in Inventory A (p. 158): 'The Seven Cartoons of Raphael copied with a Pen by Van Clein 1645'.[23] This particular sheet of the Inventory has annotations by Glover, librarian to Queen Victoria, dated November, 1840, so the drawings must have been disposed of between that date and the year 1853 when they were bought by Griffiths.

James II does not appear to have taken any great interest in the collection of drawings, but two important examples of Isaac Oliver, *Moses striking the Rock* and *Nymphs and Satyrs* (Oppé, *English Drawings*, Nos. 459, 460), are first recorded in his collection. It is uncertain whether Queen Mary added to the collection, but the passage from Huyghens' diary quoted above shows that she was at least interested in the organization and arrangement of the drawings. Queen Anne and the first Hanoverian sovereigns were little interested in works of art and it is extremely unlikely that they added any drawings of importance to the Royal Collection. It is therefore reasonable to suppose that the Bureau at Kensington contained essentially the drawings brought together by Charles I and Charles II.

The first member of the Hanoverian dynasty who added to the Collection seems to have been Frederick, Prince of Wales, eldest son of George II and father of George III, who bought from Dr. Mead, probably in 1750, the volume of studies by Poussin which had belonged to Cardinal Camillo Massimi.[24] This purchase was in accordance with his taste for seventeenth-century art, which led him to buy, amongst other paintings, a series of exceptionally fine landscapes by Poussin's brother-in-law, Gaspar Dughet.

By far the most important additions to the Royal Collection, numerically speaking, were made by George III. His earliest acquisitions were made when he was still Prince of Wales. In 1755 he appointed as his librarian Richard Dalton (1715?–91), an antiquarian who had travelled with Lord Charlemont in Southern Italy, Sicily, Greece, Egypt and Turkey, and had published in 1751–52 'A series of Engravings representing Views etc. in Sicily, Greece, Asia Minor and Egypt', illustrated with rather rough engravings after his own drawings. It was no doubt owing to his interest in ancient art that many drawings after Roman architecture now at Windsor were bought or commissioned, though only one such acquisition, that of Sterne's drawings of the Pantheon and the Temple of the Sibyl at Tivoli, is documented as being bought by him in Rome (Royal Archives, Geo. 15602–15603).

His first purchase made for the future King was probably the two volumes containing ninety-five drawings of flowers and insects by Maria Sibylla Merian, which appeared in Dr. Mead's sale on 28.i.1755 (lot 6) and are still at Windsor. This is the first surviving evidence of George III's interest in botany, which was to last throughout his life.

20. P. 101 in the reprint of 1755.
21. 'On the early history of collecting in England', *Burlington Magazine*, LXXXV, 1944, p. 227.
22. Part II, pp. 853 ff.; cf. Watson, *loc. cit.*
23. The drawings are in fact variously dated 1640, 1645, 1646.
24. See below, p. 215.

In 1762, the third year of his reign, no doubt urged on by his friend Lord Bute, George III bought the entire collection of Joseph Smith, British Consul in Venice, and the collection of drawings belonging to Cardinal Alessandro Albani in Rome.

The purchase from Smith included paintings, gems, and a magnificent library as well as the drawings with which we are here concerned.[25] The collection had been formed in Venice over a period of more than forty years, and it is natural that it should be particularly strong in the works of Venetian artists of the eighteenth century. The glory of this section is the volume containing 143 drawings by Smith's close friend Canaletto, which include a high percentage of his finest drawings, but this is supported by volumes of compositional drawings by Sebastiano Ricci, and of stage designs, landscapes and caricatures by his younger brother Marco, and by decorative and architectural studies by Antonio Visentini, who had been active in designing plates to illustrate books published by Giambattista Pasquali, who ran a fine printing press in Venice financed by Smith. It was no doubt also from the Smith collection that George III acquired the large drawings by Zuccarelli and the thirty-six fine studies of heads by Piazzetta, some of which were copied, very skilfully, by his daughter, Princess Augusta Sophia.

Smith's collection of Venetian eighteenth-century drawings was splendid but curiously one-sided: a hundred and forty-three Canalettos and no Guardis, a whole volume of Sebastiano Ricci, and only one doubtful Tiepolo. In part this choice reflects his personal taste, but it also reveals the effects of those quarrels which divided Venice into rival artistic camps, each attempting to ignore the other, while trying to snatch commissions from it.

Smith was also interested in the art of earlier periods and he owned important groups of drawings dating from the seventeenth century, most of which seem to have been bought from the heirs of the Venetian collector Zaccaria Sagredo. Sagredo owned four volumes containing the cream of the drawings by Giovanni Benedetto Castiglione. In addition he had bought the greater part of a celebrated collection formed in Bologna by members of the Bonfiglioli family. The most important single element in this collection consisted of three volumes of drawings by the Carracci, but it is likely that other drawings by Bolognese artists now at Windsor also came from this source, though the only positive evidence about them is a reference in Inventory A which states that one series of drawings by Guido Reni had belonged to the Bonfiglioli.[26]

From Smith also came two volumes of sixteenth-century drawings, which are still preserved intact at Windsor with their original bindings and elaborate frontispieces specially drawn and painted for Smith by Visentini, one containing a hundred and eighteen studies by Ambrogio Figino, and the other copies by Giulio Campi after the reliefs on Trajan's Column.

More remarkable is the fact that with the drawings from the Bonfiglioli collection Smith acquired a number ascribed to Raphael, of which three (Popham and Wilde, Nos. 790, 793, 800) are still regarded as originals, while one (*ibid.*, No. 802) is thought to be an offset made by the artist himself in order to see how his design would appear when woven in reverse in tapestry.[27] In addition a copy after Raphael's *School of Athens* by Parmigianino (*ibid.*, No. 598) probably comes via Smith from the Bonfiglioli collection.[28]

25. F. Haskell, *Patrons and Painters . . .*, London, 1963, and the forthcoming monograph by Mrs. Frances Vivian. Smith's will, listing the most important groups of drawings in his possession, is printed in K. T. Parker's catalogue of the Canaletto drawings (pp. 59 f.).

26. For fuller details about the Bonfiglioli collection, see R. Wittkower, *The Drawings of the Carracci at Windsor Castle*, London, 1952, pp. 20 f., and O. Kurz, *The Bolognese Drawings at Windsor Castle*, London, 1955, pp. 2 f.

27. Of the remaining two, one (Popham and Wilde, No. 861) is now thought to be a copy, and the other (*ibid.*, No. 392) is tentatively attributed to Francesco Granacci.

28. For further details of Smith's drawings see my catalogue of the Venetian drawings at Windsor. A number of volumes of drawings

Smith's library also contained a large number of important engravings. Many of these were by contemporary artists, such as Canaletto or Visentini, but a note in Inventory A (p. 2) proves that he also owned the magnificent set of more than three hundred etchings by Stefano della Bella, and it is more than likely that the similar series of works by Callot and Israël Silvestre belonged to him, as well as the smaller group by Castiglione.

The manuscripts belonging to Smith are not in general relevant to a history of the drawings, since most of them – now like the printed books in the British Museum – are without illustrations, but one manuscript of Virgil (King's 24) contains good late fifteenth-century North Italian illuminations, and there is still at Windsor a sheet made up of fragments of a large choir-book illuminated for Cardinal Grimaldi by Giulio Clovio (Popham and Wilde, No. 43).

The Albani collection of drawings was even more extensive than Consul Smith's and its history is more complicated. It was bought through the agency of James Adam in 1762,[29] and the story of his long and skilful negotiations with the owner, Cardinal Alessandro Albani, has been told by John Fleming.[30] The collection was one of the most famous in Rome and the Cardinal was only persuaded to sell it by his mistress, the Contessa Cheroffini, in order to provide a dowry for their daughter. Adam exploited the situation with such skill that the sale was completed without coming to the knowledge of Winckelmann who, as the cardinal's librarian, was in charge of the collection.

The greater part of the Albani collection had come to the Cardinal from his uncle, Pope Clement XI, who reigned from 1700 to 1721. In 1703 he had bought two major Roman collections, one from the heirs of Cassiano dal Pozzo, the other from the painter Carlo Maratta.

Cassiano dal Pozzo played an important part in the artistic and archaeological life of Rome in the first half of the seventeenth century.[31] In the artistic field he is now chiefly remembered as the patron of Poussin, but in his own day he was celebrated as a friend of scientists and a student of antiquity. The drawings which came to the Albani from his collection reflect all these interests. By far the most important section of them is what he called his 'Museo Cartaceo', a 'Paper Museum' in which he recorded in drawings every fragment of ancient art which he could track down and any object, however mean, which could enlarge his knowledge of the life and habits of the ancients. These records were mainly commissioned by Pozzo himself, who employed contemporary artists, principally Pietro Testa, to make the drawings which he required.[32] These were bound up in volumes of which a large number still exist at Windsor, though rearranged and probably enlarged by the insertion of drawings of the same type from other sources.[33] His interest in the arts was not however limited to antiquity, and his collection contained two volumes of drawings after mediaeval mosaics in Rome and one of tombs in Roman churches dating from the later Middle Ages and the Renaissance.

The fact that Pozzo owned drawings by Nicolas Poussin – intrinsically likely – is confirmed by Winckelmann in a note made when he was librarian to Cardinal Albani, in which he states that

from his collection were sent – presumably inadvertently – to the British Museum with his library, when George IV presented it about 1820. They include several volumes of drawings by Visentini and a companion volume to the Figino drawings, mainly containing manuscripts (King's Ms. 323).

29. Owing to delays in shipping from Leghorn to London, the cases did not arrive till July 1763. It seems that the cases which contained the Smith collection were sent in the same ship.

30. 'Cardinal Albani's Drawings at Windsor', *Connoisseur*, CXLII, 1958, pp. 164 ff.

31. For further details about his collection of paintings see F. Haskell and S. Rinehart, 'The Dal Pozzo Collection, some new evidence', *Burlington Magazine*, CII, 1960, pp. 318 ff. For his archaeological drawings see C. Vermeule, 'The Dal Pozzo-Albani Drawings of classical Antiquities', *Art Bulletin*, XXXVIII, 1958, pp. 31 ff.; 'The Dal Pozzo-Albani drawings of classical antiquities in the British Museum', *Transactions of the American Philosophical Society*, N.S., L, pp. 1 ff., and 'The Dal Pozzo-Albani drawings of classical antiquities in the Royal Library at Windsor Castle', *ibid.*, LVI, 1966, pp. 1 ff.

32. The problem of Testa's drawings after the antique is discussed below, p. 121.

33. Pozzo himself seems to have bought a certain number of drawings after antiquities by artists of earlier dates, but these are not always easy to identify.

Pozzo owned 'die besten Handzeichnungen seiner eigenen Arbeiten' and 'Viele seiner Zeichnungen nach der Antike'. We have already seen that one volume of drawings by Poussin at Windsor came from Cardinal Massimi through Dr. Mead's collection to Frederick, Prince of Wales, but Inventory A shows that there was a second volume devoted to his drawings which is probably the one referred to by Winckelmann.[34] In fact it only contains one drawing after the antique (Blunt, *French Drawings*, No. 227), but two further drawings are so described, though they are actually studies for the Long Gallery (*ibid.*, Nos. 214, 256). Pozzo may have owned other drawings after the antique by Poussin, but if so they have disappeared except for one (*ibid.*, No. 263, wrongly said to be a studio work), which is numbered in the hand which inscribed all the Pozzo drawings.

Pozzo was as actively interested in the Natural Sciences as he was in archaeology. He was a friend of Galileo and secretary to the Academy of the Lincei till its voluntary dissolution at the time of Galileo's trial, and it was probably in this way that he acquired a great number of his scientific drawings, either actually from the collection of the Academy itself or from that of Prince Cesi, its founder and president. Among these were several volumes of great curiosity, such as a copy of a treatise on Mexican plants composed in 1552 by a Jesuit called Martin da Santa Cruz, of which the original was in the Barberini Library,[35] but the bulk of the collection was contained in seventeen large folio volumes, of which four dealt with birds, six with plants, one with fishes, one with fruits, and five with fossils. Unfortunately the greater part of these were sold and broken up just after the First War, and only the five volumes of geological drawings still survive intact at Windsor.[36]

Certain groups of drawings which were certainly in the Pozzo and Albani collections are not in the Royal Library. Some of them are traceable elsewhere; others seem to have vanished.

In Sir John Soane's Museum are four volumes of drawings by G. B. Montanus consisting of his 'reconstructions' of ancient buildings, many of which are engraved in the published edition of his works. These certainly belonged to Pozzo, because several of them have the wax seal which he was in the habit of affixing to the first page of each volume in his collection and which occurs on several drawings at Windsor. Soane bought them at the sale of Robert Adam's effects, and it is hard to resist the conclusion that they were removed by James Adam from the collection between its purchase in Rome and its arrival at Buckingham House.

Two further volumes, now in the British Museum, also came from Pozzo's collection. They can be traced back to the sale of the collection of Richard Dalton, who presumably obtained them after they had come to the Royal Collection. The volumes contain drawings of markedly inferior quality to those surviving at Windsor and it is possible – though not proven – that they were rejected as not worthy of inclusion.[37]

The Maratta collection was more uniform and of a quite different kind. Not unnaturally the painter concentrated on collecting drawings by the artists whom he most admired, and in fact he succeeded in building up one of the finest collections of drawings by artists of Seicento Rome that have ever been made.

34. *Gesammelte Werke*, ed. Diepolder and Rehm, Berlin, 1957, IX, p. 275.

35. Cf. G. Gabrieli, 'Due codici iconografici di piante miniate nella Biblioteca Reale di Windsor', *Rendiconti della Reale Accademia Nazionale dei Lincei, Classe di scienze fisiche*, x, 6, 1929, p. 131. The second manuscript discussed by the author is another *Erbario Miniato*, which also belonged to Pozzo.

36. Some of the scattered drawings have recently been recovered for the Royal Library. The geological drawings are discussed by C. E. N. Bromehead, 'A geological museum of the early 17th century', *Quarterly Journal of the Geological Society of London*, CIII, 1947, pp. 65 ff.

37. Cf. Vermeule, 'The Dal Pozzo-Albani drawings . . . in the British Museum', cited in note 31 above. Vermeule also refers to certain drawings at Holkham Hall, Norfolk, and formerly at Hamilton Palace as being said to come from Pozzo, but rightly points out that this is unlikely to be the case. One drawing inscribed by Towneley as coming from the Albani collection has recently been inserted in the Franks volume (the last drawing in volume 2).

The nucleus of it was formed by the collection of Francesco Raspantino, a pupil and heir of Domenichino.[38] Raspantino had inherited almost the whole contents of Domenichino's studio, and in this way something like five-sixths of the artist's drawings eventually came to the Royal Collection. But his inventory[39] shows that the inheritance also included drawings by the Carracci, amounting to about 550 in all. These evidently form the greater part of the Carracci drawings at Windsor, though, as has already been seen, three volumes of drawings by the same artists came with the Smith collection from the Bonfiglioli family. As Inventory A only lists 586 drawings ascribed to the Carracci, either some drawings were removed and put in other volumes, perhaps with attributions to specific pupils of the Carracci, or some were abstracted from the Albani collection before it actually reached its destination.[40]

It is difficult to know precisely what else the Maratta collection contained. It is reasonable to suppose that the drawings by Maratta himself at Windsor, amounting to not far short of two hundred, come from the artist, but in other cases we are left guessing. It would, for instance, be logical to think that he was the owner of the drawings by his master, Sacchi, of which many are at Windsor, but it is recorded by the artist's biographer that at his death Sacchi bequeathed his drawings to his other pupils, on the grounds that they stood in greater need than Maratta of such aids to composition.[41] Maratta must, however, almost certainly have owned some of those at Windsor, since they are for the frescoes in the Lateran Baptistry which he executed after his master's designs, and he may have bought others after Sacchi's death; but this is speculation.[42] As regards the other important series of drawings by Roman artists of the Seicento, they may well have belonged to Maratta, but the Royal Archives show that Dalton was active in buying paintings and drawings in Rome in the 1760's and 1770's, and there is at present no means of checking what came into the Royal Collection in this way.

It is likely that Maratta also owned drawings by sixteenth-century artists. One by Raphael, a study of two heads in the *Coronation of the Virgin* (Popham and Wilde, No. 788), was included in the volumes of Maratta's own drawings and must almost certainly have belonged to him, but no others can be identified.

Three further groups of drawings can be certainly traced to the Albani collection. One is a volume of copies by Gaetano Piccini after the reliefs on the ducal palace at Urbino. The connection with the Albani family is established by the arms of Clement XI on the binding and the fact that the drawings were engraved for a book on the palace published in 1734 at the expense of Cardinal Albani.[43] The second is a volume of drawings after the antique made up by Don Vincenzo Vittoria, a Spanish ecclesiastic who was a friend and pupil of Maratta.[44] The volume of drawings itself does not provide any direct evidence of connection with the Albani family, but a manuscript by Vittoria at Windsor containing a list of engravings after Raphael is dedicated to Clement XI, which suggests

38. The history of the Raspantino collection is fully discussed by John Pope-Hennessy in *The Drawings of Domenichino at Windsor Castle*, London, 1948, pp. 9 ff.

39. Raspantino's inventory is printed by Bertolotti, *Artisti bolognesi, ferraresi ed alcuni altri*, Bologna, 1885, pp. 168 ff.

40. Inventory A does not, unfortunately, provide much information about the origin of individual drawings by the Carracci, but the entry for volume 4 ends with the sentence: 'This volume contains many spirited fine Drawings of Anibale Caracci drawn with a pen, most of which came out of the Albani Collection at Rome'. For a fuller discussion of the provenance of the Carracci drawings at Windsor see R. Wittkower, *The Carracci Drawings at Windsor Castle*, 1952, pp. 20 ff.

41. Cf. Blunt and Cooke, p. 92.

42. Diepolder and Rehm in their notes to the complete edition of Winckelmann's works (Berlin, 1957, IV, p. 580) refer to two sketches by Sacchi for the *Vision of St. Romuald* as being in the Albani collection, giving as their authorities Ramdohr and Volkmann, but these authors in fact refer to painted *bozzetti*, not to drawings.

43. See below, p. 106, No. 346.

44. For a fuller account of Vittoria, see A. Blunt, 'Don Vincenzo Vittoria', *Burlington Magazine*, CIX, 1967, pp. 31 ff.

that the author was fairly closely associated with the Albani family. Vittoria was probably also the creator of the magnificent collection of engravings after Raphael, still at Windsor, of which the manuscript is in effect a sort of catalogue.

The third item, of far greater importance, consists of fourteen volumes of drawings by Carlo Fontana and members of his studio. These cover principally the works which the architect designed for Clement XI and members of his family, or which were executed during his pontificate, and several groups are preceded by dedicatory epistles to the Pope. The volumes probably constitute the most complete documentation to survive of the activities of any architect's studio in the seventeenth or eighteenth centuries.[45]

Strictly speaking, this is all we know for certain about the contents of the Albani collection as it came to the Royal Collection, but there are certain groups of drawings at Windsor which are so closely connected either with the Albani family or with Carlo Maratta that it is reasonable to suppose that they came from this source.

There are, for instance, certain volumes of drawings after the antique which are too late to have been made for Pozzo and probably come from the Albani collection. One is a small quarto book entitled *Arme de Romani Militari e Sedie Diverse Consoli Romani*, which must date from the early eighteenth century, and is similar in character to the drawings by Piccini mentioned above. Further, the Royal Library has a volume of drawings after the reliefs on Trajan's Column, which are by Pietro Santi Bartoli and cannot therefore have been commissioned by Pozzo.[46] This has a title-page in black ink which certainly dates from the early eighteenth century and is identical in style and writing to those in two volumes of drawings by the architect Muzio Oddi.[47] The origin of these volumes is not recorded, but Oddi was an architect who was active in Urbino, from which the Albani family came, and it is probable that the drawings were acquired by them for this reason.

One further source of information exists about the Albani collection, but it is curiously disappointing. Among the manuscripts left by Winckelmann and now in the Bibliothèque Nationale is one headed: 'La Raccolta de' disegni in Casa Albani'. The entry reads as follows:

I. *de' Caracci*
 Un disegno del Perseo della Galleria Farnese da Annibale Caracci
 Se vede da molti disegni che Lodovico s'è inteso piu della grazia che Annibale
 Il Polifemo della gall. Farnese 4 fig. Alcune Herme
II. Un Volume intiero di teste del Domenichino
III. Il torso disegnato da Agostino Caracci ma troppo caricato
 Un studio delle gambe dell' Endimione della Gall. Farn. Un Pensiero per la Galatea, inchiostro
 Un altro pensiero per la medesima, terra rossa Molte Notomie disegnate da Annibale
 Un Pensiero d'Annibale per la Capella di S. Diego dipinta da Albano
IV. Il Giudizio di Salomone del Domenichino, del quale il quadro è in Spagna, terra rossa
 Faraone nel mare da Raffaelle. Il medmo copiato da Pussino Alcune Accademie in terra rossa disegni
 da Rafaelle
 Un piccolo Studio di Michel Angelo per il Giudizio estremo Il Lacoonte disegnato da Marcello
 Venusto
 Pensieri di Raffaello per la bataglia di Costantino
V. La testa d'un putto che dorme da Correggio terra rossa. bellissimo[48]

45. A full catalogue of the Fontana drawings by Dr. Allan Braham and Dr. Hellmut Hager is in the press.
46. Volume A 39 (152).
47. Volumes A 20, A 21 (182, 183); inventory numbers 9976–10188.
48. Fonds allemand, Département des Manuscrits, volume 68, folio 60. This list has been published with annotations in the edition of Winckelmann's works quoted above (IV, pp. 578 ff.). The editors suggest possible identifications of the drawings at Windsor, but most of these do not carry conviction.

This note is disappointingly short, but what is more curious is that hardly any of the items mentioned in Winckelmann's list can be associated with anything at present to be found in the Royal Library. The volume of drawings of heads by Domenichino may be one of those at Windsor, though why it should have been singled out for mention from the whole series of drawings by the artist is not clear. The drawings for the *Perseus* by Annibale Carracci may be Popham and Wilde, Nos. 294 and 295, the red chalk drawing of the *Galatea* may be No. 507, and the red chalk study by Domenichino of the *Judgment of Solomon* may be Popham and Wilde, No. 1159, but all these identifications are extremely uncertain. There are studies for Michelangelo's *Last Judgment* and for Annibale's Chapel of S. Diego and there is a copy after Raphael's *Red Sea* (Popham and Wilde, No. 848), but such drawings are so frequent that any identification must be purely speculative.

There are other references to drawings in the Albani collection in Winckelmann's published works, but they are hardly more helpful. In a passage which is somewhat obscure he mentions a drawing apparently connected with Correggio's *Io*, which does not appear to be related to anything at Windsor.[49] His references to two drawings by Raphael are more intelligible but do not correspond to any identifiable drawings; one was a copy of the *Morbetto*[50] and the other a head of a child in black chalk which had been pricked through for transfer.[51] He also speaks of drawings after the antique by Mantegna,[52] and although nothing of this kind is to be found at Windsor he may be referring to two early sixteenth-century North Italian drawings in the Franks volumes at the British Museum,[53] which might easily have been ascribed to Mantegna in the eighteenth century.

The only conclusion which can be drawn from Winckelmann's notes is that the drawings listed by him were separated from the Albani collection, either by sale before the whole collection was purchased by George III or by removal between Rome and London.

The Royal Collection contains a number of drawings by Roman artists of the generation after Maratta, such as Pietro de Pietri (1663–1716), Agostino Masucci (c. 1691–1758), Giovanni Paolo Melchiori (1664–1745), Pier Leone Ghezzi (1674–1755), and even Pompeo Batoni (1708–87), but there is no means of deciding whether they belonged to Cardinal Albani or formed part of Dalton's purchases in Italy.

There is evidence that a few drawings now at Windsor came to the Royal Collection from the collection of Baron Philipp von Stosch, a friend of Cardinal Albani and an archaeologist who acted as intelligence agent for the British Government.[54] Winckelmann examined his collection in 1758, when his nephew was trying to dispose of it to pay his debts and he left some notes on the drawings.[55] The list includes two of which the descriptions correspond very closely with drawings at Windsor:

The first reads:

> 8. Disegno d'un bassorilievo di terracotta fatto da Michelagnolo Buonarroti che rappresenta la morte del Conte Ugolino della Gherardesca figli e Nipoti nella Torre della fame in Pisa appresso il Sig. March. Guadagni dietro la Nonziata in Firenze.

This can be certainly identified as the drawing listed by Popham and Wilde as No. 1039 and in

49. *Gesammelte Werke*, ed. cit., ix, pp. 225 f.
50. *Ibid.*
51. *Geschichte der Kunst des Alterthums*, Dresden, 1764, i, p. 284.
52. *Ibid.*, p. 29.
53. Nos. 131, 156.
54. On Stosch see Lesley Lewis, 'Philipp von Stosch', *Apollo*, LXXXV, 1967, p. 321.
55. These are on fol. 248 of volume 57 of the Winckelmann papers in the Bibliothèque Nationale (cf. A. Tibal, *Inventaire des manuscrits de Winckelmann déposés à la Bibliothèque Nationale*, Paris, 1911, p. 48). I am greatly indebted to Mr. David Fenner for copying these notes for me.

Inventory A (p. 43, No. 15), which has on it an inscription which is in precisely the same terms, with only very small variations in spelling.

A few lines further on in Winckelmann's notes is a further entry:

Disegno del Bassorilievo mentovato di Michelagnolo. Copia del Buonarroti fatta da Ascanio Condivi.

It is not quite clear whether this refers to a different drawing, but if it refers to the drawing listed above, the sheet at Windsor has a good claim to be considered a copy by Condivi. Another entry in Winckelmann's notes reads:

Michelangelo
Un disegno di molte figure ignude che scoccano frezze nello Scuolo che tiene una Erma feminile, a pié della quale giace l'Amore. Su questo disegno e fatta la pittura dal Pieron del Vago nella Villa Olgiati fuori della porta Pinciana. Il disegno è intagliato col nome di Michel Angelo *Petri de Nobilibus formis a Paulo Gratiana quesita* in 4° oblongo della grandezza del disegno.

This description exactly fits the *Archers shooting at a herm*, and the entry for this drawing in Inventory A (p. 45, No. 2) seems to have been copied from the same source, presumably a note by Stosch himself: 'Men and women suspended in the Air and shooting Arrows at a Target fixed on a Term. Cupid asleep and two boys burning his Arrows. This Emblematical Subject is painted in a villa call'd Raphael's near the walls of Rome. Red chalk'. – and a hand which is probably Chamberlaine's has added in pencil after the word villa 'Orgiati'.

The problem of identifying the Stosch drawing is complicated by the fact that there are at Windsor two drawings of this composition: the original (Popham and Wilde, No. 424) and a very good copy by Bernardino Cesari (*ibid.*, No. 456), but it is likely to be the copy, since the original is known to have belonged to Cardinal Alessandro Farnese and, as will be explained below, drawings were probably bought directly from the Farnese family for the Royal Collection.

There are other entries in Winckelmann's notes which correspond in general terms to drawings at Windsor, but they are too vague to allow of any certain identification:

1. Il primo pensieri di Fra Bartolomeo della Porta per la Madonna nel Palazzo Pitti a Firenze. Il disegno originale di Fra Bartolomeo dell'istesso Quadro

could possibly refer to Popham and Wilde, Nos. 114 and 117, although the former is not closely connected with the Pitti composition. Stosch also owned 'Diversi Studj per la Scuola d'Atene' by Raphael, but there is no means of telling whether they are among those now at Windsor.

There is no direct evidence about the manner in which these drawings came to Windsor, but it is highly probable that they passed through the Albani collection, as Stosch was a close friend of the Cardinal. Some drawings which had belonged to Stosch were sold in London in 1764,[56] but they did not include any that corresponded to those now at Windsor.[57]

The Smith and Albani collections were by far the most important additions made to the Royal Collection by George III, but his librarian, Richard Dalton, who was responsible for the negotiations over the Smith collection, was also active in Italy over a long period in the search for works of art. Between 1763 and 1772 the Royal Archives show a series of payments to Dalton, sometimes for sums of over £500, but unfortunately the items bought are rarely specified. In one undated document,

56. Langford, 24.iii.1764.
57. One further item in Winckelmann's list of drawings in the Stosch collection can be certainly identified. This is a sheet by Michelangelo in the Louvre (RF 4112; Dussler, No. 359, Pl. 46), which corresponds exactly to the description given by Winckelmann, who even copied the poem on the sheet. It belonged to Wicar, who no doubt acquired it in Florence, perhaps even directly from the heirs of Stosch.

however, recording payments made to Dalton in Rome (Royal Archives, Geo. 15602–15603) he is stated to have bought a group of drawings by Sassoferrato, which are presumably the sixty still at Windsor (Blunt and Cooke, Nos. 873–932). In the same document payment is recorded for drawings by 'Busire', probably Giovanni Battista Busiri, by whom however there do not seem to be any drawings at Windsor.[58] It is also known that he commissioned the nine drawings at Windsor by the Bolognese artist Gaetano Gandolfi after the most famous altar-pieces in the city (Kurz, Nos. 271–279). Dalton was presumably also responsible for buying two volumes of offsets of Guercino, which, according to Inventory A (p. 69), came from 'Sr. Gennaro of Bologna' (Inventory Nos. 2963–3195), and a number of drawings which belonged to the painter Benedetto Luti, mainly by seventeenth-century Roman artists, which can be identified by the copies made after them by Altomonte when in Luti's collection.[59]

It is possible that Dalton may also have been responsible for one other purchase of the greatest importance. Among the most splendid drawings by Michelangelo at Windsor are three of those finished works which he made as gifts for his friend Tommaso Cavalieri, the *Tityus*, the *Phaethon*, and the *Bacchanal of Children* (Popham and Wilde, Nos. 429–431). These are known to have belonged to Cardinal Alessandro Farnese (1520–90).[60] Yet another original by Michelangelo, the *Archers shooting at a herm* (Popham and Wilde, No. 424) belonged to the miniaturist Giulio Clovio and later to the Cardinal, and yet another, the *Resurrection*, which also belonged to Clovio, may well have passed to the Farnese. Further, there are four copies after the master at Windsor which have been connected with the name of Clovio: the *Flagellation* (Popham and Wilde, No. 451), documented as being by him, the *Tityus* (*ibid.*, No. 459, a copy of No. 429), ascribed to him in a sixteenth-century inscription on the sheet, and the *Zenobia* and the *Ganymede* (*ibid.*, Nos. 454 and 457), which can be attributed to him on good indirect evidence.

It looks therefore as though a group of drawings came to the Royal Collection from the Farnese, and while there is no record of any such purchase, it is interesting to note that the Farnese family still owned drawings by Michelangelo in the later eighteenth century, just at the time that Dalton was searching for works of art in Rome. Fioravante Martinelli, in the 1761 edition of his *Roma Ricercata* (p. 49), records in the library of the palace 'alcuni Libri con molti disegni di Raffaelle, Giulio Romano, Buonaroti, Caracci, Polidoro ed altri'.[61] Did Dalton succeed in extracting one or more of these volumes from the palace? Without fuller information about the contents of the books it is impossible to say for certain, but it may be regarded as at least a possible hypothesis. If he did make this purchase, it may have included the Raphael drawing of the *Blinding of Elymas* (Popham and Wilde, No. 803), stated in Inventory A to have been bought at Rome, and the *Adam and Eve driven out of Paradise* (Popham and Wilde, No. 806) and the 'Head' attributed to him, both of which are said to come from the same collection as the *Elymas*. The 'Head' may be the copy after the *Virgin of the Rose* (Popham and Wilde, No. 832).

The Royal Collection, as recorded in the reign of George III, also contained a number of Italian drawings of the fifteenth and early sixteenth centuries. In some cases the descriptions given in Inventory A are too vague for the drawings to be identified, but they certainly include the two figure studies by Signorelli (Popham and Wilde, Nos. 29, 30), a *Christ in Majesty* by Montagna

58. For Busiri see F. Hawcroft, 'Giovanni Battista Busiri', *Gazette des Beaux-Arts*, 1959, I, pp. 295 ff. There are many drawings by Busiri in English collections, including the British Museum, but none of them seem ever to have been in the Royal Library.
59. Cf. Brigitte Heinzl, *Bartolomeo Altomonte*, Munich-Vienna, 1964, p. 68, and 'The Luti Collection', *Connoisseur*, CLXI, 647, 1966, pp. 17 ff.
60. Cf. Popham and Wilde, p. 248.
61. The same sentence occurs in the 1764 edition, on p. 48.

(*ibid.*, No. 20), a drawing of a soldier from a *Resurrection* by a follower of Mantegna (*ibid.*, No. 16), a *Nativity* connected with Giorgione (*ibid.*, No. 343), a *Female figure* by Giovanni Santi (*ibid.*, No. 28), a *Man in armour* by Perugino (*ibid.*, No. 21), and a *Youth writing* by a Florentine artist of the Quattrocento (*ibid.*, No. 33). Other more general entries, such as one containing five sheets entitled: 'Heads of the old Master; two in the stile of Pietro Perugino', are difficult to associate precisely with individual drawings, but this particular entry almost certainly included the two heads now attributed to Benozzo Gozzoli (*ibid.*, Nos. 10, 11), one of which was formerly called Fra Angelico, a name added in pencil to Inventory A at this point, two heads formerly ascribed to Perugino (*ibid.*, Nos. 24, 1040), of which one is now given to Timoteo Viti, and probably an anonymous drawing of the North Italian School (*ibid.*, No. 36), which seems to have been on the page next to the two Gozzolis.

The provenance of these drawings is unknown, but eighteenth-century collectors were not interested in works of this kind, and it is unlikely that George III or his advisers would have acquired them. Moreover, one of them, the *Presentation of the Virgin* (*ibid.*, No. 3), now regarded as a copy after Carpaccio, bears the Lanière star and may therefore have belonged to Charles I, and it is reasonable to suppose that this whole group was acquired by Charles I or Charles II, in whose time drawings of this date still had an importance as representing the art of the early Renaissance in Italy and had not been displaced by the cult of the Seicento.

George III's collection of Old Master drawings was predominantly composed of works by Italian Masters, but he also owned a number of drawings by Flemish, Dutch and German artists. The Flemish included an important group of drawings by Stradanus (Puyvelde, *Flemish Drawings*, Nos. 135–185), several attributed to Rubens (*ibid.*, Nos. 246, 277, 280, 282, 290), and three to Van Dyck (*ibid.*, Nos. 201, 217, 218). Among the Dutch drawings much the most interesting were those by Hendrik Averkamp, more than forty in number (Puyvelde, *Dutch Drawings*, Nos. 15–62), but there were others attributed to Cornelis Visscher (*ibid.*, Nos. 729–732), and the School of Rembrandt (*ibid.*, Nos. 117, 625, 658, 661), as well as a number of landscapes. The group of German drawings listed in Inventory A (p. 14) was smaller but contained a number attributed to Dürer. These certainly included one original, the *Madonna* of 1519 (Schilling, No. 22), and the drawing referred to in the inventory as 'an allegorical subject found amongst the Prints' was probably the *Pupila Augusta* (Schilling, No. 23). Of the other drawings listed under the name of Dürer some were copies, but others are now attributed to artists of the sixteenth century, such as Urs Graf (Schilling, No. 30) and Hans Schäufelein (Schilling, No. 52).[62] It is quite likely that the head of an old man by a close follower of Dürer (Schilling, No. 28) was included in the entry 'Heads of the old Masters' in the same volume as the other German drawings mentioned. There is no information about the early history of these drawings, but the same arguments apply as in the case of the early Italian drawings and it is legitimate to think that they probably formed part of the Stuart collection. In the case of Dürer's *Pupila Augusta* there is even some evidence to confirm this provenance, because 'the Prints' among which it was found are probably those listed as No. 12 in the Bureau: 'Prints of the Revelations of St. John by Albert Dürer' which survive in the Royal Library.

In comparison with his splendid collection of Italian drawings those by English artists which George III added to the Royal Collection are relatively unimportant. To the eighteenth century 'drawings' meant Old Master drawings, and those commissioned from English artists were either portraits or studies of scientific, topographical or historical interest. The only early English drawing

62. The *Crucifixion*, now ascribed to Augustin Hirschvogel (Schilling, No. 51), was almost certainly in George III's collection, but it is difficult to be certain whether it is the one attributed in Inventory A to Dürer, or another given to Lucas van Leyden (p. 126). The latter is the more likely, since the drawing, which is unusually large, corresponds to the others identifiable in the volume listed on p. 126, all of which are large in scale.

of importance acquired by George III is Samuel Cooper's portrait of Charles II, which was given to him by the Prince of Wales on one of the anniversaries of the Restoration (Oppé, *English Drawings*, No. 133). The King's real interest lay in topographical drawings and prints, and his large collection of these unfortunately went with his library to the British Museum. From this series the only ones to survive at Windsor are Dalton's views of Egypt and other parts of the Mediterranean, perhaps preserved because the author had been Royal Librarian.

Queen Charlotte owned portrait drawings of her family by Harding and Edridge, which are at Windsor (*ibid.*, Nos. 197–226), and an important series of landscape sketches by Gainsborough, which were unhappily dispersed at the sale after her death.

Finally, though the authors would probably be too modest to have wished them to be included in a history of the Royal Collection, mention must be made of the albums of drawings by the King himself, Queen Charlotte and most of their children, which show that they attained a high level of amateur performance, the most accomplished being probably Princess Augusta Sophia.

George III also owned a certain number of important Oriental illuminated manuscripts, which were presented to him by the Nawāb of Oudh in 1797 through the Governor-General, Lord Teignmouth. Much the most remarkable of these is an illustrated life of Shāh Jehān Namāh, dating from 1657–58. They are recorded as having been sent at a date before 1828 from Buckingham House to Windsor (Inventory A, p. 172). One of them may correspond to item 15 in the Bureau at Kensington: 'A Book with some Indian Pictures'. There is also at Windsor a volume with eighteenth-century paintings of Chinese life with the arms of George III on the binding.[63] The King's interest in countries outside Europe is also reflected in his possession of the original drawings for James Bruce's *Travels in Barbary*, published in 1790, also still in the Royal Library.

Seen as a whole, George III's additions to the Royal Collection of Drawings are deeply impressive. How far he bought from real enthusiasm and how far under intelligent guidance is hard to decide. In the early years of his reign Lord Bute undoubtedly led him towards an interest in the arts, but he must have been brought up in an atmosphere of collecting, and the things of beauty which he saw around him must have produced some effect. It is possible that his real enthusiasm was for the drawings illustrating natural history specimens[64] rather than for those of strictly artistic merit, but he undoubtedly felt that it was his duty as a King to enrich and enlarge the collections which he had inherited from his ancestors; and there can be no question that he did so in a spectacular manner in the field of drawings as much as in the collecting of paintings or the formation of a splendid library.

George IV devoted most of his energies as a collector to the acquisition of paintings, furniture, china and bronzes, and his purchases in the field of drawings were much less important. One part of the collection, however – the drawings of military subjects – is entirely his creation, and for many years he spent large sums on buying drawings of military themes by foreign artists, such as Langendyk and Finart, and commissioning others from English water-colour painters, of whom much the most important was Denis Dighton.[65]

A second interest of George IV was for prints and drawings connected with the theatre, of which he made an important collection, recorded by the invoices of his purchases in the Royal Archives, but of which very little survives.

63. This must be the volume listed in Inventory A (p. 152) as '1 Folio volume containing 23 drawings of Chinese Husbandry'.
64. Many of these, apart from those mentioned above as coming from Pozzo, still exist in the Royal Library, including the original water-colour illustrations to William Hayes' *Natural History of British Birds*, published in 1775, and those to Mark Catesby's *Natural History of Carolina, Florida and the Bahama Islands*, published in 1731 and 1742.
65. See A. E. Haswell-Miller and N. Dawnay, *The Military Drawings at Windsor Castle*. William IV added a certain number of items to this collection.

These two groups of drawings were collected systematically, but the King's other acquisitions seem to have been more or less a matter of chance. The few drawings by Hogarth and Rowlandson presumably appealed to the side of his character which led him to buy a large number of 'curious' drawings that were destroyed at his death. In addition he bought the fine series of water-colours made by Charles Wild to illustrate Pyne's *Royal Residences*, and a number of drawings by artists either English or active in England during his lifetime, notably David Allan, Bartolozzi, and Henry William Bunbury. By far his most important contribution, however, was laying the foundation of the collection of drawings by Paul and Thomas Sandby, which is now the great glory of the English drawings at Windsor.

We today must regret that George IV did not appreciate the school of water-colour painting which arose in England during his time as Prince Regent and King, so that the Royal Collection has no work by Turner or Cotman and only isolated and unimportant examples of John Robert Cozens and Girtin. Even Alexander Cozens, who was for some years drawing-master to the Princesses, is only represented by a copy after Marco Ricci and a view of an oak in Windsor Park acquired recently.

The King showed greater interest in water-colours by Dutch artists of the later seventeenth and eighteenth centuries, and, though these highly finished productions do not appeal to the taste of the twentieth century, the series brought together in the Royal Library undoubtedly represents the style at its best.[66]

Queen Victoria enjoyed drawings, and records in her diary a pleasant evening spent with Lord Melbourne looking at the Domenichinos in the Royal Library, but neither she nor – more surprisingly – the Prince Consort added many drawings by Old Masters to the collection.

A few important acquisitions of Old Master drawings seem to have been made by Richard Holmes, who was Librarian from 1870 to 1906. He carried on the reorganization of the drawings begun by the Prince Consort and made a number of important purchases. Some of these merely enlarged groups of works by artists already well represented in the collection, such as a drawing by Polidoro which had belonged to Paul Sandby and Lawrence (Popham and Wilde, No. 692), and a sheet of studies then attributed to Giulio Romano, which came from the collections of Lely and the elder Richardson (*ibid.*, No. 787), which he bought at the sale of William Mayor's collection in 1874; but on the same occasion he made some acquisitions of a much more remarkable kind, namely three drawings by early German masters: the *Head of an old Man* by Schongauer (Schilling, No. 53), a drawing of *St. Conrad* by a close follower of Hans Baldung Grien (*ibid.*, No. 6), and the magnificent *Madonna and Child on a grassy bank* by Dürer (*ibid.*, No. 21). He was probably also responsible for buying the Dürer drawing of a *Greyhound* (*ibid.*, No. 20), which, like the Polidoro mentioned above, had been in the collections of Sandby and Lawrence.

In 1845 his predecessor, Glover, had acquired for the Royal Collection an important group of drawings by Hogarth from the Standly collection, but Holmes' purchases of English drawings were much more imaginative. They included Isaac Oliver's full-length *Portrait of Queen Elizabeth*, which had previously belonged to Dr. Mead (Oppé, *English Drawings*, No. 457), and a large series of water-colours by Paul Sandby from the Banks sale in 1876. It was probably also owing to his initiative that

66. Many of these are catalogued in Puyvelde's *Dutch Drawings at Windsor Castle*, but a number of others, which were till recently framed and hung at Buckingham Palace, were omitted and will be discussed in the new catalogue of Dutch and Flemish drawings which is to be prepared by Mr. Christopher White.

One curious item presented to George IV by John Mangles of Hurley, Berkshire, was a volume of water-colours of flowers by Alexander Marshal, who appears to have been an English artist working about 1660 to 1690. Some pages from the book were reproduced in W. Blunt, *Tulipomania*, London, 1950.

four drawings by Blake were added to the collection, since he had been in his youth connected with the Pre-Raphaelites and had probably been influenced by their admiration for the artist.[67]

During the reign of Queen Victoria many drawings and water-colours were commissioned to commemorate episodes connected with the Royal Family or were presented by other sovereigns. Among the latter are the volumes of water-colours recording Queen Victoria's journeys to France in 1843 to stay with King Louis-Philippe at the Château d'Eu, and in 1855 to visit the Emperor Napoleon III. Though not great works of art, these water-colours by Eugène Lami and other French artists provide a unique record of these occasions.[68]

The Prince Consort did not apparently add many new drawings to the collection, but he was deeply interested in it and himself worked out a scheme for the reorganization of it on more modern lines. He began to carry out this scheme in 1853, when he set about completing the great collection of engravings after Raphael, which remains of vital importance to scholars and has recently been handed over on long loan to the British Museum Print Room. This was, however, to be a first step in the reorganization of the whole collection of prints and drawings. The latter were to be taken out of the volumes in which they had been bound up in the reign of George III and rearranged by artists and put in cases. It is said that the existing iron-boxes were invented by the Prince Consort, but most of the actual breaking up of the volumes was done long after his death. Unfortunately, in the process the original order was in many cases lost, and it has therefore been a matter of extreme complexity to relate the drawings to the old Inventory. In many cases this has been possible, but in some the confusion was so great that the connection could not be re-established.

67. Blake is frequently said to have been for a short time drawing-master to the daughters of George III, but there does not seem to be any foundation for this statement. This may, however, have been Holmes' special reason for wanting to add drawings by Blake to the Royal Collection.

68. See A. Blunt, *French Drawings*, Nos. 364 ff.

GERMAN DRAWINGS

CATALOGUE

GERMAN DRAWINGS

For the provenance of the German drawings see Introduction, pp. 15, 17.

ERHARD ALTDORFER
(c. 1480–c. 1561)

1. ST. GEORGE AND THE DRAGON (*Plate 7*) (12184)

179 × 133 mm. Pen and black ink heightened with body-colour, on olive-green prepared paper.

O. Benesch and A. Auer (*Historia Friderici et Maximiliani*, Berlin, 1957, p. 131, No. 27) attributed this drawing to the 'Master of the Historia Friderici et Maximiliani', an able follower of Albrecht Altdorfer. They compared it with a chiaroscuro drawing of the *Resurrection* at Erlangen, dated 1514 (see F. Winzinger, *Albrecht Altdorfer Zeichnungen*, Munich, 1952, Pl. 138). In his book on Altdorfer's drawings, however, Winzinger brings together a group of drawings which he ascribes to the master's brother, Erhard, and in a later article (*Wiener Jahrbuch für Kunstgeschichte*, XVIII (XXII), 1960, p. 20) he adds the Windsor drawing to the group. K. Oettinger ('Altdorferstudien', *Erlanger Beiträge für Sprach- und Kunstgeschichte*, III, 1959, pp. 85, 107) dates the drawing 1506–7, but 1510 is perhaps more likely.

JOHANN AMAN
(1765–1834)

2. THE TEMPLE OF VESTA (19312)

345 × 294 mm. Pen and brown wash. Inscribed: *Tempio restaurato di Vesta*, and signed: *d. Giov. Aman Archit. d. Princ. d. St. Biagio.*

It is not clear what temple is meant, as the drawing does not seem to correspond exactly to either of the famous circular temples traditionally called Temples of Vesta in Rome and at Tivoli.

JOST AMMAN
(1539–91)

3. ALLEGORICAL FIGURE OF ASTROLOGIA (*Plate 12*) (12186)

182 × 130 mm. Cut at top and bottom. Pen and black ink. The monogram *IA* added in brown ink by another hand.

4. ALLEGORICAL FIGURE OF TEMPERANCE (*Plate 13*) (12187)

166 × 122 mm. Cut at top and bottom. Pen and reddish-brown ink. The monogram *IA* added by another hand.

The attribution of the two drawings can be supported by comparison with early works, such as a similar allegorical figure in the Graphische Sammlung, Kunsthaus, Zurich, representing a female nude sitting beside the fragment of a column (reproduced in Kurt Pilz, *Die Zeichnungen und das graphische Werk des Jost Ammann. Die Frühzeit 1539–1565*, Zurich, 1933, No. 5).

GERHARD JUSTUS ARENHOLD
(d. 1775)

5. ALLEGORY IN HONOUR OF QUEEN ANNE (13278)

282 × 184 mm. Pen and black ink, dark grey wash. Signed: *G. J. Arenhold.*

The Queen, seated on a throne, holds on her lap a cornucopia and a bowl of coins, and in her right hand a staff, surmounted by the cup of liberty. At the foot of the throne stand two nude tattoed savages, and on the left the figure of Protestant Religion with a flaming sword, defending a model of St. Paul's against a serpent writhing at her feet amidst the emblems of popery. In front, to the right, a shield supported by a lion and a unicorn.

Arenhold, who died in Hanover, was an amateur draughtsman of portraits for German engravers.

Studio of HANS BALDUNG GRIEN

6. ST. CONRAD (*Plate 10*) (12185)

288 × 149 mm. Pen and brush, black ink and body-colour on dark brown prepared paper. Signed in white with the monogram *HBG* and dated *1520*. A repetition of the monogram in white at the top by another hand.

From the collection of Th. Dimsdale (Lugt 2426) and W. Mayor (Lugt 2799). Exhibited in London in 1874 after his death (No. 271).

The *St. Conrad* was first published by G. v. Térey (*Die Zeichnungen des Hans Baldung Grien*, Strasbourg, 1894–96, p. 61) as by a pupil of Baldung. A group of five of his drawings is attributed in C. Koch's standard work (*Die Zeichnungen des Hans Baldung Grien*, Berlin, 1941, pp. 202 f., Nos. A 28, A 29, A 29a, A 29b, A 29c) to an Alsatian master. His style is recognizable as that of the painter of the Saints on the four wings of the Altar with the Baptism of Christ in Frankfort (cf. H. Curjel, *H. Baldung Grien*, Munich, 1923, p. 152, No. 4, and H. Weizsäcker, *Die Kunstschätze des Dominikanerklosters in Frankfurt a.M.*, Munich, 1923, p. 245 f.).

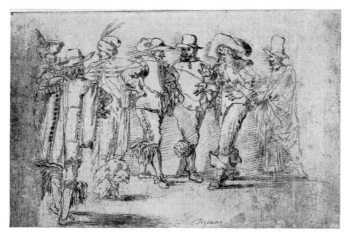

Fig. 1 Cat. No. 7 Fig. 2 cf. Cat. No. 7

JOHANN WILHELM BAUR
(c. 1600–40)

7. A GROUP OF FIGURES IN CONVERSATION
(*Fig. 1*) (6462)

166 × 250 mm. Pen and brown ink.

The attribution is based on the close similarity to a
drawing (*Fig. 2*) in the Fitzwilliam Museum, Cambridge,
inscribed *Guglielmo baur* (PD 28–1958), and to the figures
in Baur's engravings. It is confirmed by J. E. von Borries,
who is preparing a monograph on Baur.

Another very similar drawing, certainly also by Baur, is
in the Biblioteca Reale, Turin, where it is attributed to
Agostino Carracci (cf. A. Bertini, *I disegni italiani della
Biblioteca Reale di Torino*, Rome, 1958, No. 84).

ANTONIO DANIELE BERTOLI
(1678–1743)

8. COSTUME STUDY OF A YOUNG CAVALIER (13104)

257 × 174 mm. Pen and brush and grey ink.

Count Bertoli, born at Udine, lived at the Viennese Court
from 1707 onwards as a Gallery inspector, painter and
designer of theatrical costumes. The attribution of this
drawing to him is based on its similarity to studies in a
volume in the Hofbibliothek, Vienna (cf. A. D. Bertoli,
Recueil de 283 costumes de théâtre, *Denkmäler des Theaters*, ed.
F. Gregor, III, Vienna, n.d.).

Circle of JOHANN BOCKSBERGER
THE YOUNGER
(1550–1600)

9. ST. GEORGE AND THE DRAGON (*Plate 14*) (12170)

295 × 211 mm. Pen and brush, brown ink.

The draughtsman is one of the Bavarian Romanists of the
late sixteenth century. There is a certain affinity to the
pen-drawings of Johann Bocksberger the Younger, for
instance, *The Quartering of M. Suffetius* (Schlossmuseum,
Weimar).

JÖRG BREU THE YOUNGER
(1510–47)

10. A GROUP OF EIGHT DIGNITARIES, KNEELING
IN PRAYER (*Fig. 3*) (12958)

256 × 256 mm. Pen and ink.

This drawing was catalogued by Puyvelde (*Flemish
Drawings*, No. 186) as by an anonymous Flemish artist
of the sixteenth century, but it has been convincingly
attributed to Jörg Breu by J. Byam Shaw, on the basis
of its similarity to miniatures in a manuscript at Eton,
signed by Breu (cf. *Antiquaries Journal*, XV, 1935, p. 445).
The illustration with the story of Lucretia (Pl. LXVIII), in
which the main composition is also framed by Corinthian
columns, seems nearest in style. The small crowd of round-
headed figures in the background recalls the types of the

Fig. 3 Cat. No. 10

Windsor drawing, which may be dated after 1543. So far the subject remains unexplained. The drawing may have served as a sketch for a book-illustration or a miniature.

DANIEL NICOLAUS CHODOWIECKI
(1726–1801)

11. AN ALLEGORICAL FIGURE (12161)

109 × 116 mm. Pen with washes of sepia and black ink.
A winged figure standing under a tree, holding in her left hand a crown and wreath, in her right a spear. Presumably a design for an engraving.

12. FREDERICK THE GREAT (*Plate 19*) (12158)

124 × 90 mm. Water-colour.
The portrait of the King in profile to left is set in a grey circular frame with military emblems.
The water-colour resembles a print by Bergler after Chodowiecki, dated 1777, showing the King in profile to left, but on horseback. Chodowiecki's engraving of Frederick reviewing his troops in 1778 may also derive from the drawing. The profile of the King and the hair-style correspond to the engravings listed by W. Engelmann, *Daniel Chodowiecki's sämmtliche Kupferstiche*, Berlin, 1926, under Nos. 200, 200a.

13. BUST OF A BALD MAN (12163)

148 × 133 mm. Oval. Red chalk.
The drawing is apprently after a marble bust.

14. A YOUNG MAN WITH A WALKING-STICK
(*Plate 20*) (12160)

177 × 141 mm. Pen, brush and Indian ink.

After
DANIEL NICOLAUS CHODOWIECKI

15. PORTRAIT OF VOLTAIRE, STANDING BY A TABLE (12156)

223 × 114 mm. Pen and black ink over pencil, with touches of body-colour.

16. PORTRAIT OF A MAN, NEARLY FULL FACE, WITH A HAT (12159)

177 × 141 mm. Brush, sepia and Indian ink over pencil.

Attributed to
DANIEL NICOLAUS CHODOWIECKI

17. HEAD OF A WOMAN, FULL FACE, WITH HIGH COIFFURE AND FLAT HEADDRESS (12164)

150 × 119 mm. Water-colour with touches of body-colour and pencil.

18. HEAD OF A WOMAN IN PROFILE TO LEFT, WITH SIMILAR COIFFURE AND HAT (12165)

149 × 116 mm. Water-colour with touches of body-colour and pencil.
These water-colours correspond to two engravings of the 'Coiffures de Berlin' by D. Chodowiecki (Engelmann, *op. cit.*, No. 195b). There are slight differences in the prints which are executed in the same sense as the drawings, but the exact relation of the drawings to the engravings is not clear.

FRANCIS CLEYN
(1582–1658)

19. THE ADORATION OF THE SHEPHERDS (*Plate 18*) (12960)

Circular, diameter c. 205 mm; cut at top and bottom. Black chalk, pen and brown ink, with grey wash, heightened with white chalk on greenish-grey paper. Signed: *F. Clei . . .*
The name seems to be in the same ink as that used for the drawing, a fact which indicates that it is a signature and not an inscription added later. Moreover, the drawing has considerable similarity to one of an allegorical composition by Cleyn in the British Museum (cf. E. Croft-Murray and P. Hulton, *Catalogue of British Drawings*, p. 285, No. 1, Pl. 99) and to one in the Louvre (cf. L. Demonts, *Inventaire général, Écoles Allemande et Suisse*, Paris, 1937–38, II, No. 485).

ALBRECHT DÜRER
(1471–1528)

20. A GREYHOUND (*Plate 4*) (12177)

145 × 196 mm. Brush and black ink. Watermark: bull's head with cross and serpent (Briquet 15 375, Vicenza 1494).
Collections P. Sandby (Lugt 2112) and Th. Lawrence (Lugt 2445).
This greyhound is the only surviving study for the engraving of *St. Eustace* (B. 57). For this engraving, with its finely executed landscape, we may assume that a drawing existed, corresponding more or less to the elaborate study for the *Pupila Augusta* (cf. No. 23). The study of a dog appears to be based on a sketch after nature. It is slightly larger than the animal appearing in the engraving and is in the reverse sense, though the light comes from the same direction. In the drawing the animal is more powerfully modelled, especially the lower parts. The drawing is a rare example of Dürer's skill in using the point of the brush like a pen. The approximate date of the engraving, and presumably of the drawing, is 1500 (cf. F. Winkler, *Die Zeichnungen Albrecht Dürers*, Berlin, 1936–39, I, No. 241; E. Panofsky, *Albrecht Dürer*, Princeton, 1948, II, No. 1321; C. Dodgson, *Albrecht Dürer*, London, 1926, No. 32, and J. Meder, *Dürer Katalog*, Vienna, 1932, No. 60).

21. THE VIRGIN AND CHILD ON A GRASSY BANK, CROWNED BY AN ANGEL (*Plate 2*) (12176)

276 × 205 mm. Pen and black ink. Inscribed with Dürer's monogram and the date *1515*, not in the hand of the artist.
From the W. Mayor collection. Exhibited in London in 1874 after his death (No. 168).

The date 1515, though not in Dürer's hand, seems on stylistic grounds to be correct. It may have been put on the drawing to replace a date and monogram cut off from the bottom (cf. Flechsig, *Albrecht Dürer*, Berlin, 1928–31, II, p. 345). Some historians, however, believe that the drawing should be dated 1519 (cf. E. Bock, *Zeichnungen in der Universitatsbibliothek Erlangen*, Frankfort am M., 1929, No. 172; H. and E. Tietze, *Kritisches Verzeichnis der Werke Dürers*, Basle and Leipzig, 1928–38, II, i, p. 139, No. 741, and E. Panofsky, *op. cit.*, II, No. 682). A contemporary copy of this study of the Virgin by the monogrammatist NS in Erlangen, dated 1524, is evidence of its early fame.
The drawing is also discussed by the following authors: E. Heidrich (*Geschichte des Dürerschen Marienbildes*, Leipzig, 1906, pp. 112 ff., Pl. p. 111); Ch. Ephrussi (*Albrecht Dürer et ses dessins*, Paris, 1882, pp. 190 f.); F. Lippmann (*Zeichnungen von Albrecht Dürer*, Berlin, 1883–1929, No. 390); H. Wölfflin (*Dürer Handzeichnungen*, 9th edition, Munich, No. 57); F. Winkler (*op. cit.*, III, No. 534, and *Albrecht Dürer*, Berlin, 1957, p. 259).

22. THE VIRGIN AND CHILD IN A LANDSCAPE, ENTHRONED ON A GRASSY BANK. AN ANGEL BELOW, PLAYING THE LUTE (*Plate 3*) (12180)

305 × 214 mm. Slightly cut all round. Pen, black and brown ink. The fragment of the monogram *AD* and date *1519* are by the master.

Like the preceding drawing, the composition is among the most beautiful Madonnas in Dürer's new Italian mood. A direct connection with Dürer's second journey, 1505, has been pointed out by Heidrich (*op. cit.*, pp. 130 ff.). The drawing is related to the Madonna in the centre of the *Feast of the Rose Garlands* at Prague. The Virgin appears in the same upright position, seen from below, with the Child leaning over to the side.
The pen-work of the drawing in black ink shows embellishments and corrections in brown, which can even be noted in a black and white reproduction. These alterations are particularly visible in the hair of the Madonna and the Child, and in the curls of the angel. The left arm of the Child has been strengthened.
See also the following authors: M. Thausing (*Albert Dürer, His Life and Works*, London, 1882, II, p. 135); Ch. Ephrussi (*op. cit.*, p. 192); F. Winkler (*Die Zeichnungen...*, III, No. 536, and *Albrecht Dürer, op. cit.*, p. 259, Pl. 130); H. Wölfflin (*op. cit.*, No. 55); H. Tietze and E. Tietze (*op. cit.*, II, i, p. 139, No. 740, and 'Ein Beitrag zu Dürers grossem Adorationsbild von 1521–22', *Jahrbuch der Kunsthistorischen Sammlungen in Wien*, N.F., 1932, p. 121), and E. Panofsky (*op. cit.*, II, p. 139, No. 680).

23. PUPILA AUGUSTA (*Plate 1*) (12175)

250 × 194 mm. Pen and ink. Signed by Dürer with his reversed monogram and dated by another hand *1516*. Watermark: Large bull's head (Briquet 4773).

This drawing has recently been discussed in detail by the present author in an article ('Dürers "Pupila Augusta"', *Zeitschrift des Deutschen Vereins für Kunstwissenschaft*, XXII, 1–2, 1968, pp. 1 ff.).

The drawing, planned as the model for an engraving—the monogram and the inscription are reversed—is an early example of humanist influence on a northern artist and shows Dürer's veneration for the art of the Italian Renaissance. It was made about 1500 in Nuremberg, in the circle of humanists centring on Willibald Pirckheimer, to which Dürer belonged.
The inscription 'Pupila augusta' means 'august ward' and, according to G. de Tervarent (*Burlington Magazine*, XCII, 1950, p. 198), the youthful Venus was honoured with this name, but the subject of the drawing has never been fully explained. The group on the dolphin represents Venus Marina, sailing towards the coast of Cyprus with her two companions. Hesiod, *Theogony*, and the *Homeric Hymn* vi, *To Aphrodite* (*Hesiod and the Homeric Hymns*, Loeb Classical Library, pp. 903 and 427 respectively), describe three Graces, joyfully awaiting the arrival of Aphrodite or the shore; the goddess is in their care, she is 'Pupila Augusta'. But the scene represented by Dürer is not one of joyful greetings. His three women on the shore are seers, engrossed in the performance of their rites, to whom the goddess appears as a vision. Two attributes of Venus, not mentioned by Hesiod, are shown on the right of Dürer's drawing: the basket bearing the goddess' name and the putto pursuing the hare, the symbol of fertility. The fence by the tree marks the boundary of a sanctuary.
In this context Otto Kurz called my attention to the *Erotes* described by Philostratus the Elder in his *Imagines*. Although Dürer cannot have illustrated this text, it has something in common with the mood of his drawing and throws some light on the details of the drawing. The writer describes nymphs in their sanctuary in an orchard full of apple trees by a spring. The sanctuary, the nymphs and their children, the erotes, are dedicated to Aphrodite. The children play, gather apples, and chase a hare. Offerings to the goddess, inscribed with her name, are hung up in the sanctuary. The standing basket with the putti on Dürer's drawing is also an offering. Philostratus' nymphs anticipate the arrival of the goddess, to them, as to the seers on Dürer's drawing, she appears as a vision.
In content and form the *Pupila Augusta* is a *ricordo* of Dürer's first journey to Italy in 1494–95 and combines his impressions of nature and of works of art. In this highly sophisticated composition Dürer makes use of his own drawings as well as of engravings he had brought from Italy. The landscape springs from the imagination of a northern artist, and the trees belong to the repertory of Dürer's early woodcuts. The architecture of the town on the hill derives from Dürer's view of the valley of Trent (Winkler, *op. cit.*, III, No. 96), single buildings are taken from his water-colour of Innsbruck (*Ibid.*, No. 66). The northern artist had no studies of his own for the nudes, so Italian engravings had to serve. Three of them can be identified: an engraving by a Ferrarese master with the inscription *Pupila Augusta* (L. Vitali, 'Stampe italiane alla mostra di Zurigo', *Bollettino d'Arte*, XXXIV, 1949, IV, p. 368, Pl. 3), a *niello* by Peregrino (A. M. Hind, *Nielli, chiefly Italian of the XVth century, preserved in the British Museum*, London, 1936, No. 221a, Pl. XXXVII), and an engraving by Girolamo Mocetto, from which the main figure in the foreground of Dürer's drawing may be taken (J. Meder, 'Neue Beiträge zur Dürerforschung', *Jahrbuch*

der Kunstsammlungen des allerhöchsten Kaiserhauses, XXX, 1911, p. 218).

The *Pupila Augusta* is the largest and perhaps the most instructive example of a final drawing for an engraving, destined for transfer to the copper-plate. Few others have survived, and they are mostly small. The proofs of Dürer's prints give evidence of the method of transfer of a composition to the copper-plate. The process began by tracing the outlines. Single studies were often joined together in the large preparatory drawing. J. Meder, (*op. cit.*, p. 218) observed that signs of tracing are still visible on the figures in the foreground of the *Pupila Augusta*, and this is why some lines, which the master has re-drawn with the pen, seem wavering. The composition was begun with the left foreground figure, then the two companions followed. The bare trees gave the frame of the landscape, and the group with Venus was placed at its centre. Only then were the details filled in, but certain parts of the foreground remained empty, and the work seems to have come to a halt.

Dürer adapted the Italian engravings he used. So, for example, Peregrino's engraving shows the group of the goddess with her two companions on two dolphins on the high seas, and the storm ruffles the draperies of her two companions. In Dürer's drawing the waters are calm, only the left companion of Venus seems shaken by the wind, and her pose can hardly be understood without a knowledge of the engraving.

Dürer improved on the second engraving which he used, that representing the recumbent soothsayer. The name 'pupila augusta', which there appears in the clouds, is placed on the basket with putti. The putti are differently grouped, and the attitude of the recumbent figure is changed. Only the motive of the third engraving, which Meder considers the prototype for the main figure in the foreground, bears any resemblance to Dürer's drawing, and it may well be that he was inspired by another engraving.

For nearly two decades the unfinished *Pupila Augusta* lay in Dürer's portfolio. It was not till 1519 that the drawing, which was too valuable to be left aside, was partly used for the engraving of *St. Anthony* (E. Flechsig, *op. cit.*, 1931, II, pp. 101 ff.). With the help of a tracing taken from the right-hand upper part of the drawing, Dürer produced a new sketch for the *St. Anthony*. The town which appears in the distance in the oblong composition of the *Pupila Augusta* becomes the main setting of the new composition, set near the figure of the saint. Some corrections in faded ink are visible in the *Pupila Augusta* on the tree on the right and on a pointed roof, and these were used by Dürer in the engraving.

A comparison of the engraving of *St. Anthony* with the *Pupila Augusta* can give us a deep insight into Dürer's mode of creation, and the question arises why the drawing, which was so painstakingly composed, remained unfinished. The solution to this problem may be found by looking at the drawing as it would have appeared reversed in the engraving. Seen in this way, the female figures are all left-handed, a disturbing notion which has no parallel in Dürer's art. His figures are always right-handed, and he is always concerned with the correctness of their gestures. When quickly building up the whole composition from single studies, Dürer must have taken over the right-handed figures from the models without considering that they would have to be reversed for his engraving. This may be the reason why the drawing remained unfinished and the engraving was never executed.

For a full bibliography see the author's article quoted at the head of this entry.

After ALBRECHT DÜRER

24. ST. EUSTACE (12178)

399 × 294 mm. Black chalk.

This and the following drawings are listed in Inventory A, p. 14: 'Albert Dürer e Maestri Antichi Div[si]'.

After Dürer's engraving (B. 57) by a northern sixteenth-century draughtsman, who must have used a poor print as a model.

25. THE FOUR HORSEMEN OF THE APOCALYPSE (12181)

302 × 253 mm. Pen and brown ink.

A detail after the woodcut (B. 64), rather stained and faded. By an unidentified northern artist of the sixteenth century.

26. THE BETRAYAL OF CHRIST (12182)

388 × 267 mm. Pen and bistre. With a Dürer monogram in black ink.

A free copy from the *Large Passion* (B. 7), on late sixteenth- or seventeenth-century paper, perhaps by a Dutch master in the manner of Jan Swart.

27. CHRIST OPENING THE GATES OF HELL (6327)

192 × 173 mm. Pen and brown wash, heightened with body-colour. Inscribed *AD* in black chalk.

The draughtsman has combined elements from Dürer's woodcuts from the *Large Passion* (1510, B. 14) and from the *Little Passion* (1511, B. 41). The nationality of the author is difficult to determine, but there is a strong Italian flavour about the drawing. It may have been used for stained glass or decorative painting.

School of ALBRECHT DÜRER

28. HEAD OF A BEARDED MAN, FACING LEFT
(*Plate 5*) (12174)

110 × 78 mm. Pen and brown ink.

The type is one familiar in Dürer's work (cf. F. Winkler, *Die Zeichunungen Albrecht Dürers*, IV, 1939, No. 758) and may in this case be a St. Joseph. It is used in Dürer's workshop as late as 1552 by Hans Beham in his *Kunst und Lehrbüchlein*.

It is difficult to date this copy, which may belong to the years after 1520, but which also shows a connection with early studies by Baldung dating from about 1508–13 (cf. C. Koch, *Die Zeichnungen des Hans Baldung Grien*, Berlin, 1941, No. 17).

Fig. 4 Cat. No. 29

HEINRICH CHRISTOPH FEHLING
(1654–1725)

29. DESIGN FOR A WALL DECORATION (*Fig. 4*) (3693)

147 × 310 mm. Pen and brown ink, brown washes. Inscribed in ink at the foot right: *fehling* (?).

Inventory A, p. 20: 'Bolognese Moderni, Tom. III Scholars of Guido, Flamino Torri and others inferior'.

The attribution is based on the name written at the bottom of the drawing, of which, however, the last two letters are not perfectly clear. The style of the drawing would fit with the facts known about Fehling, who spent some time in Venice and Rome and painted decorative frescoes in various palaces in Dresden, most of which have disappeared.

URS GRAF
(c. 1484–c. 1528)

30. YOUNG COUPLE EMBRACING ON THE SHORE OF A LAKE (*Plate 11*) (12183)

185 × 145 mm. Pen and black ink. At the bottom fragments of a monogram.

This drawing was first published by K. T. Parker, who dated it about 1514 ('Die verstreuten Handzeichnungen des Urs Grafs', *Anzeiger für Schweizerische Altertumskunde*, N.F. XXIII, Zurich, 1921, p. 217, No. 39, and *Zwanzig Federzeichnungen von Urs Graf*, Zurich, 1922; cf. also W. Lüthi, *Urs Graf und die Kunst der alten Schweizer*, Zurich, 1928, No. 934, Pl. 89; M. Pfister-Burkhalter, *Urs Graf, Federzeichnungen*, Wiesbaden, 1958, Pl. 13; H. Koegler, *Gesamtkatalog des Werkes des Urs Graf* (unpublished), No. 489, and E. Mayor and E. Gradmann, *Urs Graf*, Basle, n.d., p. 20, Pl. 29.

AUGUSTIN HIRSCHVOGEL
(1503–53)

31. THE CRUCIFIXION (*Plate 16*) (12172)

555 × 394 mm. Pen and ink. Dated *1533*. Inscribed with a forged Cranach monogram: *L C*.

The drawing was first published by Campbell Dodgson (*Vasari Society*, XVI, 1935, No. 9), who related to it a group of nine drawings similar in style which depict scenes from the Old and New Testaments, representing types and anti-types according to the arrangement in the *Biblia Pauperum*. He added to them twenty-four slight pen sketches in a manuscript of a German translation of the *Schöne Magelone*, published by Lossnitzer ('Die Schöne Magelone', *Beiträge zur Forschung, Mitteilungen Antiquariat Rosenthal*, Munich, 1914). He describes the artist as coming from South Germany or belonging to the Danube School, and as working about 1530. H. Degering (*Die Schöne Magelone*, Berlin, 1922) came nearer to solving the problem and suggested that the author must be a member of the Danube School, who worked about 1525 and must have lived, at least for a while, in Nuremberg.

Eventually E. Baumeister ('A. Hirschvogel, Meister der Windsor Kreuzigung', *Münchner Jahrbuch der bildenden Kunst*, N.F., XIII, 1938–39, 4, p. 203) found the correct attribution of the *Calvary* and the whole group of drawings connected with it, giving it to the Nuremberg artist Augustin Hirschvogel by a study of the authentic works of the master in the Budapest print-room. They are all of his late period, between 1544 and 1558, when he lived in Vienna. As the Windsor *Calvary* is dated 1533, it belongs, like the group already mentioned and the Magelone illustrations, to the artist's early years, which he spent in Nuremberg (1503–36).

The other drawings from this period are at Basle, in the

British Museum, in the Killermann collection, Regensburg, and formerly in the Koenigs collection.

The elaborate composition of the *Calvary* looks rather like a cartoon for a painting, but as Hirschvogel does not seem to have produced any pictures, it may have been destined for a fellow artist or a patron.

HANS HOLBEIN THE YOUNGER
(1497/8–1543)

PORTRAIT OF COLET (Parker, *Holbein Drawings*, No. 59) (12199)

Sir Karl Parker rejected the identification of the sitter as Colet, but Dr. F. Grossmann has convincingly shown that the drawing was made after the bust of the Dean by Torrigiano belonging to St. Paul's School (cf. *J.W.C.I.*, XIII, 1950, p. 202).

After WOLF HUBER
(c. 1490–1553)

32. LANDSCAPE WITH A TIMBER BRIDGE (3544)

188 × 136 mm. Cut at the top and on the right. Black ink faded to brown.

A free copy of a drawing dated 1515 in the Munich Print-Room (reproduced in *Handzeichnungen Alter Meister in dem Münchener Kupferstich Kabinett*, ed. W. Schmidt, Munich, 1884–1900, VIII, Pl. 145a), which is considerably larger (211 × 160 mm.).

FRANZ CHRISTOPH JANNECK
(1703–61)

33. A DRINKING PARTY IN A PALACE (*Fig. 5*) (6653)

287 × 385 mm. Red chalk.

The attribution is due to Professor Otto Kurz.

Fig. 5 Cat. No. 33

FERDINAND KOBELL
(1740–99)

34. AN ARCHWAY BY A HOUSE IN A MOUNTAINOUS LANDSCAPE WITH A RIVER (6642)

178 × 353 mm. Pen and black wash with red chalk.

WILHELM VON KOBELL
(1766–1853)

35. COTTAGE WITH A MAN AND A WOMAN OFFERING ALMS TO A BEGGAR-WOMAN (12145)

400 × 360 mm. Water-colour.

36. FIGURES AND HORSES OUTSIDE AN INN (12146)

403 × 360 mm. Water-colour.

Probably the 'Two drawings Farrier Shop by Kobbell £8.8.0 bought by the Prince of Wales (later George IV) from Colnaghi on October 7 1799' (Windsor Archives, Invoice 27103). The water-colours belong to the artist's early period.

'MAYER'
(19th century)

37. A WOMAN SEATED WITH HER BREAST BARE (12889)

255 × 256 mm. Black and red chalk.

The attribution presumably derives from some inscription, either on the *verso* (now laid down) or on an old mount, but the drawing cannot be associated with any of the numerous artists of this name.

MARTIN VON MOLITOR
(1759–1812)

38. WOODED LANDSCAPE WITH A RUINED CASTLE (12149)

420 × 565 mm. Brush and Indian ink. Signed: *Molitor*.

39. CLASSICAL LANDSCAPE WITH A RUINED TEMPLE (12150)

420 × 565 mm. Brush and Indian ink. Signed: *Molitor*.

JOHANN ELIAS RIDINGER
(1698–1767)

40. THE BOAR HUNT (12153)

185 × 386 mm. Pen, brush and Indian ink. Signed at the bottom: *Johann Elias Ridinger invt. et delineavit. Ao 1758*.

Preparatory study for the engraving following the series *Die Par Force Jagd eines Hirschen* (G. A. W. Thienemann, *Leben und Wirken des J. E. Ridinger*, Leipzig, 1856, p. 21, No. 67).

41. TWO HOUNDS PURSUING A ROE (DAS REHE) (12154)

219 × 252 mm. Arched top. Pen, brush, and brown ink.

Preparatory study for the series *Jagtbare Tiere*, Augsburg, 1761 (cf. Thienemann, *op. cit.*, p. 41, No. 150).
This and No. 42 are said to have been acquired in Windsor in 1900.

42. HOUNDS ATTACKING A WHITE STAG (DER WEISSE THANN HIRSCH) (12155)

220 × 251 mm. Arched top. Pen and brush, brown ink. Signed: *J. E. Ridinger 1754*.

Preparatory study for the series *Jagtbare Tiere*, Augsburg 1761 (cf. Thienemann, *op. cit.*, p. 40, No. 146).

43. THE RETURN TO THE PALACE (12152)

345 × 492 mm. Pen, brush, and Indian ink. Signed in ink at the bottom right: *J. E. Ridinger.*

HERMAN TOM RING
(1521–96)

44. CHRIST AND HIS DISCIPLES ON THE SEA OF GALILEE (*Plate 15*) (5068)

202 × 184 mm. Brush and brown wash, on brown prepared paper, heightened with body-colour.

In their biography of Herman tom Ring, T. Riewerts and P. Pieper (*Die Maler tom Ring*, Munich, 1955, pp. 102 f., Nos. 90–99) list only ten drawings. They are *modelli* or studies for altarpieces and are all executed in more or less the same technique, pen and grey wash. No first sketches by this master seem to have survived. The Windsor drawing differs slightly from the *modelli* in technique and style. The brush-strokes are more refined and are enriched by heightening in white. Nevertheless, the drawing may be connected with two compositions in the Brunswick museum (Riewerts-Pieper, Nos. 91 and 92), which also show episodes from Christ's sojourn in Galilee, *Christ appearing to his Disciples on the shore of the Sea of Galilee* and *The calling of St. Andrew and St. Peter*. In the Windsor drawing tom Ring shows only eight disciples, and its upright composition does not correspond to the horizontally arranged scenes in Brunswick. It might be a fragmentary sketch for a later version. The position of the boats on the left-hand side of the two larger, documented drawings leads one to this supposition. The Brunswick sheets are signed with the artist's monogram and dated *1549*.

JOHANN HEINRICH ROOS
(1631–85)

45. TWO RAMS, ONE STANDING, THE OTHER LYING DOWN (12853)

128 × 166 mm. Black chalk. Damaged by rubbing or through the taking of a counter-proof. Signed with monogram: *J H Roos P.*

46. A STANDING SHEEP, TWO RAMS AND A SHEEP LYING DOWN (12854)

203 × 165 mm. Black chalk. A weak counter-proof damaged by rubbing. Signed: *J. H. Roos Fecit.*

PHILIPP PETER ROOS
(ROSA DA TIVOLI)
(1655/57–1706)

47. PACK-HORSES, SHEEP AND GOATS AMONG CLASSICAL RUINS (13008)

710 × 1010 mm. Red chalk, brown wash, on brown paper.

48. PEASANTS REMOVING KIDS FROM THE FLOCK (13009)

710 × 1010 mm. Red chalk, brown wash, on brown paper.

49. THE END OF THE STAG HUNT (13010)

710 × 1010 mm. Red chalk, brown wash, on brown paper.

50. THE BOAR HUNT (13011)

710 × 1010 mm. Red chalk, brown wash, on brown paper.

Inventory A, p. 158: 'Four by Monsr Rose call'd Rosa di Tivoli viz Two of Hunting and Two Pastoral'.

Similar drawings are in the Albertina (cf. A. Stix, *Beschreibender Katalog der Handzeichnungen in der Graphischen Sammlung Albertina*, IV, 1933, No. 1063), in Berlin (M. J. Friedländer and E. Bock, *Die deutschen Meister*, Berlin, 1921, No. 6335, Pl. 179), and in the British Museum.

JOHANN ROTTENHAMMER
(1564–1625)

51. THE JUDGMENT OF PARIS (*Plate 17*) (12169)

150 × 210 mm. Pen and brown ink, grey washes, heightened with body-colour, over black chalk, on pink prepared paper. Signed: *Hans Rottenhammer F. 1616.*

The drawing dates from the artist's time in Augsburg, where he settled in 1606. It is not connected with any of his numerous paintings of this subject.

HANS SCHÄUFELEIN
(c. 1480–c. 1540)

52. ST. PAUL STANDING AND HOLDING A SWORD (*Plate 8*) (12179)

295 × 192 mm. Pen and black ink. Dated *1523* in the artist's own hand; a monogram *AD* added in another hand.

Verso: St. Bartholomew with an axe in his left hand (Plate 9).

E. Buchner (Thieme-Becker, XXIX, p. 560) mentions only the drawing of *St. Paul*, but F. Winkler (*Die Zeichnungen Hans Süss von Kulmbachs und H. L. Schäufeleins*, Berlin, 1942, pp. 157 f., Nos. 65, 66) lists both *recto* and *verso*, though he has some hesitation about accepting the attribution to Schäufelein.

The principal figures are surrounded by small rapid studies of other figures. Schäufelein's characteristic round modelling pen-strokes are not to be found in these drawings, and the shading consists of areas of hatching.

MARTIN SCHONGAUER
(c. 1430–91)

53. HEAD OF A BEARDED MAN IN A TURBAN, FACING HALF LEFT (*Plate 6*) (12173)

106 × 70 mm. Pen and brown ink.

From the W. Mayor collection (Lugt 2799). Presumably sold before his death, since it does not appear in the catalogue of the 1874 exhibition.

This study was not known to Rosenberg (*Martin Schongauer, Handzeichnungen*, Munich, 1923) and was first mentioned by K. T. Parker (*Elsässische Handzeichnungen des XV. und XVI. Jahrhunderts*, Freiburg i.B., 1928, p. 28, No. 10), who groups it with six similar heads in the Louvre, with the description 'manner of Schongauer'. F. Winzinger ('Schongauerstudien', *Zeitschrift für Kunstwissenschaft*, VII, 1953, p. 25), however, attributes the drawing to Schongauer himself. It seems to form part of a pattern book, to which belong eleven other sheets, scattered in various public and private collections. They are characterized by a certain stiffness of draughtsmanship and for that reason were not at first recognized as being by Schongauer. The drawing was again mentioned by Winzinger in his monograph on Schongauer's drawings (*Die Zeichnungen Martin Schongauers*, Berlin, 1962, No. 19), but the attribution of it to Schongauer was not accepted by Rosenberg in his review of the book (*Master Drawings*, III, 4, 1965, p. 400), where he describes it as very near to the artist.

JOHANN WIRZ
(1640–1710)

54. PETER THE GREAT (12157)

153 × 104 mm. Water-colour and body-colour, on vellum.

The Emperor is shown at half-length, wearing the Order of St. Andrew.

SOUTH GERMAN ARTISTS
(late 16th century)

55. THE MIRACLE AT CANA (12166)

138 × 149 mm. Cut all round, top corners missing. Pen, brush and black ink.

Perhaps a model for stained glass.

56. THE HOLY TRINITY IN GLORY (12963)

407 × 245 mm. Pen, grey ink and water-colour.

Catalogued by Puyvelde with the traditional attribution to Denis Calvaert (*Flemish Drawings*, No. 44), but probably South German, late sixteenth century.

NUREMBERG SCHOOL
(late 17th century)

57. SWEDISH SOLDIERS FROZEN TO DEATH AFTER THE BATTLE OF COPENHAGEN, 1659 (*Fig. 6*) (12167)

175 × 126 mm. Pen and brush, Indian ink. Inscribed at the foot: *Gestalten der Erfrohrenen Schweden vor Koppenhagen, 1659, 11. Febr. Sub. Car. Gust. Cf. Francisci Lufftkreis. p. 896.*

Fig. 6 Cat. No. 57

Preparatory study for an engraving.

The inscription at the bottom of the drawing refers to *Der Wunderreiche Überzug unserer Nider-Welt oder Erdumgebende Lufft-Kreys*, Nuremberg, 1680, by Erasmus Franciscus (1627–94), a pseudo-scientific historical writer. On February 11th, 1659, Copenhagen was attacked by the Swedish army under Charles Gustavus, and in the following spring many of the attackers were found frozen in the positions in which death had overwhelmed them.

Franciscus' book was illustrated by minor Nuremberg engravers, such as J. A. Boener and Cornelis Nicolas Schurk. The drawing in the Royal Library corresponds exactly, in reverse, to an unsigned engraving in the book. It is probably by a Nuremberg artist and was no doubt made between 1660 and 1680.

SWISS SCHOOL (?)
(17th century)

58. THE GLACIER OF GRINDELWALD (*Fig. 7*)

The drawing consists of two fragments intended to be stuck together:

183 × 174 mm. Pen and black ink, grey and brown washes. (5724)

179 × 288 mm. Pen and black ink, grey and brown washes. (5725)

Fig. 7 Cat. No. 58

Both sheets inscribed: *Rotnamer*.

Inventory A, p. 119: 'A Glassiere by Rosnamek dito in the Alps'.

The site was identified by E. Holzinger as a view of the glacier of Grindelwald, and this identification was confirmed by the Bureau of Swiss Topography. The inscription is no doubt intended to indicate an attribution to Rottenhammer. The drawing is certainly seventeenth century, and is probably by a Swiss artist.

SOUTH GERMAN OR SWISS SCHOOL
(18th century)

59. LANDSCAPE WITH A RIVER (12888)

162 × 228 mm. Water-colour and body-colour.

GERMAN SCHOOL
(second half of the 18th century)

60. HEAD OF A MAN, IN PROFILE TO RIGHT (12162)

153 × 106 mm. Pen and grey ink, with black and white chalk, on blue paper.

RHENISH ARTIST
(late 18th century)

61. RESTING SOLDIERS, MERRYMAKING IN FRONT OF A SUTLER'S TENT (*Fig. 8*) (12151)

240 × 323 mm. Pen, brush, and Indian ink over black chalk. Inscribed on the roof of the tent: *Willhem. Kauffman.*

von allerlei. wein Rheinische. Burgonder. Spänische. H. E. E. C. Michmeyer durch seinen gehorsamen Diener und guten Freund Ludewick Anno 1776.

The style of the figures, especially that of the couple on the left, points to the manner of a German artist, who lived in Paris, such as Mathaeus Halm, one of the pupils of J. G. Wille. Very little is known about Halm, who was born in Coblenz and worked in Paris. He engraved after Wille *Le Concert champêtre* and *Le Goûter champêtre*, as well as portraits.

An attribution to Halm was tentatively put forward by H. Möhle.

Fig. 8 Cat. No. 61

PLATES

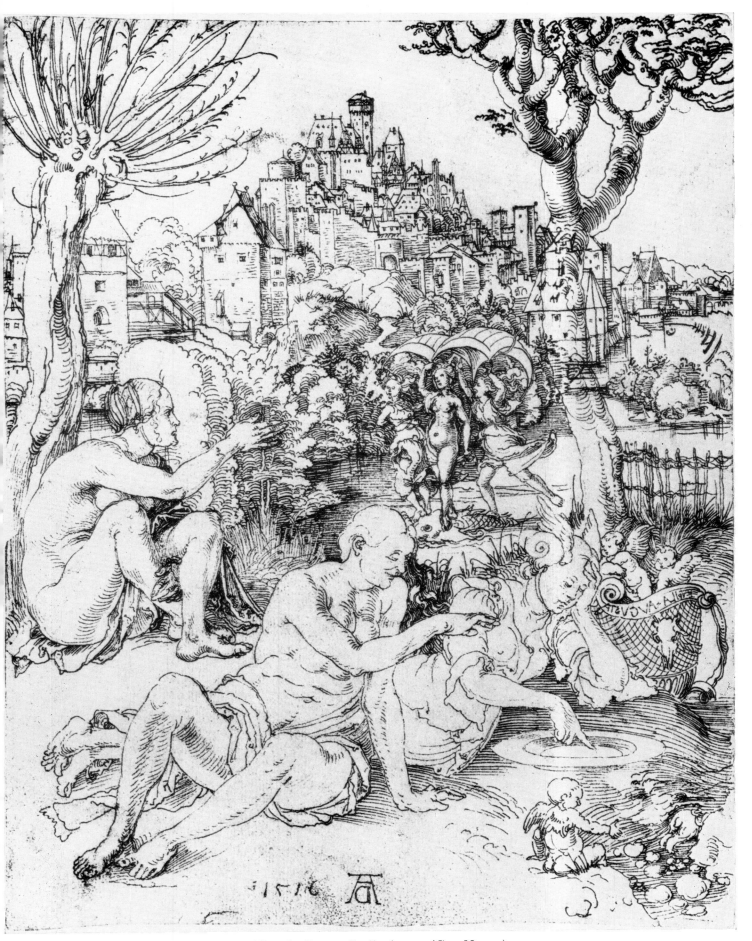

1. Albrecht Dürer: *Pupila Augusta* (Cat. No. 23)

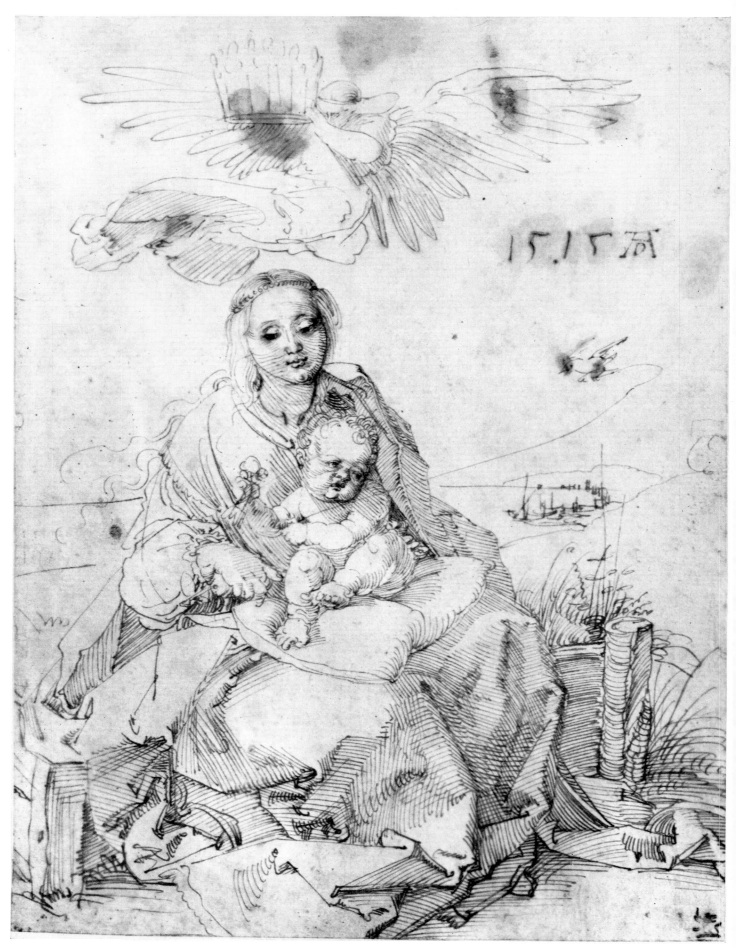

2. Albrecht Dürer: *The Virgin and Child on a grassy bank* (Cat. No. 21)

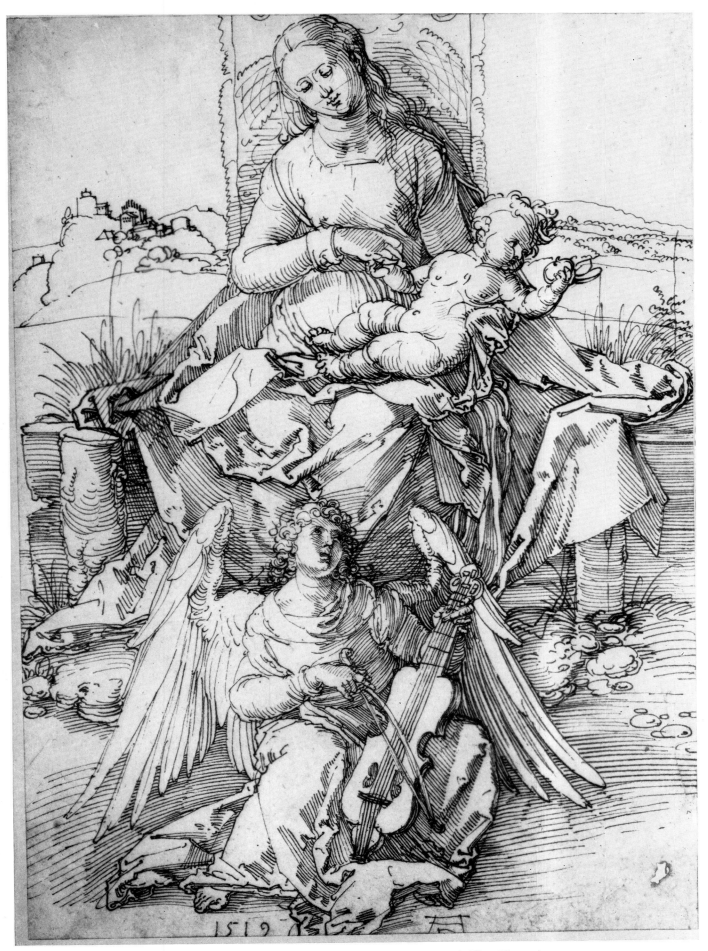

3. Albrecht Dürer: *The Virgin and Child with an angel* (Cat. No. 22).

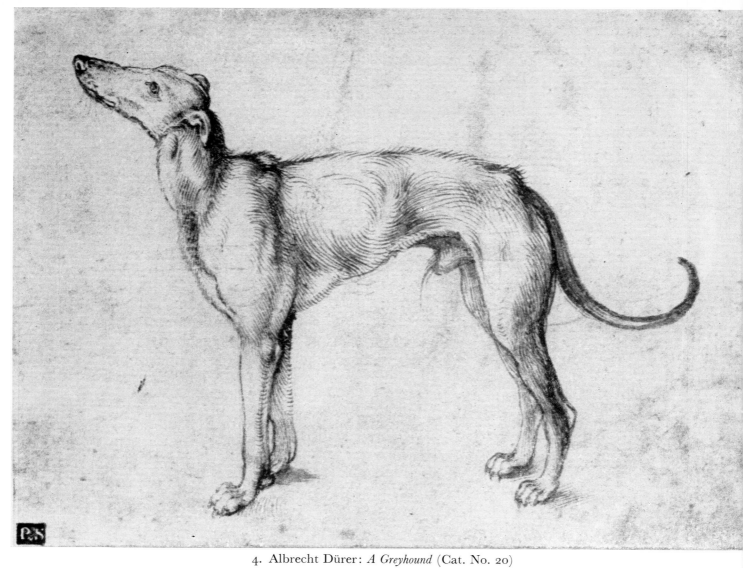

4. Albrecht Dürer: *A Greyhound* (Cat. No. 20)

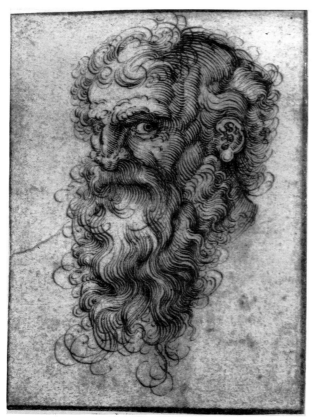

5. School of Dürer: *Head of a bearded man*
(Cat. No. 28)

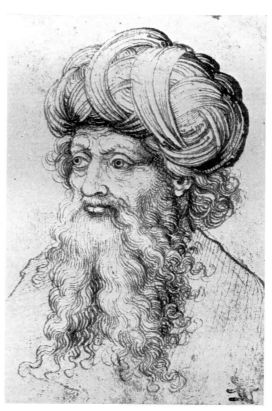

6. Martin Schongauer: *Bearded man in a turban*
(Cat. No. 53)

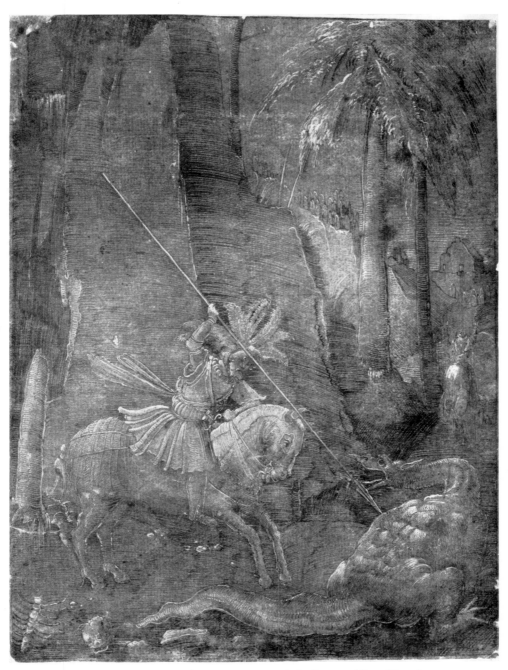

7. Erhard Altdorfer: *St. George and the Dragon* (Cat. No. 1)

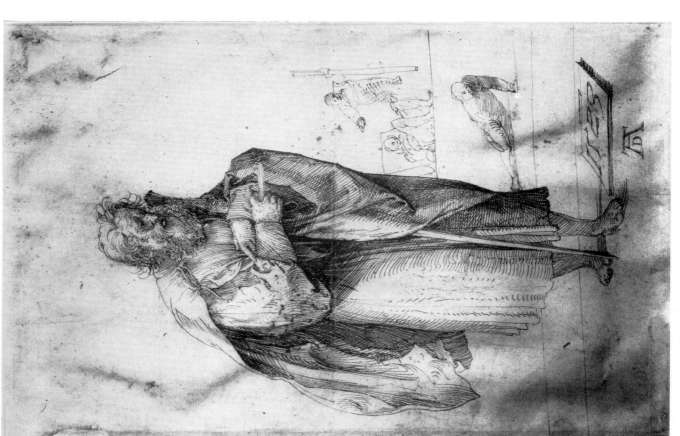

9. Hans Schäufelein: *St. Bartholomew* (Cat. No. 52 *verso*)

8. Hans Schäufelein: *St. Paul* (Cat. No. 52 *recto*)

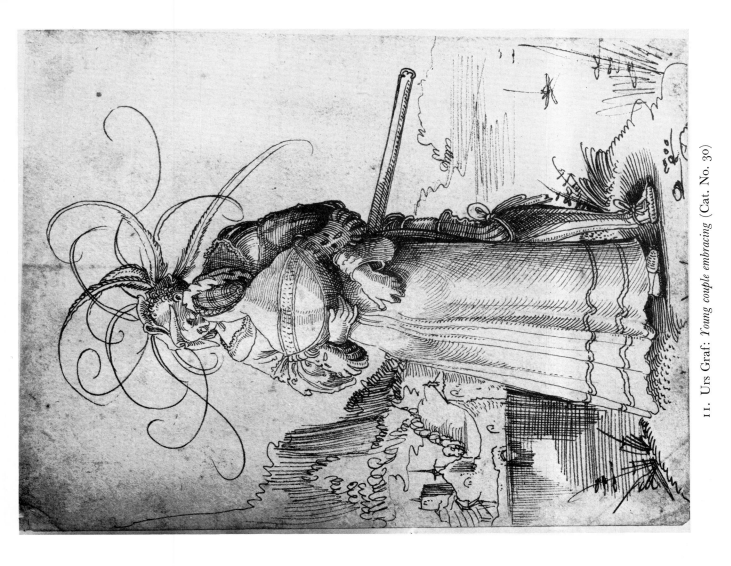

11. Urs Graf: *Young couple embracing* (Cat. No. 30)

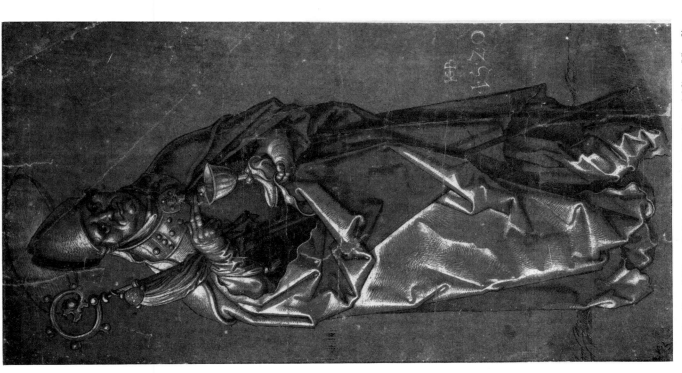

10. Studio of Hans Baldung Grien: *St. Conrad* (Cat. No. 6)

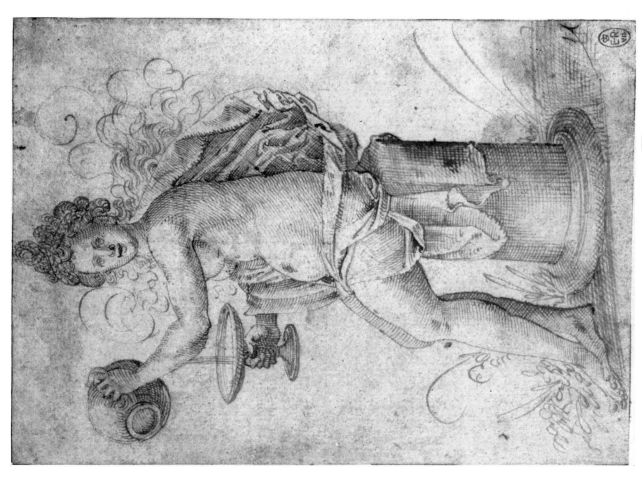

13. Jost Amman: *Temperance* (Cat. No. 4)

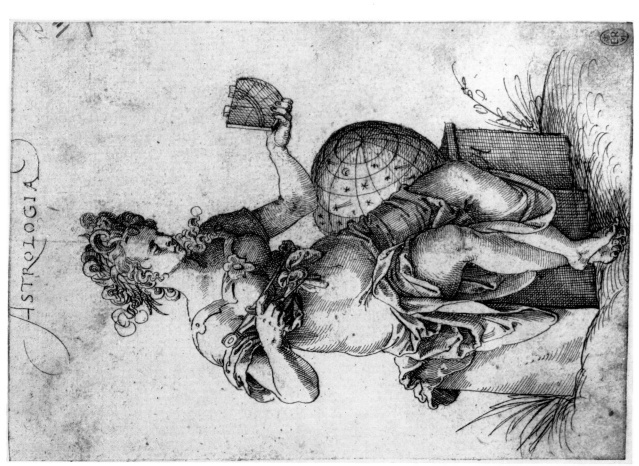

12. Jost Amman: *Astrology* (Cat. No. 3)

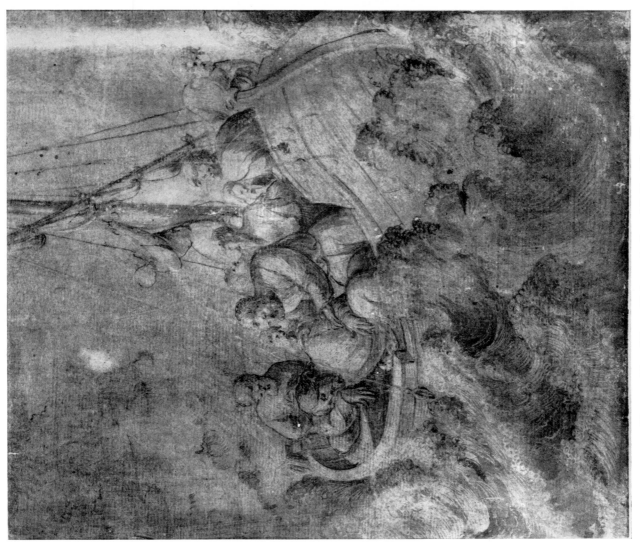

15. Herman Tom Ring: *Christ on the Sea of Galilee* (Cat. No. 44)

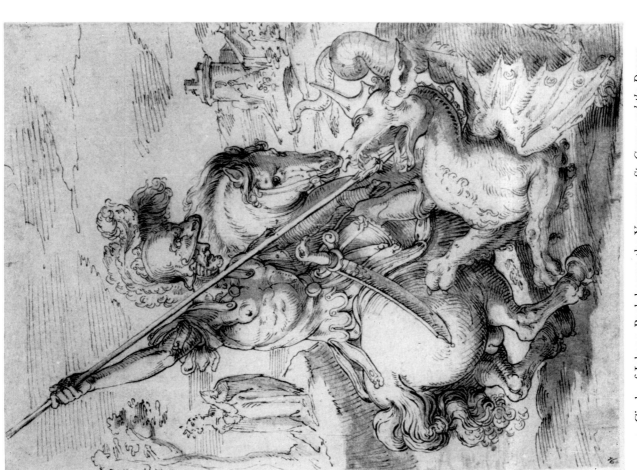

14. Circle of Johann Bocksberger the Younger: *St. George and the Dragon*
(Cat. No. 9)

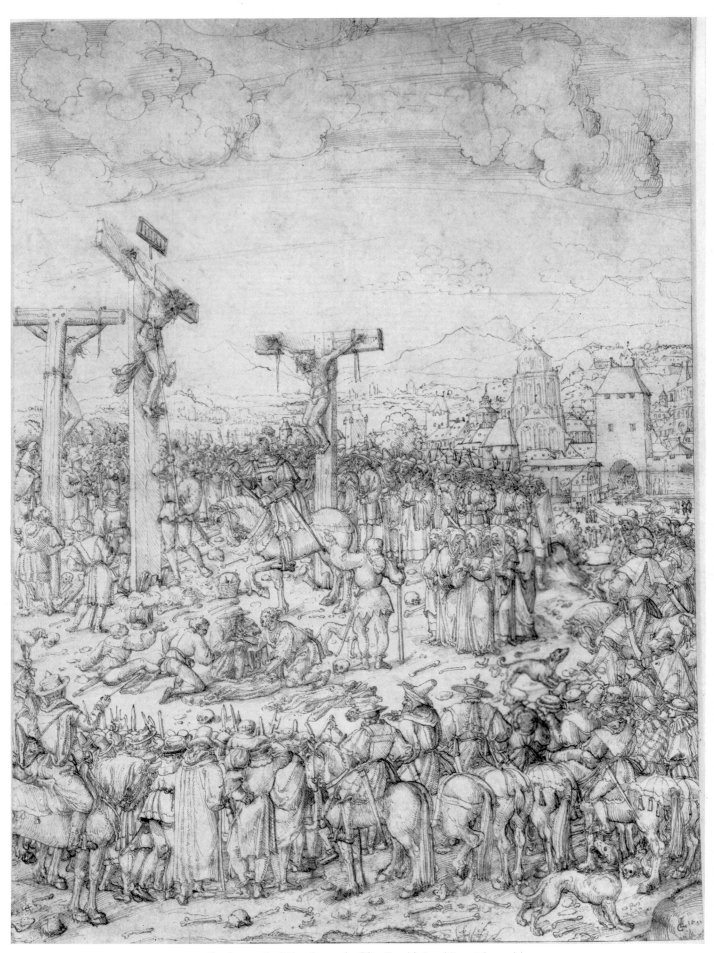

16. Augustin Hirschvogel: *The Crucifixion* (Cat. No. 31)

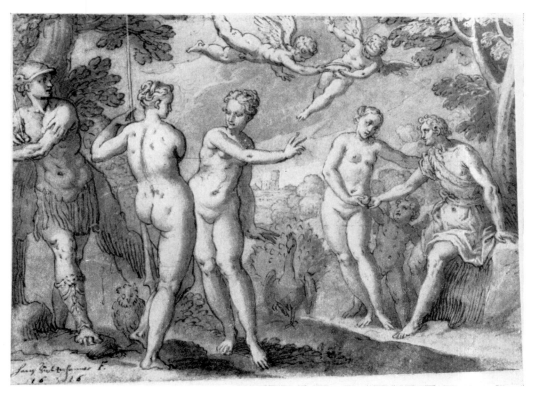

17. Johann Rottenhammer: *The Judgment of Paris* (Cat. No. 51)

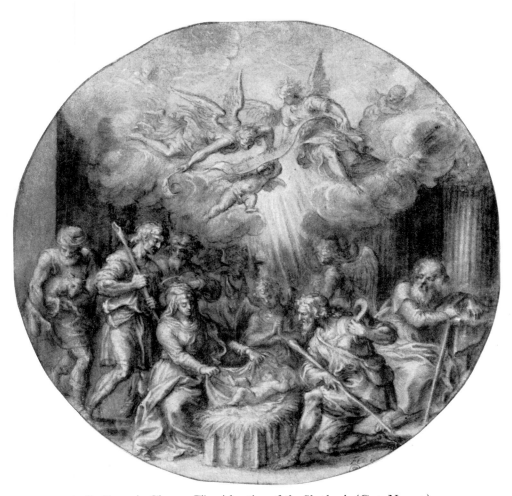

18. Francis Cleyn: *The Adoration of the Shepherds* (Cat. No. 19)

19. Daniel Nicolaus Chodowiecki:
Frederick the Great (Cat. No. 12)

20. Daniel Nicolaus Chodowiecki:
A Man with a walking-stick (Cat. No. 14)

ITALIAN DRAWINGS

ABBREVIATIONS

ANTAL: F. Antal, 'Italian Fifteenth-and Sixteenth-century Drawings at Windsor Castle', *Burlington Magazine*, XCIII, 1951, pp. 28 ff.

BEAN AND VITZTHUM: 'Disegni del Lanfranco e del Benaschi', *Bollettino d'Arte*, XLVI, 1961.

CHAMBERLAINE: J. Chamberlaine, *Original Designs of the most celebrated Masters . . . in His Majesty's Collection*, London, 1812.

FRIEDLAENDER AND BLUNT: W. Friedlaender and Anthony Blunt, *The Drawings of Nicolas Poussin*, London, 1939– .

HARRIS AND SCHAAR: Ann Sutherland Harris and E. Schaar, *Die Handzeichnungen von Andrea Sacchi und Carlo Maratta* (Katalog des Kunstmuseums Düsseldorf, *Handzeichnungen*, Band 1), Düsseldorf, 1967.

HEINZL, *Altomonte*: Brigitte Heinzl, *Bartolomeo Altomonte*, Munich-Vienna, 1964.

HEINZL, *The Luti Collection*: Brigitte Heinzl, 'The Luti Collection', *The Connoisseur*, CLXI, 647, 1966, pp. 17 ff.

Italienische Handzeichnungen: E. Schaar, *Italienische Handzeichnungen* (Katalog des Kunstmuseums Düsseldorf), Düsseldorf, 1964.

POPHAM AND FENWICK: A. Popham and Kathleen Fenwick, *European drawings . . . in the National Gallery of Canada*, Toronto, 1965.

RAGGHIANTI: C. L. Ragghianti, 'Biblioteca', *Critica d'Arte*, I, 1954, pp. 594 ff.

STAMPFLE AND BEAN: F. Stampfle and J. Bean, *Drawings from New York Collections, II, The 17th Century in Italy*, Metropolitan Museum and Pierpont Morgan Library, New York, 1967.

TOMORY: P. A. Tomory, *The Ellesmere Collection of Old Master Drawings* (publ. by the Leicester Museums and Art Gallery), Leicester, 1954.

VERMEULE: C. C. Vermeule, 'The Dal Pozzo-Albani Drawings of Classical Antiquities in the Royal Library at Windsor Castle', *Transactions of the American Philosophical Society*, N.S., LVI, pt. 2, 1966.

VITZTHUM: W. Vitzthum, 'Roman Drawings at Windsor Castle', *Burlington Magazine*, CIII, 1961, pp. 513 ff.

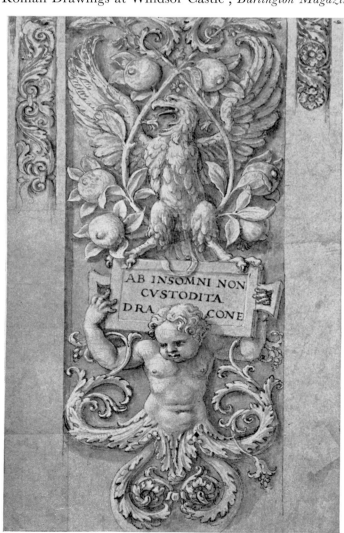

Fig. 1 Cat. No. 2

CATALOGUE

NICCOLÒ DELL'ABBATE
(c. 1512–70)

1. A SEATED SAINT (Popham and Wilde, No. 201)
(3384)

This drawing was catalogued as by Girolamo da Carpi, but Mr. John Gere has suggested an attribution to Niccolò dell'Abbate on the basis of a drawing, similar in style, in the Ashmolean Museum (Parker, II, No. 65, Pl. XXIII).

See also: *FEDERICO ZUCCARO* (Nos. 518, 519 below).

LIVIO AGRESTI
(active c. 1550, d. c. 1580)

2. DESIGN FOR THE DECORATION OF CARDINAL IPPOLITO D'ESTE'S BEDROOM AT THE VILLA D'ESTE, TIVOLI (*Fig. 1*) (10497)

352 × 224 mm. Pen and brown wash on greenish-blue paper. Inscribed: *Ab insomni non custodita dracone.*

The connection with the Villa d'Este was pointed out by Dr. A. Noach. The inscription now occurs on the carved wooden ceiling, but this drawing is probably an early design for part of the painted frieze (cf. D. R. Coffin, *The Villa d'Este at Tivoli*, Princeton, 1960, pp. 47 ff.).

FRANCESCO ALBANI
(1578–1660)

2A. See p. 147.

PHAETHON (Kurz, No. 2) (5715)
On the date of the fresco in the Palazzo Giustiniani, see M. V. Brugnoli, *Bollettino d'Arte*, XLII, 1957, pp. 266 ff.

ALLEGORY OF NIGHT (Kurz, No. 3) (5295)
For the painting, cf. M. Mahony, *Burlington Magazine*, CIV, 1962, pp. 386 ff., and *L'ideale classico del Seicento in Italia*, Bologna, 1962, No. 178b.

Manner of CHERUBINO ALBERTI
(1553–after 1614)

3. DESIGN FOR THE LEFT HALF OF A DECORATIVE PANEL (10778)
386 × 190 mm. Pen, brown wash, over black chalk.
Possibly a copy after a fresco rather than a design for it.

ALESSANDRO ALGARDI
(1595–1654)

4. THE REST ON THE FLIGHT (Wittkower, No. 527)
(*Plate 35*) (2348)
Traditionally classified as 'School of the Carracci', but attributed by Miss Catherine Johnston and Professor Vitzthum to Algardi. A closely related drawing is in Lisbon (1168 as Berettini). The drawing can be identified in Inventory A (p. 77) as one attributed to 'Algarci'.

5. A PUTTO (Kurz, No. 715) (*Fig. 2*) (3451)
Miss Catherine Johnston has suggested that this drawing, classified by Professor Kurz among the anonymous Bolognese, is by Algardi, and Professor Vitzthum agrees with this attribution.

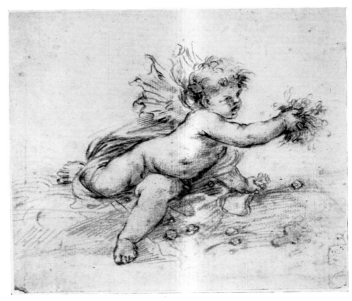

Fig. 2 Cat. No. 5

6. DESIGN FOR AN URN (Pope-Hennessy, No. 1734)
(*Plate 34*) (1561)
This design includes the Pamphili lilies and doves holding olive branches in their beaks. Dr. Vitzthum has convincingly suggested an attribution to Algardi, which is confirmed by Miss Catherine Johnston and Miss Jennifer Montagu.

7. DESIGN FOR A MONUMENT TO INNOCENT X (Pope-Hennessy, No. 1743) (*Plate 36*) (1584)
Dr. Vitzthum has identified this drawing, which comes

from the Domenichino volumes, as by Algardi. This attribution is confirmed by Miss Catherine Johnston and Miss Jennifer Montagu. The latter points out further that it is a design for the monument erected in 1650 in the Ospedale della Trinità dei Pellegrini to contain a bronze bust of the pope (cf. Bellori, *Vite*, Rome, 1672, p. 400).

The lily of the Pamphili arms is visible on the right-hand pedestal, and on the left is a sketch, difficult to decipher, which seems to represent an olive branch, perhaps held by a dove, which would allude to the same arms.

8. ROMULUS AND REMUS (Blunt and Cook, No. 602)
(5312)

Miss Jennifer Montagu has proposed an attribution to Algardi for this drawing, catalogued as by a follower of Cortona, on the grounds of its similarity to No. 4 above. She points out that the *verso* is in a quite different style and may be by a different hand.

FRANCESCO ALLEGRINI
(1587–1663)

MARTIN V ENTERING ROME (Blunt and Cooke, No. 1)
(6778)

The attribution is rejected by Dr. Walter Vitzthum (p. 514), and verbally by Mr. Keith Andrews.

9. STUDIES OF HORSEMEN (Blunt and Cooke, No. 118)
(0175)

10. A CAVALRY SKIRMISH (Blunt and Cooke, No. 119)
(0179)

These drawings were tentatively attributed to Jacques Courtois, but Dr. Vitzthum (p. 514, and Fig. 31) ascribes them to Allegrini.

11. AN ANTIQUE WARRIOR CARRYING OFF A WOMAN (Popham and Wilde, No. 215)
(4348)

Dr. Röttgen has pointed out that this drawing, catalogued with a tentative attribution to the Cavaliere d'Arpino, is connected with a painting by Francesco Allegrini at Karlsruhe.

Attributed to ALESSANDRO ALLORI
(1535–1607)

HEAD OF A CHILD (Popham and Wilde, No. 61) (5220)
Antal (p. 35) believes that this drawing is by a follower of Baroccio, whose name appears in an old hand on the drawing.

ALTICHIERO (ALIGHIERI) DA ZEVIO

See *NORTH ITALIAN SCHOOL* (No. 674 below).

MICHELANGELO ANSELMI
(1491–1554)

12. PUTTI SUPPORTING A COAT OF ARMS (2207)

158 × 179 mm. Red chalk. Inscribed in ink at the foot right: *Agostino*.

From the Carracci volumes: Inventory A, p. 78.

The coat of arms has been identified as that of Peruzzi.

The attribution was made by Mr. A. E. Popham (cf. *Correggio's Drawings*, London, 1957, Appendix No. 16, and *Parma per l'arte*, III, 1953, p. 15, and Fig. vii). The drawing dates from c. 1532–1535.

13. TWO MEN SEATED (Popham and Wilde, No. 64)
(0234)

Mr. Popham tentatively catalogued this drawing as by Anselmi and later (*Correggio's Drawings*, London, 1957, p. 171, No. 17) confirmed this attribution, suggesting that the drawing may be a study for the altar-piece of S. Agnes, in the crypt of Parma cathedral, painted in 1526.

14. ST. ANSELM APPEARING TO THE ABBOT ELSINO (Popham and Wilde, No. 1123) (0601)

The drawing was catalogued by Mr. Popham as by a member of the School of Parma, but he later identified it as a study for one of the pendentives in the Oratorio della Concezione, Parma, painted by Anselmi in 1532–33 (cf. A. E. Popham, *Correggio's Drawings*, London, 1957, p. 172, No. 18).

15. THE DEAD BODY OF CHRIST SUPPORTED BY ANGELS (Popham and Wilde, No. 1124) (0600)

Mr. Popham originally catalogued this drawing as by a member of the School of Parma, but later ascribed it to Anselmi (cf. *op. cit.*, p. 172, No. 10).

Attributed to ANTONIO ARRIGONI
(18th century)

16. A MAN, STANDING (7222)
252 × 166 mm. Black chalk.

From Consul Smith's volume of caricatures.

Attributed by Consul Smith to Carlo Arigone, but there is no artist of this name recorded. The drawing is certainly early eighteenth century and probably Venetian, so that the most likely candidate is Antonio Arrigoni, known from a few religious pictures in Venetian churches.

Attributed to AMICO ASPERTINI
(c. 1475–1552)

17. ADORATION OF THE SHEPHERDS (Popham and Wilde, No. 5) (12790 *recto*)

Attributed by Mr. Popham to the school of Lorenzo Costa. Antal (p. 35) reaffirms the connection with Aspertini tentatively suggested by Berenson, an attribution which Mr. Popham now considers possibly correct.

Manner of AMICO ASPERTINI

18. DESIGN FOR AN ORNAMENT (11300)
115 × 135 mm. overall. Pen and black ink, slight brown wash, over black and red chalk.

Attributed to SISTO BADALOCCHIO
(1581/85–1647)

19. THE BAPTISM OF CLORINDA (01248)

373 × 502 mm. Brown washes, touches of white body-colour, on brown prepared paper.

Inventory A, p. 125: 'Tancredi baptizing Clorinda, by N. Poussin'.

The drawing is certainly not by Poussin or any of his followers. It seems to be more closely related to two paintings of this subject by Sisto Badalocchio (cf. D. Mahon, 'The Seicento at Burlington House: some addenda and corrigenda', *Burlington Magazine*, XCIII, 1957, pp. 78 ff.). Another drawing, apparently connected with the group, is at Düsseldorf, wrongly attributed to Sacchi.

See also: *After LODOVICO CARRACCI* (Wittkower, No. 88) and *JACOPO DA EMPOLI* (No. 166 below).

After GIOVANNI BAGLIONE
(1571–1644)

20. ST. PETER AND ST. PAUL (5107)

318 × 228 mm. Pen and brown ink (offset).

As observed by Mr. Philip Pouncey, the two figures correspond in reverse with the *Sts. Peter and Paul* by Baglione in S. Cecilia in Trastevere, Rome (reproduced in *Bollettino d'Arte*, Series 4, VII, 1954, p. 317). The reversing is accounted for by the drawing being an offset. There are also some major differences. In the picture St. Peter's head is in profile, not full-face as in the drawing. According to Carla Guglielmi (article cited above, p. 325, note 25), there are variants of the pictures in the Galleria Spada, and a drawing at Berlin shows the two saints seated.

LAZZARO BALDI
(1623–1703)

THE VISION OF ST. JOHN ON PATMOS (Blunt and Cooke, No. 3) (5952)

A related drawing is in the Teylers Museum, Haarlem.

21. THE LAST SUPPER (Blunt and Cooke, No. 577) (0265)

This drawing was catalogued as Passeri, but Dr. Walter Vitzthum (p. 514) has proposed an attribution to Baldi.

22. SCENES FROM THE LIFE OF A CARMELITE NUN (Blunt and Cooke, Nos. 641–649) (6769–6774)

These drawings were catalogued as by a follower of Cortona, but Dr. Vitzthum (*ibid.*) has proposed an attribution to Baldi.

See also: *Attributed to PIETRO DA CORTONA* (No. 361 below).

ANTONIO BALESTRA
(1666–1740)

23. VENUS APPEARING TO AENEAS (3744)

472 × 337 mm. Black chalk.

Inventory A, p. 20: 'Bolognesi Moderni'.

Professor Dwight Miller has identified this as a study by Antonio Balestra for a painting in the Palazzo Bonaccorsi at Macerata.

24. ST. JAMES THE GREAT, ST. ANTHONY ABBOT, AND ST. PETER MARTYR ADORING THE TRINITY (3802)

336 × 188 mm. Pen and brown ink, grey washes. Inscribed on the mount: *Del Balestra*.

Attributed to BACCIO BANDINELLI
(1493–1560)

25. A YOUNG WOMAN (Popham and Wilde, No. 877) (0370)

Mr. John Gere has suggested that this drawing, tentatively catalogued as by Rosso, may be by Bandinelli. Mr. Michael Hirst endorses this suggestion.

Manner of BACCIO BANDINELLI

26. TWO RELIEFS (8184)

291 × 431 mm. Pen and brown ink.

From the passageway of the Arch of Titus (cf. Vermeule, p. 9).

Verso: Votive relief to the Springs and Nymphs.

The original is in the Capitoline Museum.

FEDERICO BAROCCI
(1526–1612)

Harold Olsen (*Federico Barocci*, Copenhagen, 1962) has discussed all the drawings at Windsor ascribed to Barocci by Mr. Popham. He accepts the attributions of all of them, except No. 100 (see below), but has new information to add.

HEAD OF A CHILD (Popham and Wilde, No. 88) (5222)

The date of the *Madonna del Popolo* is 1579, not 1569.

HEAD OF A BABY (Popham and Wilde, No. 89) (5223)

According to Olsen (*op. cit.*, p. 196) the painting was sent to Spain in 1605, not 1597.

STUDY OF A WOMAN'S HEAD (Popham and Wilde, No. 94) (5229)

Olsen (*op. cit.*, p. 226) suggests that this is a study for the head of the Virgin in the *Madonna di S. Lucia* in the Louvre, executed by assistants, c. 1590.

HEAD OF A YOUNG WOMAN (Popham and Wilde, No. 96) (5231)

Olsen (*op. cit.*, p. 179) plausibly suggests that this is a study for the head of the Virgin in the Vatican *Annunciation* (c. 1582–84).

HEAD OF A BEARDED MAN (Popham and Wilde, No. 97) (5232)

Olsen (*op. cit.*, p. 169) plausibly suggests that the drawing is connected with the *Madonna del Popolo*.

STUDY OF A SEATED YOUTH (Popham and Wilde, No. 100) (5235)

Mr. Popham recorded the traditional attribution of this drawing to Barocci with considerable reservation, but it was rejected by Olsen (*op. cit.*, p. 292). Antal (p. 32) suggested the name of Poccetti, and Dr. Shearman has proposed that of Bronzino.

THE CALLING OF ST. ANDREW (Popham and Wilde, No. 107) (6830)

Olsen (*op. cit.*, pp. 175 f.) points out that the painting sent to Spain, which still exists in the Escorial, was not the original dated 1580 but the second version completed in 1588. The landscape in the drawing differs from both versions.

Follower of FEDERICO BAROCCI

27. HEAD OF A CHILD (5416)

238 × 196 mm. Coloured chalks on grey-green paper.

Probably a study for a detail of a large religious composition. The technique is that of Barocci, but the conception is fully baroque and suggests a date in the second half of the seventeenth century.

28. A GIRL SEATED ON THE GROUND (6801)

235 × 174 mm. Red chalk.

Perhaps by a Roman or Sienese follower of Barocci.

See also: *Attributed to* ALESSANDRO ALLORI (Popham and Wilde, No. 61).

PIETRO SANTI BARTOLI
(c. 1635–1700)

29. DRAWINGS OF THE RELIEFS ON TRAJAN'S COLUMN (7918–7993)

Each drawing approximately 110 × 400 mm. Pen and brown ink. The title-page is inscribed: *I desegni originali della Colonna Traiana fatti da Pietro Santi Bartoli. I numeri correspondono a' numeri delle stampe publicate di Giovanni Pietro Bellori.*

Probably from the Albani collection.

PIETRO SANTI BARTOLI
(c. 1635–1700) and
CARDINAL CAMILLO MASSIMI
(1620–77)

30. *Title-page to the* ANTIQUISSIMI VIRGILIANI CODICIS FRAGMENTA (Rome, 1741) (9566)

326 × 184 mm. Pen and brown ink, with brown and grey wash. Inscribed in the centre:

L'ANTICHE PITTVRE MEMORIE RACCOLTE DALLE RVINE DI ROMA ESPRESSE AL'ELEGANZA VETVSTA NEL'MVSEO DI D. VINCENZO VITTORIO CANONICO DI XATIVA NEL REGNO DI *Valenza*,

and on the bases of the columns:

L'Architettura e inventione e Disegno del E^{mo} sig. Card.^e Massimi, and *Le Vittorie laterali sono disegnate da Pietro Santi Bartoli.*

From the Massimi and Vittoria collections.

This drawing now forms the title-page to a book of drawings after ancient paintings in Rome which belonged to Vincenzo Vittoria, but it seems originally to have been designed for Cardinal Camillo Massimi and drawn partly by himself and partly by Pietro Santi Bartoli, who is responsible for many of the drawings in the volume (probably Nos. 9575–9700). The book itself cannot have been put together by Massimi, because some of the drawings bear dates after his death in 1677 (one is dated 1698), and it was presumably made up for Vittoria, who lived till 1712. The drawing was later used as the title-page to Bartoli's *Antiquissimi Virgiliani Codicis fragmenta*, published in Rome in 1741. It is not known how the volume came into the Royal Library, but it may well have been with the Albani collection. The tradition that it was owned by Dr. Mead seems to be without foundation. The volume and Vittoria's activities as a collector are discussed in A. Blunt, 'Don Vincenzo Vittoria', *Burlington Magazine*, CIX, 1967, pp. 32 f.

POMPEO BATONI
(1708–87)

FIGURE STUDIES (Blunt and Cooke, No. 7) (6731)

Mr. Antony Clark believes that this drawing is not connected with the Larby painting but must be for a lost early *Stoning of St. Stephen*.

HEAD OF A GIRL (Blunt and Cooke, No. 9) (6728)

According to Mr. Clark this drawing is not connected with Batoni.

AN ALLEGORY OF MUSIC (Blunt and Cooke, No. 11) (6733)

Mr. Clark maintains his view that this drawing is not by Batoni, but is less confident of his tentative suggestion that it might be by Bonatti. It is reproduced on plate 64 of the Catalogue of Roman Drawings, not in plate 65 as stated in the text.

31. A DRAPED TORSO (Blunt and Cooke, No. 391) (4389)

Mr. Antony Clark has suggested the name of Batoni for this drawing, previously catalogued with an attribution to Maratta.

Attributed to ERCOLE BAZICALUVA
(c. 1600–?)

32. TWO WOMEN ABOUT TO CROSS A STREAM (3554)
IN A ROCKY LANDSCAPE

218 × 263 mm. Pen, on brown or faded paper.

Inventory A, p. 116: 'Paesi di Maestri Bolognesi'.

The drawing is like many ascribed to Bazicaluva, but also has some resemblance to works by Cantagallina.

DOMENICO BECCAFUMI
(c. 1486–1551)

DECORATION OF A VAULT (Popham and Wilde, No. 136) (0280)

Antal (p. 35) believed this to be a copy.

BEDOLI (GIROLAMO MAZZOLA)
(c. 1500–69)

See *FRANCESCO SALVIATI* (Popham and Wilde, No. 903).

GIOVANNI BATTISTA BENASCHI
(1636–88)

33. A SEATED DRAPED FIGURE, HAND RAISED, SEEN FROM BELOW (6113)

492 × 329 mm. Black and white chalk, on dark brown paper.

34. A SEATED DRAPED FIGURE, HAND RAISED, SEEN FROM THE RIGHT (6114)

490 × 348 mm. Black and white chalk, on dark brown paper.

35. A SEATED HALF-DRAPED FIGURE, GAZING UPWARDS (6116)

489 × 348 mm. Black and white chalk, on dark brown paper.

36. A SEATED HALF-DRAPED FIGURE, ITS RIGHT HAND EXTENDED (6117)

498 × 391 mm. Black and white chalk, on dark brown paper.

Inventory A, p. 127: 'Pietro Testa, Solimeni &c. Of Solimeni . . . five Study's of single figures'.

These drawings, formerly attributed to Solimena (cf. F. Bologna, 'Aggiunte a Francesco Solimena. I.—La giovinezza e la formazione (1674–84)', *Napoli nobilissima*, II, 1962, pp. 3 ff.), were recognized by Jacob Bean and Walter Vitzthum ('Disegni del Lanfranco e del Benaschi', *Bollettino d'Arte*, XLVI, 1961, p. 122) as being by Benaschi. Dr. Vitzthum has now identified two (Nos. 6114, 6117) as being studies for Benaschi's fresco in the dome of SS. Apostoli, Naples.

Studio of GIANLORENZO BERNINI
(1598–1680)

37. DESIGN FOR AN ALTAR (*Fig. 3*) (5593)

302 × 182 mm. Black chalk.

From the Bernini volume.

The architecture of the altar is very close to that of the altar in the Alaleona Chapel in SS. Domenico e Sisto, Rome,

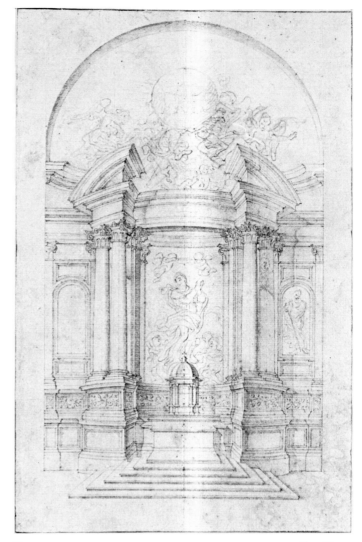

Fig. 3 Cat. No. 37

executed by Antonio Raggi under the supervision of Bernini from 1649 onwards (cf. R. Wittkower, *Gian Lorenzo Bernini*, 2nd ed., London, 1966, p. 223, Cat. No. 52). The scheme was used again for the chapel of S. Barbara in the Cathedral of Rieti (1652–55), also designed by Bernini, the statue of the saint being executed by Giovanni Antonio Mari (cf. Wittkower, *op. cit.*, p. 234, Cat. No. 60, and Fagiolo dell'Arco, *Bernini*, Rome, 1967, Cat. No. 162). The chapel was not completed till the early eighteenth century. The Windsor drawing differs from both executed schemes in that it has two full columns on each side, as opposed to a column and a square pier, and the back wall of the chapel is curved instead of straight.

The central panel shows a female figure, over whom a crown is held by two putti, and who rises through the superstructure of the altar towards a group of angels supporting a sphere, on which is the monogram *IHS*. This probably represents the Assumption of the Virgin, but in this case one would expect God the Father and probably the other two persons of the Trinity to be depicted, and it is conceivable that it may represent St. Barbara received into Heaven, in which case the drawing may actually be

connected with the Rieti altar. This is made less likely, however, by the fact that the figure in the niche to the right of the altar is almost certainly St. Paul, and it is reasonable to suppose that the empty niche on the left was to contain St. Peter, saints who would be more appropriate to the Assumption of the Virgin than to St. Barbara.

THE SCAFFOLDING FOR THE ERECTION OF THE BALDACCHINO IN ST. PETER'S

38. PLAN. 370 × 278 mm. Pen and brown wash. (10449)
Inscribed: *Pianta del Ponte fatto al Ciborio di S. Pietro per tener insieme e finirlo da i Capitelli in sù.*

39. ELEVATION. 410 × 285 mm. Pen and brown wash.
(10450)

Inscribed: *Alzata del detto Ponte*, and *Prospetto dell'istessa alzata con tutti li suoi legni.*

40. SIDE ELEVATION AND PLAN OF UPPER PART (*Fig. 4*) (10451)
417 × 277 mm. Pen and brown wash.

Inscribed: *Fianco dell'Istesso Ponte*, and *Armatura o Telarone di Abeto che tiene insieme le Quattro Colonne del detto Ciborio Quale per le parti di fori e foderata di Rame.*

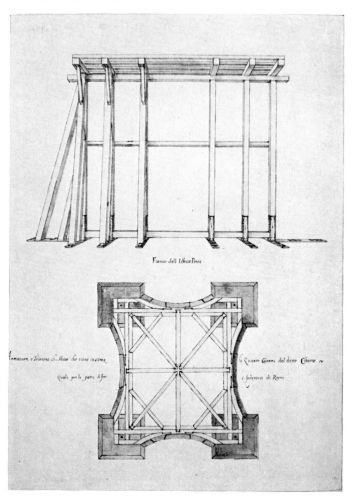

Fig. 4 Cat. No. 40

These drawings appear to be the only records of the scaffolding used to hold together the bronze columns of the Baldacchino while the superstructure was executed.

Manner of GIANLORENZO BERNINI

41. HEAD AND SHOULDERS OF A GIRL (5398)
412 × 293 mm. Black and red chalks.

Formerly attributed (Inventory A, p. 19) to Prospero Fontana (1512–97), but certainly much later. The nearest analogy technically is with the portrait drawings of Bernini, but this drawing has none of his baroque swagger.
See also: *BORROMINI* (Nos. 52, 53 below), and *ANDREA SACCHI* (No. 420a below).

GIACOMO BERTOJA
(1544–74)

42. THE ASSAULT ON A TURKISH CITY (Popham and Wilde, No. 205) (6337)
Mr. Popham has pointed out that this drawing, originally catalogued as by Bernardo Castello, corresponds to a fresco in the Castel di San Secondo by Bertoja.

43. UGOLINO ROSSI DEFEATING THE GHIBELINS AT CAMPOLDINO (Popham and Wilde, No. 206) (01196)
This drawing, attributed by Mr. Popham to Bernardo Castello and by Antal (p. 32) to Giovanni de' Vecchi, is a study for a fresco by Bertoja in the Castello of S. Secondo (cf. A. G. Quintavalle, *Il Bertoja*, Milan, 1963, pp. 25, 56).

44. HEADS OF SIX HORSES (Popham and Wilde, No. 981) (0498 *recto*)
This drawing, catalogued as by Perino del Vaga, was ascribed by Antal (p. 32) to Tibaldi and by Quintavalle (*op. cit.*, p. 56) to Bertoja. The name of Bertoja was independently proposed by Mr. Philip Pouncey in 1955.
See also: *FRANCESCO MAZZOLA, called IL PARMIGIANINO* (Popham and Wilde, No. 585).

BACCIO DEL BIANCO
(1604–56)

45. AN ALLEGORY OF TIME (*Fig. 5*) (6843)
391 × 589 mm. Pen and brown ink, on buff paper.

Inventory A, p. 126: 'Two Volumes of Large Drawings called Opere Varie: "l Emblematical . . . Callot"'. The name Baccio del Bianco is written on the mount in a late nineteenth-century hand.

At the top on the right Death and Time lead on a party of ecclesiastics, who walk towards the edge of a cliff over the sea. Below, under a rock arch, stand men with money bags and jewels, guns, a dog, and the spoils of a boar. To the left in the foreground a party of men wave to a galley, the crew of which are repulsing a boarding party. Above the galley flies a procession of cupids, headed by an old witch.

Fig. 5 Cat. No. 45

FRANCESCO GALLI BIBIENA
(1659–1739)

46. THE TEATRO FILARMONICO AT VERONA
(*Plate 74*) (10766)

305 × 355 mm. Pen and brown wash.

The theatre was built by Francesco Bibiena in 1720, burnt in 1749, but rebuilt on the same plan in 1760 (cf. A. Hyatt Mayor, *The Bibiena Family*, New York, 1945, pp. 30, 35, and Pls. 19–21). The identification of the Windsor drawing is due to Dr. A. Noach.

See also: *PIETRO PAOLO COCCETTI* (No. 128 below).

GIOVANNI BILIVERTI
(1576–1644)

See *JACOPO DA EMPOLI* (No. 167 below).

ABRAHAM BLOEMAERT
(1564–1651)

See *PARMESE SCHOOL* (Nos. 676, 677 below).

CAMILLO BOCCACCINO
(1501–46)

47. CHRIST AND THE WOMAN TAKEN IN ADULTERY
(Popham and Wilde, No. 1177) (5027)

This drawing was originally catalogued as anonymous, School of Verona, but Mr. Philip Pouncey has suggested the name of Boccaccino for it, an attribution which Mr. Popham accepts.

GIOVANNI ANTONIO BOLTRAFFIO
(1467–c. 1516)

See *ROMAN SCHOOL* (Popham and Wilde, No. 1133).

GIOVANNI BONATTI
(c. 1635–81)

THE ADORATION OF THE SHEPHERDS
(Blunt and Cooke, No. 82) (6790)
From the Luti Collection.

The copy by Altomonte in the Albertina has no inscription (cf. Heinzl, *Altomonte*, p. 70, No. 38 r, and *The Luti Collection*, p. 20, No. 38) and the name of Bonatti on the Windsor drawing was probably added later.

THE VISION OF ST. NICHOLAS OF TOLENTINO
(Blunt and Cooke, No. 83) (6819)

The subject has been identified by Miss Jennifer Montagu, who points out that the iconography is based on Algardi's group of the subject in S. Nicola da Tolentino, Rome.
See also *JOHANN CARL LOTH* (No. 228 below), and *POMPEO BATONI* (Blunt and Cooke, No. 11).

PARIS BORDONE
(1500–70)

See *TITIAN* (Popham and Wilde, No. 961).

FRANCESCO BORROMINI
(1599–1667)

48. DESIGN FOR THE FAÇADE OF THE ORATORIO
DI S. FILIPPO NERI, ROME (*Plate 72*) (5594)

406 × 338 mm. A strip about 35 mm on the right, which includes the right-hand rusticated pilaster, is a later restoration. Black chalk.

From the Bernini volume.

Shown in the exhibition *Disegni di Francesco Borromini*, Accademia di S. Luca, Rome, 1967, No. 39.
In 1637 Borromini received the commission to build the oratory and conventual buildings for the Filippini, attached to the church of S. Maria in Vallicella. The oratory itself and the library over it were completed by 1643 (cf. Hempel, *Francesco Borromini*, Vienna, 1924, pp. 61 ff.; Portoghesi, *Borromini nella cultura europea*, 1964, pp. 42 ff.; Marcello di Piazza, *Ragguagli Borrominiani*, Rome, 1968 pp. 92 ff.).
The Windsor drawing belongs to an early stage in the evolution of the whole complex of the Filippini buildings as shown in a plan in the Albertina (No. 284; reproduced Hempel, *op. cit.*, p. 71, Fig. 20). According to this scheme Borromini intended to place the oratory itself on the same axis as the two cloisters, separated by the sacristy, which lay behind it. Its façade was to be flanked by two doors, each leading to a long corridor running right through the building. Later he modified this arrangement by moving the oratory to the left (west) end of the block and abolished the left-hand door.
The Windsor drawing is closely related to one in the Albertina (No. 291; reproduced in Hempel, *op. cit.*, Pl. 38), and to an engraving in the *Opus architectonicum*, Rome, 1725, Pl. V. It is difficult to establish the precise relationship of these three schemes, but the Windsor drawing seems to be

a fair copy based on the Albertina sketch and was perhaps used for the engraving. The Windsor drawing has no pentimenti, whereas the Albertina study is full of changes, notably in the pediment and the scrolls which flank the central element. On the other hand the Albertina drawing shows the central door with straight columns, as it was executed, but in both the Windsor drawing and the engraving it has Salomonic columns. In the engraving and the Albertina drawing the upper windows of the façade have lunettes over them, as in the actual building, whereas in the Windsor version they are topped by traditionally formed pediments.

The two drawings and the engraving show a series of decorative objects along the top of the façade, all connected iconographically with S. Filippo Neri, but the three versions are different. In the Albertina drawing there are stars on the outer bays of the oratory, and pots of lilies on the inner bays (the top of the middle bay is cut off). The Windsor drawing shows an alternation of flaming urns and stars over the oratory itself and nothing over the flanking bays. The engraving shows stars at every point, including the flanking bays, in seven cases supported by fleurs-de-lys and in two by wreaths intertwined with lilies.

The Windsor drawing is of interest in that it proves that, when Borromini moved the oratory itself to the west end of the site, he did not change the external elevation, apart from eliminating the left-hand door, for the west bays correspond in all essentials to those recorded in Plate VI of the *Opus architectonicum*, except that in the latter the library had been extended to the end of the site, so that Borromini's sloping, tiled roof, shown in the Windsor drawing, had been displaced by the attic which still disfigures the elevation of the building.

49. DESIGN FOR THE GARDEN FAÇADE OF THE
PALAZZO BARBERINI (5591)

271 × 408 mm. Pen and brown ink on darkened paper.

From the Bernini volume.

The drawing was first published in the present writer's article 'The Palazzo Barberini. The contributions of Maderno, Bernini and Pietro da Cortona', *Journal of the Warburg and Courtauld Institutes*, XXI, 1958, pp. 264 ff., as by Carlo Maderno. Thelen (*Francesco Borromini. Die Handzeichnungen*, Graz, 1967, No. 66) believes that the central part is by Borromini, that the windows to the right and left of it on the ground floor, the statues, the balustrade, and the coat-of-arms are by a different hand, in the style of Maderno, and that Domenico Castelli later added the upper floor. There seems, however, to be no doubt that the whole drawing is by a single hand and that it was executed at one time. Borromini was in charge of the building of the palace under Maderno's direction and, although the design is certainly Maderno's, the execution of the drawing is probably due to Borromini. Since he believes that the upper floor is a later addition, Dr. Thelen rejects my reconstruction of Maderno's original scheme for the façade (*op. cit.*, p. 266), which I still believe to be correct.

50. DRAWING FOR THE WEST FRONT OF THE
PALAZZO BARBERINI (11591)

472 × 761 mm. Pen and brown ink, with a figure added in black chalk over the middle bay of the *piano nobile*.

The drawing was first published by the present writer (*op. cit.*, p. 274) as by Carlo Maderno, but Dr. Thelen (*op. cit.*, No. 42) convincingly ascribes it to Borromini, working under Maderno's direction. He does not, however, notice the recumbent figure added over the arched opening to the middle bay on the *piano nobile*, nor the fact that on the left and right of the drawing Borromini shows alternative designs for the window on the top floor between the loggia and the projecting wings. These are variants on window designs by Maderno (e.g. on the façade of St. Peter's), and Borromini has not yet evolved the highly personal form which this element was to take on in the palace itself. The other features in which the drawing differs from the executed building are carefully analysed by Dr. Thelen.

51. DESIGN FOR THE INSIDE WALL AT THE EAST
END OF ST. PETER'S (5595)

389 × 263 mm. Pen and brown ink. Inscribed in black chalk: *SEDENTE PAULO. V.*, the word *sedente* being on a separate piece of paper stuck on the sheet. From the Bernini volume.

The drawing is discussed and reproduced by Dr. Thelen (*op. cit.*, p. 48 and Fig. 16), who states that it is a fair copy made by Filippo Breccioli after a design of Maderno. It seems, however, to be by the same hand as a drawing which he rightly attributes to Borromini (No. 37; cf. A. Blunt, review of Thelen, *Kunstchronik*, XX, 3, 1969, p. 90). In any case the general conception of the design must derive from Maderno.

52. DESIGNS FOR THE BALDACCHINO IN ST. PETER'S
(Blunt and Cooke, Nos. 23–25) (5635–5637)

These drawings were classified by Brauer and Wittkower quite correctly as coming from the studio of Bernini, but Dr. Thelen (*op. cit.*, Nos. 24, 72, 73) attributes them plausibly to Borromini, who was in charge of the architectural and decorative parts of the Baldacchino (in his plate of the canopy (Blunt and Cooke, No. 25) the drawing is unfortunately backwards). He dates the drawing of the columns (Blunt and Cooke, No. 23) to shortly before 1625, but the other two to autumn 1631. The three drawings are, however, so similar in style that it is hard to believe that they can be so widely separated in time. Blunt and Cooke, Nos. 23 and 24, might even originally have formed part of a single drawing (cf. A. Blunt, review of Thelen, *Kunstchronik*, XX, 3, 1969, p. 93).

53. DESIGN FOR THE TOMB OF URBAN VIII
(Blunt and Cooke, No. 33) (5602)

This drawing was attributed by Brauer and Wittkower to the studio of Bernini. Dr. Thelen (*op. cit.*, No. 36) believes that the architecture was drawn by Borromini and that the figures and the sarcophagus were added by Bernini, who also went over the cartouche on the pedestal. Careful examination of the drawing, however, makes it fairly certain that it is all by one hand, and as there is another drawing, certainly from Borromini's hand (Thelen, *op. cit.*, No. 35), in which the architecture corresponds almost

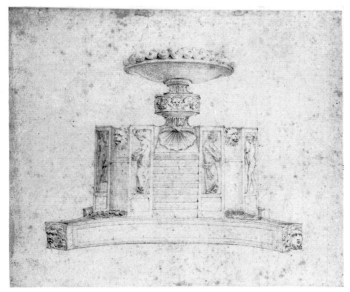

Fig. 6 Cat. No. 54

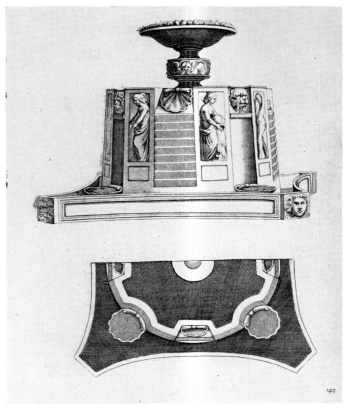

Fig. 7 cf. Cat. No. 54

exactly to the Windsor drawing, it is hard to resist the conclusion that the whole of the latter was executed by Borromini (cf. A. Blunt, review of Thelen, *Kunstchronik*, XX, 3, 1969, pp. 88 f.).

Attributed to FRANCESCO BORROMINI

54. ANCIENT FOUNTAIN IN THE GIUSTINIANI
COLLECTION (*Fig. 6*) (5622)
65 × 196 mm. Black chalk.
From the Bernini volume.

The drawing is after a fountain, apparently ancient, engraved in the *Galleria Giustiniani*, Rome, n.d., II, Pl. 149 (Fig. 7). Other drawings of the same fountain are to be found in a volume in the Uffizi ascribed, probably wrongly, to Testa (Nos. 7025, 7026). The style of draughtsmanship is very close to the manner of Borromini. The architectural features are drawn with a line which is precise but sensitive, and is broken, as always with Borromini, by little dots where the artist has pressed the hard chalk into the paper as his hand changes direction. It is worth noting that Borromini is recorded as working in the Palazzo Giustiniani in 1650–52 (cf. I. Toesca, 'Note sulla storia del Palazzo Giustiniani a San Luigi dei Francesi', *Bollettino d'Arte*, XLII, 1957, pp. 296 ff., and Marcello del Piazzo, *Ragguagli borrominiani*, Rome, 1968, pp. 116 ff.).
A drawing after the basin of the fountain by Poussin is at Bayonne (cf. Friedlaender and Blunt, V, No. 326).

Circle of FRANCESCO BORROMINI

55. FOUR PLANS OF A FOUNTAIN (8060 *verso*)
176 × 271 mm. Pen and brown ink. Inscribed twice: *sedilli*.
Recto : A drawing after a relief of the visit of Dionysus to the house of Icarius (cf. Vermeule, *Dal Pozzo*, p. 65).

The four plans all show designs related to that represented in No. 54 above, with a complicated play of convex and concave curves, and in one case with shells at the four corners.

ANDREA BOSCOLI
(c. 1550–c. 1606)

THE PRESENTATION OF THE VIRGIN (Popham and Wilde, No. 141) (5196)
Antal (p. 32) suggested the name of Jacopo Zucchi for this drawing, an attribution which Mr. Popham does not accept.
See also: *LELIO ORSI* (Popham and Wilde, No. 540); *After RAPHAEL* (Popham and Wilde, No. 856), and *ROSSO FIORENTINO* (Popham and Wilde, No. 875).

VICENZO BRENNA
(1745–1820)

See *MARCO CARLONE* (No. 89 below).

FRANCESCO BRIZIO
(c. 1575–1623)

AUGUSTUS, ANTONY AND LEPIDUS (Kurz, No. 14) (086b)
A sketch for a rare etching reproduced by H. Brauer (*Berliner Museen*, N.F. VI,1 957, p. 32). Brauer, however, curiously identifies the subject as 'The Sons of Noah dressed as Roman warriors'. On Brizio's *Second Triumvirate* see also G. Zucchini, 'Una pianta inedita di Bologna', *La Mercanzia*, XII, 1957, pp. 232 ff.

AGNOLO BRONZINO
(1503–72)

56. NARCISSUS AND THE NYMPHS (Popham and
Wilde, No. 895) (0335)

This drawing was catalogued by Mr. Popham under the
name of Salviati, but he now accepts the attribution to
Bronzino proposed by Mr. Craig Smyth.

See also: *FEDERICO BAROCCI* (Popham and Wilde,
No. 100).

DOMENICO BRUSASORCI
(c. 1516–67)

See *FLORENTINE SCHOOL* (Popham and Wilde, No.
1099).

GIOVANNI ANTONIO BURRINI
(1656–1727)

ENDYMION (Kurz, No. 16) (3591)

Mr. H. N. A. Brigstocke has pointed out that this drawing,
described by Prof. Kurz simply as 'a young man asleep', is
a study for the painting of *Diana and Endymion* recently
acquired by the City Art Gallery, York.

Attributed to GIOVANNI ANTONIO BURRINI

TWO WOMEN STANDING BEHIND A BALUSTRADE
(Kurz, No. 18) (3593)

Miss E. Feinblatt pointed out that the two figures are
copied from Rubens' *Henry IV conferring the Regency on Marie
de Médicis* in the Medici cycle.

Attributed to GUGLIELMO CACCIA, called IL MONCALVO
(1568–1625)

57. THE MADONNA OF THE ROSES (01192)

360 × 334 mm. Pen and brown ink, grey wash, over black
chalk.

Very similar to the many drawings by Moncalvo and his
associates preserved in the Royal Library at Turin.

58. A SAINT ADORING THE VIRGIN (Popham and
Wilde, No. 516) (5113)

This drawing was attributed by Mr. Popham to Pier
Francesco Morazzone, but Mr. Hugh Macandrew has
proposed the name of Moncalvo.

GIACINTO CALANDRUCCI
(1646–1707)

See *CARLO MARATTA* (No. 288 below).

GIUSEPPE CALETTI, IL CREMONESE
(1600–60)

59. A SHEPHERD KNEELING; PART OF A NATIVITY
 (0180)

149 × 95 mm. Pen. Inscribed on the *verso*: *Giuseppe Cremonese
fecit.*

60. BATHERS IN A STREAM OUTSIDE A TOWN (0236)

103 × 150 mm. Pen, a little brown wash. Squared in black
chalk.

Verso: Delilah shearing Samson. Pen and brown ink.

61. HEAD OF A GIRL, AND A CHILD; A FRAGMENT
 (0237)

77 × 79 mm. (cut irregularly). Pen and brown ink.

62. SKETCHES OF TWO FIGURES, A HAND AND
A HEAD, AND PART OF A LETTER (0238)

150 × 87 mm. Pen and brown ink.

Verso: A musical instrument, a pair of bellows, a violin-bow,
a gridiron and another subject.

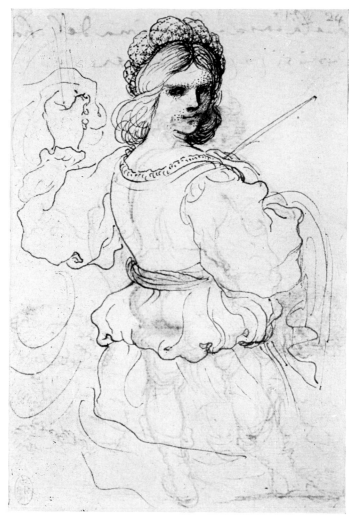

Fig. 8 Cat. No. 63 *recto*

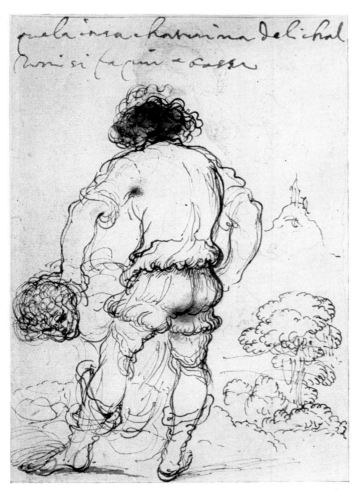

Fig. 9 Cat. No. 63 *verso*

63. A GIRL, HALF-LENGTH, HOLDING A SWORD
(*Fig. 8*) (0239)
142 × 90 mm. Pen, brown ink, and red chalk.

Verso: A study of two wrestlers, on part of a letter (Fig. 9).
Pen and brown ink.

DENIS CALVAERT
(1540–1619)

64. THE CORONATION OF THE VIRGIN WITH
ST. FRANCIS IN ADORATION (0310)
412 × 252 mm. Pen and brown ink, heightened with body-
colour.

65. PARADISE (*Plate 26*) (5096)
471 × 279 mm. Pen and brown ink.
A study for the painting in S. Maria dei Servi, Bologna.

66. THE VIRGIN AND CHILD ADORED BY
ST. FRANCIS AND ANOTHER SAINT (*Plate 27*) (5506)
352 × 236 mm. Pen and brown wash.

67. ST. FRANCIS IN PRAYER (0159)
164 × 142 mm. Pen and brown wash heightened with white
on greenish paper. Squared.
The attribution is due to Mr. A. E. Popham.

68. THE ENTOMBMENT (Popham and Wilde, No. 1062)
 (0293)
This drawing was catalogued as by a follower of Federico
Zuccaro, but Antal (p. 32) proposed an attribution to
Calvaert, which Mr. Popham accepts.
See also: Puyvelde, *Flemish Drawings*, Nos. 42, 43, 45, and
SOUTH GERMAN SCHOOL (p. 29 No. 56).

ANDREA CAMASSEI
(1602–48/9)

69. A KING (Blunt and Cooke, No. 855) (4882)
This drawing was catalogued under its traditional name of
Sacchi, but with a note to the effect that it was probably
not by him. Dr. Ann Harris believes that it is a study for
the *Gladiators* in the Prado (2315), which she attributes to
Camassei (cf. *Art Bulletin*, LII, 1970, p. 64).

70. A SLEEPING MALE NUDE (Blunt and Cooke,
No. 857) (4905)
This drawing was catalogued with a tentative attribution
to Sacchi, but Mrs. Harris has identified it as a study for a
painting of the *Death of the Niobids* by Camassei in the
Galleria Nazionale, Rome (*ibid.*, p. 59).

71. THE MARTYRDOM OF ST. EUPHEMIA
(Blunt and Cooke, No. 1002) (3753)
This drawing was attributed to Trevisani and identified as
representing Daniel. Mrs. Harris suggested verbally that it
might be a study for Camassei's *St. Euphemia*, but has now
withdrawn the proposal (cf. *Art Bulletin*, LII, 1970, p. 55).
See also: *ANDREA SACCHI* (Blunt and Cooke, Nos. 767,
768).

Imitator of LUCA CAMBIASO
(1527–85)

72. ST. PAUL, HEAD AND SHOULDERS (5408)
255 × 409 mm. Pen and brown wash, over black chalk, on
brown paper. Triangular composition.

Attributed to DOMENICO CAMPAGNOLA
(1500–after 1552)

73. A YOUTH HOLDING ON TO A TREE SPEAKS TO
A BEARDED MAN WEARING A TURBAN; BELOW
STAND TWO TURBANED MEN, ONE OF WHOM HAS
HIS ARM ROUND THE WAIST OF THE OTHER
(*Plate 42*) (5519)

207 × 144 mm. Pen and brown ink.

Inventory A, p. 53: 'Perino del Vaga, Bald^re. Peruzzi, Nico: del Abatte &c.'.

GIULIO CAMPI
(1502–72)

74. DRAWINGS AFTER THE RELIEFS ON TRAJAN'S COLUMN (7786B–7917)

c. 270 × 430 mm. each, except for No. 7786 (315 × 472 mm.), No. 7800 (264 × 278 mm.), No. 7837 (264 × 148 mm.). Pen and brown ink, with brown wash.

The title-page by Visentini (cf. *Venetian Drawings at Windsor Castle*, No. 535) reads:
Colvmna dicta Traiana qvam S.P.Q.R. divo Traiano imperatori construere decrevêre bello Dacico ab eodem foeliciter confecto. Â viro excellenti Iulio Campi Cremonensi non sine magno labore Romae dum vivebat diligentissimè delineata.

From the collection of Consul Smith.

75. THE TRANSFIGURATION (Popham and Wilde, No. 1125) (01119)

76. CHRIST HEALING A CRIPPLE (Popham and Wilde, No. 1126) (01118)

Mr. Philip Pouncey has pointed out that No. 75 corresponds to a fresco by Giulio Campi in S. Margherita, Cremona. No. 76 is probably also connected with the same cycle.

See also: *CREMONESE SCHOOL* (No. 572 below).

PETER CANDID
(c. 1548–1628)

See *BATTISTA NALDINI* (Popham and Wilde, No. 521).

ANTONIO CANALE,
called IL CANALETTO
(1697–1768)

For additions to the catalogue of the Canaletto drawings by Dr. K. T. Parker, see W. G. Constable, *Canaletto*, Oxford, 1962.

GIOVANNI ANGELO CANINI
(1617–66)

LANDSCAPE (Blunt and Cooke, No. 99) (3542)

Signora C. Bertelli has pointed out that this drawing represents the town of Sambuci, near Tivoli, where the castello of the Theodoli contains a room decorated by Canini.

77. THE CONVERSION OF ST. PAUL (Kurz, No. 646) (3612)

From the Luti collection.

This drawing was placed by Prof. Kurz among the anonymous works, but a copy by Altomonte is inscribed: *Canini*, which led Dr. Heinzl to identify the drawing as a study for

Canini's painting of this subject in San Giovanni dei Fiorentini, Rome (cf. Heinzl, *Altomonte*, p. 69, No. 25, and *The Luti Collection*, p. 20, No. 25).

REMIGIO CANTAGALLINA
(c. 1582–after 1635)

78. PEASANTS GATHERING FRUIT IN FRONT OF THATCHED COTTAGES (5793)

242 × 345 mm. Pen and brown ink.

Inventory A, p. 118: 'Dutch Masters'.

The fact that the scene is clearly northern but the style of the drawing Italian, suggests an attribution to Cantagallina, and the drawing is indeed close in style to many in the sketch-book in the Musée des Beaux-Arts, Brussels, illustrating his journey in the Low Countries.

79. A CASTLE, PARTLY RUINED (3540)

190 × 278 mm. Pen and brown washes.

Inventory A, p. 116: 'Paesi di Maestri Bolognesi'.

See also: *Attributed to ERCOLE BAZICALUVA* (No. 32 above), and *Imitator of STEFANO DELLA BELLA* (No. 155 below).

SIMONE CANTARINI
(1612–48)

THE VIRGIN AND CHILD (Kurz, No. 30) (3256)

This is a study for the painting of *Virgin appearing to Sts. Augustine and Monica* in the Pinacoteca at Fano. Another drawing for the same composition was shown at Colnaghi's in May 1969 (No. 18).

THE VIRGIN (Kurz, No. 31) (3377)

Study for the Virgin in a *Nativity*, known from a sketch in the Brera (cf. A. Emiliani, *Mostra di disegni del Seicento Emiliano nella Pinacoteca di Brera*, 1959, No. 16).

THE INCREDULITY OF ST. THOMAS (Kurz, No. 36) (3251)

A similar study, but oblong in shape, is in the Brera (cf. Emiliani, *op. cit.*, No. 63).

DIANA AND ENDYMION (Kurz, No. 41) (3674)

Another sketch of this composition is in the Brera (cf. Emiliani, *op. cit.*, No. 55).

DOMENICO MARIA CANUTI
(1620–84)

80. HERCULES RECEIVED IN OLYMPUS (*Plate 56*) (10915)

352 × 263 mm. Pen and brown wash.

The attribution to Canuti was first made by Mr. John Gere. Later Miss Feinblatt identified the drawing as a study for the Palazzo Pepoli fresco, Bologna (cf. *Art Quarterly*, XXIV, 1961, p. 271).

81. A HERMIT IN A LANDSCAPE CONTEMPLATING THE CROSS (6756)

Oval. 155 × 225 mm. Pen and brown ink, brown washes, touches of body-colour, on greenish prepared paper.

Inventory A, p. 128: 'Moderna Schuola Romana Tom. II. Of Bacicia Galli, Lazaro Baldi, Baglione etc.'

The saint is probably St. Onuphrius.

The attribution was suggested by Mr. Philip Pouncey. Other, almost identical, versions are in the Prado and the Metropolitan Museum, New York (80.3.339).

82. THE WOMAN CLOTHED WITH THE SUN (4505)

251 × 399 mm. Pen and brown ink, grey and brown washes, over black chalk.

83. 226 × 328 mm. Pen and light brown ink, grey and brown washes. An armorial collector's mark, apparently not in Lugt. (4494)

Both drawings from Inventory A, p. 113: 'Cortona, Ciro Ferri, Romanelli, Salvator Rosa &c.'.

The attribution of these two drawings is due to Mr. Philip Pouncey.

No. 82 is a study for the whole composition, whereas No. 83 shows only the woman and the angel.

84. THE CHRIST CHILD APPEARING TO ST. ANTONY OF PADUA (Blunt and Cooke, No. 169) (5516)

This drawing was catalogued as by Gaulli, but Mr. Philip Pouncey attributes it to Canuti.

85. TWO HERMITS (Blunt and Cooke, No. 1040) (1776)

This drawing was classified as anonymous, but Mr. Philip Pouncey attributes it to Canuti.

86. A POPE HANDING A PAPER TO A SUPPLIANT (Blunt and Cooke, No. 1046) (0363)

Dr. Eckhard Schaar and Mr. Philip Pouncey have independently proposed an attribution to Canuti.

LODOVICO CARDI, called CIGOLI
(1559–1613)

See *ARNOUT MYTENS* (No. 315 below), and *FEDERICO ZUCCARO* (No. 520 below).

MARCO CARDISCO
(active c. 1508–42)

87. THE PRESENTATION (Popham and Wilde, No. 1180) (5085)

88. THE ADORATION OF THE MAGI (Popham and Wilde, No. 1181) (5057)

These two drawings were placed with the Anonymous North Italian School, but F. Bologna (*Roviale spagnuolo e la pittura napoletana del Cinquecento*, Naples, 1958, p. 78) has proposed an attribution to Cardisco.

MARCO CARLONE
(1742–96)

89. THE FRESCOES IN THE GOLDEN HOUSE OF NERO, ALSO CALLED THE BATHS OF TITUS (11060–11119)

The sizes vary from c. 320 × 590 mm. to c. 500 × 535 mm. All in water-colour, some with pen and brown ink, and some with an etched outline.

The contents of this volume correspond to the engravings in the *Vestigia delle Terme di Tito Francesco Smugliewicz Pit. disegnò. Carlone incise e dipinse*, published by Lodovico Mirri in 1776. According to the inscription the frescoes were originally copied in drawings by Franciczek Smugliewicz (1745–1807) and engraved by Carlone, who also executed the water-colours in the Windsor volume. In addition to copies of the frescoes the volume contains two plans drawn by Vincenzo Brenna and a view of the ruins in water-colour by Carlone after Smugliewicz. Most of the sheets in this volume are engraved in line and coloured in water-colour, but a few are drawn with a pen. Other similar mixed volumes are known, one belonging to Mr. Lethbridge of Washington.

Attributed to MARCO CARLONE

90. VIEW OF A ROMAN OCTAGONAL BUILDING AND MOSAIC (19318)

730 × 500 mm. Pen, grey ink and water-colour.

91. DESIGNS FOR A CEILING (11607)

339 × 344 mm. Pen, grey ink and water-colour.

These two drawings appear to be by the same hand as the drawings catalogued under the last number.

GIROLAMO DA CARPI
(1501–56)

BACCHIC PROCESSION (Popham and Wilde, No. 197) (0284)

Antal (p. 32) suggested the name of Battista Franco for this drawing, an attribution which Mr. Popham does not accept.

See also: *NICCOLÒ DELL'ABBATE* (No. 1 above), *BALDASSARE PERUZZI* (No. 340 below), and *RAPHAEL* (Popham and Wilde, No. 805).

GIULIO CARPIONI
(1613–79)

92. THE REALM OF HYPNOS (6450)

235 × 190 mm. Pen and brown wash.

Inventory A, p. 105: 'Of Cor: Vischer'.

Catalogued by Puyvelde with an attribution to Lairesse (*Flemish Drawings*, No. 253), but actually a version of a subject treated by Carpioni on a number of occasions (cf. G. M. Pilo, *Carpioni*, Venice, 1961, Figs. 50, 61, 82, 88, 114, 159). The Windsor drawing does not, however, correspond exactly to any of the paintings.

THE CARRACCI

Since the publication of Professor Wittkower's catalogue of the Carracci drawings in 1952 much further work has been done on the subject, and several studies have been published in which the Windsor drawings are discussed. Of these the most important are the following, which are referred to in abbreviated form in the entries for individual drawings:

Bacou. *Musée du Louvre. Dessins des Carrache.* Paris, 1961.

Holland. Ralph Holland, *The Carracci Drawings and Paintings.* Exhibition, King's College, Newcastle upon Tyne, 1961.

Mahon, *Disegni.* D. Mahon, *Mostra dei Carracci.* Disegni, Bologna, 1956.

Martin, *Farnese Gallery.* J. R. Martin, *The Farnese Gallery,* Princeton, 1965.

Mostra dei Carracci (Catalogo). Mostra dei Carracci, Bologna, 1956. (All references are to the third edition.)

Posner. D. Posner, 'Annibale Carracci and his School: the Paintings of the Herrera Chapel', *Arte antica e moderna,* XII, 1960, pp. 397 ff.

Spear, 1967. R. E. Spear, 'The early drawings of Domenichino at Windsor Castle and some drawings by the Carracci', *Art Bulletin,* XLIX, 1967, pp. 52 ff.

Spear, 1968. R. E. Spear, 'Preparatory drawings by Domenichino', *Master Drawings,* VI, 1968, pp. 111 ff.

Stampfle and Bean. F. Stampfle and J. Bean, *Drawings from New York Collections—II, The seventeenth century in Italy.* Metropolitan Museum and Pierpont Morgan Library, New York, 1967.

Tomory. P. A. Tomory, *The Ellesmere Collection of Old Master Drawings* (publ. by the Leicester Museums and Art Gallery). Leicester, 1954.

AGOSTINO CARRACCI
(1557–1602)

93. COPY AFTER AN ANCIENT FRESCO (*Fig. 10*) (9574)
278 × 192 mm. Pen and brown ink, with some red chalk.

Inscribed: *Questi lochi qui segnati di rosso sono quelli che son rotti.*

From the Vittoria and Albani collections.

In his manuscript index to the engravings after Raphael in the Royal Library Vittoria refers to the ancient fresco in question and, after saying that Raphael made use of it in one of his compositions, adds: 'Questa pittura fu copiata da Agostino Caracci, e il disegno si conserva nel mio Libro delle Pitture Antiche'.

THE ADORATION OF THE SHEPHERDS
(Wittkower, No. 89) (2017)
For the Louvre drawing No. 7359, see Bacou, No. 17, Pl. 1; for the Ellesmere drawing, see Tomory, No. 35, and

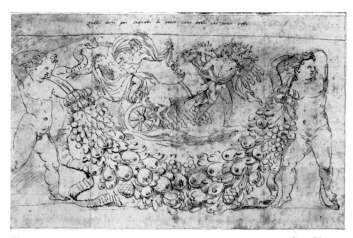

Fig. 10 Cat. No. 93

Mahon, *Disegni,* No. 71, Pl. 21. Both accept Professor Wittkower's conclusions, but Mahon dates the Ellesmere drawing later, 1598–1600. Stampfle and Bean (No. 14) give some reasons for dating this drawing to 1606, which would conflict with an attribution to Agostino. See also below, *ANNIBALE CARRACCI* (Wittkower, No. 344).

OMNIA VINCIT AMOR (Wittkower, No. 94) (1811)
Stephen E. Ostrow, in *Essays in Honor of Walter Friedlaender,* New York, 1965, p. 129, note 15, argues convincingly that the fireplace was executed soon after 1591.
A finished chalk drawing corresponding to this sheet was auctioned at Parke-Bernet, New York, on 30 March 1961 and is now in the University of Kansas Museum of Art, Lawrence, Kansas. In both the Windsor and the Kansas Museum drawing the grouping of the figures differs slightly from the execution (see also Wittkower, No. 186). Moreover, the accessories in the foreground as well as the rendering of the landscape correspond in the drawings, but were changed in the fresco. The Kansas Museum drawing is vastly superior to other drawings of the subject listed under No. 186 and is certainly from Agostino's hand. It may just have preceded the Windsor drawing.

THE RETURN OF THE PRODIGAL SON
(Wittkower, No. 95) (1755)
Holland mentions the fact that M. Jaffé considers the Chatsworth drawing to be a copy. D. Mahon (*Disegni,* p. 49, No. 50) thought that it was closer to Annibale. Professor Wittkower does not agree with either of these opinions.
A picture corresponding to the Windsor composition has recently appeared in a Swedish private collection. The original in the Orleans collection had life-size figures, and the picture in Sweden, which is 120 cm. high, seems to be a reduced copy of it.

PLUTO (Wittkower, No. 98) (2364)
For the history of the four ovals, see Martin, *Gazette des Beaux-Arts,* 1966, I, pp. 7 ff.
The drawing in the Musée Bonnat, Bayonne, is a copy after the painting (cf. J. Bean, *Les Dessins italiens de la collection Bonnat,* Paris, 1960, No. 22).

DESIGN FOR A DISH (Wittkower, No. 100) (1986)
Professor Otto Kurz ('Engravings on Silver by Annibale Carracci', *Burlington Magazine*, XCVII, 1955, pp. 282 ff.) has solved all the problems relating to the Farnese Salver. Bartsch, No. 18, is an engraving after Annibale's salver. In addition to the British Museum drawing, two Ellesmere drawings (Kurz, Figs. 15, 22) are preparatory to Annibale's final design (cf. also, J. Byam Shaw, *A Loan Exhibition of Drawings by the Carracci*, Colnaghi's, London, 1955, Nos. 12, 14).

Kurz (*op. cit.*, p. 285, note 12) finds it tempting to regard the Windsor drawing as Annibale's first sketch for his salver, but since both Annibale and Agostino made designs for salvers (which were probably intended as pendants), there is no compelling reason to abandon the attribution of the Windsor sheet to Agostino. In fact, the attribution to Agostino is strongly supported by a sketch for the salver in the National Museum in Stockholm (937/1863), showing a head of Bacchus in a wreath similar to the Windsor sketch, drawn in Agostino's unmistakable pen technique; this drawing, moreover, bought by Tessin at the Crozat sale of 1741, bears the inscription: *Augustin Carrache*.

Kurz (*op. cit.*, p. 286) has shown that Annibale also used the Silenus group of his salver for a silver bread-basket, but replaced the framing circular garland by a pergola hung with grapes and set the scene in a rich ornamental enclosure framed by Satyr-herms. The two drawings listed as Annibale (Wittkower, Nos. 289, 290) are preparatory to this ornamental border.

VENUS, VULCAN AND CUPID (Wittkower, No. 101)
(2303)
The reference to a drawing in the British Museum was based on a confusion and should be deleted. Mr. Philip Pouncey has pointed out that there is in the British Museum (U. 2-140) an engraving from the Cracherode collection which is in the same direction as the Windsor drawing. It is probably a copy after the engraving by Pietro del Po.

GALATEA (Wittkower, No. 102) (2153)
An important sheet of studies for the Galatea fresco is in the Ellesmere collection (cf. Tomory, p. 14, No. 24, Pl. VII; Mahon, *Disegni*, No. 62; *Le Cabinet d'un grand amateur P.-J. Mariette*, Musée du Louvre, 1967, No. 24, with further information).

STUDIES OF GOD THE FATHER (Wittkower, No. 133)
(1825)
Holland (No. 33) has pointed out that the standing male figure at Chatsworth (No. 409), drawn by Agostino, is similar to the figures of the Windsor drawing.

STUDIES OF FEET (Wittkower, No. 134) (2129)
For the Oxford drawing mentioned in the entry, see K. T. Parker, *Catalogue of the Collection of Drawings in the Ashmolean Museum*, II, 1956, No. 151*v*.
In the *Mostra dei Carracci* (*Catalogo*, No. 41) the Louvre *Annunciation* is dated about 1592-93. Mahon (*Disegni*, No. 53) also seemed to favour this date, but in a later article (*Gazette des Beaux-Arts*, XLIX, 1957, p. 291, note 86) he ex-

cluded the Louvre *Annunciation* from Agostino's *œuvre* and regards the connection of the Windsor drawings with the paintings as 'very far from demonstrable'. He adduces the opinion of Voss, who seems to have rejected the attribution to Agostino, and he finds Francesco Arcangeli's attribution of the picture to the young Albani (i.e. c. 1601)—mentioned in the entry of the *Mostra dei Carracci, Catalogo*, No. 41 —most tempting. Professor Wittkower, however, still regards the relation between the Windsor drawings and the Louvre painting as convincing and hopes to come back to this problem in a special paper.

HEAD OF A MAN (Wittkower, No. 155) (2142)
Mr. Mahon (*Disegni*, No. 76) agrees with Professor Wittkower's findings.

HEADS AND A FIGURE (Wittkower, No. 157) (1928)
The face mentioned as occurring in the British Museum and Darmstadt drawings is also to be found in Louvre No. 7398 (cf. Bacou, No. 19).

HEADS, EYES, AND A BEAR (Wittkower, No. 158)
(2002)
Martin (pp. 143 f.) has shown that a bear strikingly similar to the sketches in No. 158 was used in the *Transformation of Callisto* in the Farnese Gallery, as a kind of Carracci signature. A very similar animal also appears in the grotesques of the Palazzo Fava, Bologna, painted by Agostino (cf. Anna Ottani, *Gli affreschi dei Carracci in Palazzo Fava*, Bologna, 1966, Pl. 7).

SELF-PORTRAIT (Wittkower, No. 164) (2246)
Mahon (*Disegni*, No. 74), treats the identification as a self-portrait with some caution.

PORTRAIT OF A WOMAN (Wittkower, No. 170) (3430)
The oil painting of a lady with a dog, purchased by the Auckland City Art Gallery (formerly Lord Carew), closely resembles this drawing, without being directly connected (cf. *Burlington Magazine*, December 1952, *Supplement*, Pl. VII, and *Auckland City Art Quarterly*, 1957, No. 3, p. 5). Bologna (*Paragone*, VII, No. 83, 1956, p. 12, note 22) is probably correct in saying that this is a Florentine painting and by the hand of Santi di Tito.

PORTRAIT OF A YOUNG WOMAN (Wittkower, No. 171) (2245)
K. T. Parker (*Catalogue of the Collection of Drawings in the Ashmolean Museum*, 1956, No. 144, Pl. XLI), illustrates a remarkably similar drawing. Mr. Mahon (*Disegni*, No. 76) agrees with Professor Wittkower's conclusions.

OMNIA VINCIT AMOR (Wittkower, No. 186) (2126)
For the Oxford drawing, see Parker, *op. cit.*, No. 158.

CARICATURES (Wittkower, p. 123, text between entries Nos. 172 and 173)
The lost drawing referred to has been published by Tomory (No. 33, Pl. IX). The Ellesmere sheet is now deposited in

the Leicester Museum and Art Gallery; see also Mahon, *Disegni*, No. 77, Pl. 23.

See also: *ANNIBALE CARRACCI* (Wittkower, No. 426).

After AGOSTINO CARRACCI

TWO WOMEN BEFORE A CITY (Wittkower,
No. 270) (2297)

Mahon (*Disegni*, No. 65) tentatively dates the Horne drawing to the mid-nineties.

HERCULES AND CACUS (Wittkower,
Nos. 271, 272) (1812, 2172)

In the *Mostra dei Carracci* (*Catalogo*, p. 85) the *Hercules and Cacus* is attributed to Annibale; see also M. Jaffé (*Paragone*, VII, No. 83, 1956, p. 13), who published a drawing for the *Cacus* in a private collection in New York which in fact looks like an Annibale.

See also: *ANNIBALE CARRACCI* (Wittkower, No. 93), *BOLOGNESE SCHOOL* (No. 527 below), and *SCHOOL OF THE CARRACCI* (Wittkower, No. 538).

ANNIBALE CARRACCI
(1560–1609)

BUTCHER'S SHOP (Wittkower, No. 93) (2215)

The picture and, by implication, the drawing, both formerly ascribed to Agostino Carracci, are now attributed to Annibale. Mr. Mahon (*Disegni*, pp. 70 f., No. 84) dates the picture ca. 1583, or even earlier, and does not exclude 'a limited participation' by Agostino (cf. also, Mahon, *Gazette des Beaux-Arts*, 1957, I, pp. 267 f.). J. R. Martin (*Art Bulletin*, XLV, 1963, pp. 263 ff.) supports the attribution to Annibale with new and interesting arguments. The whole question is brilliantly examined (with full bibliography) by J. Byam Shaw, *Paintings by Old Masters at Christ Church, Oxford*, London, 1967, pp. 100 f., No. 181.

THE TRIUMPH OF ROMULUS OVER ACRON
(Wittkower, No. 275) (2064)

Mr. Mahon (*Disegni*, No. 102) agrees with Professor Wittkower's conclusions. Other drawings for the Palazzo Magnani are Uffizi 12413 F (cf. Mahon, *Disegni*, No. 94), Louvre, No. 7535 (cf. Mahon, *ibid.*, No. 95, Pl. 32; Bacou, No. 27, Pl. IX, and Ottani, *Gli affreschi dei Carracci in Palazzo Fava*, Bologna, 1966, p. 72, who, following Arcangeli, attributes this drawing as well as the fresco to Lodovico), and Louvre No. 7200 (cf. Bacou, No. 28, Pl. V).

STUDY OF A HEAD (Wittkower, No. 278) (2115)

For the Louvre drawing, No. 7310, see Bacou, No. 29.

PORTRAIT OF GIOVANNI GABRIELLI
(Wittkower, No. 279) (2277)

Mr. Mahon (*Disegni*, No. 102) proposes a date of c. 1593–94, and discusses again the problem of the identity of the sitter in the Dresden portrait, without arriving at any firm conclusion. In his entry for the Vienna drawing (*ibid.*, No. 103)

he mentions a copy of it in the Louvre (No. 7625). He questions the authenticity of the Uffizi drawing.

A fine red and black chalk drawing, close to the painting, appeared on the New York art market and was exhibited at Detroit (cf. *Art in Italy 1600–1700*, 1965, Catalogue No. 74).

DESIGN FOR A DISH (Wittkower, Nos. 289, 290)
 (2165, 1967)

Professor Kurz (*Burlington Magazine*, XCVII, 1955, pp. 284 ff.) has shown that these two drawings are Annibale's preparatory designs for the decorative border surrounding the Farnese bread-basket, as shown in the engraving by Villamena. Kurz's Fig. A illustrates the engraving.

THE CAMERINO FARNESE

DESIGN FOR THE DECORATIVE FRAMEWORK OF
THE CEILING (Wittkower, No. 280) (2065)

Mahon (*Disegni*, No. 144) draws attention to the Louvre drawing No. 7306, a detailed study for the allegory of *Securitas* in the decorative framework of the Camerino. For this drawing, see also Bacou, No. 53.

CARTOON OF A SIREN (Wittkower, No. 281) (2025)

Cf. Mahon, *Disegni*, No. 145.

CARTOON OF A PUTTO (Wittkower, No. 282) (2024)

Cf. Mahon, *ibid.*, No. 146.

CIRCE (Wittkower, No. 283) (2066)

Cf. Mahon, *ibid.*, No. 136. For the Louvre drawings Nos. 7201, 7203, 7211, see Bacou, No. 49, and *Le Cabinet d'un grand amateur P.-J. Mariette*, Musée du Louvre, 1967, No. 31.

STUDY FROM THE NUDE (Wittkower, No. 284) (2365)

Martin, *Farnese Gallery*, p. 176, note 3, expresses strong doubts about the authenticity of the drawing, which he believes to be 'studio work'.

THREE SIRENS (Wittkower, No. 285) (2026)

Cf. Mahon (*Disegni*, Nos. 139 and 140 for Louvre, No. 7324). For the latter drawing see also Bacou, No. 48.

STUDY FOR AMPHINOMUS (Wittkower, No. 286) (1850)

A much larger chalk study for the same group is in the Musée Atger, Montpellier (No. 116; cf. Mahon, *Disegni*, No. 142).

THE FARNESE GALLERY (Wittkower, text between
entries Nos. 286 and 287)

The subject of the fresco referred to here as the *Galatea* has since been identified as *Glaucus and Scylla* (cf. Martin, *Farnese Gallery*, pp. 105 ff.).

DECORATIVE SCHEME (Wittkower, No. 287) (2155)
For Louvre, No. 8048, see Bacou, No. 56. For the relation of No. 287 to the Louvre drawing, see Martin, *Farnese Gallery*, pp. 192 ff.

AN ATLAS (Wittkower, No. 288) (2354)
This drawing is mentioned neither in the text nor in the catalogue of Martin's *Farnese Gallery*, an indication that he does not accept it as belonging to the Galleria.

DECORATIVE SKETCHES (Wittkower, No. 291) (2142)

A SATYR AS ATLAS (Wittkower, No. 292) (1860)
Neither of these drawings is mentioned by Martin, and Professor Wittkower is now very doubtful about their connection with the Farnese Gallery.
As regards the Louvre drawings, Nos. 7420 and 7422, Professor Wittkower now accepts the view of Tietze, which he challenged in the entry (cf. Martin, *Farnese Gallery*, p. 250, No. 44).

STUDIES FOR ATLANTES, ETC. (Wittkower, No. 293)
(2131)
For a full discussion of this important drawing see Martin, *Farnese Gallery*, pp. 194 f. Mahon (*Disegni*, No. 148) called attention to the inscription *Innocencio fe.* along the thigh of the middle Atlas and suggested that the geometric designs might be by Innocenzo Tacconi, Annibale's pupil. Martin (*Farnese Gallery*, p. 195), in addition, discovered on the larger of the two geometrical constructions the letter *I* twice.
The sketch of the seated Virgin and Child is not, as suggested in the catalogue, a preparation for the *Virgin and Child with a Swallow*, but, as Mahon pointed out (*Gazette des Beaux-Arts*, XLIX, 1957, I, p. 285, No. 68), for the *Nativity of the Virgin* in the Louvre (*Mostra dei Carracci, Catalogo*, No. 105).

STUDIES FOR *PERSEUS AND PHINEUS* AND
THE *ANDROMEDA* (Wittkower, Nos. 294–301)
(1948, 1973, 2003, 2039, 2072, 2073, 2106, 2357)
These drawings were dated in the Carracci catalogue to about 1600. Mahon (*Disegni*, No. 200) still dated the Andromeda drawing (No. 301) 'about 1601–2', but in 1961 he revised the dating of the two frescoes to 1604–5 (cf. Bacou, pp. 57 ff.). This has now been generally accepted, and Martin (*Farnese Gallery*, pp. 60 ff.) argues that Annibale alone painted the *Perseus and Phineus* in 1604, and that the Andromeda fresco was also begun by him in the same year and finished by Domenichino in 1605, after Annibale had been stricken by paralysis. The stylistic idiosyncrasies in the preparatory drawings of these frescoes, mentioned by Professor Wittkower, are regarded by Martin (*Farnese Gallery*, p. 231) as characteristic of Annibale's late Roman manner (i.e. of 1604).

STUDY FOR A NEREID (Wittkower, No. 302) (2106)
For the drawings mentioned in this entry, see the following later references: for Louvre No. 7189 (wrongly referred to

in the previous catalogue entry as 7389), see Mahon, *Disegni*, No. 171, Bacou, No. 73, and Martin, *Farnese Gallery*, No. 121. For Louvre No. 7196, see Mahon, *Disegni*, No. 166; Bacou, No. 71, and Martin, *Farnese Gallery*, No. 84. For Louvre Nos. 7197, 7198, see below under Annibale (Wittkower, No. 507). For Louvre No. 7303bis (study of an arm, mentioned by Professor Wittkower without an inventory number), see Martin, *Farnese Gallery*, No. 88. For Louvre No. 7319, see Mahon, *Disegni*, No. 167, Bacou, No. 72, Martin, *Farnese Gallery*, No. 85, and *Le Cabinet d'un grand amateur P.-J. Mariette*, Musée du Louvre, 1967, No. 33. For Louvre No. 7329, see Bacou, No. 75, and Martin, *Farnese Gallery*, No. 91. For Besançon No. 2293, see Mahon, *Disegni*, No. 165, and Martin, *Farnese Gallery*, No. 87.
Martin (*Farnese Gallery*, p. 222, No. 101) relates Besançon No. 1538 to the legs of the *ignudo* to the left of *Hero and Leander*, a suggestion which is accepted by Professor Wittkower as probably but not certainly correct.

STUDY FOR POLYPHEMUS (Wittkower, No. 303) (1944)
The Koenigs drawing (I. 183) is now in the Museum Boymans-van Beuningen, Rotterdam. The Louvre drawing mentioned in the last line but one of the entry is No. 7191, not 7323 (cf. Mahon, *Disegni*, No. 185, Bacou, No. 77, and Martin, *Farnese Gallery*, No. 124). For Louvre 7323, see Mahon, *Disegni*, No. 189, Bacou, No. 78, and Martin, *Farnese Gallery*, No. 105.

PAN AND SELENE (Wittkower, No. 304) (1858)
For the Chatsworth drawing, No. 414, see Martin, *Farnese Gallery*, No. 72. For Louvre No. 7190, see Mahon, *Disegni*, No. 160; Bacou, No. 64, and Martin, *Farnese Gallery*, No. 75.

STUDIES OF GOATS (Wittkower, No. 305) (1978)
Martin (*Farnese Gallery*, p. 205, No. 63) regards it as possible that this drawing may not be for the *Bacchanal*.

THE TRIUMPH OF BACCHUS AND ARIADNE
(Wittkower, No. 305A) (12065)
The identification of the drawing proposed by Professor Wittkower was accepted by Mahon (*Disegni*, text to No. 151), Holland (No. 143), and Bacou (No. 58). Martin (*Farnese Gallery*, pp. 208 f.), however, has given good reasons for regarding it as a copy after the cartoon, of which the right half survives in Urbino.

CUPID (Wittkower, No. 307) (2089)
For the iconography of this drawing, see Martin (*Farnese Gallery*, p. 86 ff.), and also Vitzthum's comment on the Metropolitan Museum drawing with two cupids carrying a third (Martin, *Farnese Gallery*, No. 125), which he regards as an illustration of Ficino's concept of threefold love (*Master Drawings*, IV, 1, 1966, p. 48).
For Louvre 7305, see Mahon, *Disegni*, No. 188, and Martin, *Farnese Gallery*, No. 126. For Louvre 7395, see Bacou, No. 81, and Martin, *op. cit.*, No. 131.

STUDY FOR ATLANTES (Wittkower, No. 308) (2087)
For Louvre 7363, see Mahon, *Disegni*, No. 187, Bacou, No. 79, Martin, *Farnese Gallery*, No. 120, and *Cabinet d'un*

grand amateur P.-J. Mariette, 1967, No. 34. For Louvre
7354, see Mahon, *Disegni*, No. 198, Bacou, No. 76, and
Martin, *op. cit.*, No. 116. For Besançon D2296, see Mahon,
op. cit., No. 186, and Martin, *op. cit.*, No. 119. For Besançon
D2297, see Mahon, *Disegni*, No. 199, and Martin, *op. cit.*,
No. 115. For Turin 16075, see Mahon, *op. cit.*, No. 172,
and Martin, *op. cit.*, No. 117.

ATLAS (Wittkower, No. 309) (2366)

Mahon (*Disegni*, No. 197) accepts the tentative connection
of the drawing with the Atlas to the right of the *Diana and
Endymion*. According to Martin (*Farnese Gallery*, p. 225 and
No. 110) it is 'almost certainly a design for the figure in
question'. For other drawings connected with the same
Atlas, see Martin, *ibid.*, Nos. 109, 111.

ATLAS (Wittkower, No. 310) (2083)

Mahon, (*Disegni*, under No. 177) accepted this drawing
as an original. Martin, however, in his catalogue (*Farnese
Gallery*, No. 113) classifies it as a 'study for or perhaps copy
after' the fresco, and in his text (p. 225) suggests that it is
either a copy by a pupil or reworked. Professor Wittkower
still maintains that it is an original.
For Besançon D1451 see Mahon, *ibid.*, No. 179, and
Martin, *ibid.*, No. 108. For Besançon D1490, see Mahon,
ibid., No. 175, and Martin, *ibid.*, No. 102. For Louvre
7317, see Mahon, *ibid.*, No. 196, Bacou, No. 69, and
Martin, *ibid.*, No. 107. For Louvre 7325, see Mahon,
ibid., No. 191, Bacou, No. 83, and Martin, *ibid.*, No. 99.
For Uffizi 12425, see Mahon, *ibid.*, No. 180, and Martin,
ibid., No. 114. For Turin 16071, see Mahon, *ibid.*, No. 177,
and Martin, *ibid.*, No. 112.

APOLLO AND MERCURY (Wittkower, No. 312) (2285)

Professor Wittkower's conclusions about this drawing have
been generally accepted (cf. Mahon, *Disegni*, under No.
202; *L'ideale classico del Seicento*, Bologna exhibition, 1962,
No. 153, and Martin, *Farnese Gallery*, No. 143).
For Louvre 7178, see Martin, *ibid.*, No. 142. For Louvre
7194, see Bacou, No. 86, and Martin, *ibid.*, No. 146. For
Louvre 7195, see Martin, *ibid.*, No. 147. For Louvre 7207,
see Bacou, No. 87, and Martin, *ibid.*, No. 144. For Louvre
7208, see Martin, *ibid.*, No. 145.

JUSTICE (Wittkower, No. 313) (2146)

Martin (*Farnese Gallery*, p. 236; No. 150 with further
references) has shown that the pose of this drawing was
used for the *Allegory of Fortitude*.

DRAWINGS ASSOCIATED WITH THE FARNESE
GALLERY (Wittkower, Nos. 315–328)

(1823, 1946, 1947, 1949, 2053, 2096, 2105, 2356, 2358,
2366, 2367, 2371, 2372, 5309)

Of the drawings classified under this heading in Professor
Wittkower's catalogue only one (No. 323) is mentioned by
Martin (*Farnese Gallery*, under No. 110), and that is des-
cribed as not connected with the Gallery. It is to be
presumed that he does not accept the connection of the
others with the frescoes.

For Louvre 7339, see Mahon, *Disegni*, No. 58, Bacou, No.
21, and Martin, *ibid.*, No. 79.

A RECLINING FIGURE (Wittkower, No. 320) (2053)

Mr. Richard Spear has pointed out that the *recto* of this
drawing is a study for a painting in the Longhi collection,
published by E. Borea (*Paragone*, No. 191, 1966, Pl. 60)
as by Domenichino, but which Mr. Spear believes to be
by Annibale Carracci.

THE CAPPELLA S. DIEGO IN S. GIACOMO DEGLI
SPAGNOLI (Wittkower, p. 141, text between Nos. 328
and 329)

For the drawings connected with this fresco cycle, see
D. Posner, 'Annibale Carracci and his School: the Paintings
of the Herrera Chapel', *Arte antica e moderna*, XII, 1960,
pp. 397 ff. For later literature, see Vitzthum (*Burlington
Magazine*, CIV, 1962, pp. 76 ff.); Schleier (*ibid.*, p. 255);
Vitzthum (*Master Drawings*, III, 4, 1965, p. 413), and Spear
(*Art Bulletin*, XLIX, 1967, p. 57). Despite all these contri-
butions, many problems remain to be solved.

STUDIES OF A MONK (Wittkower, Nos. 329, 330)

(1790, 1791)

Posner, Mahon (in Bacou, p. 60) and others agree to the
attribution of these two frescoes to Annibale. Vitzthum
(*Master Drawings*, III, 4, 1965, p. 413) published Annibale's
sketch for *S. Diego receiving the Habit* in the Staedel Institute,
Frankfort, as well as the whole series of studio drawings
in Stockholm for scenes in the Herrera Chapel. They were
first made known by Per Bjurström in the exhibition
catalogue *Italienska Barockteckningar*, Nationalmuseum,
Stockholm, 1965, Nos. 4–10, and attributed to Albani.

A KNEELING FIGURE (Wittkower, No. 334) (2085)

Posner (p. 404), taking up Professor Wittkower's suggestion
that this study had similarities to certain drawings by
Lanfranco, definitely ascribed the sheet to him, but
Schleier (*Burlington Magazine*, CIV, 1962, p. 255) rejected
the attribution. Professor Wittkower is still inclined to
accept Annibale as the most likely author.

STUDIES FOR THE *ASSUMPTION* (Wittkower, Nos. 331,
332) (1796, 1798)

See below, Wittkower, Nos. 476, 480.

STUDY FOR ST. PAUL (Wittkower, No. 337) (2074)

This drawing was ascribed by Posner (p. 404) to Lanfranco,
but this attribution was rejected by Schleier (*loc. cit.*),
correctly in the view of Professor Wittkower.

ST. JOHN THE BAPTIST (Wittkower, No. 338) (2366)

Martin (*Farnese Gallery*, p. 225) states that a fragmentary
sketch on the left half of the *verso* is connected with the
Atlas on the right, but it in fact shows a figure in a quite
different pose, with the left arm raised.

THE VIRGIN AND CHILD WITH ST. ELIZABETH AND
ST. JOHN (Wittkower, No. 343) (2342)

Mahon (*Disegni*, No. 210) agrees with the attribution to Annibale and dates the drawing to the first Roman period.

STUDY OF A BOY (Wittkower, No. 344) (2083)

A pen study by Annibale for figures in the *Adoration of the Shepherds* in a private collection, New York, was published by Stampfle and Bean (No. 14). The New York drawing is on the *verso* of a proof impression of Annibale's *Ecce Homo* etching, dated 1606; hence the authors of the catalogue entry regard 1606 as the *terminus post quem* for the picture. For stylistic reasons this seems difficult to accept. Moreover, since Agostino's drawing in the Ellesmere collection, referred to above under Agostino (Wittkower, No. 89; Tomory, No. 35) shows motifs definitely connected with Annibale's picture, the latter cannot be dated later than 1602, the year of Agostino's death.

Schleier dates Lanfranco's *Adoration of the Shepherds*, painted for the Marchese Sannesi (now at Alnwick Castle) and derived from Annibale's composition, to 1606–1607.

THE YOUNG BACCHUS (Wittkower, No. 345) (1784)

For the painting, see *Mostra dei Carracci, Catalogo*, No. 97, and Mahon, *Disegni*, No. 117. Both catalogues agree on a date of c. 1598–1600.

The Louvre drawing referred to in Professor Wittkower's catalogue is in fact No. 7338, and not 7199. For this drawing and another Louvre drawing (7193) for the head of Silenus, see Mahon, *ibid.*, No. 117, and Bacou, Nos. 38, 39.

STUDIES FOR THE ST. GREGORY ALTARPIECE (Wittkower, No. 351) (2335)

Mahon (*Disegni*, No. 120) dates the Chatsworth drawing c. 1600–1601. For this drawing, see also *Old Master Drawings from Chatsworth*, loan exhibition circulated by the Smithsonian Institution, 1962–3, Pl. 13. A study for the Angel to the right, formerly in the collection of Mr. and Mrs. Hugh Squire (Holland, No. 154), is now in the Metropolitan Museum (cf. Stampfle and Bean, No. 13).

STUDY FOR ST. ANDREW (Wittkower, No. 352) (2121)

Posner (note 67) dates the Munich picture c. 1606.

STUDIES FOR THE SELF-PORTRAIT ON AN EASEL (Wittkower, No. 353) (1984)

Mahon (*Disegni*, No. 122) dates this c. 1602–1603.

DANAE (Wittkower, No. 355) (1954)

Professor Wittkower accepts Mr. Mahon's dating to early 1605 (*Disegni*, No. 126).

THE ADORATION OF THE SHEPHERDS (Wittkower, No. 356) (2118)

Mr. Mahon (*Disegni*, No. 263) dates this drawing c. 1604–1605.

PIETÀ (Wittkower, No. 357) (2169)

Mahon (*Disegni*, No. 123) suggested a date of c. 1603–1604,

but later (*Gazette des Beaux-Arts*, 1957, I, p. 288, note 75) revised the date of the picture and also of the drawing to c. 1599, which, in Professor Wittkower's view, is probably correct.

The drawing is engraved in Chamberlaine (Pl. 30).

PUTTI (Wittkower, No. 358) (2127)

J. R. Martin, 'Drawings by Annibale Carracci for the "Sleeping Venus"', *Master Drawings*, II, 2, 1964, pp. 160 ff., discussed the iconography of the theme. He suggested that the Windsor and Frankfort drawings originally formed a single sheet, and that Annibale drew the ink lines over the chalk after he had torn off the figure of Venus. He also identified Cupid curling his hair before a looking glass in the Louvre drawing No. 7303 as supplementing the Windsor drawing in the lower right-hand corner. He regards the pen and wash drawing in the Louvre (7571) as a copy after the painting.

STUDY FOR ST. MARK (Wittkower, No. 359) (2056)

Mahon (*Disegni*, No. 128) and Spear (1967, p. 57) accept Professor Wittkower's conclusions. Spear recognized another Windsor drawing as a study by Annibale for the same chapel (cf. below, Wittkower, No. 477).

SELF-PORTRAIT (Wittkower, No. 360) (2254)

While Mahon (*Disegni*, No. 220) agrees with the dating of Uffizi 762 proposed by Professor Wittkower, he suggests advancing the date of the present drawing to c. 1584— mainly on the basis of the similarity to Wittkower, No. 370 (see below)—and concludes that such a date would imply abandoning the self-portrait hypothesis, since at that time Annibale was twenty-four years old (Mahon, *ibid.*, No. 212). *Non liquet* seems the only verdict possible at the moment.

HEAD AFTER THE ANTIQUE (Wittkower, No. 365) (2028)

Mahon (*Disegni*, Nos. 208, 209) and Bacou (No. 51) accept the main points made by Professor Wittkower in his entry for this drawing.

STUDY FOR JASON AND CHIRON (Wittkower, No. 370) (1937)

Francesco Arcangeli identified this drawing as a sketch for *Jason and Chiron* in the Palazzo Fava, Bologna, of c. 1584 (cf. Mahon, *Disegni*, No. 212).

TWO YOUNG MEN ASLEEP (Wittkower, No. 381) (1809)

For Uffizi 12398 (described as young man who seems to lift a stone), see Mahon, *Disegni*, No. 223. For the drawing from the Koenigs collection, now in the Boymans-van Beuningen Museum, Rotterdam, see Mahon, *ibid.*, No. 227. Mahon dated both drawings to the mid-1580's.

ST. SEBASTIAN (Wittkower, No. 386) (1801)

For Louvre RF 607, see *Le Cabinet d'un grand amateur P.-J. Mariette*, 1967, No. 25. Bacou (under No. 27) regards Louvre 7895 as a copy rather than an original.

HERCULES AND OMPHALE (Wittkower, No. 390) (1780)
Mahon (*Disegni*, No. 205) accepts Professor Wittkower's
conclusions.

ALLEGORY OF THE VIRGIN (Wittkower, No. 407)
 (2119)
For Louvre 7194, see Bacou, No. 86, and Martin, *Farnese
Gallery*, No. 146.

AN EXECUTION (Wittkower, No. 411) (1955)
There seems to be general agreement that Annibale drew
an execution which he had seen (cf. I. Fenyö, *Bulletin du
Musée Hongrois des Beaux-Arts*, No. 17, 1960, p. 42; Holland,
No. 80, thinks it was probably drawn from memory;
Mahon, *Disegni*, No. 234, probably c. 1595).

ST. CECILIA AND ST. VALERIANO CROWNED BY AN
ANGEL (Wittkower, No. 412) (2136)
Miss Catherine Johnston has identified a copy of this
drawing in the Louvre (12403).

THE MARTYRDOM OF ST. STEPHEN (Wittkower,
No. 414) (2148)
Mahon, in Bacou, p. 60, dates the drawing 'considérable-
ment plus tard' than Professor Wittkower.
For the Louvre painting, see *Mostra dei Carracci, Catalogo*,
No. 111, as dating from 1604–1605; Vitzthum (*Burlington
Magazine*, CIV, 1962, pp. 76 f.) accepted this date. Both
Mahon and Vitzthum regard the Louvre drawing 7172 as
a studio drawing, reflecting a sketch by Annibale.
Spear (1967, pp. 52 f.) gave good reasons for dating the
Louvre *St. Stephen* before 1603.

THE VIRGIN AND CHILD WITH ST. JOSEPH
(Wittkower, No. 415) (2133)
The Ellesmere picture, sold at Christie's in 1946, was
bought by Mr. John Pope-Hennessy.

PLENTY AND FELICITY (Wittkower, No. 426) (2147)
Mahon (*Disegni*, No. 110) does not exclude the possibility
of Agostino's authorship in 'un momento eccezionalmente
felice' between 1597–1600. For the time being, however, it
seems safer to stick to Annibale as author.

STUDIES OF WOMEN WALKING (Wittkower, No. 431)
 (1842)
On the *verso* are two sketches, one a study of a left hand,
and the other a rapidly drawn profile of a man, both in pen.

TWO DRAPED FIGURES (Wittkower, No. 444) (2097)
Mahon (*Disegni*, No. 211) fully accepts Professor Wittkower's
conclusions.

STUDY FOR AN ANGEL (Wittkower, No. 476) (2099)
Spear (1967, p. 57) believes these sketches to be originals
by Annibale and connects them with the Herrera Chapel:
'The putto on the right of the *verso* can be identified with
a putto in the lower right-hand corner of the *Assumption*,

while the putto at the left should be associated with a
putto who clings to a cloud in the lantern fresco of God the
Father'. The study on the *recto* is probably a preliminary
design for the putto below the left hand of God the Father
in the same painting.

STUDY OF ST. JOHN THE BAPTIST (Wittkower,
No. 477) (2081)
This drawing was identified by Spear (1967, p. 57) as
Annibale's original study for the pendentive with St. John
in the chapel of S. Nilus at the Badia of Grottaferrata
(cf. above, Wittkower, No. 359).

STUDY FOR AN APOSTLE (Wittkower, No. 480) (2104)
Correctly identified by Spear (1967, p. 57) as a study by
Annibale for the Apostle at the tomb farthest left in the
fresco of the Herrera Chapel.

After ANNIBALE CARRACCI

93A LANDSCAPE WITH JACOB ASLEEP UNDER A TREE
 (5774)
334 × 240 mm. Pen and brown ink.
Inventory A, p. 119: 'Paesi Diversi. 13 By Fratti and
Donato Creti of Bolognese'.
A copy after a drawing in the Duke of Sutherland's
collection, reproduced in the catalogue of the exhibition
The Ellesmere Collection of Old Master Drawings, Museum
and Art Gallery, Leicester, 1954, No. 64, Pl. XV, and in
Mahon, *Disegni*, 1956, No. 241.

LANDSCAPE WITH THE FLIGHT INTO EGYPT
(Wittkower, No. 76) (5729)
M. Jaffé ('Some Pen Drawings of Landscape with Figures
by Annibale Carracci', *Bulletin du Musée Hongrois des
Beaux-Arts*, No. 25, 1964, pp. 87 ff., Fig. 59) published a
Landscape with the Rest on the Flight in the Budapest
Museum of Fine Arts as by Annibale (Inventory, No. 2309)
and mentioned the Windsor drawing (hitherto attributed
to Lodovico), Louvre 7428, and Chatsworth 459 as copies
after it.

ST. JEROME (Wittkower, No. 484) (2154)
Spear (*Arte antica e moderna*, Nos. 34–36, 1966, pp. 226 f.)
maintains that this drawing is an original by Annibale,
but it appears to lack the clarity of definition to be found
even in Annibale's rapid sketches.

JUSTICE (Wittkower, No. 502) (2037)
Martin (*Farnese Gallery*, p. 237 and No. 151) is inclined
to believe that this is an original study by Domenichino
(cf. also Martin, *Bollettino d'Arte*, XLIV, 1959, pp. 42 ff.,
Fig. 7).

CHARITY (Wittkower, No. 506) (2038)
According to Martin (*Farnese Gallery*, p. 237) an exact copy
by a pupil after the painting (cf. also, Martin, *Bollettino
d'Arte*, XLIV, 1959, Fig. 10).

POLYPHEMUS AND GALATEA (Wittkower, No. 507)
(1799)

Cf. Holland, No. 182. Mahon (orally) suggested that Louvre 7198 may be by Agostino. Bacou (under No. 71) maintains that it is probably an old copy after an original by Annibale, and that Louvre 7197 is by Agostino. Martin (*Farnese Gallery*, No. 86) correctly accepts Louvre 7197 as an original by Annibale. He also states (p. 216) that Louvre 7198 is a student's exercise after the fresco, and accepts Professor Wittkower's view that the Windsor drawing is a copy after it.

THE DEATH OF JUDAS (Wittkower, No. 511) (1956)

For Louvre 7436, see Mahon, *Disegni*, No. 245 (dated c. 1600), and Bacou, No. 101. Another copy of Louvre 7436 is Louvre 7629.

THE RESURRECTION (Wittkower, No. 513) (2125)

For the painting, see *Mostra dei Carracci, Catalogo*, No. 82.

FÊTE CHAMPÊTRE (Wittkower, No. 540) (2314)

This is a studio copy after Annibale's original in Paris (Louvre 7446), dating from the early Bolognese period (cf. Bacou, No. 93).

Attributed to ANNIBALE CARRACCI

94. STUDY FOR A HERM (*Plate 29*) 4343

444 × 310 mm. Black chalk, with some heightening in white chalk.

From the Maratta volumes.

The names of Rubens, Bernini, and Pietro da Cortona have been verbally suggested for the author of this fine drawing, but none of them seems satisfactory. It is, however, certainly connected with the herms on the ceiling of the Farnese Gallery, and Mr. J. Byam Shaw believes that it is actually from the hand of Annibale Carracci. He points out that it is related to the herm to the right of the *Polyphemus and Galatea* (cf. Martin, *Farnese Gallery*, Fig. 41). He suggests that the Windsor drawing was Annibale's first idea for this figure, and that he then developed it into the type shown in the Louvre drawing (Martin, *ibid.*, Fig. 155) before giving it the form shown in the fresco. The drawing is also similar in style to two other drawings connected with the Gallery at Windsor (*ibid.*, Fig. 224) and Turin (*ibid.*, Fig. 226). In pose it has also a fairly close resemblance to the herm to the left of Jupiter and Juno (*ibid.*, Fig. 43). A further link with the Farnese ceiling is the band of laurel supported by the herm, which also occurs, though in a slightly different position in the frescoes.

Technically the drawing has some resemblance to the manner of Guercino, particularly in the shading down the right-hand side of the torso, where the chalk seems to have been rubbed to show the texture of the rough paper. Professor Wittkower does not agree with the attribution to Annibale.

Follower of ANNIBALE CARRACCI

95. THE HOLY FAMILY (?) 637B

470 × 339 mm. Pen and brown ink.

A drawing by Domenichino (Pope-Hennessy, No. 941) had been laid down over this drawing, which is in the manner of Annibale Carracci, but too loose to be from his own hand. The drawing is so sketchy that the subject is hard to identify, but it seems to be a Holy Family.

96. A LAKE BETWEEN HILLS, THE SEA IN THE DISTANCE (6153)

247 × 367 mm. Pen and dark brown ink, on brown paper.

97. LANDSCAPE WITH A RIVER (5761)

186 × 347 mm. Pen and brown ink.

The style derives ultimately from the manner of Annibale Carracci.

See also: *LODOVICO CARRACCI* (Wittkower, No. 38); *DOMENICHINO* (Pope-Hennessy, Nos. 255*v*, 1006*v*, and Nos. 162, 163 below); *ANDREA SACCHI* (Blunt and Cooke, No. 738); *VENTURA SALIMBENI* (No. 427 below).

LODOVICO CARRACCI
(1555–1619)

98. HEAD OF THE VIRGIN AND CHILD (0598)

201 × 254 mm. Red chalk, on light brownish-grey paper.

Inventory A, p. 123: 'Heads (in red chalk) of a Virgin and Child' under 'Correggio Parmetiano etc.'.

Mahon was the first to attribute this drawing to Lodovico (orally) and to connect it with the fresco in the Oratorio di San Pellegrino, Bologna, to be dated c. 1588 (cf. *Mostra dei Carracci, Catalogo*, No. 9). M. Jaffé (*Burlington Magazine*, CII, 1960, p. 31, Fig. 42) published Mahon's conclusions. In spite of the close similarity of poses in the drawing and the fresco, some doubt remains as to the correctness of the attribution and the relation to the fresco.

Following a suggestion by Francesco Arcangeli, Mahon also related a drawing of the *Virgin and Child* in the Ellesmere collection to the San Pellegrino fresco (cf. *Disegni*, No. 29, Pl. 11). While the attribution to Lodovico of this drawing cannot be doubted (cf. Tomory. No. 10), its relationship to the fresco is far from certain.

THE MARTYRDOM OF ST. URSULA (Wittkower, No. 1)
(2326)

Mr. Denis Mahon (*Gazette des Beaux-Arts*, 1957, I, p. 199, note 15) points out that this drawing is a study for the lost painting of 1615, once at Mantua. Mlle Bacou (p. 21) refers to a variant in the Louvre (7812; probably a copy).

THE DELIVERANCE OF CARPI (Wittkower, No. 2)
(1765)

According to Campori (*Artisti italiani negli stati estensi*, Modena, 1855, pp. 134 ff.) the picture was signed and dated 1619.

For the Louvre drawing (7715), see Bacou, pp. 20 f., No. 15.

THE CROWNING WITH THORNS (Wittkower, No. 5) (01189)
Mahon (*Gazette des Beaux-Arts*, 1957, I, p. 203, note 17) accepts Bodmer's dating, c. 1595–96.
For Louvre 7680, see Bacou, p. 16, No. 4.

ST. BENEDICT SAVING THE KITCHEN FROM FIRE (Wittkower, No. 13) (1881)
Holland (No. 3) suggests that the Chatsworth drawing is a study for an executioner in a *Flagellation* rather than for the figure in the S. Michele in Bosco fresco. This view has been accepted by M. Jaffé (*Burlington Magazine*, CIV, 1962, p. 29), and in *Old Master Drawings from Chatsworth*, loan exhibition, Smithsonian Institution, 1962–3, No. 17.

ULYSSES BEFORE CIRCE (Wittkower, No. 35) (2122)
Professor Wittkower catalogued this drawing as by Lodovico Carracci. Mr. Mahon (*Disegni*, No. 33) attributes it to a 'direct pupil of Lodovico' and dates it c. 1600. Martin (*Farnese Gallery*, p. 32, note 48) calls it a Carraccesque drawing which combines features taken both from Tibaldi and Annibale. He does not commit himself as to authorship. Professor Arcangeli (*Arte antica e moderna*, I, 1958, p. 356), apparently supported by Dr. Vitzthum (*Burlington Magazine*, CIV, 1962, p. 79, note 7), has proposed an attribution to Albani. Professor Wittkower still feels that Lodovico is the most likely candidate.
Klara Garas ('The Ludovisi Collection of Pictures in 1633', *Burlington Magazine*, CIX, 1967, p. 339, note 5) connects with this drawing the Ludovisi picture described in 1633 as 'di mano del Carracci'. She also refers to the *Circe* mentioned by Malvasia (*Felsina Pittrice*, Bologna, 1678, I, p. 393) in the Vigna Ludovisi as by Lucio Massari.

THE ANNUNCIATION (Wittkower, No. 38) (2137)
Mr. Stephen Pepper suggests that this drawing is related to Lodovico's *Annunciation* in the frame of the *Misteri del Rosario* altar in S. Domenico, Bologna, a hypothesis which Professor Wittkower regards as possible but not absolutely certain.
F. Bologna (*Paragone* VII, No. 83, 1956, p. 12, note 22) states 'quasi certamente Annibale verso il 1595'. Professor Wittkower does not agree with this re-attribution.

THE MARTYRDOM OF ST. CECILIA (Wittkower, No. 39) (2193)
Mahon (*Disegni*, pp. 42 f., No. 43) suggests that the drawing is a 'first idea' for the painting in S. Maurizio (Cappella di S. Margherita), Mantua, for which Lodovico received the commission in 1619 (*Mostra dei Carracci, Catalogo*, 'Regesto', p. 103), and which was executed after his death by a pupil. This would involve dating the Windsor drawing to 1619.

ALEXANDER AND ROXANA (Wittkower, No. 44) (2329)
Mahon (*ibid.*, p. 42, No. 42) suggests dating the drawing in

the last years of Lodovico's life. Professor Wittkower accepts this suggestion and proposes a date of c. 1615.

VIRGIN AND CHILD WITH ST. CATHERINE (Wittkower, No. 65) (2344)
Engraved in Chamberlaine, Pl. 26.

99. PORTRAIT OF A CARDINAL IN A CARTOUCHE (Popham and Wilde, No. 1198) (*Plate 28*) (5209)
Though he catalogued this drawing without any positive attribution, Mr. Popham suggested on stylistic grounds a connection with Lodovico Carracci. Miss Catherine Johnston has confirmed this by pointing out that the drawing corresponds exactly to a composition in honour of an unnamed Cardinal, described in detail by Malvasia, (*op. cit.*, I, p. 86) and engraved in 1606 by Oliviero Gatti.

100. THE VISITATION (Pope-Hennessy, Nos. 1176, 1177) (782, 1220B)
Spear (1967, p. 54) has pointed out that these two drawings, both catalogued as by Domenichino, are connected with Lodovico Carracci's painting of the *Visitation* in S. Domenico, Bologna. The small red chalk drawing which was used to patch up Domenichino's sheet to compose 1177 is an original study by Lodovico, and 1176 is a copy after the painting.

After LODOVICO CARRACCI

DESIGN FOR ALLEGORICAL FIGURES SURROUNDING A CARDINAL'S ESCUTCHEON (Wittkower, No. 75) (2208)
Another version of this drawing, also a copy, is in the Victoria and Albert Museum, London.

SALMACIS AND HERMAPHRODITUS (Wittkower, No. 88) (2224)
The composition of the Horne Foundation drawing served as the basis for Albani's picture in the Louvre (Inventory, No. 19).
The composition executed for Marino, *Salmacis making love to Hermaphroditus in mid-stream*, exists in a number of versions, e.g. Turin (Deposito, No. 382, by Albani, and No. 624, Albani studio); Petworth (No. 142), etc. For Albani's versions, see *L'ideale classico*, Bologna, 1962, No. 39.
E. Schaar (*Zeitschrift für Kunstgeschichte*, XXVI, 1963, p. 58) favours an attribution of the Horne Foundation drawing to Sisto Badalocchio. This is an interesting point, in view of the fact that Tietze ascribed the Rospigliosi painting to Badalocchio, an attribution which was accepted by Zeri (*Galleria Pallavicini in Rome*, Florence, 1959).

Attributed to LODOVICO CARRACCI

101. DESIGN FOR A FRAME FOR A PORTRAIT OF AN ELDERLY MAN (10777)
320 × 216 mm. Pen and brown ink, light brown wash, over black chalk.

The oval medallion surmounts a decorative cartouche, and is supported on either side by the figures of Justice and Charity, while the figure of Fame flies above.

The attribution is due to Mr. A. E. Popham.

102. THE CORONATION OF ST. CECILIA AND ST. VALERIANO (Blunt and Cooke, No. 1045) (5517)

This drawing was catalogued among the anonymous Roman drawings, but Mr. Philip Pouncey has suggested an attribution to Lodovico Carracci. Professor Wittkower has identified the subject and has pointed out the connection with Domenichino's fresco of the scene in S. Luigi dei Francesi, Rome. He does not, however, accept the drawing as an original by Lodovico, but believes that it is either a copy of a lost original, which was known to Domenichino, or a drawing by a pupil, who knew Domenichino's fresco.

A drawing of the same subject by Annibale is also at Windsor (Wittkower, No. 412).

Manner of LODOVICO CARRACCI

103. THE VISION OF ST. JEROME (5336)

280 × 203 mm. Red chalk, heightened with body-colour.

Inventory A, p. 82: 'Francesco Albano, C. Cigniani &c.'.

Mr. Philip Pouncey has pointed out that the style of the drawing is very close to that of Lodovico Carracci.

104. ALLEGORY ON THE FOUNDATION OF THE UNIVERSITY OF BOLOGNA (Kurz, No. 704) (*Fig. 11*) (3618)

This drawing was listed by Professor Kurz among the anonymous Bolognese, but Miss Catherine Johnston has kindly supplied the following information, which makes it possible to identify the subject of the drawing and to give it an approximate date.

The Windsor drawing is closely related to two others, one in the Louvre (No. 7798; Fig. 12), the other No. 176 in the *Codice Resta* in the Ambrosiana (Fig. 13), and all three appear to be connected in theme with an engraving by Oliviero Gatti, dated 1619, listed by Bartsch (XIX, p. 15, No. 40), and described by Malvasia (*Felsina Pittrice*, Bologna, 1678, I, p. 109) as follows:

> Similmente a bollino del 1619. un'altra, oue sul trono medesimo, e stesso baldachino, ò padiglione sostenuto da duoi Angeletti, l'uno de' quali alza il triregno, l'altro la corona Imperiale, Celestino Papa alla destra, & alla sinistra Teodosio Imperatore, che a S. Petronio genuflesso porgono il priuilegio dello Studio, e Felsina riuerente, posta la destra sull'arme della Libertà, a piedi hà sei volumi di quegli antichi Glossatori anche Bolognesi, a' quali rubò l'esposizioni, e le glosse il buon'Accursio, e le ne fè bello; scritti perciò i loro nomi sulle carte, e sono il Bulgaro, Martino, Ugolino, l'Azone, il Tancredi, e il Viuiano.

The three drawings differ from this description in many details, but they all show the Pope Celestinus I and the Emperor, Theodosius II, the legendary founder of the University of Bologna (S. Petronio does not appear), as well as the figure of Bologna leaning on the shield of Liberty (in the Ambrosiana drawing this is inscribed *LIB...*), and having under her foot the six books mentioned by Malvasia.

The Windsor drawing, which seems to be cut at the top, only has the lower half of the composition, but in this part it agrees in all essentials with the Louvre study. The Ambrosiana sketch differs considerably in the arrangement of the group of figures representing the arts and sciences, and in the figures on the clouds at the top of the design. Furthermore, the composition is set in a round-headed arch and it does not include the river gods or the figures of Pope and Emperor.

The passage from Malvasia quoted above comes immediately after the description of an etching by Gatti, explicitly stated to be after Lodovico, and the use of the word *similmente* (not used in other descriptions of Gatti's etchings) seems to imply that the second etching is in the same category as the first. Further, both the Louvre and the Ambrosiana drawings are traditionally ascribed to Lodovico, and the former is stylistically very close to him. The Windsor drawing is not like him in execution, but it must be by an artist belonging to his circle and aware of his composition.

See also: *ALBANI* (No. 2A above); *After ANNIBALE CARRACCI* (Wittkower, No. 76), *DOMENICHINO* (Pope-Hennessy, No. 1220), and *GUIDO RENI* (Nos. 386, 387 below).

School of THE CARRACCI

With reference to Wittkower, text on p. 163 between entries Nos. 525 and 526, for Antonio Carracci, see Mahon, *Disegni*, Nos. 249–251.

Mahon accepts Chatsworth 471 as by Antonio. He doubts, however, that the drawings in Turin and Oxford, mentioned by Professor Wittkower, are by the same hand. He makes no mention of Nos. 520–524.

DIANA AND ENDYMION (Wittkower, No. 538) (2201)

Ostrow (*Essays in Honor of W. Friedlaender*, 1965, p. 133) dates this drawing c. 1596–7 and attributes it to Agostino, a view with which Professor Wittkower emphatically disagrees.

HEAD OF A YOUNG MAN (Wittkower, No. 579) (2232)

A similar head, perhaps representing the same sitter but slightly older, in the same technique—red chalk—and of better quality is in the Art Museum, Princeton (cf. J. Bean, *Italian Drawings in the Art Museum Princeton University*, 1966, No. 28 and plate).

See also: *ALESSANDRO ALGARDI* (No. 4 above).

Manner of THE CARRACCI

105. MADONNA AND CHILD, A KNEELING FEMALE SAINT, AND TWO ANGELS (089)

130 × 90 mm. Pen and grey ink, grey washes, on paper tinted brown.

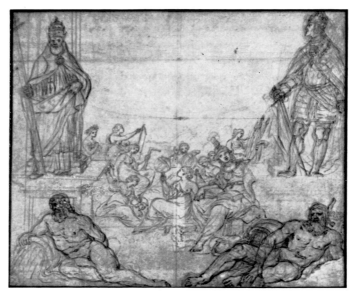

Fig. 11 Cat. No. 104

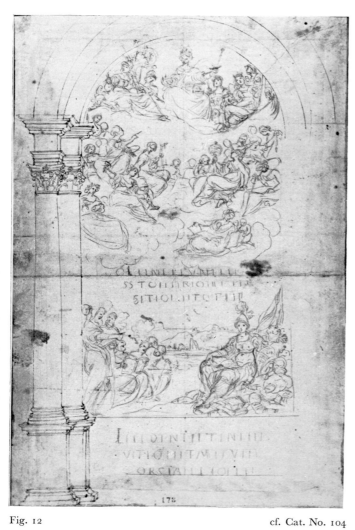

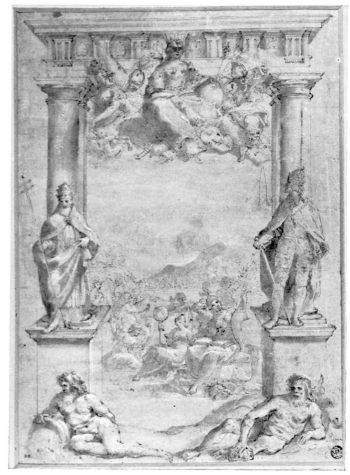

Fig. 12 cf. Cat. No. 104 Fig. 13 cf. Cat. No. 104

106. A LANDSCAPE: A BABY IN ITS CRADLE PLAYING WITH A LEOPARD, WATCHED BY A TURK IN A TREE. ON THE LEFT A CURTAIN WITH BLANK SHIELDS (5513)

354 × 233 mm. Pen and brown ink, grey wash over black chalk.

Inventory A, p. 53: 'Perin del Vaga, Baldre Peruzzi, Nico: del Abatte &c.'.

Mr A. E. Popham has tentatively proposed the name of Lodovico Carracci for this drawing.

107. PORTRAIT OF A SMALL BOY WITH A DOG (1818)

293 × 220 mm. Pen and dark ink, on brown paper. Inscribed at foot: *Marchone Vinnoli d'Anni 3. Nel Come di S. Antº di Savena 1711.*

From the Carracci volumes.

Interesting as an instance of conscious imitation of the style of the Carracci a century after their time.

BERNARDO CASTELLO
(1557–1629)

108. THE SURRENDER OF A CITY (Popham and Wilde, No. 1075) (5119)

This drawing was catalogued with an attribution to Taddeo Zuccaro, but Mr. Philip Pouncey has proposed the name of Castello for it, an attribution which Mr. Popham accepts.

See also: *GIACOMO BERTOJA* (Popham and Wilde, Nos. 205. 206).

Attributed to VALERIO CASTELLO
(1625–59)

109. THE MYSTIC MARRIAGE OF ST. CATHERINE
(*Plate 63*) (6784)

105 × 133 mm. Pen and brown ink.

Inventory A, p. 128: 'Moderna Schuola Romana'.

The style of the drawing derives from that of Castiglione, and the composition bears a close relation to Valerio Castello's paintings of this kind of religious subject.

GIOVANNI BENEDETTO CASTIGLIONE
(c. 1610–65)

In his review of the catalogue of the Windsor drawings attributed to this artist (*Burlington Magazine*, XCVII, 1955, pp. 325 ff.) Mr. James Byam Shaw, probably with good reason, suggests that the catalogue is too severe in rejecting drawings as by studio hands. In particular he supports the claim of Nos. 237, 238, 243, 246–251, 253–257, 260–262 to be from the hand of Castiglione himself.
For the following information I am greatly indebted to Miss Ann Percy, who is undertaking a major study of Castiglione's drawings and paintings.

HAGAR AND ISHMAEL (Blunt, *Castiglione*, Nos. 19 and 31) (3996, 4012)

Two paintings connected with these drawings are in the Palazzo Rosso and the Palazzo Negrotto-Giustiniani-Durazzo-Pallavicini, Genoa.
Further drawings are in the Staatliche Museen Dahlem, Berlin, and in the Robert Manning collection, New York.

ST. PHILIP BAPTIZING THE EUNUCH (Blunt, *Castiglione*, No. 22) (3904)

In the catalogue it was suggested that this drawing represents St. Peter baptizing the Centurion, but a brush drawing in the Dahlem Museum, Berlin, clearly shows the scene taking place beside a river, with a chariot in the background, which can only refer to the Baptism of the Eunuch by St. Philip.

THE SATYR FAMILY (Blunt, *Castiglione*, No. 54) (3911)

Other drawings, with numbers in the same hand, are listed by F. Stampfle and J. Bean (p. 59, No. 79).
Miss Ann Percy (*Master Drawings*, VI, 1968, p. 145) notes that No. 54 is numbered *26* and connects it with a group of drawings which all bear similar numbers.

SATYR DRINKING (Blunt, *Castiglione*, No. 57) (3988)

A copy of this drawing, made before the original was cut down, is in the British Museum (1950–11–11–32).

GOD THE FATHER APPEARING TO JACOB (Blunt, *Castiglione*, No. 61) (3872)

A copy of the Misme drawing is in the Städelsches Kunstinstitut, Frankfort, perhaps the same as the drawing which appeared in the Koster sale, Leipzig, 13.xi.1924, lot 109.
Another version of this drawing is in the Metropolitan Museum, New York (65.176; cf. Stampfle and Bean, p. 58, No. 76).

ST. JOHN THE BAPTIST PREACHING (Blunt, *Castiglione*, No. 67) (3880)

A variant of this drawing is in the Accademia, Venice.

SHEPHERDS WITH FLOCKS (Blunt, *Castiglione*, No. 79)
(3870)

A painting connected with this drawing is in the Palazzo Reale, Genoa.

THE ADORATION OF THE SHEPHERDS (Blunt, *Castiglione*, Nos. 102, 175, 253) (4049, 3864, 3885)

These drawings are related to a painting in a private collection in Genoa (exhibited at *La Madonna nell'arte in Liguria*, Genoa, 1952, No. 59).

THE FLIGHT INTO EGYPT (Blunt, *Castiglione*, No. 103)
(4068)

A brush drawing related to this design was in the Rokit-Berger sale, Paris, 28.xi.1934, lot 28.

PAN AND SYRINX (Blunt, *Castiglione*, No. 105) (3881)

A variant is in the Victoria and Albert Museum, London (Dyce 347).

MOSES STRIKING THE ROCK (Blunt, *Castiglione*, No. 124)
(4042)

A painting of the same subject is in the Walter P. Chrysler collection, New York.

THE NATIVITY (Blunt, *Castiglione*, No. 131) (4058)

A similar drawing in reverse is in the Albertina, Vienna (Stix and Spitzmüller, 518).

ALLEGORY IN HONOUR OF THE REGENT OF MANTUA (Blunt, *Castiglione*, Nos. 132, 141, 223) (4052, 4013, 3860)

Another brush drawing of this composition is at Budapest.

BACCHANAL WITH A LION (Blunt, *Castiglione*, Nos. 135, 142) (4041, 3893)

Two further drawings are related to this, one in the Städelsches Kunstinstitut, Frankfort, the other exhibited at Colnaghi's in 1964 (No. 30).

DEUCALION AND PYRRHA (Blunt, *Castiglione*, Nos. 150, 151, 226, 244) (4033, 4062, 3843, 3963)

Mr. Jacob Bean has pointed out that the real subject of these drawings is Deucalion and Pyrrha recreating man after the Flood by throwing stones over their backs, which were transformed into human beings (Ovid, *Metamorphoses*, I), and that they are connected with a painting by Castiglione in Berlin (2078).

THE SACRIFICE OF NOAH (Blunt, *Castiglione*, Nos. 163, 235) (3952, 3853)

A pen sketch for the woman at the right is in the Ashmolean Museum, Oxford. A painting in a private collection, Genoa, said to be dated 1659, is also related to the composition (cf. W. Arslan, *Arte Lombarda*, x, 1965, p. 178, Fig. 6). No. 235 is further related to a drawing in the Louvre (9445), engraved by Van Loo in 1746, and to one in the British Museum (1887–6–13–75).

CHRIST ON THE CROSS (Blunt, *Castiglione*, No. 190)
(4075)

An almost identical drawing is in the collection of Colonel G. O. C. Probert (from the Rev. Thomas Carwardine collection; exhibited Colchester, 1964, No. 72).
The hypothesis that the group of mourning figures represents the penitent Jews is strengthened by the fact that in No. 190 and the Probert drawing one man in the group on the extreme left of the design wears the kind of pointed cap traditionally worn by Jews in sixteenth-century art (Dürer, Bosch, etc.). This trio of figures was probably the nucleus later developed into the larger group in No. 192.

CHRIST ON THE CROSS (Blunt, *Castiglione*, No. 191)
(3959)

Three other painted variants of this design are known, all

in private collections in Genoa, one of which was published by E. Arslan (*Arte Lombarda*, x, 1965, p. 178, Fig. 7). Other drawings connected with the design also exist: a brush drawing in the Rhode Island School of Design (exhibited at Colnaghi's, London, in 1950), and a pen drawing in the Dahlem Museum, Berlin.

THE VIRGIN ADORED BY ST. FRANCIS AND ST. ANTONY OF PADUA (Blunt, *Castiglione*, No. 194) (3969)

This is a *modello* for a painting ordered by Cardinal Verospi in September 1649 and paid for 8.x.1650 (cf. A. B. Gabrielli, *Commentari*, VI, 1955, p. 261), recently bought by the Minneapolis Institute of Arts (cf. E. K. Waterhouse, *The Minneapolis Institute of Arts Bulletin*, LVI, 1967, p. 5).
A pen drawing in the Cooper Union shows at the top the Coronation of the Virgin and below a study for the Immaculata related to the Windsor brush drawing.
As Professor Waterhouse has pointed out, the fact that the painting, and therefore the drawing, is datable to 1649–50, affects the whole later chronology of Castiglione's drawings.

ST. FRANCIS (Blunt, *Castiglione*, No. 197) (4007)

An oil sketch on canvas after this drawing is in a private collection, Genoa (cf. E. Arslan, *op cit.*, p. 177, Fig. 3).

ST. FRANCIS (Blunt, *Castiglione*, No. 200) (3985)

Another version is in the Ashmolean Museum, Oxford.

THE ANIMALS GOING INTO THE ARK (Blunt, *Castiglione*, No. 220) (3850)

A painting related to the present drawing is in a private collection, Genoa (cf. E. Arslan, *op. cit.*, p. 169, Fig. 1), and a school drawing in the Louvre (9482) is also connected with it.

THE ADORATION OF THE SHEPHERDS (Blunt, *Castiglione*, No. 221) (3895)

Engraved by Bartolozzi.

CIRCE (Blunt, *Castiglione*, No. 224) (3849)

A studio drawing in Stockholm is related to this drawing.

PASTORAL SCENE WITH A BOY DECORATING A HERM (Blunt, *Castiglione*, No. 227) (3848)

Engraved by Bartolozzi.

SHEPHERDS AND FLOCKS (Blunt, *Castiglione*, No. 231)
(3889)

Two almost identical drawings are in the Städelsches Kunstinstitut, Frankfort, and the British Museum (1895–9–15–798).

THE SACRIFICE OF NOAH (Blunt, *Castiglione*, No. 245)
(3837)

This drawing is a copy after one in the Fogg Museum, Cambridge, Mass., engraved by Bartolozzi.

THE NATIVITY (Blunt, *Castiglione*, No. 251) (3993)
A sketch for the angel is in the Museo Civico, Bassano, and drawings related to the Virgin and Child are at Princeton, in the Ashmolean Museum, Oxford, and the Palazzo Rosso, Genoa.

CHRIST APPEARING TO ST. MARY MAGDALENE (Blunt, *Castiglione*, No. 257) (3973)
A pen and wash sketch of this composition was with Colnaghi's, London, in 1955.

NYMPH, SATYR AND CUPID (Blunt, *Castiglione*, No. 261) (4060)
A brush drawing of a similar composition was sold at Sotheby's, London, 12.iii.1963, lot 127. The design is related to the *Bacchanal* at Turin.

Manner of
GIOVANNI BENEDETTO CASTIGLIONE

110. A STANDING AND A SEATED FIGURE IN A LANDSCAPE. MERCURY AND BATTUS (?) (*Fig. 14*) (11918)

109 × 192 mm. Pen and dark ink.
Verso: A rounded arch, flanked by a Doric pilaster. Red chalk. Inscription in ink (unconnected with the drawing): [*?*] *I inguento sulis* [*?*].
From the Poussin volumes.

Fig. 14 Cat. No. 110

The drawing is related to the styles of Testa, Rosa and Castiglione, and a positive attribution is difficult.
See also: *PIETRO TESTA* (No. 456 below).

PASQUALE CATI
(c. 1550–1620)

See *Follower of FEDERICO ZUCCARO* (Popham and Wilde, Nos. 1064, 1065).

GIACOMO CAVEDONE
(1577–1660)

See *GUIDO RENI* (No. 384 below).

ANDREA CELESTI
(1637–1706)

See *ANTONIO GIONIMA* (Kurz, No. 282).

GIUSEPPE CESARI,
CAVALIERE D'ARPINO
(1568–1640)

The following comments are due to Dr. Herwarth Röttger of Darmstadt:

A WOMAN BEING RAPED BY A SEA-GOD (Popham and Wilde, No. 213) (01257)
A late drawing, about 1630.

STUDIES OF A WOMAN, ETC. (Popham and Wilde, No. 214) (5219)
An early drawing.

HEAD OF A MAN (Popham and Wilde, No. 216) (5404)
About 1593.
Dr. Röttger rejects the attribution to Cesari of the following drawings ascribed to him by Mr. Popham: Nos. 219 (perhaps near Marco Pino), 220, 221, 222, 223, 224, 225 and 226 (perhaps near the Circignani), 227 (mid-seventeenth-century Roman School), 228.
See also: *FRANCESCO ALLEGRINI* (No. 11 above).

Imitator of
GIUSEPPE CESARI,
CAVALIERE D'ARPINO

111. ST. FRANCIS (5218)
320 × 203 mm. Black and red chalks, heightened with white (oxidised).
Mr. Philip Pouncey has suggested the attribution to a follower of the Cavaliere d'Arpino and has pointed out the similarity of the drawing to certain works of Francesco Allegrini (1587–1663). Dr. Herwarth Röttger confirms the connection with Cesari.
See also: *After ANTONIO ALLEGRI DI CORREGGIO* (No. 147 below), and *After ANTONIO TEMPESTA* (Popham and Wilde, Nos. 940, 941).

BARTOLOMEO CESI
(1556–1629)

112. STUDY FOR THE VIRGIN IN THE DEPOSITION IN THE CHURCH OF S. GEROLAMO, BOLOGNA (Kurz, No. 583) (3672)
The connection with Cesi's *Deposition* (cf. Graziani, *Critica d'Arte*, II, 1939, Fig. 43) was pointed out by Miss Catherine Johnston.

113. A SAINT KNEELING (Kurz, No. 670) (3696)
This drawing was catalogued as by an anonymous Bolognese artist, but Miss Catherine Johnston has proposed an attribution to Cesi.

POMPEO CESURA DELL'AQUILA
(d. 1571)

THE MYSTIC MARRIAGE OF ST. CATHERINE (Popham and Wilde, No. 232) (6025)

This drawing was catalogued as by Cesura, but F. Bologna (*Roviale spagnuolo e la pittura napoletana nel Cinquecento*, Naples, 1958, p. 97) believes it to be by Pellegrino Pellegrini Tibaldi.

GIUSEPPE CHIARI
(1654–1727)

114. PENTECOST (Blunt and Cooke, No. 186) (4177)

This drawing was catalogued as by Lanfranco, but according to Dr. Walter Vitzthum (p. 514) it is a study for Chiari's tapestry in the Vatican (reproduced Vitzthum, Fig. 35).

115. THE PRESENTATION (Blunt and Cooke, No. 680) (4178)

This drawing was catalogued as by Pietro de Pietri, but Dr. Vitzthum (p. 514) has proposed an attribution to Chiari.

AGOSTINO CIAMPELLI
(1577–1642)

See *ANTONIO TEMPESTA* (Popham and Wilde, No. 939).

CARLO CIGNANI
(1628–1719)

116. THE DEATH OF ST. JOSEPH (Kurz, No. 139) (3656)

Mr. Dwight Miller has pointed out that this drawing is a study by Cignani for the fresco executed by his assistant Franceschini in S. Filippo Neri at Forlì.

After CARLO CIGNANI and EMILIO TARUFFI
(1633–66)

117. ST. ANDREW PROTESTING HIS FAITH (5314)

293 × 209 mm. Black chalk. Inscribed in red chalk at foot: *Calabrese*.

Inventory A, p. 82: 'Francesco Albano, C. Cigniani &c.'. A copy of the fresco in the apse of S. Andrea della Valle, Rome.

NICOLO CIRCIGNANI
(c. 1517–96)

118. A POTENTATE RECEIVES A GENTLEMAN (Popham and Wilde, No. 1151) (6013)

Mr. Popham is now in agreement with the attribution to Circignani, proposed by Mr. Philip Pouncey and Antal (p. 35), for this drawing catalogued as anonymous Roman.

PIER FRANCESCO CITTADINI
(1616–81)

THE PRODIGAL SON (Kurz, No. 153) (3270)

Cf. E. Riccomini, *Arte antica e moderna*, XIII–XIV, 1961, p. 371.

GIULIO CLOVIO
(1498–1578)

THE ADORATION OF THE SHEPHERDS (Popham and Wilde, No. 245) (0382)

The miniature referred to in the entry is in fact for the *Hours of Cardinal Alessandro de' Medici* (1546), now in the Pierpont Morgan Library, New York (MS 69).

PIETRO PAOLO COCCETTI
(active 1724–26)

119. THE TEATRO DEL CORSO, CALLED TEATRO DI GAETANO, ROME (9250)

515 × 259 mm. Black chalk, pen and black ink, with black and red wash. Signed: *Pietro Paolo Coccetti Arch°*. On the *verso* is a note addressed to Coccetti dated *1724*.

THE THEATRE AT PARMA

120. PLAN

695 × 570 mm. Pen and black wash. (9246)

121. SECTION OF AUDITORIUM

478 × 350 mm. Pen and black ink. (9245)

122. SECTION OF AUDITORIUM AND STAGE (9244)

518 × 697 mm. Pen and brown ink, with grey wash.

123. ELEVATION OF STAGE

478 × 655 mm. Pen and brown ink, with grey wash. (9243)

Inscriptions on the last two drawings state that they are copies made by Pietro Paolo Coccetti in 1726.

DESIGNS FOR A CONCLAVE PALACE TO BE ATTACHED TO ST. PETER'S

124. PLAN (9238)

427 × 680 mm. Pen and grey ink, with pink wash. An engraved plan of St. Peter's is stuck on the upper part of the drawing. A long description gives details of each part of the building.

125. SECTION (9239)

400 × 650 mm. Pen and brown wash. At the bottom a scale inscribed in Coccetti's hand.

126. ELEVATION (9240)

405 × 767 mm. Pen and grey wash. At the bottom a scale inscribed in Coccetti's hand.

The drawing of the elevation bears the arms of Benedict XIII (1724–30). The inscriptions on the drawings seem to be in the hand of Coccetti, but Dr. Hellmut Hager has proposed the name of Filippo Raguzzini as the author of the designs. He will discuss them in detail in a forthcoming work on the Sacristy of St. Peter's. He suggests that they were probably planned in connection with the Holy Year of 1725.

127. THE ALTAR IN THE DANDINI CHAPEL IN
S. MARCELLO, ROME (9242)

477 × 347 mm. Pen and grey ink, with grey, blue and red wash. The scale is inscribed in Coccetti's hand, and below is an inscription: *Altare della B. Giuliana Falconieri in S. Marcello*, apparently in Pier Leone Ghezzi's hand.

The Dandini Chapel is dedicated to S. Filippo Benizi, and the altarpiece, representing the saint presenting S. Alessio and S. Giuliana Falconieri to the Virgin, was commissioned from Pier Leone Ghezzi by Cardinal Falconieri in 1725. L. Muñoz Gasparini (*San Marcello al Corso*, Rome, n.d., p. 52) gives the date 1725 for the opening of the chapel with the new altarpiece, and this is confirmed by a passage in Valesio's *Diario* (in the Archivio Storico Capitolino), which reads: 'Nella Chiesa di S. Marcello si fece per la prima volta la festa del B. Alessio Falconieri fatta a spesa del Card.le di tal cognome e ue ne hà posto il quadro nella Cappella gia di S. Filippo Benizi avendola ristorata nell'altare' (this passage was kindly brought to my attention by Dr. Hellmut Hager). The existing altar does not correspond to the design shown in the drawing and appears to belong to the earlier restoration of the chapel, carried out in 1652 (cf. Muñoz Gasparini, *loc. cit.*).

128. PLAN OF THE TEATRO ALIBERT, ROME (9241)

755 × 650 mm. Pen and grey ink, with yellow and pink wash.

The theatre was designed by Francesco Galli Bibiena (1659–1739).

129. PLAN OF A THEATRE (9248)

764 × 495 mm. Pen and brown ink, with pink wash. Inscribed with the names of the owners of the different boxes.

The identity of the theatre is not given in the inscriptions, but the names attached to the various boxes prove that it must have been in Rome.

130. PLAN OF THE TOR DI NONA THEATRE, ROME (9249)

522 × 380 mm. Pen and brown ink, with grey wash.

As the inscription states, the theatre was built by Carlo Fontana. His plans for it will be discussed in the volume of this catalogue by Dr. Allan Braham and Dr. Hellmut Hager dealing with the Fontana drawings.

131. PLAN OF THE BASILICA OF MAXENTIUS (9231)

416 × 311 mm. Pen and brown wash over black chalk.

132. PLAN OF AN ANCIENT BUILDING IN THE
FARNESE GARDENS ON THE PALATINE (9232)

465 × 720 mm. Pen and brown ink, with grey and yellow wash.

The inscription states that the building was discovered in 1724.

PLANS OF A TEMPLE OUTSIDE THE PORTA
MAGGIORE, ROME

133. 355 × 357 mm. Pen and grey wash. (9254)

134. 355 × 357 mm. Pen and grey wash. (9255)

In addition to inscriptions in Coccetti's hand, these four drawings have notes in a hand which may be that of Pier Leone Ghezzi.

135. THE ENTRANCE TO THE VILLA GIULIA, ROME (9229)

465 × 370 mm. Pen and brown ink, with grey wash.

136. A WALL FLANKING THE GARDEN IN THE
VILLA GIULIA, ROME (9233)

357 × 468 mm. Pen and grey ink, with grey and red wash.

137. THE PORTA DI S. GIOVANNI, ROME (9234)

370 × 485 mm. Pen and grey wash.

138. PORTA PORTESE, ROME (9235)

370 × 483 mm. Pen and grey ink, with grey and red wash.

DRAWINGS OF THE VILLA MEDICI, ROME
THE LOGGIA OVERLOOKING THE BORGHESE
GARDENS

139. 465 × 375 mm. Pen and grey ink, with grey and red wash. (9236)

140. 470 × 373 mm. Black chalk. (9237)

141. THE ORANGERY (9230)

354 × 1360 mm. Pen and grey ink, with grey and red wash.

These drawings are all clearly by the same hand, and the inscriptions are certainly in the writing of Coccetti.

142. PLAN OF THE VILLA MADAMA (9256)

520 × 380 mm. Pen and brown ink, with grey wash.

143. PLAN OF A BATH (9247)

463 × 645 mm, with a flap on the left side 425 × 280 mm. Pen and brown ink with grey and blue wash.

The attribution of Nos. 142 and 143 to Coccetti is based on the fact that they bear inscriptions and scale measurements in exactly the style and hand as Nos. 120–123, which are signed by the architect, and are also numbered by a single hand in a series which suggests that they all come from an older volume which had been broken up

and the contents rearranged. One of Marchetti's drawings of the Lateran (9228) bears a similar number.

SALVATORE COLONELLI-SCIARRA
(active 1726)

144. THE COLONNA GALLERY (11522–11526)

Each 333 × 542 mm. Water-colour with gold, on vellum.

The drawings show the exact positions of the paintings, which are identified in a list.

ANGELO MICHELE COLONNA
(1600–87)

145. DESIGN FOR A CEILING (10933)

305 × 179 mm. Pen and brown ink, pink, blue, green, brown and gold wash. Scale. The mount is inscribed in pencil: *DEL COLONNA*.

In the centre of the design a feigned opening to the sky contains angels carrying the Santa Casa di Loreto.
Similar in style to Kurz, No. 185.

SEBASTIANO CONCA
(c. 1680–1764)

PORTRAIT OF A LADY (Blunt and Cooke, No. 109)
 (0197)

Mr. Antony Clark has pointed out that the inscription and the style of the drawing are similar to those of drawings by Conca dating from before 1715.

FRANCESCO CONTINI
(recorded 1650–59)

146. PLAN OF PART OF HADRIAN'S VILLA (10389)

491 × 271 mm. Pen and brown ink, with water-colour. Inscribed: *Pianta d'una parte della Villa d'Hadriano à Tivoli, vista & levata da Pirro Ligorio Antiquario insigne, che di essa fece Discorso, che si vede Manoscritto, Laquale estata da uno Schizzo del Sudetto tirata nella forma che si vede da Francesco Contini Romano. I Disegni di detta Villa furon portati in Francia da Monsù di Autreville, che g'l'haveva compri da un Rigattiere Ferrarese. Questa Parte si crede sia o quella, ò vicino à quella dove di presente hà la Vigna Monsigr. Bulgarini Segretario della Congregatione dell'Acque.*

The drawing is a fair copy after a rough sketch by Ligorio at Windsor (No. 10377 *recto*). It corresponds with the plan of the Little Palace at Hadrian's Villa as shown in an engraving, published by Contini in *Adriani Caesaris in Tiburtino Villa* (Rome, 1668), and dedicated to Cardinal Francesco Barberini, except that in place of the oval hall represented both in Ligorio's drawing and the copy the engraving shows a building which corresponds more or less with what survives today. The book was reprinted in 1751, but the engraving in this edition has no section which corresponds at all to the drawing.

ANTONIO ALLEGRI DA CORREGGIO
(c. 1488–1534)

(0101, 0593B, 0594, 0596-7)

The drawings at Windsor attributed by Mr. Popham to Correggio (Popham and Wilde, Nos. 246–249) are listed and discussed in his *Correggio's Drawings* (London, 1957), catalogue Nos. 2, 55, 81, A131, A132.

After ANTONIO ALLEGRI DA CORREGGIO

147. HEAD AND SHOULDERS OF AN ANGEL (4222)

260 × 165 mm. Black and red chalks.

From the Maratta volumes.

After a detail from Correggio's *Rest on the Flight into Egypt* in the Parma Gallery.

Follower of LORENZO COSTA
(1460–1535)

See *AMICO ASPERTINI* (No. 17 above).

JACQUES COURTOIS
(1621–75)

148. A CAVALRY ENGAGEMENT (6332)

256 × 409 mm. Pen with brown and grey washes.

Inventory A, p. 127: 'The three or four last are by Borgognone'.

A BATTLE OUTSIDE A TOWN (Blunt, *French Drawings*, No. 33) (6344)

Mr. Edward Holt has pointed out that this is an exact preparatory study for a painting in the Vatican (442, Inv. 219).

A BATTLE (Blunt, *French Drawings*, No. 34) (6343)

Mr. Holt has pointed out that this drawing is almost identical with a painting in the collection of Earl Spencer at Althorp. This painting, recently ascribed to Salvator Rosa (cf. *Italian Art in Britain*, R.A., 1960, No. 44), was always listed in the Althorp inventories, no doubt correctly, as by Courtois.

Attributed to JACQUES COURTOIS

149. A SOLDIER ON HORSEBACK (6347)

196 × 250 mm. Pen and brown wash, heightened with body-colour, on greenish-grey paper.

Verso: A trumpeter on horseback. Approximate size 155 × 100 mm. Same technique.

Inventory A, p. 127: 'The three or four last are by Borgognone'.

See also, *FRANCESCO ALLEGRINI* (Nos. 9, 10 above).

Attributed to DANIELE CRESPI
(1590–1630)

150. A NUN, FULL-FACE, KNEELING (*Plate 69*) (4883)

319 × 221 mm. Black chalk, touches of white, on brown paper.

Verso: Studies of three heads, one of them perhaps for a musician angel. Black and white chalk.

Inventory A, p. 106: 'Andrea Sacchi'.

The attribution to Crespi was tentatively proposed by Mr. Philip Pouncey.

DONATO CRETI
(1671–1749)

151. HEAD OF A WOMAN; HEAD OF A CHILD; STUDY OF A LEG (*Fig. 15*) (3453)

214 × 255 mm. Pen and brown ink.

Inventory A, p. 80: 'Guido Etc.'.

The attribution to Donato Creti is due to Mr. Philip Pouncey.

Fig. 15 Cat. No. 151

Attributed to DONATO CRETI

152. A HOUSE BEYOND A BRIDGE (*Fig. 16*) (3561)

194 × 298 mm. Red chalk.

Inventory A, p. 116: 'Paesi di Maestri Bolognesi'.

An old inscription in ink on the back of the drawing, now laid down, reads 'Donato Creti', but the drawing is attributed by Sir Carl Parker and Mr. James Byam Shaw to Watteau.

See also: *GIUSEPPE ROLLI* (No. 391 below).

Fig. 16 Cat. No. 152

FABIO CRISTOFANI
(d. 1689)

153. TWO ALLEGORICAL FIGURES (Blunt and Cooke, No. 160) (4525)

This drawing was catalogued as by Gaulli, but Dr. Peter Dreyer has shown that it is a study for a cartoon representing the *Election of Urban VIII* by Fabio Cristofani (cf. *Berliner Museen*, N.F., XVIII, 1968, p. 65).

DANIELE DA VOLTERRA
(1509–66)

See *ANDREA DEL SARTO* (No. 434 below).

STEFANO DELLA BELLA
(1610–64)

154. THE PALAZZO PITTI (Blunt, *French Drawings*, No. 22) (4614)

As has been pointed out by M. D. Ternois (*Jacques Callot. Catalogue complet de son œuvre dessiné*, Paris, 1962, p. 175 D), in spite of being apparently signed *Callot* and dated *1630*, this drawing is a deliberate falsification by Stefano della Bella.

CHRIST TEACHING (Blunt, *Stefano della Bella*, No. 2) (4674a)

Mr. Hugh Macandrew has pointed out that this drawing is probably based on an anonymous reversed copy after Marcantonio's print (Bartsch, XIV, p. 332, No. 442).

FIGURE IN FANTASTIC DRESS (Blunt, *Stefano della Bella*, No. 21) (4692)

The anonymous author of a review of the catalogue in the *Times Literary Supplement* (2.vii.1954) points out that this drawing represents a well-known Florentine game, played with a blown-up bladder, which can be punctured by the spikes with which the players are equipped.

THE SPHINX AND THE PYRAMIDS (Blunt, *Stefano della Bella*, No. 124) (4598)

Mr. J. Byam Shaw ('A view of Cairo by Stefano della Bella', *Master Drawings*, 1, 2, 1963, p. 46) has discovered a further drawing by Stefano della Bella showing the Nile at Cairo (Uffizi, 289), which seems to establish beyond doubt that the artist actually visited Egypt.

Imitator of STEFANO DELLA BELLA

155. VIEW OF A TOWN ON THE OTHER SIDE OF A RIVER, A TREE IN THE FOREGROUND (3556)

302 × 434 mm. Pen and bistre, on paper now much darkened.

Inventory A, p. 116: 'Paesi di Maestri Bolognesi'.

The drawing is related in style to both Bazicaluva and Cantagallina.

156. BATTLE SCENE (01114)

444 × 738 mm. Pen.

Inventory A, p. 158: 'A Battle, drawn with a pen by Stefano della Bella'.

157. LANDSCAPE WITH TREES AND A DISTANT TOWN (0828)

192 × 301 mm. Pen.

Inventory A, p. 133: 'Drawing by Giacomo Callot'.

AN ARMY IN FORMATION (Blunt, *Stefano della Bella*, Nos. 151, 152) (11382–3)

These drawings appear to be by the same hand as a group in the National Gallery of Scotland, where they are ascribed to Albert Flamen. They may even belong to the same series as the Edinburgh set.

Other drawings, apparently by the same hand, are in a small sketch-book in the Séminaire de Saint-Sulpice at Montreal, which has the name *Darsun* and the date *1675* on the first sheet.

DOMENICO ZAMPIERI
called IL DOMENICHINO
(1581–1641)

Much work has recently been done on the drawings by Domenichino at Windsor by Mr. Richard E. Spear. The greater part of his identifications have been published in three important articles: 'The early drawings of Domenichino at Windsor Castle and some drawings by the Carracci', *Art Bulletin*, XLIX, 1967, pp. 52 ff. (referred to below as *Spear, 1967*); 'Preparatory drawings by Domenichino', *Master Drawings*, VI, 1968, pp. 111 ff. (referred to below as *Spear, 1968*), and 'The Cappella della Strada Cupa in S. Maria in Trastevere', *Burlington Magazine*, CXI, 1969, pp. 12 ff. Mr. Spear has generously placed at my disposal his unpublished notes, which include important new identifications quoted in the following entries.

Fig. 17 Cat. No. 158

Some of the Windsor drawings are reproduced and discussed in E. Borea, *Domenichino*, Florence, 1965.

DESIGNS FOR THE DOOR OF THE PALAZZO LANCELOTTI, ROME (*Fig. 17*)

158. 428 × 349 mm. On two sheets of paper joined together. The tablet over the door is on a separate piece of paper stuck on to the main sheet. Pen and brown wash, with red and black chalk. A few measurements noted in ink.

(1576)

159. 507 × 382 mm. Pen and brown ink, with black chalk. Scale at foot and some measurements noted in ink. (1577)

From the Domenichino volumes.

Bellori (*Vite*, Rome 1672, p. 350) states that Domenichino designed the door to the Palazzo Lancelotti, and these two drawings correspond to it, No. 158 more closely than 159.

160. DESIGNS FOR THE VAULT OF S. ANDREA DELLA VALLE (*Plates 30–31*) (10934)

266 × 201 mm. Pen and dark brown ink, with dark brown wash over black chalk.

The two drawings on the *recto* and *verso* show alternative designs for one bay of a vault. On the *recto* the main rib is formed of a crouching female figure, above which is a console carrying an atlas. He supports a scroll and a cornice, on which sits a putto. The area between this rib

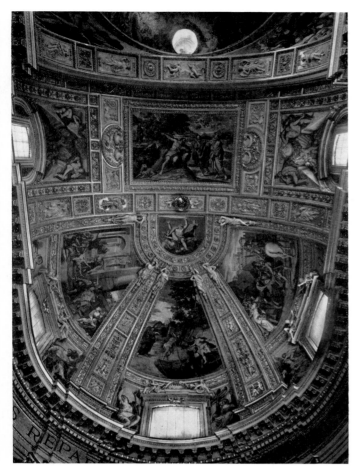

Fig. 18 cf. Cat. No. 160

and the next, which is barely indicated, is filled with a relief—painted or real—consisting of two seated male nudes supporting a wreath of flowers and fruit. Below the wreath is a shell, in which stand two children, one of whom picks fruit from the wreath and hands it to the other. Below the shell are two putti reclining on the arch below. This panel is separated from the rib by a band of floral decoration, which is continued over it by a band of alternating lions' masks and palmettes. Above this is a cartouche flanked by consoles which support a frame.

In many essential features this design corresponds to the panels over the windows in the first bay of the choir of S. Andrea della Valle (Fig. 18): the seated nudes, the wreath, the shell with putti, the bands of ornament, the cartouche, and the frame. The arrangement differs in certain ways, notably in the fact that in the *recto* drawing the vault is continued down to a semi-circular opening, whereas in the actual building it is pierced by a cross-vault, but the sketch on the *verso* shows a variant which corresponds much more closely to the building as executed. In some details the *recto* drawing corresponds precisely to the actual vault. The left-hand nude is almost identical with the one in a similar position in the panel over the left-hand window, and the right-hand putto lying on the

arch is very similar to his counterpart in the fresco. The figure standing on the console is closely related to one on the corresponding rib in the vault. Finally it should be noticed that the console on the *recto* drawing is decorated with three *monti*, and the putto sitting on it holds a star, elements which can only be allusions to the arms of Cardinal Montalto, the patron who commissioned Domenichino's frescoes in S. Andrea.

The most unexpected feature of the drawing is the very dark ink used for the wash, which gives it a dramatic character unusual in Domenichino's work, but it is stylistically allied to other decorative drawings certainly from his hand. In general character it is similar to a design for a vase (Pope-Hennessy, No. 1724), and the figures in the *tondo* on the *verso* are close to those in the spandrel panels in the design for a monument to Cardinal Agucchi (Pope-Hennessy, No. 1742) and to those in a drawing for a hanging lamp (Pope-Hennessy, No. 1726).

The drawings are of interest in that they throw some light on Domenichino's original scheme for the decoration of the vault. As far as the first bay of the choir is concerned, drawings and vault correspond in their general lay-out, but the sketches imply a quite different arrangement for the decoration of the half-dome over the apse. It is clear that in the drawings the cornice over the panel containing the two seated nudes was to be continued over the frescoed panel to the right. In the building as executed this panel is greatly heightened, so that it occupies practically the whole curve of the vault, leaving only a small space for the central fresco showing St. Andrew being received into Heaven. As a result of this alteration, the figure standing on the console is raised to a much higher level, though he still supports the same rather unusual kind of scroll. The crouching figure of a woman below the console in the drawing may be the first idea for the painted figures which flank the windows in the actual vault. In the latter the allusions to the Montalto arms are left out.

The drawing was not found among those in the Domenichino volumes in the Royal Library, but, owing to its interest as a decorative design, it may have been separated and put in the volume of such drawings, in which it is actually mounted today (cf. below, No. 161).

161. DESIGN FOR AN URN (11330)

345 × 264 mm. Pen and brown wash.

This drawing was not included in the Domenichino volumes in the Royal Library, but it may have been separated from them and put in a volume of decorative drawings for the same reason as No. 160. Stylistically, however, it conforms to the few designs of this kind executed by Domenichino in this medium (cf. Pope-Hennessy, No. 1724).

SEATED MALE FIGURE (Pope-Hennessy, No. 50) (734)

As has been pointed out by Mr. Spear, this sheet contains drawings for the Grottaferrata frescoes. The *recto* is a study for the figure of God the Father in the cupola, and the *verso* is for the young assistant on the extreme left of the *Building of the Abbey Church*.

STUDIES FOR THE BORGHESE *SIBYL* (Pope-Hennessy, No. 100 *verso*) (884)

Identified by Spear (1968, p. 119) as studies for the hands of the Sibyl.

THE DEATH OF ADONIS (Pope-Hennessy, No. 113) (1015)

On the *verso* (laid down) is a study for the legs of Adonis.

BEARDED MALE HEAD (Pope-Hennessy, No. 118 *verso*) (693)

This is a study for the figure of God the Father, not for Odoardus, as suggested in the catalogue.

A MALE HEAD (Pope-Hennessy, No. 120) (707)

This was catalogued as a study for the Grottaferrata frescoes, but it is actually for the figure of Ahasuerus in the *Esther before Ahasuerus* in S. Silvestro al Quirinale, Rome.

FIGURE OF A MAN (Pope-Hennessy, No. 137 *verso*) (687)

This figure is a study for the painting of *Christ falling under the Cross* in the collection of Mr. John Pope-Hennessy (cf. *L'ideale classico*, Bologna, 1962, p. 384, No. 164).

MALE FIGURE (Pope-Hennessy, No. 142) (718)

Mr. Spear has pointed out that this is a study for the upper figure in the *S. Agnese* altarpiece at Bologna.

MALE FIGURE (Pope-Hennessy, No. 184) (697)

As Mr. Spear has suggested, the studies on the *recto* and verso are for the *David* and *Isaiah* respectively on the end wall of the chapel.

STUDY OF A PUTTO (Pope-Hennessy, No. 189 *recto*) (1487)

Identified by Mr. Spear (1968, p. 121) as a study for a putto in the *Madonna of the Rosary* in Bologna.

STUDIES FOR THE *LAMENTATION* (Pope-Hennessy, Nos. 195, 199) (897, 802)

The study of a head (Pope-Hennessy, No. 195) is for the National Gallery painting, not for the ex-Kinnaird version, whereas the drawing of the *Virgin* (Pope-Hennessy, No. 199) is for the latter.

MALE NUDE (Pope-Hennessy, No. 255 *verso*) (1052)

Mr. Spear (1967, p. 54) has suggested that this drawing is by Annibale Carracci, but Professor Wittkower is not altogether convinced by this hypothesis.

HEAD OF A GIRL (Pope-Hennessy, No. 256) (268)

Mr. Pope-Hennessy regarded this as a study for the head of Susanna, but Mr. Spear (1967, p. 55) considers it to be a copy after the painting.

HEAD OF A BEARDED MAN (Pope-Hennessy, No. 257) (591)

This drawing was tentatively connected by Mr. Pope-Hennessy with Domenichino's *Susanna* in Munich, but Mr. Spear (1967, pp. 54 f.) suggests that it is probably later and is connected with the *Last Communion of St. Jerome* in the Vatican.

FIGURE STUDIES (Pope-Hennessy, Nos. 393 *recto* and *verso*, 1172 *recto* and *verso*, 1173 *recto* and *verso*, 1279, 1308, 1442 *recto*) (1182, 517, 1141, 1289, 1071, 173)

These drawings have been identified by Mr. Spear (1968, pp. 127 f.) as studies for the *Funeral of a Roman Emperor* in the Prado.

STUDY OF AN ARM (Pope-Hennessy, No. 727) (428)

Mr. Spear has suggested that the drawing on the *verso* (laid down) may possibly be a study for the figure of God the Father in the *Martyrdom of St. Agnes*.

STUDIES FOR THE DECORATION OF THE CAPPELLA DELLA STRADA CUPA IN S. MARIA IN TRASTEVERE (Pope-Hennessy, Nos. 753–5, 1515, 1544 *recto*) (1556, 1554, 1557, 1399, 1407)

Mr. Spear ('The Cappella della Strada Cupa', *Burlington Magazine*, CXI, 1969, pp. 12 ff.) has identified these drawings as studies for the decoration of the Cappella della Strada Cupa in S. Maria in Trastevere, designed by Domenichino in 1628–29.

MALE FIGURE IN FULL LENGTH (Pope-Hennessy, No. 885) (1147)

Mr. Pope-Hennessy connected this drawing tentatively with the *Scourging of St. Andrew* in S. Gregorio Magno, but Mr. Spear (1967, p. 55) has pointed out that it is a study for the executioner in the fresco of the same subject in S. Andrea della Valle.

BEARDED MALE FIGURE (Pope-Hennessy, No. 1006 *verso*) (898)

Mr. Spear (1967, p. 54) has suggested that this drawing is by Annibale Carracci. The problem is similar to that raised by Pope-Hennessy, No. 255v, but in this case the similarity of the drawing to Annibale is more obvious.

JUDITH WITH THE HEAD OF HOLOFERNES (Pope-Hennessy, No. 1016) (610)

A further drawing for this group is in the Ambrosiana (cf. Borea, *op. cit.*, p. 186).

SEATED MALE FIGURE (Pope-Hennessy, No. 1175) (1020)

On the *verso* is a study of a standing female (?) figure.

Fig. 19 cf. Pope-Hennessy No. 1195

THE HOLY FAMILY (Pope-Hennessy, No. 1195) (817)
Mr. Spear has called attention to the fact that a full-scale cartoon of the design by Domenichino is at Chatsworth (No. 2000A; Fig. 19).

CHRIST SHOWN TO THE PEOPLE (Pope-Hennessy, No. 1220) (795)
Mr. Spear has pointed out that this drawing is not based on Titian, as suggested in the catalogue, but on Lodovico Carracci's *Ecco Homo* fresco in S. Filippo Neri, Bologna.

THE MARRIAGE OF ALEXANDER AND ROXANA (Pope-Hennessy, No. 1261) (1005)
As indicated by Mr. Spear, this drawing is not based on the Farnesina fresco but on the drawing by a pupil of Raphael in the Louvre.

REMUS PURSUING THE STOLEN HERDS (Pope-Hennessy, No. 1273) (1051)
Mr. Spear has called attention to the fact that this drawing reproduces Lodovico's drawing in the Louvre and not the fresco.

STUDIES OF A YOUTH (Pope-Hennessy, No. 1292 *verso*) (2370)
The figure with a pole is connected with the Borghese *Diana*, as Mr. Spear has indicated.

FEMALE FIGURE (Pope-Hennessy, No. 1363 *recto*) (601)
Mr. Spear has pointed out that this drawing represents St. Catherine, and that it cannot therefore, as suggested by Mr. Pope-Hennessy, be connected with the *Esther* in S. Silvestro al Quirinale, Rome.

THE HEAD OF THE BAPTIST (Pope-Hennessy, No. 1431) (143)
Identified by Mr. Spear (1968, p. 126) as a study for the *Head of the Baptist* in the Academia de San Fernando, Madrid.

STUDY OF A PUTTO (Pope-Hennessy, No. 1542 *recto*) (1398)
Identified by Mr. Spear (1968, p. 121) as a study for the figure symbolizing Astronomy in the *Allegory of Agriculture, Astronomy and Architecture* in the Galleria Sabauda, Turin.

SLEEPING CHILD (Pope-Hennessy, No. 1556) (1418)
Mr. Spear has identified this as an early study for the Vatican *St. Jerome*.

HEAD OF A BEARDED MAN (Pope-Hennessy, No. 1663) (70)
Mr. R. Hodge has pointed out that this drawing was engraved by Chamberlaine as by Annibale Carracci.

VIEW OF A TOWN (Pope-Hennessy, No. 1692) (1503)
On the *verso* is a series of drawings of faces in profile.

GROUPS OF BUILDINGS (Pope-Hennessy, No. 1706) (1527)
This may be a view of Grottaferrata.

STUDIES FOR A TABLE-FOUNTAIN (Pope-Hennessy, Nos. 1727–1728) (1599A, 1598)
Mr. Pope-Hennessy suggested that some of the designs on these sheets might be for salts or table-ornaments, but they seem all to be for table-fountains, since the water is shown in all of them. The design shown on the right in No. 1728 must be supported on at least six and probably eight columns.

STUDIES FOR A CHURCH FAÇADE (Pope-Hennessy, Nos. 1735–1739) (1559A, 1578–80)
Mr. Pope-Hennessy suggested that these sheets of sketches were connected with a design for the façade of S. Andrea della Valle, and this hypothesis is confirmed by the fact that the top left-hand design on Pope-Hennessy No. 1735 shows on the pediment a shield on which a bend is clearly visible, together with small dots, which may indicate that the arms also contained some other element. This would suggest that they were in fact the Peretti arms, used by Cardinal Montalto, the builder of the church, who was a nephew of Sixtus V.

MALE NUDES (Pope-Hennessy, No. 1756) (2061)
On the *verso* is a drawing of a 'Captive', which, as Mr. Spear has pointed out, is for a figure on the other end wall of the Gallery.

162. STUDY FOR THE *DEATH OF ADONIS* IN THE PALAZZO FARNESE (Wittkower, No. 375) (2094)
Mr. Spear (1967, p. 53) has identified this drawing, hitherto catalogued as by Annibale Carracci, as a study for the head and shoulders of Adonis in the *Death of Adonis*, Domenichino's first independent commission, dating from about 1603.
On the *verso*, visible through the paper, is a drawing for the whole composition.

163. JUSTICE (Wittkower, No. 502) (2037 *recto*)
This drawing was catalogued by Wittkower as a copy after the fresco in the Galleria Farnese by a pupil in a style near to Domenichino's, but J. R. Martin (*Bollettino d'Arte*, XLIV, 1959, p. 42) suggests that it is an original study for the fresco by Domenichino.

THE STONING OF ST. STEPHEN (Pope-Hennessy, No. 90) (1110)
This drawing was catalogued by Mr. Pope-Hennessy as a study for the picture at Chantilly, but Mr. Spear (1967, p. 56) suggests that it is a copy after a sketch in the Uffizi.

See also: *ALESSANDRO ALGARDI* (Nos. 6, 7 above); *ANNIBALE CARRACCI* (Wittkower, No. 320); *After ANNIBALE CARRACCI* (Wittkower, No. 502), and *LODOVICO CARRACCI* (No. 100 above).

GIOVANNI ANTONIO DOSIO
(1533–1609)

The drawings by Dosio are all after ancient architecture and will be catalogued in the volume devoted to this section of the collection, but it may be useful to record here that C. Huelsen (*Das Skizzenbuch des Giovannantonio Dosio*, Berlin, 1933, p. 73) lists the following Windsor drawings as being by him: Nos. 10780–92, 10799, 10830, 12101–02, 12107–8.

Attributed to
GIOVANNI ANTONIO DOSIO

164. ANCIENT SACRIFICIAL IMPLEMENTS (11123)
295 × 222 mm. Pen and brown ink.
The attribution to Dosio is due to Dr. A. Noach.

After ADAM ELSHEIMER
(1578–1610)

165. TOBIAS AND THE ANGEL (6300)
157 × 197 mm. Oval.
Attributed by Puyvelde (*Dutch Drawings*, No. 118) to Elsheimer, this drawing is a variant, probably by an Italian artist of the first half of the seventeenth century, of a composition by Elsheimer known from engravings by H. Goudt.

JACOPO DA EMPOLI
(1551–1640)

166. HEAD OF A BOY (Kurz, No. 9) (5389)
This drawing was catalogued by Prof. Kurz with a tentative attribution to Sisto Badalocchio, but Mr. Philip Pouncey believes that it is by Jacopo da Empoli.

Attributed to JACOPO DA EMPOLI

167. A GROUP OF FIGURES (*Fig. 20*) (9191 *verso*)
202 × 318 mm. Black chalk. Inscribed: *P. giorgio dura assistante del Padre generale*.

Fig. 20 Cat. No. 167

On the *recto* is a drawing of an early Christian sarcophagus. Another drawing of a similar sarcophagus appears on the *verso*, and the figure group appears to be drawn over it. The style suggests the Florentine School of c. 1600 and is close to that of Jacopo da Empoli. It shows a group of figures in conversation, wearing late sixteenth- or early seventeenth-century dress.
Mr. Michael Hirst has suggested a tentative attribution to Biliverti.

ANIELLO FALCONE
(1600–66)

168. RIDERS IN ARMOUR ON A BATTLEFIELD (*Plate 61*) (6346)
124 × 189 mm. Red chalk.
The attribution to Falcone is based on the similarity to a drawing of a battle reproduced in the *Journal of the Warburg Institute*, III, 1939–40, Pl. 12a.

169. DEBORAH AND BARAK (Blunt and Cooke, No. 854) (4847)
Dr. Walter Vitzthum has identified this drawing, previously attributed to Sacchi, as a study for Falcone's painting of this subject in S. Paolo Maggiore, Naples (cf. catalogue of *Disegni napoletani del Sei e del Settecento nel museo di Capodimonte*, 1966–67, No. 15). The painting is reproduced by Saxl, *Journal of the Warburg Institute*, III, 1939–40, Pl. 14a.

PAOLO FARINATO
(1524–1606)

See *VENETIAN SCHOOL* (Nos. 721, 722 below).

FERRAU FENZONI
(1562–1645)

170. FIGURES IN A PORTICO BESIDE THE SEA
(Fig. 21) (2157)

475 × 401 mm. Pen and grey wash, over black chalk, on stained paper.

From the Carracci volumes.

The attribution to Fenzoni is due to Mr. Philip Pouncey and Mr. John Gere.

See also: *ITALIAN SCHOOL, late sixteenth century* (Popham and Wilde, No. 1201).

CIRO FERRI
(1634–89)

MOSES STRIKING THE ROCK (Blunt and Cooke, No. 125)
(01117)

Mr. Antony Clark has suggested that this drawing may be connected with the fresco commissioned in 1665 for S. Maria Maggiore at Bergamo (cf. F. Haskell, *Patrons and Painters*, London, 1963, p. 218).

PERSEUS BEING ARMED BY JUPITER AND MINERVA
(Blunt and Cooke, Nos. 127, 128) (6835, 6836)

P. Dreyer ('Pietro Lucatelli', *Jahrbuch der Berliner Museen*, IX, 1967, p. 246) has pointed out that these two drawings are for a composition referring to the victory of Leopold I over the Turks, which was engraved by Roullet. According to the inscription on the engraving the drawings should be by Lucatelli after the designs of Ferri.

URBAN VIII PROTECTING ROME FROM PLAGUE AND FAMINE (Blunt and Cooke, No. 130) (4507)

P. Dreyer (*op. cit.*, pp. 248 ff.) shows that the correct title for this composition is that given above and not 'Urban VIII invoking the protection of Sts. Peter and Paul', as stated in the catalogue.

URBAN VIII INSPECTING PLANS (Blunt and Cooke, No. 131) (4506)

A drawing at Chicago, in pen and wash and inscribed *Ciro Feri*, shows in the left half the same group as that in No. 131, but in reverse. The composition is extended to the left by a viaduct and on the right by cavalry and infantry on the march. The drawing, which is insensitive in treatment, may be an adaptation of Ferri's design for an engraving.
Dr. Vitzthum (p. 514) points out that the date 1683 given for the series of tapestries with which this drawing is connected is confirmed by a document published by Campori in the *Arazzeria Estense*.
On the other hand documents discovered by Miss Jennifer Montagu prove that some at least of the tapestries were woven during the life-time of Cardinal Francesco Barberini, who died in 1676 (cf. P. Dreyer, *op. cit.*, pp. 248 ff.). Miss Montagu has further pointed out that No. 131 is almost certainly the composition referred to in the accounts as 'Repairing the Walls of Rome'.

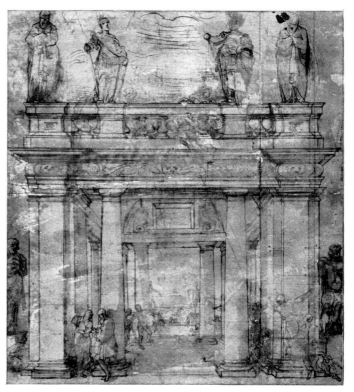

Fig. 21 Cat. No. 170

ELIJAH AND THE WIDOW OF ZAREPHATH
(Blunt and Cooke, No. 133) (4501)
Dr. Vitzthum (p. 515) points out that a preliminary drawing for this composition is in the Louvre, wrongly classed as Pietro da Cortona.

ERMINIA AND THE SHEPHERDS (Blunt and Cooke, No. 135) (4352)
The drawing has an old inscription *Ferri*, which is cut by the edge of the sheet.

170a. A SAINT RECEIVING A PAIR OF MANACLES FROM THE VIRGIN (Blunt and Cooke, No. 616) (4483)
Dr. Vitzthum (p. 515) has convincingly proposed an attribution to Ferri rather than Cortona.

171. AUGUSTUS AND THE SIBYL (Blunt and Cooke, No. 622) (4517)
From the Luti collection.

A copy by Altomonte in the Albertina is inscribed: *Ziro feri*, indicating an attribution to Ciro Ferri rather than Pietro da Cortona, which is supported by Dr. Karl Noehles (cf. Heinzl, *Altomonte*, p. 69, No. 14, and *The Luti Collection*, p. 20, No. 14).

172. STUDY FOR THE HIGH ALTAR OF THE CHIESA NUOVA (Blunt and Cooke, No. 657) (4482)
Dr. Karl Noehles (*Bollettino d'Arte*, XLV, 1960, pp. 123 f.,

and *Miscellanea Bibliothecae Hertzianae*, Munich, 1961, pp. 429 ff.) has established that this is a design by Ferri for the altar in the Chiesa Nuova, and the attribution in the catalogue to a follower of Cortona can be changed for a precise ascription to Ferri.

173. ALLEGORICAL SUBJECT (Blunt, *French Drawings*, No. 300) (4500)

This drawing was attributed to François Spierre because of the engraving by him, but it is in fact the original drawing by Ferri on which the engraving was based. This is confirmed by the fact that the drawing comes from a volume described in Inventory A (p. 113) as *P. Cortona, Ciro Ferri, Romanelli, Salvator Rosa &c.*

See also: *PIETRO DA CORTONA* (Nos. 347, 350 below).

ALBERT FLAMEN
(active 1648–69)

See *Imitator of STEFANO DELLA BELLA* (Blunt, *Stefano della Bella*, Nos. 151, 152).

GIOVANNI BATTISTA FOGGINI
(1652–1725)

174. A BATTLE BETWEEN MEN ON HORSEBACK AND WOMEN (*Plate 60*) (5955)

250 × 403 mm. Pen and brown ink, brown and grey washes, over black chalk.

Inventory A, p. 146: 'A Drawing by Gio. Battista Foggini'.

175. A BATTLE SCENE, INCLUDING WOMEN COMBATANTS (4520)

234 × 419 mm. Pen and brown washes, over black chalk.

Inventory A, p. 111: 'Pietro Beretino da Cortona'.

PROSPERO FONTANA
(1512–97)

176. OCCASION SEIZING FORTUNE BY THE FORELOCK (Popham and Wilde, No. 1066) (5990)

This drawing was attributed to Taddeo Zuccaro, but Mr. John Gere has argued that both the drawing and the stucco-relief for which it is a study are by Prospero Fontana (cf. *Burlington Magazine*, CVII, 1965, pp. 201 f.).

See also: *Manner of GIANLORENZO BERNINI* (No. 41 above).

PIER FRANCESCO DI JACOPO FOSCHI
(active 1535)

See *After ANDREA DEL SARTO* (No. 434 below).

CARLO GIUSEPPE FOSSATI
(1735–1805)

177. A BALLERINA (Croft-Murray, *Venetian Drawings*, No. 195) (7416)

This drawing is apparently listed by Consul Smith under the name of 'Davide Fossati', but Dr. C. Palumbo has pointed out that this artist was invariably known as Davide Antonio to distinguish him from a rich uncle, who was simply Davide. Moreover, according to Dr. Palumbo, the style of the drawing is unlike that of Davide Antonio Fossati and much closer to that of his cousin Carlo Giuseppe, to whom he would ascribe it.

DAVIDE ANTONIO FOSSATI
(1743–84)

See *CARLO GIUSEPPE FOSSATI* (No. 177 above).

MARCO ANTONIO FRANCESCHINI
(1648–1729)

THE ADORATION (Kurz, No. 212) (3761)

THE CIRCUMCISION (Kurz, No. 213) (3762)

The frescoes for which these drawings are studies, destroyed in the war, are reproduced from old photographs in D. C. Miller, *Bollettino d'Arte*, XLI, 1956, pp. 318 ff.

ST. CATHERINE (Kurz, No. 217) (3764)

From the Luti collection.

A copy by Altomonte is in the Albertina (cf. Heinzl, *Altomonte*, p. 71, No. 64 *recto*, and *The Luti Collection*, p. 21, No. 64), and is inscribed: *Franzescini*.

CHARITY (Kurz, No. 219) (3585)

D. C. Miller, *op. cit.*, p. 322) has pointed out that this drawing is a study for a fresco of the same subject at Piacenza, destroyed in the war, and not for that in Corpus Domini at Bologna. The drawings in the Uffizi and the Galleria Davia-Bargellini are also connected with the Piacenza fresco.

MERCURY SUMMONING THE GODDESSES TO THE JUDGMENT OF PARIS (Kurz, No. 226) (3587)

Mr. D. C. Miller has identified this drawing as a study for a fresco in the Palazzo Brazzetti, formerly Palazzo Monti, Bologna (*Burlington Magazine*, CII, 1960, p. 32). The similar drawing with Apollo, mentioned in the catalogue, now belongs to the Pierpont Morgan Library, New York.

DIANA HUNTING (Kurz, Nos. 230–231) (3767, 3655)

Cf. D. C. Miller, *Burlington Magazine*, XCIX, 1957, p. 233.

PASTORAL (Kurz, No. 239) (3797)

A painting by Franceschini, 'una Pastorale capricciosa con un Pastore, Ninfa e due o tre putti in alto bizarro e curioso', should be mentioned for its similar subject (cf. F. Haskell,

'Stefano Conti, patron of Canaletto and others', *Burlington Magazine*, xcviii, 1956, p. 297).

178. THE RISEN CHRIST APPEARING TO ST. THOMAS (Blunt and Cooke, No. 1035) (6742)

Mr. Dwight Miller has pointed out that this drawing, catalogued among the anonymous Roman drawings, is a study for Marco Antonio Franceschini's *Christ appearing to St. Thomas Aquinas* in a room in the Convent connected with San Domenico, Bologna.

See also: *DOMENICO PIOLA* (Nos. 365–366 below).

Attributed to BATTISTA FRANCO
(c. 1498–1561)

179. HELLENISTIC-TYPE ROMAN RELIEF: VISIT OF DIONYSUS TO THE HOUSE OF ICARIUS (*Plate 12*) (8488)

276 × 417 mm. Fine pen and dark brown ink.
From the Pozzo-Albani drawings.
The attribution is due to Mr. A. E. Popham.
After a relief in the British Museum (cf. Vermeule, p. 32).

180. MAIDENS DANCING (THE HORAE) (8503)

206 × 508 mm. Pen and brown ink.
From the Pozzo-Albani drawings.
In reverse from the sculpture in the Louvre, known as the 'Borghese Dancers' (cf. Vermeule, p. 33).

181. DESIGN FOR A DISH AND OTHER SKETCHES (*Plate 11*) (10888)

259 × 397 mm. Cut on all sides. Brown ink and chalk.
The attribution is due to Mr. A. E. Popham.

182. TWO SEPARATE STUDIES OF FIGURES FROM BACCHIC SARCOPHAGUS FRONTS OR ENDS (8630)

178 × 317 mm. Pen and brown ink, over pencil.
From the Pozzo-Albani drawings.
After a sarcophagus in the Vatican (cf. Vermeule, p. 43).

183. SARCOPHAGUS RELIEF: THE INDIAN TRIUMPH OF DIONYSUS (8633)

168 × 396 mm. Fine pen and brown ink. The drawing is continued on the *verso*.
From the Pozzo-Albani drawings.
The original was formerly in the Villa Ludovisi, Rome (cf. Vermeule, p. 43).

184. THE RIGHT FRONT OF A SARCOPHAGUS RELIEF: THE INDIAN TRIUMPH OF DIONYSUS (8634)

241 × 330 mm. Fine pen and brown ink.
From the Pozzo-Albani drawings.
The original is in the Palazzo Rospigliosi, Rome (cf. Vermeule, p. 43).

185. THE LEFT FRONT OF THE SAME SARCOPHAGUS (8635)

241 × 400 mm. Fine pen and brown ink.
From the Pozzo-Albani drawings.

186. A SARCOPHAGUS RELIEF: A BACCHIC PROCESSION (8632)

131 × 425 mm. Pen and brown ink.
From the Pozzo-Albani drawings.
The original is at Woburn Abbey (cf. Vermeule, p. 43).

187. FRONT OF A NEREID SARCOPHAGUS (8598)

155 × 432 mm. Pen and brown ink, over black chalk.
Verso: The front right of the same sarcophagus.
From the Pozzo-Albani drawings.
The original sculpture is now in the Louvre (cf. Vermeule, p. 40).

188. AN OLD MAN WITH TWO WOMEN (Popham and Wilde, No. 1038) (0168)

This drawing was catalogued as by Pierino da Vinci, but Mr. Popham now accepts Mr. John Gere's suggestion that it is more likely to be by Battista Franco.

See also: *GIROLAMO DA CARPI* (Popham and Wilde, No. 197).

DOMENICO MARIA FRATTA
(1696–1763)

189. WOODLAND LANDSCAPE (6651)

454 × 333 mm. Pen and brown ink.
Catalogued (like Kurz, Nos. 266* and 268*) by Puyvelde with an attribution to Gillis Neyts (cf. *Flemish Drawings*, No. 271), but certainly by Fratta.

FRANCESCO FURINI
(c. 1600–46)

190. HEAD OF A GIRL (Blunt and Cooke, No. 1074) (354)

Mr. Philip Pouncey attributes this drawing to Furini.

ANTONIO DOMENICO GABBIANI
(1652–1726)

191. LANDSCAPE WITH A HERMIT (Blunt and Cooke, No. 543) (6162)

This drawing was catalogued as by Pier Francesco Mola, but Dr. Mina Gregori has suggested an attribution to Gabbiani.

GAETANO GANDOLFI
(1734–1802),
after GUIDO RENI

TRIUMPH OF JOB (Kurz, No. 273) (01208)

Reproduced in the *Gazette des Beaux-Arts*, 1958, 1, p. 304, Fig. 3.

Attributed to GAETANO GANDOLFI

192. ST. PETER, HEAD AND SHOULDERS (5368)

304 × 214 mm. Black chalk, touches of white, on grey paper.

Inventory A, p. 19: 'Teste di Diversi Maestri, Tom. I: Of the School of Carracci'.

The attribution is due to Mr. Philip Pouncey.
The same hand as No. 193.

193. ST. ANTONY OF PADUA, HEAD AND SHOULDERS, IN PROFILE TO LEFT (5429)

303 × 217 mm. Black chalk, touches of white, on grey paper.

By the same hand as No. 192.

LUIGI GARZI
(1638–1721)

ST. CATHERINE RECEIVED INTO HEAVEN
(Blunt and Cooke, No. 137) (6824)

This drawing was catalogued as a study for the fresco in S. Caterina a Magnanapoli, Rome, but the catalogue of the exhibition *Römische Barockzeichnungen*, Berlin-Dahlem, 1969 (under a related drawing, No. 74), states that it is actually for S. Caterina a Formello, Naples, though the designs for this were later reused for the decoration of the Roman church.

A *modello* of the composition was shown at the Lasson Gallery, London, in 1967 (reproduced *Burlington Magazine*, CIX, 1967, p. 599, Fig. 65).

See also: *GIOVANNI BATTISTA GAULLI* (Blunt and Cooke, No. 159).

BERNARDINO GATTI, IL SOJARO
(c. 1495–1575)

THE REST ON THE FLIGHT INTO EGYPT (Popham and Wilde, No. 337) (0599)

Sir Karl Parker has pointed out that a copy in coloured chalks by Ozias Humphrey, dated 1781, is in the Ashmolean Museum, Oxford.

STUDIES (Popham and Wilde, No. 340) (0595)

Mr. Popham has established that this drawing is a study for a seated angel below and to the right of Christ in Gatti's *Ascension* in S. Sigismondo, Cremona.

GIOVANNI BATTISTA GAULLI,
called BACICCIO
(1639–1709)

THE HOLY FAMILY WITH ST. ELIZABETH AND ST. JOHN (Blunt and Cooke, No. 150) (5554)

The drawing was published and its relation with the Czernin painting discussed by R. Enggass, *Art Quarterly*, XXI, 1958, pp. 283 f.

VENUS AND ADONIS (Blunt and Cooke, No. 155) (6761)

From the Luti collection.

A copy by Altomonte in the Albertina is inscribed *Gio. Batista Gaulli Bacicio* (cf. Heinzl, *Altomonte*, p. 70, No. 31, and *The Luti Collection*, p. 20, No. 31).

In a review of the Baciccio exhibition at Oberlin in the *Burlington Magazine* (CIX, 1967, pp. 184 ff.) Prof. Robert Enggass pointed out that this drawing was a study for a painting at Burghley House, but doubted the attribution of either the painting or the drawing to Baciccio. Later, however, in a letter to the *Burlington Magazine* (*ibid.*, p. 187) he changed his view and accepted the attribution of both to the artist, calling attention to another drawing at Düsseldorf connected with the same composition.

THE HOLY TRINITY (Blunt and Cooke, No. 159) (6822)

Mr. Antony Clark believes that this drawing has nothing to do with Gaulli, but may be nearer to Luigi Garzi.

See also: *DOMENICO MARIA CANUTI* (No. 84 above); *FABIO CRISTOFANI* (No. 153 above); *CARLO MARATTA* (No. 289 below), and *GIUSEPPE PASSERI* (No. 336 below).

ORAZIO GENTILESCHI
(c. 1565–1650)

See *ROMAN SCHOOL* (Blunt and Cooke, Nos. 1006, 1007).

FRANCESCO GESSI
(1588–1649)

194. HEAD OF ST. CHARLES BORROMEO (5348)

309 × 275 mm. Red chalk on dark grey paper, touches of white.

Professor Dwight Miller has pointed out that the drawing is a study for the painting of *St. Charles ministering to the plague-stricken of Milan* in S. Maria dei Poveri, Bologna.

194A. See p. 147.

ANTONIO GHERARDI
(1644–1702)

195. DESIGN FOR A MONUMENT TO PIUS II (*Fig. 22*)
 (6794)

377 × 255 mm. Pen and brown ink, with grey wash, over black chalk. Inscribed on the drawing itself: *PIO. II. P.O.M. SEN. CAROLUS BIGHIUS S.-VE. CAR*, and on the mount: *GHERARDI*.

Dr. M. S. Weil and Dr. Hellmut Hager have confirmed the traditional attribution to Gherardi by comparison with a drawing in Dresden which is certainly from his hand. Professor Ulrich Middeldorf has pointed out that *SEN.* must stand for *Senensis*, and that the person dedicating the monument is Cardinal Carlo Bichi, who was born in 1638, was made Cardinal in 1690, and died in 1718 (cf. A. M. Guarnacci, *Vitae, et res gestae Pontificum Romanorum,*

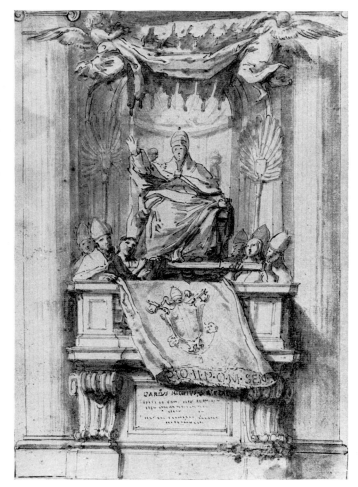

Fig. 22 Cat. No. 195

ANTONIO GIONIMA
(1697–1732)

ESTHER, AHASUERUS AND HAMAN (Kurz, No. 282)
(3582)

A preparatory drawing for the same composition has been much discussed in recent years. A. Bettagno (*Disegni e dipinti di G. A. Pellegrini*, 1959, No. 104) attributes it to Pellegrini; according to T. Pignatti (*Burlington Magazine*, CI, 1959, p. 452, No. 10) it is Riccesque, perhaps by Gionima, while for M. Muraro (*The Art Quarterly*, XXIII, 1960, p. 370) it is 'either Celesti or Gionima'.

196. THE SUPPER OF ST. DOMINIC (Kurz, No. 629)
(3668)

This drawing, classed by Prof. Kurz as anonymous, is a study for the painting formerly in the Chiesa della Mascarella, Bologna, destroyed in the last war (reproduced D. G. Fornasini, *La chiesa di S. Maria e S. Domenico detta la Mascarella*, 1943, Fig. 5, and R. Roli, *Arte antica e moderna*, XI, 1960, Pl. 92a).

LUCA GIORDANO
(1632–1705)

197. CHRIST DISPUTING WITH THE ELDERS (6440)
282 × 389 mm. Black and some red chalk, pen and brown wash, on blue paper, badly stained.

Inventory A, p. 105, as Flemish School.

The drawing was formerly attributed to Jordaens, perhaps owing to a confusion of his name with that of Giordano, and was catalogued as such by Puyvelde (*Flemish Drawings*, No. 247). It is, however, a study for a painting ascribed to Luca Giordano in a private collection, Bologna (cf. O. Ferrari and G. Scavizzi, *Luca Giordano*, Naples, 1966, II, p. 42).

Attributed to LUCA GIORDANO

198. THE RAISING OF LAZARUS (1757)
183 × 367 mm. Black chalk and ochre wash.

Inventory A, p. 73: 'Christ raising Lazarus by Lud. Carracci'.

The attribution to Giordano was suggested by Mr. John Gere.

199. ST. PETER AND ST. ANDREW (5198)
130 × 209 mm. Pen and brown ink, dark brown wash, over black chalk, on dark grey paper; touches of white, in a feigned oval.

Manner of GIOVANNI DA UDINE
(1487–1564)

200. COPY OF A WALL DECORATION (11418A)
285 × 430 mm. Pen, light brown washes.

201. DESIGNS FOR CEILINGS (10860)

Rome, 1751, cols. 355 ff.). Since Gherardi died in 1702, the drawing must have been made between 1690 and that date.

ESTHER AND AHASUERUS (Blunt and Cooke, No. 170)
(6708)

Dr. Vitzthum (p. 517) has pointed out that this is a study for Gherardi's painting of this subject in the Palazzo Nari, Rome (reproduced A. Mezzetti, *Bollettino d'Arte*, XXXIII, 1948, Figs. 5, 7).

GIACINTO GIMIGNANI
(1611–81)

FLORA, CERES, BACCHUS AND VERTUMNUS (Blunt and Cooke, No. 735) (0155)

DIANA AND AN ATTENDANT (Blunt and Cooke, No. 736) (0156)

Mrs. Sutherland-Harris has suggested that these drawings, catalogued with a tentative attribution to Romanelli, are nearer in style to Gimignani.

See also: *PIETRO DA CORTONA* (No. 351 below).

252 × 187 mm. Pen and brown ink, over black chalk. Perhaps a copy.

See also: *PERINO DEL VAGA* (Nos. 477–481 below).

GIULIO ROMANO
(?1492–1546)

APOLLO AND PAN (Popham and Wilde, No. 349)

(0495)

Professor Hartt (*Giulio Romano*, New Haven, 1958, I, pp. 186, 301) wrongly identified the subject as Apollo and Marsyas and suggested, without good reason, that it is a study for the *Appartamento di Troia* in the Palazzo Ducale, Mantua.

OMEN OF THE GREATNESS OF AUGUSTUS (Popham and Wilde, No. 350)

(0308)

According to Professor Hartt (*op. cit.*, p. 171) this is part of a study by Giulio for one of the *favole* in the Gabinetto dei Cesari in the Palazzo Ducale, Mantua; for its position in the room see E. Verheyen, 'Correggio's *Amori di Giove*', *J.W.C.I.*, xxix, 1966, p. 173).

See also: *RAPHAEL* (Popham and Wilde, Nos. 12750, 1251, 12754).

After GIULIO ROMANO

202. FRAGMENTS OF THE FRONT RELIEF OF A BACCHIC SARCOPHAGUS: SILENUS CARRIED ON AN ASS (8639)

178 × 325 mm. Pen and brown ink, with grey wash.

From the Pozzo-Albani drawings.

After a sarcophagus in the Vatican (cf. Vermeule, p. 44).

Studio of GIULIO ROMANO

203. PART OF A DESIGN FOR DECORATION, WITH SATYRS SUPPORTING A CANOPY (11335)

253 × 355 mm. overall. Pen, light brown wash.

Possibly a copy of a lost drawing by Giulio Romano.

204. VESSEL IN THE SHAPE OF A HORN (11336)

183 × 240 mm. Cut irregularly. Pen and brown ink, with grey wash.

DESIGNS FOR A TABLE-FOUNTAIN

205. 133 × 78 mm. Pen and brown ink, brown wash.

(11303)

206. 133 × 78 mm. Pen and brown ink, brown wash.

(11305)

These designs incorporate the oak-branches and acorns of the della Rovere family, presumably of the Urbino branch, which was connected with the Gonzagas by marriage.

207. TABLE ORNAMENT IN THE SHAPE OF A CLASSICAL SHIP (11306)

64 × 136 mm. Pen and brown ink, grey wash. Probably a copy.

208. DESIGN FOR A CHAFING DISH (11307)

139 × 278 mm. Pen and brown ink, grey wash, over chalk indications.

On the top of the lid are the Farnese arms.

209. DESIGN FOR A BASIN (11261)

123 × 154 mm. Pen, grey and brown wash.

The attribution is due to Mr. John Gere.

210. DESIGN FOR A TOMB OVER A DOORWAY (10760)

433 × 257 mm. On two pieces of paper, joined together. Damaged and cut all round. Pen and brown wash. Inscribed on the upper part of the tomb: *Exurge et tolle crucem tuam et seque christum.*

211. DESIGN FOR A FREE-STANDING COLUMN ON A HIGH PEDESTAL (10744)

394 × 170 mm. Pen and brown ink, light brown wash.

212. DESIGN FOR A CANDLESTICK (*Fig. 23*) (10743)

376 × 184 mm. Pen and brown ink, pale brown wash, over indications of chalk.

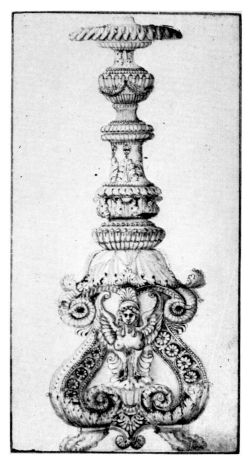

Fig. 23 Cat. No. 212

FOUR DESIGNS FOR EWERS

213. 122 × 65 mm. Pen and pale brown ink. (11318)

214. 151 × 70 mm. Pen and pale brown ink. (11319)

215. 152 × 79 mm. Pen and pale brown ink. (11320)

216. 110 × 83 mm. Pen and pale brown ink. (11321)

All four drawings have been cut round the contours. They appear to be by the same hand as Nos. 211, 212.

217. SARCOPHAGUS RELIEF: THE INDIAN TRIUMPH OF DIONYSUS AND THE TRIUMPH OF HERCULES
(8636)

248 × 433 mm. Pen and brown ink, brown and grey washes, over black chalk.

From the Pozzo-Albani drawings.

The original is at Woburn Abbey (cf. Vermeule, p. 43).

Verso: Studies from Raphael's ceiling in the Sala di Psiche of the Farnesina. Pen and brown ink, brown and grey washes, over black chalk.
Study of a mutilated torso of a sandal-binding Venus. Red chalk.

See also: *After POLIDORO DA CARAVAGGIO* (No. 371 below).

GIOVANNI FRANCESCO GRIMALDI
(1606–80)

218. LANDSCAPE WITH TREES AND A BOAT ON A LAKE
(01125)

485 × 738 mm. Pen with brown and black ink, grey washes over red chalk, on faded paper. Inscribed in the 'deceptive' hand: *Agostino Caracci*.

Inventory A, p. 161: 'Portfolio of Large Drawings of Landscapes: 1 by Agostino Carracci'.

Attributed to
GIOVANNI FRANCESCO GRIMALDI

219. BEE-KEEPING AT HOSTILIA (*Fig. 24*) (5765)

192 × 310 mm. Pen and brown wash.

Inventory A, p. 119: 'Paesi Diversi . . . By Fratti and Donato Creti of Bolognese'. The last two words do not make sense as they stand, and, although they could be amended to read 'of Bologna', it is also possible that they should be 'and Bolognese', which could refer to Giovanni Francesco Grimaldi, who was commonly known as 'Il Bolognese'.

The drawing illustrates a passage in Pliny (*Natural History*, XXI, xliii, 73), which reads as follows:

> 'Hostilia is a village on the bank of the Padus. When bee-fodder fails in the neighbourhood, the natives place the hives on boats and carry them five miles upstream by night. At dawn the bees come out and feed, returning every day to the boats, which change their position until, when they have sunk low in the water under the mere weight, it is understood that the hives are full, and then they are taken back and the honey is extracted.'

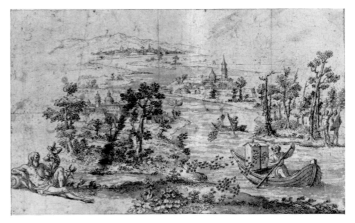

Fig. 24 Cat. No. 219

Hostilia, now called Ostiglia, was in classical times an important city on the Padus (i.e. the Pò), but is now little more than a village. In the left foreground of the drawing the artist has shown a river-god representing the Padus. On the extreme right we see two of Phaeton's sisters being transformed into trees as they mourn for their dead brother, who fell to his death on the banks of this river. The landscape includes a tall Venetian campanile.

The author of the drawing cannot be identified with certainty, but the combination of the Bolognese tree-drawing with the more Roman figure style suggests Giovanni Francesco Grimaldi.

If this attribution is correct, the drawing was probably made in Rome, where Grimaldi spent a considerable part of his career, in which case the bees are almost certainly an allusion to the *imprese* of the Barberini family, with whom many of the drawings at Windsor are connected.

DESIGNS FOR ECCLESIASTICAL VESSELS AND IMPLEMENTS

220. 75 × 408 mm. Pen and brown ink, dark brown wash.
(11338)

221. 75 × 408 mm. Pen and brown ink, dark brown wash.
(11339)

LANDSCAPE WITH A BOAT (Kurz, No. 298)

This is a copy after a drawing by Domenichino in the Pierpont Morgan Library, New York (cf. Stampfle and Bean, p. 32, No. 29).

See also: *Imitator of SALVATOR ROSA* (No. 405 below).

JACOB JORDAENS
(1593–1678)

See *LUCA GIORDANO* (No. 197 above), and *NEAPOLITAN SCHOOL* (No. 646 below).

FILIPPO JUVARA
(1675–1736)

222. DRAWING IN HONOUR OF MARCO RICCI (5906)

332 × 401 mm. Pen and brown ink, grey wash, on brown paper.

From the volume containing Marco Ricci's architectural drawings.

Discussed and reproduced in Blunt and Croft-Murray, *Venetian Drawings*, pp. 42 f.

WILLIAM KIRBY
(d. 1771)

See *GIOVANNI STERN* (No. 450 below).

GERARD DE LAIRESSE
(1641–1711)

See *GIULIO CARPIONI* (No. 92 above).

GIOVANNI LANFRANCO
(1582–1647)

THE ASSUMPTION (Blunt and Cooke, No. 184) (4350)

Dr. Vitzthum (p. 517) does not believe that the drawing is connected with the Augsburg picture.

ST. ANDREW (Blunt and Cooke, No. 185) (5704)

Schleier (*Burlington Magazine*, CIV, 1962, p. 255) rejects the connection with the Berlin picture.

THE MARTYRDOM OF ST. MATTHEW (Blunt and Cooke, Nos. 194, 195) (5674, 5680)

Other drawings for this composition are in the Museo di Capodimonte, Naples (*Disegni di Lanfranco per la Chiesa dei SS. Apostoli*, 1964, Nos. 63–68), the Uffizi (reproduced *Bollettino d'Arte*, XLVI, 1961, p. 114), and the Metropolitan Museum, New York (56.219.4 and 87.12.64).

STUDIES OF A HORSE AND A HAND (Blunt and Cooke, No. 203 *verso*) (5681)

Schleier (*loc. cit.*) has pointed out that these studies are preparations for the *Crucifixion* in S. Martino and that the *recto* drawings also belong to the Naples period and are not connected with the Parma *St. Peter healing*.

STUDY FOR THE FIGURE OF A SAINT (Blunt and Cooke, No. 204) (2103)

The attribution to Lanfranco was originally proposed by Professor Wittkower (cf. Carracci catalogue, No. 338), and was accepted by Schleier (*Burlington Magazine*, CIV, 1962, p. 255, note 32).

THE ADORATION OF THE CROSS (Blunt and Cooke, No. 205) (5711)

Dr. Vitzthum (p. 517) does not accept the connection with the Scholz drawing.

STUDY OF A WOMAN (Blunt and Cooke, No. 211) (5701)

Dr. Vitzthum (p. 517) has pointed out that the *recto* is a study for one of the framing figures in the Sala dei Corazzieri in the Quirinal.

STUDIES OF A MAN (Blunt and Cooke, No. 212) (5692)

According to E. Schleier (*Arte antica e moderna*, VIII, 1965, p. 345) this is a study for the *Last Supper*, formerly in S. Paolo fuori le mura, Rome.

STUDIES FOR AN ANGEL (Blunt and Cooke, No. 215) (5703)

E. Schleier (*loc. cit.*) does not accept the connection with the picture of *St. Theresa*.

THE TRANSFIGURATION (Blunt and Cooke, No. 218) (5667)

The attribution to Lanfranco has been challenged—with some reason—by Dr. Walter Vitzthum (p. 517), but is supported by the existence of a fairly similar painting in the Galleria Nazionale, Rome (2246), also attributed to Lanfranco.

THE VIRGIN APPEARING TO A MONK (Blunt and Cooke, No. 220) (5668)

A study for a painting in the apse of SS. Apostoli, Naples (cf. Vitzthum, p. 517, and Bean and Vitzthum, p. 111).

FIGURE STUDY (Blunt and Cooke, No. 231) (5676)

Dr. Vitzthum (p. 517) has pointed out that this is a study for the painting of *Judah and Tamar* in the Galleria Nazionale, Rome (reproduced *Paragone*, III, 1952, No. 29, Fig. 7).

A FEMALE SAINT SUPPORTED ON CLOUDS (Blunt and Cooke, No. 232) (5669)

The drawings on the *recto* and *verso* have been identified by E. Schleier (*Arte antica e moderna*, VIII, 1965, pp. 346 f.) as studies for the fresco on the dome of S. Andrea della Valle.

223. A SAINT (Kurz, No. 660) (3363)

Miss Catherine Johnston has pointed out that this hitherto anonymous drawing is by Lanfranco. The *recto* is a study for the Blessed Hugh in the San Martino frescoes, and the *verso* is a sketch for the *Martyrdom of Sts. Philip and James* in SS. Apostoli, Naples.

See also: *ANNIBALE CARRACCI* (Wittkower, Nos. 334, 337), *GIUSEPPE CHIARI* (No. 114 above), and *ANDREA SACCHI* (No. 421 below).

ANDREA LANZANI
(1650–1712)

224. STUDY OF A KNEELING MAN (3824)

375 × 278 mm. Red and white chalk on grey paper. Inscribed in the 'deceptive' hand: *Lanzani*.

Inventory A, p. 21: 'Bolognese Moderni'.

The old attribution is confirmed by the similarity to paintings by Lanzani such as the *Vision of St. Francis* at Pommersfelden.

FILIPPO LAURI
(1623–94)

GIDEON AND THE FLEECE (Blunt and Cooke, Nos. 243, 244) (4538, 4537)

Dr. Norbert Wibiral's attribution of these drawings to Lauri, mentioned in the catalogue as the basis of a verbal communication, was published in the *Bollettino d'Arte*, XLV, 1960, pp. 140 f.

See also: Attributed to *MICHELANGELO RICCIOLINI* (No. 390 below).

GIOVANNI BATTISTA LENARDI
(1656–1704)

DECORATIVE DRAWINGS (Blunt and Cooke, Nos. 1011–1016) (4471, 5629–33)

Dr. Eckhard Schaar has suggested that these hitherto anonymous drawings may well be by Lenardi, perhaps after Schor and other artists (cf. *Italienische Handzeichnungen*, No. 74).

PIRRO LIGORIO
(c. 1510–83)

225. DESIGN FOR A CEILING (*Plate* 24) (10494)

353 × 348 mm. Pen and brown ink. Round the circle of the Zodiac in the central panel is the inscription: SAECVLVM FELIX, and in the middle of each side of the design are figures, below which are the words: AEQVITAS, CONCORDIA, IVSTITIA, and PAX.

In two corners are coats of arms, which have not so far been identified. The attribution was first proposed by Mr. A. E. Popham and is confirmed by Mr. Howard Burns, who has pointed out that there are similar drawings by Ligorio at Turin of grotesques combined with allegories (cf. D. R. Coffin, 'Pirro Ligorio and decoration of the late 16th century at Ferrara', *Art Bulletin*, XXXVII, 1955, p. 167).

A POPE CROWNING AN EMPEROR (Popham and Wilde, No. 396) (0111)

This drawing was catalogued as by Pirro Ligorio, but F. Bologna (*Roviale spagnuolo e la pittura del Cinquecento*, Naples, 1958, pp. 52, 85) has suggested an attribution to Pedro de Rubiales, known as Roviale Spagnuolo.

See also: *FRANCESCO CONTINI* (No. 146 above), and *Follower of PERINO DEL VAGA* (No. 511 below).

GIACOMO LIGOZZI
(c. 1547–1626)

See *ROMAN SCHOOL* (No. 698 below).

Attributed to ANDREA DI LIONE
(1610–85)

226. A MAN WITH CYMBALS (Blunt and Cooke, No. 775) (4279)

This drawing was accepted by Posse as by Sacchi and catalogued as by him in the volume on Roman drawings, but it has been pointed out by Dr. Ann Harris and Professor Walter Vitzthum that it is almost certainly related to a painting in the Prado representing *Elephants in a Roman Circus*. This picture has been attributed to Testa and Castiglione, but Soria suggested the name of Andrea di Lione, which seems convincing (cf. A. E. Perez Sanchez, *Pintura italiana del siglo XVII en España*, Madrid, 1965, p. 402). The figure in the drawing is close to one in the right foreground of the painting. In the background appear architectural features, which are common to all the members of the series of Roman scenes to which the *Elephants* belongs. In the drawing these include a pyramid, which may be an early form of the obelisk in the painting. Another drawing for this composition is in the Jathorne-Hardy collection. Drawings connected with other paintings in the series are in the Uffizi (cf. *Cento disegni napoletani*, Uffizi, 1967, Nos. 56 f.), but these are attributed to Falcone.

JOHANN CARL LOTH
(1632–98)

227. BOY PLAYING A TAMBOURINE (6800)

201 × 242 mm. Pink and brown wash, heightened with white chalk over black chalk, on blue paper. Inscribed on *verso* (laid down): *Carlo Lotti*.

The drawing, which is no doubt a study for a ceiling decoration, probably dates from the time when the artist was in Venice, where he settled before 1663. The attribution to Loth is confirmed by Dr. G. Ewald.

228. LOT AND HIS DAUGHTERS (Blunt and Cooke, No. 81) (6758)

From the Luti collection

The drawing was catalogued as by Bonatti, on the basis of an old inscription, but a copy by Altomonte in the Albertina is inscribed *Carlo Lotti* (cf. Heinzl, *Altomonte*, p. 70, No. 37, and *The Luti Collection*, p. 20, No. 37).

PIETRO LUCATELLI
(1634–1710)

See *CIRO FERRI* (Blunt and Cooke, Nos. 127, 128).

BENEDETTO LUTI
(1666–1724)

229. SEATED ACADEMY STUDY (5956)

553 × 404 mm. Black and white chalks, on blue paper. Inscribed: *Benedetto Luti*.

230. ACADEMY STUDY OF A RECUMBENT MAN (5957)

385 × 550 mm. Black and white chalks, on blue paper. Inscribed: *Benedetto Luti*.

231. HEADS OF THREE CHILDREN (5427)

220 × 355 mm. Black, red, brown and black chalks, on grey paper.

The middle head is a study for the Virgin as a child in the painting of the *Virgin and St. Anne* in Munich (cf. H. Voss, *Die Malerei des Barock in Rom*, 1924, p. 366).

Manner of BENEDETTO LUTI

232. HEAD OF A GIRL TO LEFT (6797)

150 × 127 mm. Black, white and red chalks, on grey-blue paper.

Inventory A, p. 128: 'Moderna Schuola Romana'.
The technique is that of Luti.

LUZIO LUZZI,
called LUZIO ROMANO
(active 1528–75)

The following drawings belong to a large group of decorative designs from the circle of Perino del Vaga. The problem of their attribution is discussed on page 124 with the entries under Perino del Vaga's name, but on the basis of the documented drawings for the Palazzo dei Conservatori (see below, Nos. 233–238), coupled with the expert advice of Konrad Oberhuber, who was kind enough to examine the drawings, it has been thought better to form a group of drawings which can be tentatively ascribed to Luzio.

DESIGNS FOR DECORATIONS IN THE PALAZZO DEI CONSERVATORI, ROME

233. DESIGN FOR AN OVAL DOME WITH PANEL SHOWING ROMULUS AND REMUS WITH THE WOLF
(*Plate 14*) (10851)

170 × 225 mm. Pen and brown ink over black chalk, with blue wash.

234. DESIGN FOR AN OVAL DOME WITH FIGURES OF CHRIST AND SAINTS (*Plate 13*) (10854)

217 × 172 mm. Pen and brown ink over black chalk, with blue wash.

235. DESIGN FOR THE SOFFIT OF AN ARCH (10867)

230 × 120 mm. Pen and brown ink over black chalk, with blue wash. The right-hand design inscribed: *ILARITAS PUBLICA* on an oval panel, and *SPQR* in a cartouche.

236. DESIGN FOR AN OVAL DOME WITH ALLEGORICAL FIGURES (10850)

205 × 161 mm. Pen and brown ink over black chalk, with blue wash. Inscribed with the letters *SPQR* in a cartouche.

DESIGNS FOR A CIRCULAR DOME (*Plate 15*)

237. 221 × 223 mm. Pen and brown ink, with blue wash.
 (10852)

238. 180 × 173 mm. Pen and brown ink, with blue wash.
 (10853)

These drawings are connected with the decoration of the shallow domes over the staircase to the first-floor landing outside the Sala degli Orazii e Curiazii in the Palazzo dei Conservatori (Figs. 25–6).

No. 233 corresponds in its main features to the first bay with the panel of Romulus and Remus, No. 234 to the second, although it differs in detail. The drawing shows as its four principal figures St. John the Baptist, St. Michael, St. Peter and St. Paul, whereas the vault itself has Christ, Moses, David and St. John the Baptist. The panel of the *Annunciation* appears in both the drawing and the stucco, but the other panels do not correspond.

The right-hand drawing on No. 235 corresponds to the soffit of one of the arches on the staircase. The left-hand design does not have any exact parallel in the decoration as executed, but the inscriptions show that it must be connected with the scheme. No. 236 corresponds in its general lay-out to No. 234 and also has the inscription *SPQR*. Nos. 237, 238 are in exactly the same style and technique as the drawings just discussed and correspond in their general pattern to the shallow domes of the staircase.

The inscription *ILARITAS PUBLICA* on No. 235, which surrounds a group signifying Charity, might appear to be a mistake for *CHARITAS PUBLICA*, but the idea of *Ilaritas* occurs in Valeriani (cf. *Hieroglyphica*, Venice, 1603, p. 565) and seems to be used in the sense of Public Well-being.

The attribution and dating of the stuccoes are established by payments to Luzio Romano made in 1575, published by Pio Pecchiai (*Il Campidoglio nel Cinquecento*, Rome, 1950, pp. 135 ff.). Pecchiai reproduces (p. 97) the vault to which No. 234 corresponds. The drawings which cannot be exactly related to the existing stuccoes may be either rejected designs for them, or drawings for the vault of one of the vestibules in the palace executed in 1569 but now destroyed (cf. Pecchiai, *op. cit.*, p. 135).

239. DESIGNS FOR TWO PANELS OF A FRIEZE
 (10859)

135 × 423 mm. Ink, chalk, blue wash. Cut on all sides.

The decoration of the left-hand panel incorporates the symbol of Capricorn.

DESIGNS FOR FRIEZES

240. 197 × 188 mm. Pen and brown ink, blue wash. Cut at the sides. (10861)

241. 168 × 261 mm. Pen and brown ink over black chalk, with blue wash. Watermark: lily in double oval. (10863)

242. 287 × 264 mm. Pen and brown ink, with blue wash.
 (10864)

243. 107 × 258 mm. Pen and brown wash over black chalk.
 (10865)

Fig. 25

cf. Cat. No. 233–8

Fig. 26

cf. Cat. No. 233–8

244. 164 × 270 mm. Pen and brown ink over black chalk, with blue wash. (10869)

245. 213 × 163 mm. Pen and brown wash. On two pieces of paper joined together. (10887)

246. 213 × 405 mm. Pen and brown ink over black chalk. (10920)

247. 155 × 265 mm. Blue wash over black chalk. (10922)

248. DESIGN FOR STUCCO DECORATION, PERHAPS FOR A SOFFIT (10866)

234 × 120 mm. Pen and brown wash over black chalk.

250. DECORATION OF A ROOM (10883)

253 × 413 mm. Brown ink, black chalk, guiding lines, grey wash.

The decoration includes two unicorns, which probably refer to the *imprese* of one of the Farnese. The design may be connected with the decoration of a room in the Castel S. Angelo.

DESIGNS FOR THE DECORATION OF A WALL AND A CEILING

251. 328 × 315 mm. Cut irregularly (overall measurements). Pen and brown ink, with blue washes. (11484C)
The drawing includes the Farnese lily.

252. 421 × 331 mm. Pen and brown ink over black chalk, with blue wash and some body-colour. Watermark: two crossed arrows. (10885)

253. 423 × 345 mm. Pen and brown ink, with blue wash. (10917)

254. 396 × 393 mm. Pen, brown ink, and grey-brown wash. (10918)
The drawing includes the arms of the Orsini family.

DESIGNS FOR THE DECORATION OF VAULTS OR CEILINGS

255. 183 × 305 mm. Pen and brown wash. (10871)

256. 228 × 350 mm. Pen, brown wash, and black chalk. (10875)
Verso: Four designs for vessels of various shapes. Pen and brown ink.

257. 267 × 265 mm. Pen and brown ink, with blue wash. (10919)

258. 203 × 200 mm. Pen and brown ink, with grey and brown wash. (11484D)

259. 206 × 405 mm. Pen and brown wash. (11484E)
The central panel shows the story of Diana and Actaeon.

260. 356 × 268 mm. Pen and brown ink, with grey-brown wash. (10849)

261. 176 × 379 mm. Pen and brown wash. (10855)
The drawing is cut and gives probably half the design for the ceiling of a gallery.

262. 103 × 170 mm. Black chalk, with grey and brown wash. (10932)

263. 141 × 280 mm. Pen and brown wash. (11488C)

264. DESIGN FOR A CEILING WITH THE ARMS OF PIUS IV (10923)

169 × 171 mm. Pen and brown wash over black chalk.

The central panel bears the Medici arms with the papal tiara. The style of the drawing suggests a date after the middle of the century, so they are likely to be those of Pius IV (1559–65) rather than those of one of the two earlier Medici popes, Leo X and Clement VII.

265. DESIGN FOR A DECORATION WITH A CANON'S ARMS (10889)

247 × 396 mm. Pen and brown wash over black chalk.

The arms, *une bande engoulée de deux têtes de dragon*, are borne by several families, mainly Spanish (Andrada, Anleo, Freire, Orquezio, Sanchez, Santo-Domingo, Tovar; cf. T. de Renesse, *Dictionnaire des figures héraldiques*, Brussels, 1892–1903, v, p. 546), and there does not seem to be any means of deciding for which of them this drawing was made.

DESIGNS FOR THE DECORATION OF A WALL

266. 262 × 193 mm. Pen and brown ink, chalk, with grey and brown wash. (10891)

267. 348 × 422 mm. Pen and brown ink over black chalk, with blue wash. (10884)
Figures of Faith and Charity are shown over the door.

268. 240 × 235 mm. Pen and brown ink over black chalk. (10921)

DESIGNS FOR THE CEILING OF A CHAPEL

269. 180 × 153 mm. Grey wash over black chalk. (10924)
In the central panel is the figure of Christ holding the Cross.

270. 110 × 115 mm. Pen and brown ink, with blue wash. Inscribed in three of the corner panels: *evangelista*.
(10925)

In the middle panel is the dove of the Holy Ghost. In the borders putti carry the symbols of the Passion.

DESIGNS FOR THE FRIEZE OF A CHAPEL

271. 61 × 256 mm. Pen and brown ink, with blue wash. (10926)

One panel shows the *Expulsion from Eden*.

272. 62 × 198 mm. Pen and brown ink, with blue wash. (10927)

The right-hand panel (cut off) shows *Adam delving and Eve spinning*. No doubt part of the same frieze as No. 272.

273. DESIGN FOR A NICHE (10892)

405 × 230 mm. Pen and brown wash over some black chalk.

The decoration is in the manner of Perino del Vaga, but the architecture suggests the north of Italy. The drawing may, therefore, have been made when Luzio was working with Perino in Genoa.

274. DESIGN FOR A COVERED DISH (11272)

148 × 212 mm. Pen and brown ink, with grey wash.

The attribution is due to Mr. Philip Pouncey and Dr. Konrad Oberhuber, but Dr. John Shearman has pointed out the resemblance to drawings by Giulio Romano in the British Museum and elsewhere.

DESIGNS FOR A CANDELABRUM

275. 425 × 135 mm. Pen and light brown wash. (11247)

276. 411 × 136 mm. Pen and brown wash. (11246)

Two very similar drawings are in the Victoria and Albert Museum, where they are attributed to Perino del Vaga (reproduced *Connoisseur*, CXLIX, 1962, p. 159).

277. DESIGN FOR A MACE (11267)

853 × 230 mm. Pen and brown wash over black chalk. On two pieces of paper, joined together.

A variant of the design is in the British Museum (cf. P. Pouncey and J. Gere, *Italian Drawings in the British Museum, Raphael and his Circle*, London, 1962, p. 112, No. 188).

278. DESIGN FOR A EWER (11273)

352 × 200 mm. Pen and brown ink. Blackened for transfer.

279. DESIGN FOR A SAUCE-BOAT (11326)

180 × 175 mm. Pen and brown wash.

CARLO MADERNO
(1556–1629)

See *FRANCESCO BORROMINI* (Nos. 49, 50, 51 above).

CARLO MAGNONI
(d. 1653)

See *ANDREA SACCHI* (Blunt and Cooke, Nos. 741, 742).

RUTILIO MANETTI
(1571–1639)

280. A SAINT ASSISTING AT A MASS (3498)

380 × 264 mm. Grey, brown and white oil paint. Partly marked off for squaring by means of a ruled scraped line.

Inventory A, p. 81: 'Guido &c'.

The attribution to Manetti was made by Mr. Philip Pouncey and confirmed by Dr. P. A. Riedl.

281. THE FUNERAL OF ST. ROCH (Popham and Wilde, No. 995) (3499)

This drawing was tentatively ascribed by Mr. Popham to Francesco Vanni, but Professor Maurice Cope has identified it as a study for Manetti's fresco in the Sala del Consiglio of the church of S. Rocco alla Lupa in Siena.

GIUSEPPE MANNOCCHI
(1731–82)

282. STUDIES FOR GROTESQUE DECORATION (10944–10959)

Each drawing is about 600–650 mm high by 100–150 mm wide. Pen and brown ink and water-colour.

283. DESIGNS FOR CEILINGS (9257, 11596–11609)

The sizes vary from c. 370 × 430 mm to c. 525 × 750 mm. All are in pen and grey ink, with water-colour.

Attributed to GIOVANNI MANOZZI, called GIOVANNI DA SAN GIOVANNI
(1592–1636)

284. FEMALE FIGURE SEATED ON CLOUDS (*Plate 62*) (3636)

215 × 192 mm. Red chalk.

VINCENZO MANOZZI
(active c. 1650)

285. HEAD OF A BOY, THREE-QUARTERS TO LEFT, LOOKING DOWN (4334)

288 × 204 mm. Red chalk.

Verso: A squeeze of a similar head, looking up.

286. A BOY, HEAD AND SHOULDERS, LOOKING UP TO LEFT (*Fig. 27*) (4335)

280 × 215 mm. Red chalk.

Verso: A squeeze of a similar head, looking down.

287. HEAD OF A BOY, THREE-QUARTERS TO RIGHT (4336)

264 × 206 mm. Red chalk.

The attribution to Manozzi is based on three drawings in the same style and of the same model in the Uffizi, reproduced in *Bollettino d'Arte*, 1922–23, pp. 523 f., which appear to be the only other works attributed to this minor pupil of Furini.

CARLO MARATTA
(1625–1713)

288. THE VIRGIN AND CHILD APPEARING TO A BISHOP (Blunt and Cooke, No. 86) (4421)

From the Luti collection.

This drawing was catalogued as by Calandrucci, but a copy by Altomonte in the Albertina is inscribed *Carlo*

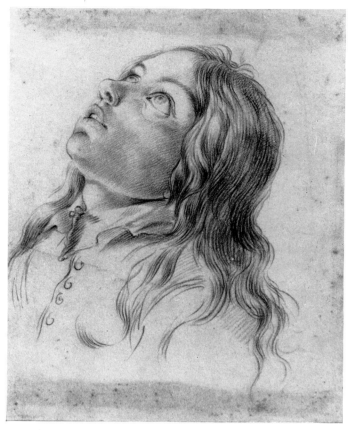

Fig. 27 Cat. No. 286

Marati (cf. Heinzl, *Altomonte*, p. 69, No. 16, and *The Luti Collection*, p. 20, No. 16).

289. THE ADORATION OF THE SHEPHERDS
(Blunt and Cooke, No. 158) (0258)
This drawing was catalogued with a tentative attribution to Gaulli, but Dr. Schaar has shown that it is a study for Maratta's fresco in the Vatican (cf. Harris and Schaar, p. 97).

290. ALLEGORY OF THE OLD AND NEW
DISPENSATIONS (Blunt and Cooke, No. 167) (4179)
This drawing was catalogued with a tentative attribution to a follower of Baciccia, but Mr. Peter Dreyer (*Master Drawings*, VII, 1969, pp. 24 f.) has pointed out that it is closely connected, in reverse, with an engraving by Giovanni Girolamo Frezze after Carlo Maratta, dated 1708. Another drawing of the same subject in red and black chalk is in the Metropolitan Museum, New York. It is so much finer in quality that, although Mr. Dreyer is firm in attributing the Windsor drawing to Maratta himself, it is permissible to wonder whether it is not a copy.

THE MADONNA WITH ST. AMBROSE AND TWO
OTHER SAINTS (Blunt and Cooke, No. 255) (4137)
Further drawings are at Düsseldorf and in the Uffizi (cf. Harris and Schaar, p. 105).

THE BIRTH OF THE VIRGIN (Blunt and Cooke,
No. 256) (4135)
Further drawings are at Düsseldorf and Madrid (cf. Harris and Schaar, p. 125).

LA TINTURA DELLA ROSA (Blunt and Cooke, No. 258)
 (4173)
Further drawings are at Düsseldorf and Madrid (cf. Harris and Schaar, p. 198).

MADONNA WITH THE CHRIST CHILD ASLEEP
(Blunt and Cooke, No. 260) (6096)
Mr. Antony Clark plausibly suggests that this is an engraver's drawing after the painting.

THE MADONNA AND CHILD APPEARING TO ST.
FRANCIS OF SALES (Blunt and Cooke, No. 263) (4128)
Further drawings are at Düsseldorf (cf. Harris and Schaar, p. 133).

THE MARTYRDOM OF ST. BLAISE AND ST.
SEBASTIAN (Blunt and Cooke, No. 264) (4126)
Further drawings are at Düsseldorf, Madrid and Berlin (cf. Harris and Schaar, p. 122).

ST. LUKE PAINTING THE VIRGIN (Blunt and Cooke,
No. 266) (4151)
Further drawings are at Düsseldorf (cf. Harris and Schaar, p. 192).

HAGAR AND ISHMAEL (Blunt and Cooke, No. 269)
 (4093)
Further drawings are at Düsseldorf (cf. Harris and Schaar, p. 150).

THE VISION OF ST. STANISLAS KOTSKA (Blunt and
Cooke, No. 272) (4154)
Further drawings are at Düsseldorf (cf. Harris and Schaar, p. 128).

ST. CHARLES BORROMEO RECEIVED INTO GLORY
(Blunt and Cooke, No. 273) (4123)
Further drawings are in the Christie-Miller collection and at Düsseldorf. A copy of a drawing for the head of St. Charles is in the Barber Institute of Fine Arts, Birmingham (cf. Harris and Schaar, pp. 130, 132 f.).

THE AGONY OF ST. FRANCIS XAVIER (Blunt and
Cooke, No. 276) (4130)
Further drawings are in the British Museum, at Madrid and at Düsseldorf (cf. Harris and Schaar, pp. 114 f.), and in the Ambrosiana (cf. Vitzthum, *Burlington Magazine*, CX, 1968, p. 362).

ST. JOSEPH IN GLORY (Blunt and Cooke, No. 277)
 (4164)
Further drawings are at Düsseldorf (cf. Harris and Schaar, p. 89).

THE AGONY IN THE GARDEN (Blunt and Cooke, No. 280) (4217)

Dr. Schaar endorses the view that this drawing is a copy after the painting (cf. Harris and Schaar, p. 96).

MADONNA WITH ST. FRANCIS AND ST. JAMES (Blunt and Cooke, No. 283) (4150)

Further drawings are in Madrid, Oxford, Berlin (cf. *Römische Barockzeichnungen*, Berlin, 1969, No. 125) and Düsseldorf (cf. Harris and Schaar, p. 129).
A study for the St. Francis was with Charles E. Slatkin, New York, in 1966 (catalogue, No. 13, Pl. 10).

MADONNA WITH ST. IGNATIUS AND ST. CHARLES BORROMEO (Blunt and Cooke, No. 287) (4132)

Further drawings are at Düsseldorf (cf. Harris and Schaar, p. 112).

JUDITH AND HOLOFERNES (Blunt and Cooke, No. 288) (4166)

Mr. Antony Clark has pointed out that two further studies exist in the Biblioteca Nacional, Madrid.

JAEL AND SISERA (Blunt and Cooke, Nos. 293–295) (4103, 4435, 4161)

The drawing mentioned as being in the Pierpont Morgan Library is actually in the Metropolitan Museum (cf. Stampfle and Bean, p. 76, No. 115).
Further drawings are at Düsseldorf (cf. Harris and Schaar, p. 120).

STUDY FOR THE ELIJAH (Blunt and Cooke, No. 296) (4118)

From the Luti collection.
A copy by Altomonte in the Albertina has the initials *C.M.* (cf. Heinzl, *Altomonte*, p. 69, No. 11, and *The Luti Collection*, p. 19, No. 11).

BILEAM (Blunt and Cooke, Nos. 297, 298) (4124, 4125)

The subject of these drawings is Bileam and not an Evangelist, as stated in the catalogue.
Further drawings for the same figure are at Düsseldorf (cf. Harris and Schaar, p. 118).

PORTRAIT OF CARDINAL ANTONIO BARBERINI (Blunt and Cooke, No. 300) (4162)

A further drawing is at Düsseldorf (cf. Harris and Schaar, p. 102).

THE ADORATION OF THE SHEPHERDS (Blunt and Cooke, No. 301) (4475)

A further drawing is at Düsseldorf (cf. Harris and Schaar, p. 97).

ST. PHILIP NERI ADORING A PAINTING OF THE VIRGIN (Blunt and Cooke, No. 302) (4149)

A similar drawing, in reverse, was with Charles E. Slatkin, New York, in 1966 (catalogue, No. 8), and appears to be the original of which the Windsor drawing is a reversed copy. If this is correct, then the studies of hands on the *verso* of Blunt and Cooke, No. 303, are not likely to be connected with the composition, since they correspond in direction to the reversed copy and not the original.

THE HOLY FAMILY WITH ST. JOHN (Blunt and Cooke, No. 307) (4359)

A further drawing is at Düsseldorf (cf. Harris and Schaar, p. 151).

WINTER AND SPRING (Blunt and Cooke, No. 315) (01120)

An original drawing for the composition is at Düsseldorf (12125).

ALLEGORY IN HONOUR OF PIETRO DA CORTONA (Blunt and Cooke, No. 317) (4091)

Mr. Hugh Honour (*Connoisseur*, CXLVIII, 1961, p. 241) has pointed out that this allegory is in honour of Pietro da Cortona and that the portrait is based on F. Chéron's medal of him.

LUCRETIA STABBING HERSELF (Blunt and Cooke, No. 340) (4121)

The painting was formerly in the Francesco Montioni collection, Rome. An original drawing for the composition is at Düsseldorf, as well as copies of the Windsor drawing by Calandrucci and Passeri (Harris and Schaar, pp. 80, 135).

FOUR HEADS (Blunt and Cooke, No. 359) (4110)

Dr. Schaar has identified this and No. 360 as studies for the *Madonna of the Rosary* in the Oratorio di S. Zita, Palermo (cf. Harris and Schaar, p. 134). Further drawings for it are at Düsseldorf (*ibid.*).

HEAD OF A WOMAN (Blunt and Cooke, No. 360) (4106)

From the Luti collection.
A copy by Altomonte in the Albertina has the initials *C.M.* (cf. Heinzl, *Altomonte*, p. 69, No. 11, and *The Luti Collection*, p. 19, No. 11).

HEAD OF A GIRL (Blunt and Cooke, No. 363) (4213)

Miss Catherine Johnston has pointed out that this is a copy of the head of a girl on the left of Guido Reni's *Salome*, formerly in the Colonna collection, where it was called *Judith*, and now in Chicago.

BUST OF A WOMAN (Blunt and Cooke, No. 366) (4228)

Miss Johnston has pointed out that this is a copy of one of the Hours in Guido Reni's *Aurora* in the Casino of the Palazzo Rospigliosi.

HEAD OF APOLLO (Blunt and Cooke, No. 374) (4117)

Dr. Schaar has pointed out that, though based on the Apollo Belvedere, this is a study for the painting at Stourhead representing *The Marchese Pallavicini introduced by Apollo to Maratta*.

CHRIST IN THE GARDEN (Blunt and Cooke, No. 506)
(4090)

Miss Johnston has pointed out that this is a copy after a painting by Guido Reni, formerly in the French Royal Collection and now at Sens, which was engraved by Le Blond and I. Falch.

291. PORTRAIT OF A MAN (Blunt and Cooke, No. 1073)
(5188)

Mr. Antony Clark endorses the suggested connection with Maratta.

Studio of CARLO MARATTA

ALLEGORIES (Blunt and Cooke, Nos. 507, 508)
(4204, 4189)

Mr. F. H. Dowley has pointed out that these are copies after grisaille figures on the ceiling of the Camerino in the Palazzo Farnese.

SHEET OF STUDIES (Blunt and Cooke, No. 510) (4191)

Mr. F. H. Dowley has pointed out that these are both copies after Guido Reni's *Nativity of the Virgin* in the Quirinal.

FIGURE OF A MAN (Blunt and Cooke, No. 511) (4322)

Mr. F. H. Dowley has pointed out that this is a copy after a figure in the *Justification of Leo III* in the Stanze.

292. THE STATUE OF ST. MATTHEW (Blunt and Cooke, No. 737)
(4168)

This drawing was catalogued as by Rusconi, but Dr. Schaar (Harris and Schaar, p. 156) has pointed out that it is in fact Maratta's drawing for Rusconi's statue in the Lateran. Other drawings by Maratta for the series are at Düsseldorf (*ibid.*), and in the collection of Mr. Ralph Holland (cf. Vitzthum, *Burlington Magazine*, cx, 1968, p. 362).

293. THE BAPTISM (Kurz, No. 576) (5294)

This drawing was catalogued as by an anonymous Bolognese artist, but Dr. Schaar (Harris and Schaar, p. 146) has pointed out its close relation to Maratta's painting of the subject in the Certosa di S. Martino, Naples.

See also: *POMPEO BATONI* (No. 31 above); *GIUSEPPE PASSERI* (Blunt and Cooke, No. 584); *Attributed to GUIDO RENI* (No. 389 below,) and *FRANCESCO TREVISANI* (No. 461 below).

GIUSEPPE MARCHETTI
(early 18th century)

294. SURVEY OF THE CHURCH OF ST. JOHN LATERAN, ROME
(10960–10965, 10967–11019, 11021, 9228)

A series of drawings of St. John Lateran, probably made by Giuseppe Marchetti in the early eighteenth century (cf. R. Krautheimer, 'La façade ancienne de Saint-Jean-de-Latran à Rome', *Revue archéologique*, series 6, v, 1935, pp. 231 ff.). The drawings show the church after the restoration of the interior by Borromini, but before the execution of Galilei's façade in 1734.

One drawing in the volume (11017) is signed *Giop.e Marchetti*, and the others seem to be by the same hand. The inscriptions contain a number of references to the Council of 1725, and the drawings were probably made at or soon after that date. The volume also includes four drawings connected with St. Peter's (see below). No architect called Giuseppe Marchetti seems to be recorded at the relevant time. No. 9228 is not in the volume devoted to the Lateran, but it probably comes from it, because the altar bears the name of Innocent XIII (1724–30).

295. THE TOMB OF QUEEN CHRISTINA OF SWEDEN
(11023)

269 × 190 mm. Black chalk, pen and brown ink. Inscribed: *Pianta, e Facciata del Deposito della Regina di Svezia nella chiesa di S. Pietro in Vaticano. No. 22. Pianta. elevazione.*

THE FONT IN ST. PETER'S

296. 202 × 179 mm. Pen and brown ink. Inscribed and numbered: *20.* (11022a)

296a. 548 × 406 mm. Black chalk, and a little red chalk. Inscribed and numbered: *78.* (11020)

297. PLAN OF THE LOGGIA DELLA BENEDIZIONE AT ST. PETER'S (10966)

485 × 710 mm. Pen and black ink, with black and grey-brown washes. Inscribed: *Pianta della Loggia della Benedizione—No. 7.*

298. GRILLE TO THE CAPPELLA DEL SACRAMENTO, ST. PETER'S (11022b)

150 × 170 mm. Pen and brown ink. Inscribed and numbered: *11.*

299. THE CROSSING OF ST. PETER'S WITH THE PAPAL THRONE ON A TEMPORARY DAIS (10767)

500 × 355 mm. Pen and water-colour.

300. A COLLATION FOR THE COLLEGE OF CARDINALS IN HOLY WEEK (10768)

530 × 380 mm. Pen and water-colour.

The subject is identified by an inscription, but it is not known what room in the Vatican is shown. The tapestries on the wall bear the arms of the Altieri pope, Clement X (1670–76), but the drawing is evidently later and by the same hand as No. 299. Both drawings presumably come from the volume catalogued under No. 294.

Attributed to
MARCO MARCHETTI DA FAENZA
(?d. 1588)

THE CONVERSION OF ST. PAUL (Popham and Wilde,
No. 416) (6010)

Antal (p. 32) proposed an attribution to Taddeo Zuccaro,
a suggestion with which Mr. Popham does not agree
(cf. *Burlington Magazine*, XCIII, 1951, p. 131).

ALESSIO DE MARCHIS,
called DA NAPOLI
(1710–52)

301. A VILLAGE OVER A RAVINE (*Plate 75*) (6638)
371 × 529 mm. Brown wash, over red chalk.

The attribution, which is due to the late A. P. Oppé, is
based on the similarity of the drawing to various drawings
inscribed with the name of *Alessio* (e.g. Uffizi, 8229, and
British Museum 1948–11–16–1). The Windsor drawing is
discussed and reproduced in an article by Marco Chiarini,
Paragone, September 1965, Pl. 58, and *Master Drawings*, V,
3, 1967, pp. 289 ff.

LUCIO MASSARI
(1569–1633)

302. HEAD OF A MONK (Kurz, No. 720) (1886)
Miss Catherine Johnston has identified this as a study for
the head of the Blessed Corradino Ariosti in the painting
of the *Elemosina* in the Ariosti Chapel in S. Paolo Maggiore,
Bologna, painted c. 1625.

CARDINAL CAMILLO MASSIMI

See *PIETRO SANTI BARTOLI* and *CARDINAL
CAMILLO MASSIMI* (No. 30 above).

AGOSTINO MASUCCI
(c. 1691–1758)

See *PIETRO DE PIETRI* (No. 362 below).

PIER FRANCESCO MAZZUCHELLI,
called MORAZZONE
(1571–1626)

303. THE HOLY FAMILY WITH ADORING ANGELS
(*Fig. 28*) (5129)
259 × 188 mm. Pen and grey wash, heightened with body-
colour, on pink paper. Inscribed in the 'deceptive' hand:
Romanino da Brescia. The scroll held up by the putti at the
top of the composition bears the inscription: EN(?) . . .
MEL. O PRVDENS EMANVEL BVTIRV. . . .

The attribution to Morazzone was first suggested by Mr.
Philip Pouncey, who has since found a painting related to
the drawing in the collection of Viscount Scarsdale at
Kedleston.

See also: *Attributed to GUGLIELMO CACCIA, called IL
MONCALVO* (No. 58 above).

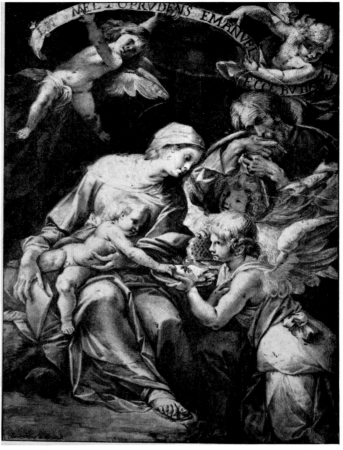

Fig. 28 Cat. No. 303

ALTOBELLO MELONI
(active 1497–1517)

304. HEAD OF A YOUNG MAN (Popham and Wilde,
No. 1087) (4776)
C. L. Ragghianti (p. 595) has proposed the name of
Altobello Meloni for this drawing, an attribution which
Mr. Popham regards as possibly correct.

VINCENZO MEUCCI
(1699–c. 1766)

305. REST ON THE FLIGHT INTO EGYPT (0360)
300 × 202 mm. Grey washes on faded paper.

An inscription on the mount attributing the drawing to
Meucci is probably a copy of an older one.

MICHELANGELO
(1475–1564)

'ECORCHÉS' (Popham and Wilde, Nos. 439–441)
(*Plates 1–3*) (0624, 0802, 0803)
In the catalogue of the sixteenth-century drawings these

Fig. 29 Popham and Wilde, Cat. No. 443 *verso*

three anatomical studies were catalogued as 'School of Michelangelo', though it was pointed out that they were very close indeed to the master in style. When, however, they were shown in the exhibition organised by Professor Wilde and Mr. Popham at the British Museum in 1953 of drawings by Michelangelo (Cat. Nos. 116, 117), the element of doubt was removed and the drawings were firmly attributed to Michelangelo on the authority of both scholars. They were dated c. 1515–20. Two other drawings from the same series are in the Teyler Museum, Haarlem, and the Gathorne-Hardy collection (British Museum exhibition, No. 118). All the drawings are further discussed in J. Wilde, *Michelangelo's 'Victory'*, Oxford, 1954, p. 16.

'ECORCHÉS' (Popham and Wilde, Nos. 442, 443)
(*Plates 4–5*) (0474, 0475)
Like the red chalk drawings discussed above, these pen studies were catalogued as from the workshop of Michelangelo, but Mr. Michael Hirst believes that they were drawn by Michelangelo himself. The drawings by Michelangelo closest in style are four in the same medium in the Casa Buonarroti (10F, 48F, 11F and 44F; cf. P.

Barocchi, *Michelangelo e la sua scuola, I. disegni di Casa Buonarroti e degli Uffizi*, Florence, 1962, Nos. 71–74). If the two Windsor drawings are accepted as autograph, they are likely to date from between 1520 and 1524. For No. 443 verso see Fig. 29.

AURELIANO MILANI
(1675–1749)

306. THE MARTYRDOM OF A FEMALE SAINT (6743)
265 × 194 mm. Pen and dark brown ink, grey wash, over red chalk.

Inventory A, p. 128: 'Moderna Schuola Romana'.

The attribution is due to Professor Dwight Miller.

PIER FRANCESCO MOLA
(1612–66)

BACCHUS AND ARIADNE (Blunt and Cooke, No. 538)
 (6799)
Dr. Walter Vitzthum (p. 517) has pointed out that there are other drawings connected with this composition in the

Louvre and at Haarlem. Mr. Richard Cocke proposes a date of c. 1647–50.

THE HOLY FAMILY (Blunt and Cooke, No. 539) (6776)
It has been pointed out by Dr. J. Müller-Hofstede and Mr. Richard Cocke that this drawing is based on an engraving by M. Lasne after Rubens (Rooses, 1, No. 227; Vorheelm Scheevogt, Nos. 123–125). The attribution to Mola has been generally rejected, but no alternative has been suggested. The drawing is clearly Italian, and probably Roman.

WOMAN WITH A UNICORN (Blunt and Cooke, No. 540) (6798)

Mr. Cocke suggests a date of 1650–55.

VENUS FINDING THE DEAD ADONIS (Blunt and Cooke, No. 541) (3598)
The attribution to Mola has been rejected by Dr. Vitzthum (p. 517) and Mr. Cocke, who, however, considers the drawing to be near to Mola in style.

ST. JOHN THE BAPTIST IN THE WILDERNESS (Blunt and Cooke, No. 542) (6766)
Mr. Cocke considers that this drawing reflects a design by Mola, but is not from his own hand.

WOODED LANDSCAPE (Blunt and Cooke, No. 544) (0831)

No. 544 appears to be by the same hand as a drawing at Rennes, given to Mola.

LANDSCAPE WITH FIGURES (Blunt and Cooke, No. 545) (6151)

LANDSCAPE WITH FIGURES BESIDE A STREAM (Blunt and Cooke, No. 546) (0830)
Mr. Cocke suggests a date of c. 1660–66.

LANDSCAPE (Blunt and Cooke, No. 548) (1504)
Mr. Cocke suggests that this drawing may be connected with a *Flight into Egypt* rather than with *Tobias and the Angel*, as suggested in the Catalogue of Roman Drawings.

STUDIES OF THE VIRGIN AND CHILD (Blunt and Cooke, No. 549) (6785)
Mr. Cocke has pointed out that this drawing is probably connected with Mola's early fresco in the church at Coldrerio.

TREES IN A WOOD (Blunt and Cooke, No. 550) (5805)
Mr. Richard Cocke rejects the attribution to Mola and believes the drawing to be by an artist of a generation earlier.

Fig. 30 Cat. No. 307

THE VISION OF A HERMIT (Blunt and Cooke, No. 1027) (6805)
Mr. Cocke has suggested, not very convincingly, that the drawing may be based on a lost composition by Mola.
See also: *ANTONIO DOMENICO GABBIANI* (No. 191 above); *BOLOGNESE SCHOOL* (No. 550 below), and *ITALIAN SCHOOL* (No. 627 below).

GIOVANNI BATTISTA MONTANO
(1534–1621)

DRAWINGS OF ROMAN ALTARS

307. 248 × 188 mm. Pen and dark brown wash. (*Fig. 30*). (10435)

308. 253 × 178 mm. Pen and dark brown wash. (10436)

309. 237 × 161 mm. Pen and dark brown wash. (10437)

DESIGNS FOR VASES

310. 232 × 338 mm. Pen and brown wash. (11312)

311. 263 × 345 mm. Pen and brown wash. (11313)

Fig. 31 Cat. No. 312

312. *248 × 346 mm. Pen and brown wash.* (*Fig. 31*).
 (11316)

313. *250 × 358 mm. Pen and brown wash.* (11317)
The attribution to Montano of these drawings was made
by Mr. Nicholas Ward-Jackson. No. 312 has the crowned
eagle and dragon of the Borghese family on the handle.

FRANCESCO MONTI
(1683–1768)

MYTHOLOGICAL SUBJECTS (Kurz, Nos. 323–331)
 (3646–7, 3658–9, 3799, 3800, 5326–8)
The traditional attribution of these drawings to Monti has
been defended by R. Rolli (*Arte antica e moderna*, XVII, 1962,
pp. 96 f.).

ALESSANDRO MORETTO (BONVICINO)
(c. 1498–1554)

See *Attributed to GIROLAMO ROMANINO* (Popham and
Wilde, No. 872).

GIROLAMO MUZIANO
(1528–92)

See *ROMAN SCHOOL* (Popham and Wilde, No. 1152).

'MUZIUS'
(second half of the 16th century)

314. DESIGN FOR THE HEAD OF A CROZIER (11337A)
*458 × 284 mm. overall. Pen and brown wash, much
damaged, torn and faded.* At the bottom on the left a
long and mostly illegible inscription, which begins: *Andrea
Romero manu ppria.* On the crozier itself: *MUS BONAN
(? BONAR) F.*

The signature probably refers to the artist who signed his
name *Muzius* on one of the crystals in a crucifix and two
candlesticks, now in the Vatican Treasury, made by
Antonio Gentile da Faenza for Cardinal Alessandro
Farnese. The crystals were delivered in 1581 and engraved
in 1582. The models were almost certainly by Guglielmo
della Porta, who is known to have worked with Gentile.
A preparatory drawing, dated 1561, was in the Weinmüller
sale, Munich, 13.f.x.1938, lot 732 (as Vittoria). The
Windsor drawing is also close in its forms to Guglielmo
della Porta and is probably based on his design. If the
reading *BONAN* is correct, Muzius, who does not appear
to be otherwise recorded, was presumably Bolognese by
birth. This information was kindly supplied by Dr. John
Shearman.

ARNOUT MYTENS
(1541–1602)

315. CHRIST MOCKED (Popham and Wilde, No. 236)
 (01221)

Otto Benesch (*Burlington Magazine*, XCIII, 1951, pp. 351 f.)
identified this drawing, catalogued with an attribution to
Cigoli, as a study for a painting by Mytens in Stockholm.

BATTISTA NALDINI
(1537–91)

THETIS RECEIVING FROM VULCAN THE SHIELD OF
ACHILLES (Popham and Wilde, No. 521) (0163)
Antal (p. 31) considered this to be a drawing by Vasari's
assistant, Peter Candid, for the painting by the former in
the Uffizi. It is, however, in reverse compared with the
painting. Mr. Popham does not accept Antal's suggestion.
(cf. *Burlington Magazine*, XCIII, 1951, p. 130, and Antal,
ibid., p. 132).

PIETRO NEGRONI
(1503–65)

316. THE ADORATION OF THE SHEPHERDS
(Popham and Wilde, No. 1183) (5056)
This drawing was catalogued as belonging to the North
Italian School, but F. Bologna (*Roviale Spagnuolo e la
pittura Napoletana del Cinquecento*, Naples, 1958, p. 77) has
assigned it to Pietro Negroni. Antal (p. 32) suggested a fol-
lower of Polidoro.

GILLIS NEYTS
(1647/48–53)

See *DOMENICO MARIA FRATTA* (No. 189 above).

MAURO ODDI
(1639–1703)

317. A NUN TAKING THE VOW BEFORE A BISHOP
(5525)

337 × 210 mm. Pen and brown wash, heightened with body-colour. Signed in margin at foot: *Mauro Oddi. f.*

The inscription is in the same ink as the drawing and appears to be a signature. Other drawings by this little-known artist are in the Library at Parma.

LELIO ORSI
(1511(?)–87)

APOLLO DRIVING THE CHARIOT OF THE SUN
(Popham and Wilde, No. 534) (0224)

Yet another version of this drawing is in the collection of Milton Hebald, Rome.

Attributed to LELIO ORSI

318. DESIGN FOR A TABLE DECORATION, WITH APOLLO AND THE PYTHON (11341)

261 × 268 mm. Pen and brown ink, grey washes.

The attribution is due to Dr. Konrad Oberhuber.

FANTASTIC SCENE (Popham and Wilde, No. 540)
(5208)

Attributed by Antal (p. 32) to Boscoli, but Mr. Popham does not accept this attribution.

FRANCESCO PAGANI
(active 1644–51)

A series of drawings illustrating the life of St. Francis of Paola.

319. DEDICATION TO THE ABBATE ROBERTO FONTANA (7751)

204 × 118 mm. Pen and brown ink and brown and white oil paint, on paper. Inscribed round the frame of the portrait: MONSIG. ABBATE ROBERTO FONTANA REF. DELL'VNA, E L'ALT SIGNAT. DI N. S. AMBASCIAT. DEL SER.MO DI MODENA IN MILANO, and below: *Non sapendo ò potendo appresentare cosa uscita dal mio peñello a V. S. Ill.ma di maggior preggio che il Ritratto di se stessa la supp.co ad aggradirlo, come consacro anche me stesso alla sua protectione et me l'inchino. Milano li 9 Aprile 1644. Di V. S. Ill.ma Humilissimo servo Francesco Pagani.*

320. THE PARENTS OF ST. FRANCIS PRAY FOR A CHILD; THE BIRTH OF THE CHILD; THE CHILD GIVING ALMS TO A BEGGAR (7756)

189 × 273 mm. Brown and white oil paint on paper. Incised with a stylus.

321. SIGNS OF EARLY DEVOTION IN ST. FRANCIS
(7759)

168 × 267 mm. Brown and white oil paint on paper. Incised with a stylus.

322. ST. FRANCIS MINISTERING TO THE SICK (7755)

185 × 275 mm. Brown and white oil paint on paper. Incised with a stylus.

323. ST. FRANCIS TAKING THE HABIT (7760)

177 × 276 mm. Brown and white oil paint on paper. Incised with a stylus.

324. ST. FRANCIS HEALING A BLIND CHILD (7754)

183 × 279 mm. Brown and white oil paint on paper. Incised with a stylus.

325. ST. FRANCIS PERFORMING MIRACLES (7753)

185 × 272 mm. Brown and white oil paint on paper. Incised with a stylus.

326. SIXTUS IV RATIFYING THE ORDER OF MINIMS; ST. FRANCIS PROPHESIES THAT GIULIANO DELLA ROVERE WILL BECOME POPE (7757)

193 × 280 mm. Brown and white oil paint on paper. Incised with a stylus.

327. ST. FRANCIS VISITING PRISONERS AND PREACHING (*Plate 65*) (7758)

188 × 281 mm. Brown and white oil paint on paper. Incised with a stylus.

328. ST. FRANCIS WITH A DEAD CHILD (*Plate 64*)
(7761)

178 × 265 mm. Brown and white oil paint on paper. Incised with a stylus.

329. THE DEATH OF ST. FRANCIS (7763)

181 × 271 mm. Pen and brown wash, heightened with body-colour.

330. ST. FRANCIS AND ANOTHER ECCLESIASTIC
(7752)

161 × 121 mm. Brown and white oil paint on paper. Incised with a stylus. Numbered: *63*.
Study for the two principal figures in No. 329.

331. THE BODY OF ST. FRANCIS LYING IN STATE
(7762)

184 × 275 mm. Pen and brown wash, on blue paper, heightened with body-colour.

Most of the drawings show more than one scene from the life of the saint, and in some cases the subsidiary episodes are difficult to identify. The most useful Life of St. Francis is the *Vita e Miracoli di S. Francesco di Paola* by Paola Regio, Bishop of Vico (Venice, 1591).
The books of reference do not record a Francesco Pagani working in Milan in 1644, but the Ospedale Maggiore contains a portrait of Giovanni Ambrogio Rosate, dated 1651, which is ascribed to Francesco Pagano (reproduced

G. C. Bassapè, *Le Raccolte d'arte dell'Ospedale Maggiore in Milano*, Milan, 1956, p. 144), who is no doubt identical with the author of these drawings.

The artist was probably a member of the Florentine family of Pagani, for the architecture in the drawings is clearly Florentine, the types and poses are derived from Callot, and the unusual technique can be paralleled in drawings by Gregorio Pagani (1558–1605), who may even have been Francesco's father.

332. A FEMALE MARTYR BROUGHT TO JUDGMENT
(3500)

261 × 198 mm. Brown, grey and white oil paint.

Inventory A, p. 81: 'Guido &c. Tom 6: Drawings of inferior Masters of the Bologna School'.

The attribution to Pagani is based on the close similarity to the series of drawings illustrating the life of St. Francis of Paola (see last entry).

JACOPO PALMA (GIOVANE)
(1544–1628)

See *DOMENICO CRESTI, called PASSIGNANO* (No. 337 below).

PIETRO GIACOMO PALMIERI
(1737–1804)

See *Imitator of SALVATOR ROSA* (No. 405 below).

FRANCESCO MAZZOLA,
called PARMIGIANINO
(1503–40)

Many of the drawings by Parmigianino catalogued in Popham and Wilde are further discussed (and some reproduced) in A. E. Popham, *The Drawings of Parmigianino*, London, 1953.

333. ST. STEPHEN (*Plate 8*)
(3365)

288 × 203 mm., top corner cut. Black and white chalk, on blue-grey paper.

Inventory A, p. 80: 'Guido, &c.'.

Dr. Arcangeli and Mr. Popham have pointed out that this drawing is a study by Parmigianino for the *Madonna with St. Stephen and St. John the Baptist* at Dresden (160), painted for the church of S. Stefano at Casalmaggiore after 1539.

APOLLO AND ORPHEUS (Popham and Wilde, No. 585)
(0584)

Attributed by Mr. Popham to Parmigianino, but by Quintavalle (*Il Bertoja*, Milan, 1963, pp. 22, 56) to Bertoja.

334. STUDY FOR THE *Madonna with St. John the Baptist and St. Jerome* (Blunt and Cooke, No. 1065)
(883)

This drawing, which was originally in the Domenichino

volume, was catalogued among the anonymous Roman drawings, of the early seventeenth century, but it has been pointed out by Dr. Konrad Oberhuber and Mr. Philip Pouncey that it is a study for the drapery over the legs of St. Jerome in the National Gallery *Madonna with St. John the Baptist and St. Jerome*. The attribution to Parmigianino is accepted by Mr. Popham.

The drawing of a seated nude on the *verso* is quite different in style and technique and may be by another hand.

After PARMIGIANINO

TWO CUPIDS (Popham and Wilde, No. 572)
(2309)

Mr. Popham has pointed out that this drawing is a copy after one belonging to Professor Dr. J. Q. van Regteren-Altena.

HEAD OF A BOY (Popham and Wilde, No. 599)
(0530)

Mr. Popham has established that this is a copy of a drawing at Stockholm (cf. O. Sirén, *Italienska Handteckningar från 1400– och 1500– talen i National Museum*, Stockholm, 1917, No. 219).

THE VESTAL TULLIA (Popham and Wilde, No. 610)
(01346)

Mr. Popham (*British Museum, Italian Drawings. Artists working in Rome*, 1967, No. 164) has pointed out that the object carried by the girl is clearly identifiable in the British Museum as a sieve, and that the drawing therefore represents the Vestal Virgin Tullia.

BARTOLOMEO PASSAROTTI
(1529–92)

335. HEAD OF A YOUNG MAN, THREE-QUARTERS TO RIGHT
(5384)

173 × 139 mm. Pen and dark brown ink, on dark brown paper. Inscribed in pencil or chalk: *Del Tempesta*.

The attribution is due to Mr. Philip Pouncey.

GIUSEPPE PASSERI
(1654–1714)

336. DESIGN FOR THE CEILING OF A CHURCH (Blunt and Cooke, No. 161)
(5563)

According to Mr. Antony Clark this is nearer to Passeri than to Gaulli, to whom it was tentatively ascribed.

THE MADONNA OF THE ROSARY (Blunt and Cooke, No. 568)
(0270)

Dr. Eckhard Schaar has pointed out that there is an almost identical sketch at Düsseldorf (F.P. 2306).

THE FLAGELLATION (Blunt and Cooke, No. 578) (0275)
From the Luti collection.

A copy by Altomonte in the Albertina is inscribed *Gioseppe Passeri* (cf. Heinzl, *Altomonte*, p. 69, No. 19r, and *The Luti Collection*, p. 20, No. 20).

ERMINIA AND THE SHEPHERDS (Blunt and Cooke, No. 584) (0273)

Dr. Schaar has pointed out that there is a red chalk drawing for the same composition at Düsseldorf, where it is traditionally attributed to Maratta.

See also: *LAZZARO BALDI* (No. 21 above).

PASSIGNANO (DOMENICO CRESTI)
(1558/60–1638)

337. THE BAPTISM (Popham and Wilde, No. 556) (6674)

This drawing, catalogued as Palma Giovane, was ascribed by Antal (p. 32) to Passignano, an attribution with which Mr. Popham agrees.

338. ST. CECILIA (Popham and Wilde, No. 1100) (3639)

This drawing was catalogued as by an anonymous Florentine artist, but Antal (p. 32) proposed an attribution to Passignano, which Mr. Popham accepts.

See also: *GIOVANNI DE' VECCHI* (Nos. 514, 515 below).

GIUSEPPE PEDRETTI
(?1694–1778)

339. UNIDENTIFIED SUBJECT (3743)

526 × 378 mm. Black and white chalk, on blue paper, within ruled margin.

Inventory A, p. 20: 'Bolognesi Moderni'.

Professor Dwight Miller has identified the drawing as an autograph replica of one in the Accademia Clementina in Bologna, made by Pedretti for a prize offered by the Academy in 1728.

GIOVANNI ANTONIO PELLEGRINI
(1675–1721)

See *ANTONIO GIONIMA* (Kurz, No. 282).

LUCA PENNI
(d. 1556)

See *School of RAPHAEL* (Popham and Wilde, Nos. 806–808).

BALDASSARE PERUZZI
(1481–1563)

340. THE ADORATION OF THE SHEPHERDS (Popham and Wilde, No. 202) (0327)

This drawing was catalogued as by Girolamo da Carpi, but Mr. Popham is now inclined to accept Antal's attribution of it (p. 32) to Peruzzi.

341. A WOMAN WITH TWO PUTTI (Popham and Wilde, No. 1134) (12959)

Mr. Popham is now inclined to accept the attribution to Peruzzi proposed by Sir Charles Robinson and confirmed

by Antal (p. 35), although he originally classified the drawing among the anonymous Roman works.

342. A MAN ON A HORSE (Popham and Wilde, No. 1135) (0510)

Mr. Popham catalogued this drawing as anonymous, Roman School, but now accepts Antal's attribution (p. 35) to Peruzzi.

After BALDASSARE PERUZZI

343. DESIGN FOR A CENSER (11346)

384 × 238 mm. Pen, brown wash. Numbered: *584*.

From the Pozzo and Albani collections.

Copy of a drawing by Peruzzi in the Hermitage. The identification is due to Dr. John Shearman.

344. SATYRS AND A NYMPH (0333)

170 × 235 mm. In a feigned oval, cut on all four sides. Pen and brown wash, heightened with white, on brown paper.

After a drawing by Peruzzi at Chatsworth.

Manner of BALDASSARE PERUZZI

345. PUTTI PLAYING AMONG ACANTHUS VOLUTES, A WINGED MONSTER AMONG THEM (10912)

170 × 440 mm. Pen and black ink, grey wash, heightened with body-colour, on dark blue paper. Squared in black chalk.

SIMONE PETERZANO
(active c. 1573–c. 1592)

See *MILANESE SCHOOL* (Popham and Wilde, No. 1114).

CALLISTO PIAZZA,
called CALLISTO DA LODI
(before 1500–61)

See *Attributed to GIROLAMO ROMANINO* (Popham and Wilde, Nos. 872, 873).

GIOVANNI BATTISTA PIAZZETTA
(1682–1754)

In a review of the *Venetian Drawings* (*Connoisseur*, cxv, 1957, p. 121) Mr. Francis Watson points out that the provenance of the Piazzetta drawings at Windsor from Smith's collection is confirmed by a passage in Guarienti's 1753 edition of Orlandi's *Abecedario*.

The drawings in the Royal Library also include copies by Princess Augusta Sophia, daughter of George III, after the drawings by Piazzetta in the same collection. Two are noted by A. P. Oppé (*English Drawings*, Nos. 13, 14) and another, after Blunt and Croft-Murray No. 32, has recently been identified (L. C. D. Inventory No. Windsor 1400), signed and dated *1785*.

GAETANO PICCINI
(early eighteenth century)

346. DRAWINGS OF BAS-RELIEFS (11959A–12046)

Each 145 × 95 mm. Pen and brown ink, with grey wash.

From the collections of Clement XI and Cardinal Albani.

The drawings were identified by Dr. A. Noach as preparations for the engravings, signed *Caietanus Piccinus fec*, representing reliefs on the exterior of the Palazzo Ducale at Urbino, illustrating the *Descrizione del Palazzo Ducale d'Urbino* by Bernardino Baldi, originally published in 1590, but reprinted with further text by Francesco Bianchini in the *Memorie concernanti la città d'Urbino* (Rome, 1724). This edition was dedicated by Cardinal Annibale Albani, Cardinal of S. Clemente, to Prince James Francis Edward Stuart, 'The Old Pretender'.

PIETRO DA CORTONA
(1596–1669)

347. LANDSCAPE, A ROCKY COAST-LINE, TREES, AND DISTANT SHIPS (*Plate 40*) (5797)

330 × 486 mm. Grey and brown washes on faded paper.

Inventory A, p. 119. From the Grimaldi volume.

One of the few pure landscape drawings by Cortona, very close in style to his small landscape paintings. The attribution was suggested verbally by Mr. John Gere, and published by Dr. Walter Vitzthum (*Master Drawings*, IV, 1966, p. 303), who calls attention to a copy after it by Ferri at Haarlem.

348. SARCOPHAGUS RELIEF WITH BACCHIC SCENES (8640)

183 × 556 mm. Pen and brown ink, brown and grey-green washes, on grey-green prepared paper, heightened with white. Numbered: *168*.

From the Pozzo and Albani collections.

The original is in the Palazzo Mattei (cf. Vermeule, p. 44). The attribution to Cortona is due to Dr. Vitzthum (p. 518).

349. COPY OF THE ALDOBRANDINI WEDDING (19228)

255 × 1033 mm. Pen and brown ink, brown and blue washes.

The attribution to Cortona is due to Dr. Vitzthum (p. 518).

350. DESIGN FOR THE HIGH ALTAR OF S. GIOVANNI DEI FIORENTINI (Blunt and Cooke, No. 129) (01115)

In spite of the early and explicit inscription, Dr. K. Noehles, and Dr. W. Vitzthum (p. 518) independently proposed that this is a design for the altar by Cortona. The drawing is indeed entirely in conformity with his manner, and an attribution to him would account for the many differences between the design and the altar as erected by Borromini and Ferri.

THE TRIUMPH OF BACCHUS (Blunt and Cooke, No. 588) (4515)

There is a copy of this drawing at Chatsworth (822) ascribed to Romanelli.

DESIGN FOR THE ARTIST'S TOMB (Blunt and Cooke, No. 592) (4449)

From the Luti collection.

A copy by Altomonte in the Albertina is inscribed: *Pietro da Cortona* (cf. Heinzl, *Altomonte*, p. 71, No. 62v, and *The Luti Collection*, p. 21, No. 62). Dr. Noehles (*La Chiesa dei SS. Luca e Martina*, Rome, 1970, p. 111) ascribes the drawing to Ciro Ferri.

THE HOLY TRINITY (Blunt and Cooke, No. 595) (4533)

A drawing of the upper part is at Chatsworth, (cf. *Old Master Drawings from Chatsworth*, Smithsonian Institute, Washington, 1962–63, No. 22; identified in the second edition only).

THE ARMS OF DON TADDEO BARBERINI (Blunt and Cooke, No. 602) (4481)

An identical drawing, apparently also an original by Cortona, is at Chatsworth (cf. D. Dubon, *Tapestries from the Samuel H. Kress Collection*, London, 1964, pp. 17 f.).

ALEXANDER ASSAULTING PERA (Blunt and Cooke, No. 608) (01121)

The original painting by Pietro da Cortona is in the Palazzo del Vicariato, Rome (cf. C. Pietrangeli, *Bollettino dei Musei comunali di Roma*, IV, 1957, pp. 5 ff., and G. Briganti, *Pietro da Cortona*, Florence, 1962, No. 64b).

STUDY FOR THE PAMPHILI GALLERY (Blunt and Cooke, No. 661) (6820)

Dr. Walter Vitzthum (p. 517) believes that this drawing, catalogued as by a follower of Cortona, is an original design by the artist for an early stage of the vault fresco in the Gallery of the Palazzo Pamphili, Rome.

351. THE MARTYRDOM OF ST. ERASMUS (Blunt, *French Drawings*, No. 275) (11991)

In the opinion of the writer this drawing is by Pietro da Cortona and a study for his altarpiece in St. Peter's (cf. Blunt, *Nicolas Poussin*, New York, 1967, pp. 85 f.), but Dr. Vitzthum believes it to be by Giacinto Gimignani.

After PIETRO DA CORTONA

DESIGN FOR A TOMB (Blunt and Cooke, No. 638) (4450)

This drawing was catalogued as 'Studio of Cortona', but Dr. K. Noehles has pointed out that it is a copy after an original by Cortona in Munich (cf. *Arte antica e moderna*, XXV, 1964, p. 94, note 9, Fig. 27b).

Attributed to PIETRO DA CORTONA

352. DESIGN FOR A SAUCE-BOAT (*Plate 21*) (11327)

213 × 193 mm. Black chalk, touches of pen and brown ink. No drawings for metalwork are known from the hand of Cortona, but the forms are like those to be seen in the decorative parts of his frescoes, and the technique is close to certain of his drawings.

Fig. 32 Cat. No. 354

353. AN ORNAMENTAL DISH, SUPPORTED BY A
DOLPHIN (11329)

199 × 235 mm. Black chalk.

Apparently by the same hand as No. 352.

354. DETAIL OF A CORINTHIAN ENTABLATURE
(*Fig. 32*) (10431)

291 × 210 mm. Pen and brown ink over red chalk, with
blue wash. Numbered: *61*.

From the Pozzo and Albani collections.

355. DRAWING OF A CAPITAL (10750)

137 × 145 mm. Black chalk. Numbered: *57*.

From the Pozzo and Albani collections.

356. A SHEET OF STUDIES (8548 *verso*)

245 × 462 mm. Black chalk, with a tree in pen and brown
ink. Inscribed: *largeza*.

The right-hand half of the *verso* consists of a drawing after
the Antique, but the left half contains studies of a base,
capital, and entablature of the Corinthian Order.

357. FRAGMENT OF A SARCOPHAGUS RELIEF (8725)

200 × 241 mm. Pen and grey-brown wash.

Verso: Study of a figure of a man, perhaps Bacchus. Red
chalk.

358. DESIGN FOR A CHALICE (11345A)

360 × 210 mm. Pen and grey ink, slight wash. Faded,
stained, torn and damaged.

359. SEATED FIGURE SEEN FROM BELOW, WITH
THE RIGHT ARM RAISED (0243)

380 × 281 mm. Cut on the left. Black chalk, touches of
white, on brown prepared paper.

The attribution is based on the similarity of the drawing
to certain studies by Cortona for the Pitti frescoes (cf. M.
Campbell, Catalogue of the *Mostra di disegni di Pietro
Berettini da Cortona per gli affreschi di Palazzo Pitti*, Florence,
1965, Figs. 15, 21, 22, 29, 33).

360. STUDIES OF SANDALLED FEET (11173)

100 × 106 mm. Black chalk, pen and brown wash, heigh-
tened with body-colour.

361. ST. BRUNO DEFENDING THE SACRAMENT AGAINST
BERENGAR OF TOURS AT THE COUNCIL OF 1079
(Blunt and Cooke, No. 853) (5203)

Mrs. Ann Sutherland-Harris has identified the subject of
the drawing and has pointed out that it is a study for a
fresco in the Chapel of St. Bruno, in the cathedral of Segni.
The author of the fresco is not recorded, but he appears to
have been a follower of Pietro da Cortona. The drawing
at Ottawa referred to in the entry for this drawing in the
Catalogue of Roman Drawings, and said to be near in
style to Sacchi, is now attributed by Dr. Vitzthum to
Lazzaro Baldi (cf. Popham and Fenwick, *European Drawings
in . . . the National Gallery of Canada*, Toronto, 1965, p. 61,
No. 88).

THE FALL OF THE DAMNED (Blunt and Cooke,
No. 609) (4508)

THE SACRIFICE OF ISAAC (Blunt and Cooke, No. 610)
 (4485)

NOLI ME TANGERE (Blunt and Cooke, No. 613) (4484)

Dr. Vitzthum (p. 518) rejects the attribution to Cortona
of these three drawings.

See also: *ALESSANDRO ALGARDI* (No. 8 above); *CIRO
FERRI* (Nos. 170a, 171 above), and *GIOVANNI FRAN-
CESCO ROMANELLI* (No. 392 below).

PIETRO DE PIETRI
(1663–1716)

362. TWO HEADS (Blunt and Cooke, Nos. 533, 534)
 (4404, 4403)

These drawings were catalogued as by Masucci, but Mr.
Antony Clark believes that the traditional attribution to
Pietro de Pietri is correct.

ST. CLEMENT GIVING THE VEIL TO S. FLAVIA
DOMITILLA (Blunt and Cooke, Nos. 668, 669)

(4412, 4413)

Another study of this composition was with Matthiesen, London, in 1963 and appeared in an anonymous sale, Sotheby, 29.i.1964, lot 198. It was exhibited in the same year at the Alfred Brod Gallery, No. 24. Yet another is in Berlin (cf. *Römische Barockzeichnungen*, Berlin, 1969, No. 145).

THE VIRGIN AND CHILD ADORED BY SAINTS
(Blunt and Cooke, No. 670)　　　　　　　　(5649)

Another drawing for this composition is in Düsseldorf (cf. *Italienische Handzeichnungen*, No. 130).

THE PRESENTATION (Blunt and Cooke, No. 671) (4409a)

A larger rectangular version of this composition belongs to Mr. Julian Benson, London. It is inscribed on one side: *Pietro de Pietri*, and on the other *Maratta*.

GOD THE FATHER WITH THE DEAD CHRIST
(Blunt and Cooke, Nos. 683, 684)　　　　(5656, 4433)

As Dr. Walter Vitzthum has pointed out (p. 518), these drawings are studies for Pietro de Pietri's altarpiece for the Quirinal.

Studio of PIETRO DE PIETRI

363. A GIRL TAKING A VOW OF POVERTY (Blunt and Cooke, No. 1039)　　　　　　　　　　(5654)

According to Mr. Milton J. Lewine (*Art Bulletin*, XLV, 1963, p. 146) the subject of this drawing is the Investiture of Carloman. Mr. Antony Clark suggests that this drawing is by a member of the studio of Pietro de Pietri.

See also: *GIUSEPPE CHIARI* (No. 115 above).

BARTOLOMEO PINELLI
(1781–1835)

364. DRAWINGS OF MYTHOLOGICAL SCENES
About 200 × 270 mm. Mostly in pen, black ink and sepia wash, but one with water-colour.

Ten drawings of various mythological scenes, signed by Pinelli and dated Rome, 1825–27, have been inserted in a manuscript translation of the *Odes of Horace* in the Royal Library.

DOMENICO PIOLA
(1627–1703)

365. ALLEGORY (Kurz, No. 224)　　　　　　(3763)

Mr. Jacob Bean (*Revue des Arts*, VIII, 1958, p. 272) has pointed out that this drawing is by Piola and not by Franceschini. Another drawing by Piola for the same composition, with Fleurville, Paris, was reproduced as an advertisement in the *Burlington Magazine* in July 1956.

366. ALLEGORIES ON THE HISTORY OF GENOA
(Kurz, Nos. 240–242)　　　　　　　(3766, 3756–7)

Mr. Bean (*loc. cit.*), Mr. Philip Pouncey and Piero Torriti (*Burlington Magazine*, CIV, 1962, p. 424) have pointed out

that, although these drawings were catalogued as by Franceschini, the traditional attribution to Piola is correct. A drawing in the British Museum corresponds to the lower half of No. 242.

367. ALLEGORY OF INNOCENCE (Blunt and Cooke, No. 1042)　　　　　　　　　　　　(6791)

Mr. Philip Pouncey attributes this hitherto anonymous drawing to Piola.

GHERARDO POLI
(first half of the eighteenth century)

368. TRAVELLERS ON A ROCKY BRIDGE AMONG
TREES　　　　　　　　　　　　　　(0121)

117 × 266 mm. Pen, dark grey and brown washes.

Inventory A, p. 133: 'Ditto [a Landscape] by Simonini'.

The old attribution to Simonini is not convincing, and the composition and the drawing of the figures are both close to paintings by Gherardo Poli and his son (cf. *70 pitture e sculture del '600 e '700 fiorentino*, Palazzo Strozzi, Florence, 1965, particularly No. 45).

369. LANDSCAPE WITH FIGURES AND A DOG　(6147)

202 × 297 mm. Brown and red wash.

Apparently by the same hand as No. 368.

POLIDORO DA CARAVAGGIO
(1498/1500–41/45)

370. DESIGN FOR AN ENTABLATURE　　　　(10909)

165 × 259 mm. Pen and black ink, brown and grey wash.

The attribution to Polidoro was suggested by Mr. Philip Pouncey and Mr. John Gere.

THE MADONNA AND CHILD (Popham and Wilde, No. 690)　　　　　　　　　　　　　(0383)

F. Bologna (*Roviale spagnuolo e la pittura napoletana del Cinquecento*, Naples, 1958, p. 837) has pointed out that this drawing is connected with an altarpiece executed by Polidoro for the church of S. Maria delle Grazie alla Pescheria, Naples.

After POLIDORO DA CARAVAGGIO

371. A TROPHY AND THE YOUNG ST. JOHN THE
BAPTIST　　　　　　　　　　　　　(10936)

265 × 224 mm. Pen and brown wash, heightened with body-colour, on blue-grey paper.

Mr. Popham has pointed out that the trophy is copied from an engraving after Polidoro and that the drawing is by the same hand as one at Windsor of *Cupid sharpening an arrow* after Giulio Romano (Popham and Wilde, No. 378).

372. A WARRIOR BINDING UP THE HEAD OF A
WOUNDED MAN (Popham and Wilde, No. 944)　(5439)

Mr. Philip Pouncey has pointed out that this is a copy after one of Polidoro's frescoes on the Palazzo Gaddi, Rome.

HORATIUS COCLES (Popham and Wilde, No. 702) (5470)
F. Bologna (*op. cit.*, p. 51) ascribes this copy to Pedro de Rubiales.

Attributed to
POLIDORO DA CARAVAGGIO

373. CHRIST RISING FROM THE TOMB (Popham and Wilde, No. 972) (01360)
This drawing was catalogued as by Perino del Vaga, but Antal suggested an attribution to Polidoro, which Mr. Popham regards as possibly correct.

Manner of
POLIDORO DA CARAVAGGIO

DESIGNS FOR DECORATIVE PANELS

374. 254 × 112 mm. On two pieces of paper joined together. Pen and brown wash, heightened with body-colour, on grey-blue paper. (10903)

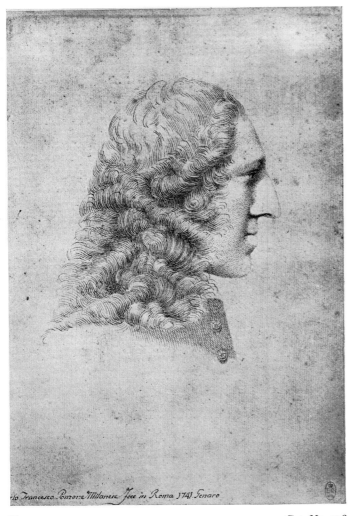

Fig. 33 Cat. No. 376

375. 260 × 114 mm. Pen and brown wash, heightened with body-colour, on grey-blue paper. (10904)
The attribution of these two drawings is due to Dr. Arnold Noach.
See also: *NORTH ITALIAN SCHOOL* (Popham and Wilde, No. 1183).

ANTONIO POLLAIUOLO
(1431/2–98)

A BATTLE OF NAKED MEN (Popham and Wilde, No. 27) (059)
Antal (p. 35) believed that this is a copy after a drawing by Pollaiuolo, dating from c. 1500. C. L. Ragghianti (p. 594) associates the drawing with the circle of Raphael. Mr. Popham agrees with the idea of a later dating proposed by these two critics.

CARLO FRANCESCO PONZONE
(18th century)

376. JAMES STUART, THE OLD PRETENDER (*Fig. 33*) (12055)
230 × 153 mm. Pen and light brown ink. Inscribed at foot: [*Ca*]*rlo Francesco Ponzone Milanese Fece in Roma 1741 Genaro.*
Engraved in reverse anonymously (O'Donoghue, No. 36; see *Royal Portraits*, XII, p. 74) with the title *Quaerit Patria Caesarem*, published in 1747. Possibly the 'Drawing of yᵉ King done with yᵉ pen . . . extremely well done and a very good likeness' mentioned in two letters, June 15th and July 4th, 1741 (Royal Archives, Stuart Papers: Vol. 233, No. 103, and Vol. 234, No. 85).

FRANCESCO MORANDI, called IL POPPI
(1544–97)

See *FRANCESCO SALVIATI* (Popham and Wilde, No. 900).

GIUSEPPE PORTA (SALVIATI)
(c. 1520–c. 1575)

377. A WOMAN (Popham and Wilde, No. 1080) (5130)
This drawing was catalogued among the anonymous Bolognese works, but Antal (p. 35) suggested an attribution to Giuseppe Porta, which Mr. Popham accepts.
See also: *TADDEO ZUCCARO* (No. 523 below).

GUGLIELMO DELLA PORTA
(d. 1577)

See '*MUZIUS*' (No. 314 above).

CARLO PORTELLI
(d. 1574)

See *FRANCESCO SALVIATI* (Popham and Wilde, No. 895).

BERNARDINO POSSENTI
(first half of the 17th century)

378. LANDSCAPE WITH FIGURES OUTSIDE A WALLED TOWN (3537)

160 × 231 mm. Pen and brown ink.

An inscription on the back of the sheet, which is laid down, appears to read: *Il Possente* and *Carata* (or *Caraza*). This points to a member of the Bolognese family of Possenti, of whom Bernardino appears to be the only one to have been concerned with landscape.

FRANCESCO PRIMATICCIO
(1504–70)

See *FRANCESCO SALVIATI* (No. 429 below).

After PRIMATICCIO

See *FRENCH SCHOOL* (p. 219, No. 34 below).

CAMILLO PROCACCINI
(c. 1551–1629)

379. THE ADORATION OF THE SHEPHERDS (3816)

217 × 117 mm. Red chalk. Inscribed in the 'deceptive' hand: *Cristoforo Storis*(?).

As Mr. Philip Pouncey has pointed out, the drawing style is like that of Camillo Procaccini, and the drawing is almost certainly a preliminary study for his *Adoration of the Shepherds* in Bologna.

THE TRANSFIGURATION (Popham and Wilde, No. 768)
(01220)

Mr. Pouncey has pointed out that this is a study for one of the doors of the organ case in Milan Cathedral. A monochrome painting corresponding to this design in the Accademia Carrara, Bergamo (No. 758), appears to be a copy after the Windsor drawing.

AN ELDERLY MAN ADMONISHING A YOUTH SEATED AT HIS FEET (Popham and Wilde, No. 778) (5963)

Mr. Philip Pouncey has identified this drawing as a study for a fresco by Camillo Procaccini in the apse of S. Prospero, Reggio Emilia.

380. THE ENTOMBMENT (Popham and Wilde, No. 971)
(5999)

Mr. Pouncey has pointed out that this drawing, regarded by Antal as a copy after Trotti, is after a painting by Camillo Procaccini in S. Prospero, Reggio Emilia.

See also: *Studio of CRISTOFORO RONCALLI (IL POMERANCIO)* (No. 400 below).

BIAGIO PUPINI (DALLE LAME)
(active 1511–c. 1575)

381. CHRIST FEEDING THE MULTITUDE (Popham and Wilde, No. 783)
(044)

C. Ruland (*The Raphael Collection . . . at Windsor Castle*, 1876, p. 43, No. xxiii, 4) states that this drawing is for part of a composition executed by Pupini and Bagnacavallo in the refectory of S. Salvatore, Bologna.

After LORENZO QUAGLIO
(1730–1804)

382. A STAGE SET IN THE GOTHIC STYLE (13039)

271 × 339 mm. Pen and black ink. Inscribed: *Mense Novembri 1765. Juxta originale D^{ni} Architecti Quaglio fecit. T. Feller.*

The inscription does not give the Christian name of the designer, but it is likely to be Lorenzo, the most important member of the Quaglio family, though Martin (active 1764–70) and Giuseppe (1747–1828) were also alive at the time the copy was made. Nothing seems to be recorded of the copyist T. Feller.

LUIGI QUAINI
(1643–1717)

ST. NICHOLAS (Kurz, No. 334) (3630)

On the painting, for which this drawing is a study, see A. Arfelli, *L'Archiginnasio*, LII, 1957, p. 229.

FILIPPO RAGUZZINI
(c. 1680–1771)

See *PIETRO PAOLO COCCETTI* (Nos. 124–126 above).

RAPHAEL
(1483–1520)

THE MASSACRE OF THE INNOCENTS (Popham and Wilde, No. 793 *recto*) (12737)

The outlines have been *pounced*, not *pricked* through as stated in the catalogue.

NUDE FIGURES (Popham and Wilde, Nos. 798, 799)
(12736, 12735)

These drawings are studies for the altarpiece in the Chigi Chapel in S. Maria della Pace (cf. M. Hirst, *J.W.C.I.*, XXIV, 1961, pp. 171 ff.). They date from 1513–14.

LANDSCAPE (Popham and Wilde, No. 801) (0117)

The drawing is on grey, not buff paper.

CHRIST GIVING THE KEYS TO ST. PETER (Popham and Wilde, No. 802) (12751)

THE BLINDING OF ELYMAS (Popham and Wilde, No. 803) (12750)

These two drawings were wrongly attributed to Giulio Romano by F. Hartt (*Giulio Romano*, New Haven, 1958, pp. 20, 286).

THE THREE GRACES (Popham and Wilde, No. 804)

(12754)

This drawing was attributed to Raphael by Passavant (*Raphael d'Urbin*, Paris, 1839, II, pp. 347, 545); to Giulio Romano by Morelli (*Kunstchronik*, 1892, p. 144, n.) and by Fischel (*Raphael's Handzeichnungen*, Strasbourg, 1898, p. 266). Fischel later abandoned the attribution to Giulio and connected the drawing with Raphael, in one instance (*Raffaello Santi: ausgewählte Handzeichnungen*, Berlin, n.d., n. 31) without qualification, and in another (*Raphael*, 1948, pp. 185, 366) with the gloss that it was drawn by a pupil and retouched by the master. Recently J. Shearman ('Die Loggie der Psyche in der Farnesina', *Jahrbuch der kunst-historischen Sammlungen in Wien*, LX, 1964, p. 90) has re-affirmed an unqualified attribution to Raphael himself.

THE LAST SUPPER (Popham and Wilde, No. 805)

(12745)

C. C. Ragghianti (p. 595) suggested that this drawing was by Girolamo da Carpi, an attribution which Mr. Popham rejects.

School of RAPHAEL

THE EXPULSION FROM PARADISE (Popham and Wilde, No. 806)

(12729)

K. Oberhuber ('Die Fresken der Stanza dell'Incendio im Werk Raphaels', *Jahrbuch der kunsthistorischen Sammlungen in Wien*, LVIII, 1962, p. 59) believes that the chalk under-drawing, which is all that now remains, is by Raphael himself, but this view can hardly be correct. P. Pouncey and J. Gere (*British Museum, Italian Drawings: Raphael and his circle*, 1962, I, p. 51) ascribe the drawing to Penni.

THE DISTRIBUTION OF THE LAND BY LOTS (Popham and Wilde, No. 807)

(12728)

THE MIRACULOUS DRAUGHT OF FISHES (Popham and Wilde, No. 808)

(12749)

P. Pouncey and J. Gere (*op. cit.*, I, pp. 51, 56) ascribe both these drawings to Penni. Dr. Shearman is inclined to agree with this attribution for No. 808, but is doubtful about No. 807.

TARQUIN AND LUCRETIA (Popham and Wilde, No. 812)

(0506)

The inscription on the *verso* appears to read *M° Polidoro*.

After RAPHAEL

FIGURES FROM THE 'DISPUTA' (Popham and Wilde, No. 856)

(0412)

According to Mr. Pouncey this copy is by Boscoli.

Circle of RAPHAEL

See *ANTONIO POLLAIUOLO* (Popham and Wilde, No. 27).

GUIDO RENI
(1575–1642)

383. SAMSON SLAYING THE PHILISTINES (*Plate 33*)

(3410)

370 × 201 mm. Pen and brown wash, over black chalk.

From the Bonfiglioli, Sagredo and Smith collections.

Inventory A, p. 80: 'Guido &c . . . A first study for his *Sampson destroying the Philistines*. Painted at Bologna in the Palazzo Publico'.

The drawing is not related to the famous painting, now in the Pinacoteca at Bologna, but Miss Catherine Johnston (*L'Œil*, No. 169, January 1969, p. 23) has pointed out that it is a study for the fresco of the same subject in the Sala delle Nozze Aldobrandini in the Vatican, painted for Paul V in 1608 (cf. G. C. Cavalli, *Guido Reni*, Florence, 1955, Pl. 20). The drawing is mentioned in the Bonfiglioli inventory of 1696 (p. 12, l.3; cf. Kurz, pp. 2 ff.).

384. HEAD OF CHRIST (Kurz, No. 72)

(5283)

This drawing was ascribed by Kurz to Cavedone, an attribution which was accepted by L. Grassi (*Il disegno italiano*, Venice, 1956, p. 128) and G. Fraetti (*Rivista Genova*, 1957, No. 6).

Miss Johnston has, however, identified it as a study by Reni for the *Salvator Mundi* in S. Salvatore, Bologna, executed by F. Gessi on Reni's designs (Cf. Malvasia, *Le pitture di Bologna*, Bologna, 1766, p. 193). Payments to Reni are recorded between February and December 1620 (cf. *Archivio Storico dell'Arte*, VII, 1894, p. 369).

PHAETHON (Kurz, No. 336)

(1535)

Mr. Pepper (*Burlington Magazine*, CXI, 1969, p. 480) proposes a date of 1596–97 for both the drawing and the fresco.

STUDY FOR APOLLO (Kurz, No. 340)

(3460)

Another study for this figure is in the Uffizi (cf. Johnston, *op. cit.*, p. 25).

THE VIRGIN (Kurz, No. 344)

(3371)

A study for the hand of the *Madonna Tanari* (cf. A. Emiliani, *Mostra di disegni del Seicento Emiliano nella Pinacoteca di Brera*, 1959, No. 91).

HEAD OF A YOUTH (Kurz, No. 374)

(3396)

Mr. Howard Hibbard has pointed out that this is a study for Reni's *Sacred and Profane Love in* the Palazzo Spinola, Genoa (reproduced C. Gnudi and G. C. Cavalli, *Guido Reni*, Florence, 1955, Pl. 16).

EROS AND ANTEROS (Kurz, No. 421) (*Fig. 34*)

(2295)

Attributed in the catalogue to the School of Reni. Miss Johnston is, however, inclined to regard it as an original sketch by Reni for the Spinola painting. Three other drawings for this composition are known: two in the Accademia, Venice, and one in the Mather collection, Princeton (reproduced by Panofsky, *Oud-Holland*, 1933, p. 211).

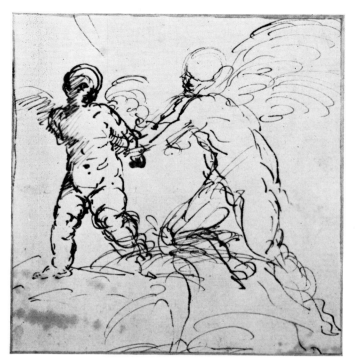

Fig. 34 Kurz, Cat. No. 421

HEAD OF A YOUNG MAN (Kurz, No. 449) (*Plate 70*)
(3301)

Miss Johnston has pointed out that this is a study for the St. John the Baptist in Reni's *Incontro di Gesù e S. Giovannino* in the Sacristy of the Gerolomini, Naples, probably painted in 1621 (reproduced in Gnudi and Cavalli, *op. cit.*, Pl. 95).

385. ST. STEPHEN AND THE RABBIS (Kurz, No. 575) (*Plate 37*)
(3407)

This drawing was catalogued by Kurz among the anonymous Bolognese works, but Miss Johnston proposes an attribution to Reni.

The subject of this drawing is given in Inventory A (p. 80) as *Christ among the Doctors*, but Miss Johnston (*op. cit.*, p. 23) has pointed out that it is a companion to another drawing by Reni in the Uffizi (12463 F), also for a lunette, showing the consecration of a deacon. Both, therefore, are likely to refer to the story of St. Stephen, and the Windsor drawing probably represents the rare subject of St. Stephen disputing with the Rabbis.

386. THE BIRTH OF ST. JOHN THE BAPTIST (Wittkower, No. 11) (*Plate 32*)
(2328)

Professor Wittkower ascribed this drawing to Lodovico Carracci and connected it with another drawing of the same subject (Wittkower, No. 12), though he remarked on the fact that No. 12 was much closer than No. 11 to the painting by Lodovico in the Pinacoteca, Bologna. Miss Johnston has, however, suggested (*op. cit.*, p. 25) that No. 11 is by Guido Reni and is in fact the drawing mentioned by Malvasia as belonging to Bonfiglioli (cf. *Felsina pittrice*, Bologna, 1678, II, p. 12) and recorded in the 1696 inventory of the Bonfiglioli collection (cf. Kurz, p. 2). Professor Wittkower accepts her suggestion.

387. THE ANNUNCIATION (Wittkower, No. 28) (2189)
This drawing was ascribed by Professor Wittkower to Lodovico Carracci, but Mr. Stephen Pepper (*Master Drawings*, VI, 1968, p. 374) and Miss Johnston (*op. cit.*, p. 20) have suggested that it is an early work by Reni, perhaps executed when he was still working in the studio of the Carracci. In a later article (*Burlington Magazine*, CXI, 1969, p. 482) Mr. Pepper suggests that the drawing is connected with a painting executed for the church of Pieve di Cento in 1599.

After GUIDO RENI

JOB (Kurz, No. 377) (3476)
Reproduced in the *Gazette des Beaux-Arts*, 1958, I, p. 303, Fig. 2.

Attributed to GUIDO RENI

389. HEAD OF THE MADONNA (Blunt and Cooke, No. 502)
(4207)
From the Luti collection.

Catalogued as a copy after Maratta, but a copy of it by Altomonte is inscribed *Guido* (cf. Heinzl, *Altomonte*, p. 69, No. 10, and *The Luti Collection*, p. 19, No. 10).
Miss Johnston points out that the head derives from a studio copy of Reni's *Crucifixion* in the Cappuccini, Bologna, made for the Gessi Chapel in S. Maria della Vittoria, Rome (now in the Duke of Northumberland's collection), which would have been readily available to Maratta or members of his studio.

See also: *GAETANO GANDOLFI* (Kurz, No. 273), and *CARLO MARATTA* (Blunt and Cooke, Nos. 363, 366, 506, 510).

GIOVANNI BATTISTA RICCI (DA NOVARA)

(1545–1620)

See *GIOVANNI BATTISTA DELLA ROVERE* (No. 415 below).

MARCO RICCI

(1676–1730)

A. Bettagno in his catalogue of the exhibition *Caricature di Anton Maria Zanetti* (Fondazione Cini, Venice, 1969) discusses many caricatures of sitters who were also drawn by Marco Ricci and in some cases gives new identifications or confirms those which were doubtful.

AN ITALIAN TOWN: A CAPRICCIO (Blunt and Croft-Murray, No. 71)
(5927)
Mr. Michael Levey (*The later Italian pictures in the collection of H.M. The Queen*, London, 1964, No. 598) confirms the traditional reading of 1719 as the date of this drawing, as opposed to my reading of 1710.

See also: *Attributed to ANTOINE WATTEAU* (p. 217, No. 25 below).

SEBASTIANO RICCI
(1659–1734)

The dating of various paintings by Sebastiano Ricci in the Royal Collection with which drawings in the Royal Library are connected is discussed by Mr. Michael Levey (*op. cit.*, pp. 96 ff.).

Attributed to
MICHELANGELO RICCIOLINI
(1654–1715)

390. SCENES FROM THE LIFE OF ST. LAWRENCE (Blunt and Cooke, Nos. 246–249) (4544–4547)

Dr. Vitzthum has pointed out that these four drawings, catalogued as by F. Lauri, are by the same hand as three others attributed, apparently correctly, to Ricciolini, one in the Ambrosiana, and the other two at Berlin-Dahlem (18156, 18157), the latter being inscribed on the mount *Ricciolini il Seniore*, and both representing scenes from the life of St. Lawrence. Another drawing, apparently by the same hand, is in the Uffizi (5067S) under the name of G. Nasini.

GIUSEPPE ROLLI
(1645–1727)

391. GROUP OF ANGELS (Kurz, No. 203) (3704)

Miss E. Feinblatt has identified the author of this drawing, previously attributed to Creti, as Giuseppe Rolli. Together with a drawing in the Louvre it is related to Rolli's ceiling in the Palazzo Marescotti at Bologna.

GIOVANNI FRANCESCO ROMANELLI
(1610–62)

392. SAMSON KILLING THE PHILISTINE (Blunt and Cooke, No. 611) (4540)

From the Luti collection.

A copy by Altomonte in the Albertina is inscribed *Romanelli* (cf. Heinzl, *Altomonte*, p. 69, No. 13, and *The Luti Collection*, p. 20, No. 13), an attribution which is supported by Dr. Karl Noehles, as opposed to one to Pietro da Cortona as suggested in the catalogue. The subject may be Cain killing Abel, since Cain is often shown attacking his brother with the jaw-bone of an ass.

Attributed to
GIOVANNI FRANCESCO ROMANELLI

393. JACOB AND LABAN (*Plate 41*) (4541)

240 × 195 mm. Pen and brown wash.

Inventory A, p. 111. From a volume containing drawings by Pietro da Cortona and his school.

394. RUSTICS BOILING A BOAR (8026)

190 × 169 mm. Pen, brown and grey washes, over pencil. Numbered: *117*.

From the Pozzo and Albani collections.

After a piece of Roman sculpture in the Museo Nazionale, Naples (cf. Vermeule, p. 63).

Very near in style to Pietro da Cortona and perhaps by Romanelli.

395. NEREIDS, TRITONS, EROTES, ETC. (8104)

70 × 278 mm. Pen over pencil, slight brown wash.

From the Pozzo-Albani drawings.

After an ancient sarcophagus in the Louvre (cf. Vermeule, p. 69).

By the same hand as No. 394.

396. ORPHEUS AMONG THE BEASTS (8100)

170 × 220 mm. Pen and black chalk. Unfinished.

From the Pozzo-Albani drawings.

After a relief formerly in the Mattei collection, Rome (cf. Vermeule, p. 68).

Verso: Sketch of a Silenus-type face in black chalk, and a leg in pen.

See also: *GIACINTO GIMIGNANI* (Blunt and Cooke, Nos. 735, 736); and *PIETRO DA CORTONA* (Blunt and Cooke, No. 588).

Attributed to
GIROLAMO ROMANINO
(1484/9–1566)

TWO WOMEN SEATED IN CONVERSATION (Popham and Wilde, No. 872) (4793)

The drawing has been attributed to Romanino by Mr. Popham and Professor Wilde and by G. Gombosi (*Moretto da Brescia*, Basle, 1943, p. 116); to Moretto by Mr. Antony Clark and Gronau, and to Callisto Piazza by M. L. Ferrari. Miss Florence Kossoff believes it to be nearer to Moretto than to Romanino (cf. Catalogue of the Romanino exhibition, Brescia, 1965, No. 134).

A PARTY OF MUSICIANS IN A BOAT (Popham and Wilde, No. 873) (0338)

Shown in the Romanino exhibition at Brescia in 1965 (No. 132), when the attribution to Romanino was generally accepted. M. L. Ferrari (*Romanino*, Milan, 1961, Pl. 82) associates the drawing with the frescoes in S. Antonio, Breno.

Manner of GIROLAMO ROMANINO

397. THE NATIVITY (5036)

236 × 157 mm. Pen and brown ink. The paper damaged and repaired.

The principal group of the Christ Child adored by the Virgin and St. Joseph is accompanied on the right by a shepherd and on the left by two figures, one of whom wears a monk's habit and carries a Cross, while the other, wearing what appears to be a cardinal's hat, may be St. Jerome. The attribution to Romanino was first proposed by Mr. John Gere.

398. A GROUP OF FIGURES SINGING (*Plate 10*) (0747)
139 × 230 mm. Pen and grey ink, heightened with body-colour, on dark grey prepared paper.

Very similar groups are to be found in the works of Romanino, e.g. in the frescoes in the Castello del Buonconsiglio at Trent and in a drawing in the Uffizi. The technique, on the other hand, is not his but is much more like that of Niccolò dell'Abbate, who also painted similar groups, for instance in the frescoes on the façade of the Beccherie at Modena (now in the Galleria Estense) and in the Palazzo dell'Università at Bologna.

399. TWO LANDSKNECHTE FLANKING A DOOR (*Plate 9*) (6464)
191 × 249 mm. Pen and brown wash, heightened with body-colour, on blue paper.

Catalogued by Puyvelde (No. 198) as Flemish School, 1510–15, but certainly North Italian and very close to the manner of Romanino.

The drawing must be a design for the external decoration of a house, of a type usual in northern Italy. The closest parallel is to be found in the Palazzo Pona-Geremia at Trent (reproduced in *Architettura*, XIII, 1967, p. 195), of which the main door was originally flanked by two standing soldiers in German uniform. The frescoes are now so damaged that it is impossible to say whether the drawing is an actual sketch for them, but it may be connected with Romanino's activity in Trent in 1531–32. In actual draughtsmanship, however, it is not like Romanino, and it is very likely to be by one of the artists who collaborated with him in his work in the Palazzo del Buonconsiglio at Trent. A tradition, recorded in the T.C.I. Guide, ascribes the frescoes on the Palazzo Pona-Geremia to Fogolino, but this does not seem to be correct.

Studio of CRISTOFORO RONCALLI (IL POMERANCIO)
(1552–1626)

400. ST. MATTHEW (Popham and Wilde, No. 772)
(5970)

The drawing was catalogued by Mr. Popham under the name of Camillo Procaccini, but he now agrees with the attribution to the studio of Roncalli, proposed by Mr. Philip Pouncey.

SALVATOR ROSA
(1615–73)

401. ALLEGORY OF PAINTING (*Plate 43*) (6124)
304 × 221 mm. Pen and brown ink, brown wash. Inscribed in chalk in an eighteenth-century hand: *S.̱ Rosa*.

This and the five following drawings are mentioned in Inventory A, p. 113: '10 Different Sketches of Salvator Rosa'.

The scroll held by the putto above the figure of the seated woman is inscribed *Sig.ri fate La Limosina alle povera Pittura*. The handwriting is Salvator Rosa's.

The traditional attribution of this and the three following drawings is confirmed by Dr. Michael Mahony, who included them in his still unpublished catalogue of Rosa's drawings. The theme of this drawing is in keeping with the artist's satire *Della pittura*.

402. A MAN SEATED ON A ROCK, FACING LEFT, HAND RAISED (*Plate 45*) (6127)
141 × 94 mm. Pen and brown wash, on faded paper. Inscribed: *S. Rosa*, in black chalk.

Sketch in reverse for the etching B. 50 of 1656.

403. SOLDIERS BESIDE TWO CLASSICAL URNS (6125)
324 × 258 mm. Pen and brown wash, on faded paper.

404. A MAN SEATED ON A ROCK UNDER A TREE (*Plate 44*) (6128)
128 × 99 mm. Pen and black ink.

Imitator of SALVATOR ROSA

405. FIGURES IN A STORMY LANDSCAPE (6121)
289 × 191 mm. Pen and brown ink.

Dr. Michael Mahony has suggested that this drawing might be by Pietro Giacomo Palmieri (1737–1804). Mr. John Gere has proposed the name of Giovanni Francesco Grimaldi (1606–80).

406. A GIRL STANDING WITH ARMS RAISED (6126)
233 × 124 mm. Pen and brown ink on coarse grey paper.

407. A BATTLE SCENE; MEN IN ARMOUR AND ORIENTALS (6333)
274 × 403 mm. Black, brown, grey and white oil paint on brown paper.

The technique suggests Venice, but the composition is closer to Salvator Rosa's battle pieces.

408. TREES IN A RAVINE (5752)
268 × 195 mm. Pen and brown ink, brown and white washes, on grey-green paper.

Inventory A, p. 119: 'Paesi Diversi . . . "Five Lombard"'.

409. FIGURES FROM THE COMMEDIA DELL'ARTE (*Plate 78*) (13074)
260 × 189 mm. Pen and dark ink.

Verso: Studies of a figure in armour, and of a recumbent nude man, one arm raised.

MATTEO ROSSELLI
(1578–1650)

410. TOBIAS AND THE ANGEL (6036)
265 × 379 mm. Cut on all sides. Black and red chalks. An offset.

Mr. Philip Pouncey pointed out, and Miss Fiametta Faini has confirmed, that this drawing is closely connected with

one by Rosselli in the Uffizi (1057 F). It seems in fact to be an offset from it, slightly cut down and retouched.

411. AN ECCLESIASTIC (Popham and Wilde, No. 1187) (5239)

412. A YOUTHFUL SAINT (Popham and Wilde, No. 1188) (5240)

Mr. Philip Pouncey has suggested that these drawings, catalogued as anonymous North Italian School, are by Rosselli, an attribution which Mr. Popham regards as probably correct.

Attributed to ANGELO DE' ROSSI
(1670 (or 1694)–1742 (or 1755))

413. DESIGN FOR A CEILING (10906)

299 × 247 mm. Pen and brown ink, grey wash.

In the centre a drawing in black chalk of Apollo and three putti.

The arms could be those of the following families: Barucci of Florence, Bentaccordo of Verona, or Turriani of Udine. Angelo de' Rossi, to whom this drawing is ascribed on grounds of style, worked in Florence and Venice and might have been employed by any of these three families.

CARLO ROSSI
(1775–1849)

414. DESIGNS FOR A SALOON (19314–19317)

445 × 620 mm (19314), and 345 × 590 mm (19315–7). Pen and grey ink and water-colour. Signed: *Charles Rossy architecte de LL. MM. II.*, with scales in English and Russian feet.

The artist spent the greater part of his career in Russia, and these drawings are evidently for a Russian palace, probably in St. Petersburg, but it has not so far been possible to identify the actual building.

ROSSO FIORENTINO
(1495–1540)

STUDY OF THREE FIGURES OF A MASSACRE OF THE INNOCENTS (Popham and Wilde, No. 875) (0311)

C. C. Ragghianti (p. 595) regarded this as a copy, whereas Antal (p. 36) attributed it to Andrea Boscoli. Mr. Popham maintains his original attribution to Rosso.

See also: *Attributed to BACCIO BANDINELLI* (No. 25 above).

GIOVANNI BATTISTA DELLA ROVERE
(1561–c. 1627)

415. SCENES FROM THE PASSION ETC (Popham and Wilde, Nos. 862–868) (0228–30, 0233, 5058, 5987, 6022)

These drawings were catalogued as by Giovanni Battista Ricci da Novara, on the basis of their similarity to a drawing in the British Museum signed on the *verso I. B. R.*, initials which were interpreted by W. Y. Ottley as referring to this artist. Mr. Philip Pouncey has, however, established that they are in fact the initials of Giovanni Battista della Rovere, to whom therefore the Windsor drawings must be ascribed.

PEDRO DE RUBIALES,
called ROVIALE SPAGNUOLO
(1511–82)

See *PIRRO LIGORIO* (Popham and Wilde, No. 396), and *After POLIDORO DA CARAVAGGIO* (Popham and Wilde, No. 702).

ALFONSO RUSPAGIARI
(1521–76)

416. DESIGN FOR A SALVER WITH THE GONZAGA ARMS (11337)

261 × 181 mm. Fine pen.

Verso: An inscription in pen: *ruspagiari.*

The name Ruspagiari on the *verso* was deciphered by Dr. John Shearman and is clearly legible. It is preceded by a mark which might be the letter *j*, but this is not at all clear, and no artist with this initial seems to be recorded. Ruspagiari came from Reggio Emilia and may well have worked for the Gonzaga family at Mantua or Sabbioneta.

LORENZO SABBATINI
(c. 1530–76)

417. THE VIRGIN ENTHRONED (Popham and Wilde, No. 1057) (5099)

418. LUNETTE (Popham and Wilde, No. 1058) (6032)

419. A SIBYL (Popham and Wilde, No. 1060) (5969)

420. THE PRESENTATION (Popham and Wilde, No. 1063) (5047)

These drawings were catalogued as by a follower of Federico Zuccaro, but Antal (p. 32) proposed an attribution to Sabbatini, which Mr. Popham accepts.

See also: *FLORENTINE SCHOOL* (Popham and Wilde, No. 1103).

ANDREA SACCHI
(1599–1661)

420a. THE TOMB OF URBAN VIII (Blunt and Cooke, No. 34) (5558)

Mrs. Ann Harris believes that the drawing is by Sacchi, though based on Bernini's statue in St. Peter's.

421. STUDIES FOR STANDING FIGURES (Blunt and Cooke, No. 202) (5684)
Though catalogued as by Lanfranco, this drawing is by Sacchi. The *verso* is a study for figures in the decoration of the Farmacia in the Collegio Romano, and the *recto* is probably for the *Pasce oves meas* (cf. Harris and Schaar, pp. 28, 59; in the second reference the drawing is wrongly referred to as No. 20, instead of No. 202).

STUDY OF A MAN (Blunt and Cooke, No. 738) (4887)
In the catalogue this drawing was identified as a study for the *Drunkenness of Noah*, but it is perhaps rather an academy later used for the Noah. In this case the statement in the inscription that it is after Annibale Carracci may be correct.

THE THREE MAGDALENS (Blunt and Cooke, No. 740) (4349)
Further drawings for this composition are at Düsseldorf (cf. Harris and Schaar, pp. 21, 39).

AURORA (Blunt and Cooke, Nos. 741, 742) (4872, 4172)
These drawings may be connected with the lost painting known to have been executed by Carlo Magnone after Sacchi's design (cf. *L'Arte*, XXVII, 1924, p. 70).

CHRIST CARRYING THE CROSS (Blunt and Cooke, No. 743) (3608)
This drawing is probably not connected with the Orleans painting (which is actually a version of the *St. Veronica* in St. Peter's) and Mrs. Harris does not believe that it is by Sacchi (cf. Harris and Schaar, p. 23).

THE DEATH OF ST. ANNE (Blunt and Cooke, No. 744) (4856)
Further studies are at Düsseldorf (cf. Harris and Schaar, pp. 52 f.).

THE DESTRUCTION OF PAGAN IDOLS (Blunt and Cooke, Nos. 745 ff.) (4860, 4862, 4863, 4865, 4867, 4869, 4921, 4923, 4926, 4940, 4958-9)
Further studies for this fresco are at Düsseldorf (cf. Harris and Schaar, pp. 47 ff., 62). In her entry for the Düsseldorf drawings (p. 47) Mrs. Harris appears not to accept Windsor drawings Nos. 750, 752, 754, 756, but she has authorized me to say that this was not her intention and that she believes them to be by Sacchi and to be connected with the Lateran Baptistery fresco.

STUDIES OF LIMBS (Blunt and Cooke, Nos. 757-759) (4930, 4932, 4943)
Not, as stated in the catalogue, studies for the *Destruction of the Idols*, but for the painting of the *Baptist* in S. Nicola at Fabriano (cf. Harris and Schaar, pp. 23, 53 f.).

ST. ANTHONY REVIVING A DEAD MAN (Blunt and Cooke, No. 761) (4347)
Further studies are at Düsseldorf (cf. Harris and Schaar, pp. 37 f.).

ST. ANDREW ADORING HIS CROSS (Blunt and Cooke, No. 763) (4934)
The payments for the altarpiece were made in 1633-34 (cf. H. Posse, *Andrea Sacchi*, Leipzig, 1925, p. 55). The drawing on the *verso* is not for this painting, but at least one study on it is for the *Martyrdom of St. Longinus* in St. Peter's (cf. Harris and Schaar, p. 42).

A BEARDED MONK (Blunt and Cooke, No. 764 *verso*) (4931)
Almost certainly a study for the *Vision of St. Romuald* in the Vatican Gallery (cf. Harris and Schaar, p. 33).

THE MASS OF ST. GREGORY (Blunt and Cooke, No. 765) (4857)
Another study for this composition is in the École des Beaux-Arts (cf. Catalogue of the exhibition *Art italien des XVIIe et XVIIIe siècles*, at the School, 1937, p. 27, No. 143).

ELIJAH ASCENDING TO HEAVEN (Blunt and Cooke, No. 766) (0183)
Mrs. Harris does not accept the attribution of this drawing to Sacchi.

TOBIAS LEAVING HIS FAMILY (Blunt and Cooke, No. 767) (4095)
An almost identical drawing, of less good quality, is in the Gabinetto Nazionale, Rome (124785), described as 'intorno al Camassei'.

ST. FRANCIS AND OTHER SAINTS ADORING THE VIRGIN (Blunt and Cooke, No. 768) (4094)
An almost identical drawing, in this case of slightly better quality but also described as 'intorno al Camassei', is in the Gabinetto Nazionale, Rome.

STUDY OF A MAN (Blunt and Cooke, No. 773) (4942)
Mrs. Harris has called attention to a drawing in the Louvre (14132) representing *Latona and the peasants*, in which this figure occurs. An inscription on the Louvre drawing shows that it is by Bartolomeo Postiglione, a pupil of Sacchi.

FIGURE STUDIES (Blunt and Cooke, Nos. 774, 820) (4944, 4935)
These drawings may be connected with the decoration of the Casino of Cardinal del Monte. If so, they must date from before 1627.

FIGURE OF A MAN (Blunt and Cooke, No. 776) (4280)

A DRAPED TORSO (Blunt and Cooke, No. 777) (4391)
Mrs. Harris regards both of these drawings as copies (cf. Harris and Schaar, p. 23).

STUDY OF A HEAD (Blunt and Cooke, No. 778) (4877b)
Connected with the *Destruction of the Idols* (cf. Harris and Schaar, p. 47).

PUTTI AND A GROTESQUE MASK (Blunt and Cooke, No. 781) (4866)

A study for the frescoes in the Lateran Baptistry (cf. Harris and Schaar, p. 46).

STUDIES OF DRAPERY (Blunt and Cooke, No. 782) (4949)

Some of these studies are connected with the *Vision of St. Romuald* in the Vatican Gallery, others with the *St. John the Baptist* at Fabriano (cf. Harris and Schaar, pp. 24, 34).

DESIGN FOR A CARTOUCHE (Blunt and Cooke, No. 786) (4972)

The dog (*Domini Canis*) which appears in the design is also to be found in the decoration of the Sacristy of the Minerva and confirms the connection with it proposed by Posse.

THE DECORATION OF THE VAULT OF S. LUIGI DEI FRANCESI (Blunt and Cooke, Nos. 789–819)
(4861, 4870–1, 4884, 4906, 4922, 4924–5, 4927, 4933, 4937–9, 4941, 4945–7, 4950–3, 4957, 4962–9, 4971)

In the catalogue a possible connection with the decoration of the vault of S. Luigi was suggested, but rejected on the grounds that the drawings would not fit the shape of the vault, but Mrs. Harris has examined the problem more carefully and has come to the conclusion that this is not the case (cf. Harris and Schaar, p. 22).
Moreover, there can be little doubt that one of this series, probably No. 805, corresponds to the description of a sheet of studies given in the inventory of Maratta's possessions: 'Altro foglio con tre disegni, studi d'Andrea Sacchi rappresentanti certi termini per San Luigi de' Francesi' (cf. R. Galli, *Archiginnasio*, XXII, p. 236, No. 79).
The provenance of this drawing from Maratta suggests that at least the greater part of the Sacchi collection at Windsor came from the same source. The fact that others are not mentioned in the inventory is no argument against this hypothesis, as the inventory only lists drawings that were framed and hung on the wall.

See also: *ANDREA CAMASSEI* (Nos. 69, 70 above); *School of PIETRO DA CORTONA* (No. 361 above); *ANIELLO FALCONE* (No. 169 above), and *ANDREA DI LIONE* (No. 226 above).

DANIEL SAITER
(1649 (47?)–1705)

422. DIANA AND ENDYMION (*Plate 54*) (6720)
343 × 227 mm. Pen and brown ink, grey wash, heightened with body-colour. Squared in black chalk, on grey-blue paper. Inscribed in pencil: *Monsr. Danielle.*
Professor O. Kurz and Mr. P. Pouncey have both pointed out that the composition is closely related to an oil painting in the Camera da letto della Regina, Palazzo Reale, Turin (cf. P. Pouncey, 'Two Studies by Daniel Saiter for Ceiling paintings in Turin', *Master Drawings*, V, 1967, p. 287).

423. HERCULES CHAINING PROMETHEUS (*Plate 53*) (0131)
169 × 126 mm. Pen and brown ink, grey wash, heightened with body-colour, over red chalk, on grey paper.
From the Luti collection.
Dr. E. Schilling has suggested an attribution to Saiter for this drawing, and this is confirmed by the existence of a copy by Luti in Vienna (cf. Heinzl, *Altomonte*, p. 70, No. 36), bearing the inscription *Cavaliere Danieli*, which certainly refers to Saiter. The style of the drawing is still reminiscent of Saiter's master, Carlo Loth.

424. ALLEGORICAL SUBJECT (6722)
243 × 245 mm. Pen and brown ink, grey wash, heightened with body-colour, over black chalk, on blue paper. Squared in black chalk. Inscribed in black chalk: *monsr. Danielle.*
A warrior in a chariot drawn by two horses strikes down and rides over an old hag, perhaps representing Heresy or Envy.

425. ILLUSTRATION TO AESOP'S FABLE *UNION GIVES STRENGTH* (*Plate 55*) (0130)
140 × 205 mm. Pen and black ink over black chalk, grey wash, heightened with body-colour, on blue paper.
In the well-known fable, 'Union gives strength', a father, by using a symbol, shows to his sons that single sticks may be easily broken, but united into a bundle are unbreakable. The drawing is stylistically related to one by Saiter's master, Carlo Loth (cf. Ewald, *Carlo Loth*, p. 142, No. 40, Pl. 49; also reproduced in *Ausstellung der deutschen Maler und Zeichner des 17. Jahrhunderts*, Berlin, 1966, Cat. No. 165, Pl. 169).

426. AN ALLEGORY OF DAWN (Blunt and Cooke, No. 1050) (4489)
This drawing, catalogued among the anonymous Roman drawings, is in fact a study for a fresco by Daniel Saiter on the ceiling of the Sala del Caffè in the Palazzo Reale, Turin (cf. P. Pouncey, *op. cit.*, p. 286).

VENTURA SALIMBENI
(c. 1567–1613)

427. TWO STONEMASONS (Wittkower, No. 378) (1805)
This drawing was catalogued as by Annibale Carracci, but the left-hand figure appears in a fresco painted by Salimbeni in 1605 in the first cloister of SS. Annunziata, Florence, representing Chiarissimo dei Falconieri building the church of the Annunziata.

FRANCESCO SALVIATI
(1510–63)

429. SURGICAL ILLUSTRATION (Popham and Wilde,
No. 756) (0791)

The greater part of the series to which this drawing
belongs is in the Bibliothèque Nationale, Paris, but Mr.
Popham has pointed out that one is in the Biblioteca
Nacional, Madrid, where it is ascribed to Penni (cf. Angel
M. Barcia, *Catálogo . . . de dibujos originales de la Biblio-
teca Nacional*, Madrid, 1966, No. 7616).

The series will be discussed in a forthcoming article by
Mr. Michael Hirst, who believes that many of the drawings,
including the Windsor sheet, are by Salviati.

SCENES FROM THE HISTORY OF THE PAPACY
(Popham and Wilde, Nos. 888–891) (5081, 5060,
 6321, 5062)

Antal (p. 31) proposed an attribution to Stradanus, which
Mr. Popham rejects (cf. *Burlington Magazine*, XCIII, 1951,
p. 131, and Antal, *ibid.*, p. 133).

DESIGN FOR A SALVER (Popham and Wilde, No. 893)
 (6002)

A drawing which is evidently of the same series as this was
exhibited at Colnaghi's in May 1969 (No. 6).

DESIGN FOR A DISH (Popham and Wilde, No. 894)
 (0282)

Antal (p. 32) proposed an attribution to Taddeo Zuccaro,
which Mr. Popham rejects.

NARCISSUS AND THE NYMPHS (Popham and Wilde,
No. 895) (0335)

The name of Bronzino was suggested for this drawing by
Professor Craig Smyth, and that of Carlo Portelli by B.
Davidson.

SCENE BEFORE A CLASSICAL ALTAR (Popham and
Wilde, No. 900) (5468)

Antal (p. 32) attributed this to Francesco Morandini, Il
Poppi.

PORTRAIT OF A LADY (Popham and Wilde, No. 903)
 (5151)

Antal (p. 32) attributed this to Girolamo Mazzola-Bedoli.
Mr. Popham does not accept this attribution.

430. THE ANGEL OF THE LORD (Popham and Wilde,
No. 949) (5958)

This drawing was catalogued as by Tibaldi on a suggestion
made by Bodmer. Mr. John Gere has proposed the name
of Salviati, which Mr. Popham accepts.

Circle of FRANCESCO SALVIATI

431. DESIGN FOR A CASSONE (*Plate 25*) (10746)
200 × 265 mm. Grey chalk, slight wash.

The decoration includes masks of satyrs and the keys and
baldacchino of the Papacy. Alternative designs for the feet
are given.

The style is Florentine, about the middle of the sixteenth
century, but the presence of the papal emblem indicates
that the drawing must have been made in Rome. This
suggests that it was produced in the circle of Salviati,
perhaps for Paul III.

See also: *AGNOLO BRONZINO* (No. 56 above); *After
PERINO DEL VAGA* (No. 473 below), and *TADDEO
ZUCCARO* (Nos. 523, 524 below).

ORAZIO SAMACCHINI
(1532–77)

A BATTLE (Popham and Wilde, No. 906) (5117)
Another drawing of this series is at Bergamo (cf. L.
Ragghianti, Collobi and Carlo Ragghianti, *Disegni del-
l'Accademia Carrara di Bergamo*, Venice, 1962, p. 60, Fig. 121).

THE VIRGIN WITH SAINTS (Popham and Wilde,
No. 909) (5508)

Mr. E. Pillsbury has called attention to the fact that this
drawing is connected with a painting of the same subject
which seems to have been at one time on the New York
art market and of which a photograph exists in the Library
at I Tatti, Florence, with a tentative attribution to Vasari.

**THE APPARITION OF THE ARCHANGEL MICHAEL
TO ST. GREGORY** (Popham and Wilde, No. 910) (6021)

Mr. Pouncey has called attention to the existence of a close
variant at Munich, attributed there to 'Zuccaro'.

After FRANCESCO DA SANGALLO
(1494–1576)

**432. DRAWING OF THE TOMB OF PAOLO GIOVIO IN
THE CLOISTER OF S. LORENZO, FLORENCE** (10759)

260 × 195 mm. Ink and black wash over black chalk.

The tomb was identified by Dr. Arnold Noach. The draw-
ing seems to be a copy of the tomb rather than a design
for it.

After FRANCESCO DE SANTIS
(1693–1740)

433. PLAN OF THE SPANISH STEPS, ROME (9251)
430 × 285 mm. Pen and black ink.

The draughtsman was probably a Frenchman, because the
scale is given in *Toises* and *Piedi francesi*. The inscription may
be in the hand of Pier Leone Ghezzi.

After ANDREA DEL SARTO
(1486–1531)

434. HEAD OF A MAN (Popham and Wilde, No. 264)
 (5158)

As was pointed out by Antal (p. 32), this drawing, cata-

logued as by Daniele da Volterra, is a copy after a lost drawing by Andrea del Sarto for a head in the Panciatichi *Assumption* in the Pitti (cf. J. Shearman, *Andrea del Sarto*, Oxford, 1965, I, p. 127, II, p. 385, and S. J. Freedberg, *Andrea del Sarto*, Cambridge, Mass., 1963, p. 118). The drawing has recently been attributed to Pier Francesco di Jacopo Foschi by A. Pinelli (*Gazette des Beaux-Arts*, 1967, I, p. 93), but the attribution does not seem to be justified.

GIOVANNI BATTISTA SALVI, called IL SASSOFERRATO (1609–85)

For the provenance of the drawings by Sassoferrato, see p. 14.

JUDITH (Blunt and Cooke, No. 903) (6078)

Mr. Denis Mahon (*Burlington Magazine*, XCIII, 1951, p. 81) has pointed out that this is a study for a painting in S. Pietro, Perugia.

GIOVANNI GIROLAMO SAVOLDO (c. 1480–1550)

435. HEAD OF A BEARDED MAN (Popham and Wilde, No. 1112) (088)

This drawing was catalogued as by an anonymous Milanese artist, but Mr. Creighton Gilbert has proposed the name of Savoldo, which Mr. Popham regards as a convincing attribution.

BARTOLOMEO SCHIDONE (1566–1616)

436. A GIRL SEATED, HER HANDS CLASPED ROUND HER KNEE (*Plate 39*) (5699)

291 × 244 mm. Red chalk, touches of white, on grey-green paper.

From the Lanfranco drawings.

This drawing was exhibited (*Holbein and other Masters*, Royal Academy, London, 1950–51, No. 427) as Lanfranco, but was identified by Mr. Denis Mahon as a study for the *Massacre of the Innocents* by Schidone in the Pinacoteca, Naples (cf. *Burlington Magazine*, XCIII, 1951, p. 81).

437. HEAD OF A MAN (*Plate 38*) (5385)

213 × 145 mm. Red and black chalks on faded paper.

The attribution is due to Professor E. K. Waterhouse.

GIOVANNI PAOLO SCHOR (1615–74)

NOAH WATCHING THE ANIMALS GOING INTO THE ARK (Blunt and Cooke, No. 937) (4513)

The drawing and fresco are both reproduced and discussed by E. Wibiral (*Bollettino d'Arte*, XLV, 1960, pp. 145 f., 152 f.).

THE ARMS OF CLEMENT X (Blunt and Cooke, No. 949) (4441)

Miss Jennifer Montagu has read the inscription as *Gio Paolo Tedesc*, which confirms the attribution to Schor.

DESIGNS FOR COACHES (Blunt and Cooke, Nos. 951, 952) (4461–2)

Further designs of the same kind are at Düsseldorf (cf. *Italienische Handzeichnungen*, No. 150).

After GIOVANNI PAOLO SCHOR

See *GIOVANNI BATTISTA LENARDI* (Blunt and Cooke, Nos. 1011–1016).

Attributed to GIOVANNI PAOLO SCHOR

STUDIES OF CAPITALS

438. 256 × 186 mm. Pen and brown ink. (5639)

439. 238 × 136 mm. Black chalk and grey wash, with a series of concentric circles in brown ink. (5640)

440. A COMPOSITE CAPITAL WITH ITS ENTABLATURE (5641)

156 × 175 mm. Pen and brown ink. Inscribed: *A trito (?) il ovale* (referring to a letter *A* on the drawing), and *pitura*; with measurements for the different members of the entablature.

All three drawings come from the Bernini volume. No. 440 may be after an ancient model.

AGOSTINO SCILLA (1629–1700)

441. ABSALOM KILLING AMNON (6779)

243 × 315 mm. Brown washes over black chalk, squared in black chalk. Inscribed at the foot in black chalk: *Agostino Scilla*.

Inventory A, p. 128: 'Moderna Schuola Romana'.

Attributed to GIOVANNI SEGALA (1663–1720)

442. DELILAH ABOUT TO SHEAR SAMSON (5192)

145 × 192 mm. Oval. Pen and brown wash.

The attribution is based on the similarity to a drawing of St. Sebastian by Segala in the British Museum (cf. C. Dodgson, *Old Master Drawings*, X, 1935, p. 38).

Attributed to FRANCESCO SIMONINI (1686–1753)

443. A BATTLE SCENE (01113)

425 × 764 mm. Pen and brown ink, grey washes. Inscribed on the *verso*: *Monsieur Polard (?Poland)*.

An eighteenth- or early nineteenth-century inscription *Simonini* on the mount.

The inscription on the *verso* may possibly refer to Josef Poland, a Viennese history painter (1692–1740), but so little is known of him that it is impossible to confirm the connection.

Manner of ELISABETTA SIRANI
(1638–65)

444. THE RETURN OF TOBIAS AND THE ANGEL
(5205)

313 × 458 mm. Grey and brown washes over black chalk.

ANTONIO SOLARIO
(active 1502–14 (1518?))

See *ROMAN SCHOOL* (Popham and Wilde, No. 1133).

FRANCICZEK SMUGLIEWICZ
(1745–1807)

See *MARCO CARLONE* (No. 89 above).

Attributed to
GIOVANNI GIOSEFFO DAL SOLE
(1654–1719)

445. THE BLESSING OF JACOB (5206)

225 × 295 mm. Pen and brown wash with body-colour, on brown paper.

The attribution was made independently by Mr. Philip Pouncey and Professor Dwight Miller.

FRANCESCO SOLIMENA
(1657–1747)

446. A VISION OF PARADISE (*Plate 57*) (6118)

463 × 275 mm. Pen and brown wash, over black chalk. Inscribed in black chalk: *Francesco Solimena*.

A study for the ceiling of the Sacristy of S. Domenico, Naples (cf. F. Bologna, *F. Solimena*, 1958, Fig. 148).

447. A SEATED NUDE FIGURE, SEEN FROM BELOW, THE LEFT HAND RAISED (6119)

405 × 244 mm. Black chalk, touches of white, on grey-green paper. Inscribed in ink: *Solimena fecit*.

See also: *GIOVANNI BATTISTA BENASCHI* (Nos. 33–36 above).

LO SPAGNA (GIOVANNI DI PIETRO)
(c. 1450–1528)

See *Attributed to TIMOTEO VITI* (Popham and Wilde, No. 1040).

PROSPERO SPANI,
called IL CLEMENTI
(1516–84)

448. DESIGN FOR A TOMB (10498)

500 × 305 mm. Pen and brown ink on grey prepared paper. Pricked for transfer.

The attribution to Clementi proposed by Mr. A. E. Popham is strongly supported by the similarity of the drawing to one in the Uffizi (reproduced in *Rassegna d'Arte*, VI, 1906, p. 157), which might even be an alternative design for the same tomb.

ILARIO SPOLVERINO
(1657–1734)

449. THE FAÇADE OF PARMA CATHEDRAL (*Plate 73*)
(10738)

418 × 496 mm. Pen and brown ink.

The attribution to Spolverino is due to Dr. A. Noach. In fact the drawing was engraved in reverse by M. Francia as plate 2 in the *Ragguaglio nelle nozze della Maestà di Filippo Quinto, e di Elisabetta Farnese . . . celebrate in Parma l'anno 1714*, Parma, 1717. Mr. E. Croft-Murray has called my attention to another drawing by Spolverino for plate 3 of the same work, which came with the Payne-Knight collection to the British Museum Print Room (Oo-3-3).

GIOVANNI STERN
(c. 1734–after 1794)
and WILLIAM KIRBY
(d. 1771)

450. ARCHITECTURAL DRAWINGS
(11527–11573, 11579–11590, 11609–11611)

Various sizes. Pen and black ink, in most cases with water-colour.

A series of large architectural drawings of ancient Roman buildings, Roman churches, palaces and villas of the sixteenth and seventeenth centuries, and some buildings contemporary with the draughtsmen and apparently either French or English. Some are signed by Stern, many others bear the monogram *W. K.* with inscriptions in English and scales in English feet, and dates between 1768 and 1770 appear on drawings signed by both artists.
It is difficult to distinguish the shares of the two artists in this enterprise, apparently undertaken for an English patron, and they seem to have collaborated so closely that it is hard to allot the unsigned drawings to one artist rather than the other.

STRADANUS (JAN VAN DER STRAET)
(1523–1605)

See *FRANCESCO SALVIATI* (Popham and Wilde, Nos. 888–891).

EMILIO TARUFFI
(1633–66)

See *After CARLO CIGNANI* (No. 117 above).

ANTONIO TEMPESTA
(1555–1630)

HISTORICAL SCENE (Popham and Wilde, No. 939)
(5120)

This drawing was catalogued as by Tempesta, but ascribed by Antal (p. 32) to Ciampelli. Mr. Philip Pouncey has, however, identified it as a study for a fresco by Tempesta on the vault in a chapel in the left aisle of S. Giovanni dei Fiorentini, Rome.

Attributed to ANTONIO TEMPESTA

STUDIES OF SACRIFICIAL BULLS

451. 295 × 320 mm. Pen, brown wash, on faded paper.
(11387)
452. 282 × 324 mm. Pen, brown wash, on faded paper.
(11388)

The attribution is due to Dr. Konrad Oberhuber.

After ANTONIO TEMPESTA

A CAVALRY ENGAGEMENT (Popham and Wilde, Nos. 940, 941) (0449, 01250)

Antal (p. 35) suggested the name of Arpino for these drawings, an attribution which Mr. Popham does not accept.

PIETRO TESTA
DRAWINGS AFTER THE ANTIQUE

When I catalogued the Testa drawings for the volume of Roman drawings in the Royal Collection, published in 1960, I spoke very cautiously about the drawings after the Antique, because at that time it did not seem possible to arrive at even a tentative hypothesis. Since then, however, much work has been done on Testa's drawings, particularly by Miss Karin Hartmann, who recently completed a thesis on the artist for London University, and certain positive clues have turned up which help to clarify the situation.

The starting point for any study of this problem must be Baldinucci's statement in *Notizie dei professori del disegno* (1845–47, v, p. 313) to the effect that Testa made 'di sua mano' five volumes of drawings after the Antique for Cassiano dal Pozzo. These were divided as follows:

1. 'tutte quelle cose . . . che alla falsa opinione appartengono, tanto di deità quanto di sacrificii.'
2. 'Riti nuziali, abiti consolari, e di matrone, inscrizioni, abiti di artifici, materie lugubri, spettacoli, cose rusticali, bagni e triclini.'
3. 'I bassirilievi, che si vedono negli archi trionfali, storie romane e favole.'
4. 'Vasi, statue, utensili diversi antichi.'
5. 'Le figure del Vergilio antico e del Terenzio della Vaticana, il musaico del tempio della Fortuna di Preneste, oggi Palestrina, fatto da Silla, ed altre cose colorite.'

Since most of Cassiano dal Pozzo's drawings came via the Albani collection to Windsor, those after the Antique should contain a very large number by Testa. Unfortunately the drawings were rearranged after they were bought by George III and a few were added from other sources, so that the contents of each Pozzo volume cannot always be identified. It might be possible to reconstruct some of the volumes, at least in part, because a high percentage of the drawings considered in this section bear numbers in a hand which is either that of Pozzo himself or one of his amanuenses. These numbers are repeated on more than one drawing and probably refer to a catalogue of the whole series numbered according to the sculpture copied. So, for instance, all the drawings of the circular reliefs on the Arch of Constantine are numbered *76*, those on the Arch of Titus *79*, and so on. Further some volumes at Windsor correspond precisely to the sections described by Baldinucci. For instance, the Royal Library contains two sets of copies after the Vatican *Virgil*, one in pen only (No. 19319) and the other in water-colour (No. 19320); it also includes a set of water-colours after the Vatican *Terence* (No. 19321) and others after the mosaics at Palestrina (Nos. 19201–19219), to which are added a few more water-colours after other mosaics and paintings (Nos. 19220–19227), and this group would correspond exactly to Baldinucci's fifth volume. Unfortunately this volume was broken up on arrival in the Royal Library. The drawings after the *Virgil* and *Terence* were rebound in smaller oblong volumes, bearing the stamp of George III. The others were put in a folio, from which they were removed at some time in the present century. One volume (184), which has survived in its original state and in an Italian vellum binding, contains a number of drawings (10189–10297) which correspond to Baldinucci's fourth volume: 'Vasi, statue, utensili diversi antichi'. Curiously enough these drawings do not have Pozzo's numbers, but the volume must have belonged to him, as several of the drawings (e.g. Nos. 10202–10205, 10259, 10265 *v*) correspond exactly to descriptions given by Skippon of drawings which he saw when he visited the Pozzo collection (cf. *An account of a journey . . .*, in *A Collection of Voyages and Travels*, London, 1732, VI, pp. 679–80; reprinted in Blunt, 'Poussin and his Roman patrons', in *Walter Friedlaender zum 90. Geburtstag*, Berlin, 1965, p. 71). Another volume (158) contains many drawings which correspond to Baldinucci's second volume, particularly to 'materie lugubri, spettacoli, cose rusticali, bagni e triclini'; the reliefs on the triumphal arches (Vol. 155), and those from the columns of Trajan and Marcus Aurelius (Vol. 152) go to make up Baldinucci's third volume.

It is clear, therefore, that the drawings in the Pozzo volumes at Windsor correspond with a high degree of accuracy to those described by Baldinucci as the work of Testa.

There is one clue which leads to the identification of a large group of drawings after the Antique as almost certainly by Testa. This is a drawing on the *verso* of No. 8526 (Fig. 35), a design for a richly carved bed, for which a much more finished drawing also exists at Windsor (Fig. 36). These two drawings are in a style entirely in accordance with Testa's independent figure drawings, and it is reasonable to assume that the drawing on the *recto* of 8526 (Fig. 37) is also from his hand. On the basis of this drawing it is possible to sort out the following numbers as being almost certainly by Testa:

8151, 8153–83, 8185–225, 8227–36, 8238–48, 8253–55, 8270–95, 8297–314, 8323, 8325–28, 8338–54, 8359–60,

8370–72, 8374–77, 8380–98, 8409–17, 8442–46, 8462–64, 8485–87, 8489–8502, 8504–97, 8609, 8611–26, 8628, 8641–47, 8649–717, 8719–37, 8743–78, 8784–90, 8794–8804, 8806–7, 8813–16, 8819–20, 8857–60, 10751–53, 11120–22, 11124–43, 11153–54, 11156–59, 11167–69, 11178–11180, 11190–91, 11197–11215, 11232–43, 11238–43, 11251–11152, 11254–55, 11264–65, 11291, 11351–52, 11357–74, 11495, 11512, 11514–17, 19287. (See *Plates 46–52*.)

These drawings have in common a fine but sensitive pen line, though they lack the lively expressiveness of Testa's independent drawings, no doubt because the process of copying from an ancient model exercised a restraining influence on his style. The line is invariably in brown ink, usually the very pale bistre which is normal in Testa's work, but sometimes in a darker colour. The wash is often in grey, but sometimes in varying shades of bistre. It is usually applied in small vivacious touches, but in some cases, particularly when the artist is depicting archaeological objects such as vases, domestic utensils, or equipment connected with boxing and other sports, the wash is applied broadly and smoothly to indicate the roundness of the objects. In one small group (Nos. 8151, 8153–80, 8591–94) the artist has drawn the composition in black chalk, sometimes finishing it with pen overdrawing and a little wash.

These form the main groups of drawings for which attribution to Testa seems reasonably certain, but there are others which must be considered possible candidates. The drawings in volume 184 are in a very lively style of pen and deep brown wash, which is not at first sight like Testa's technique; but in a number of cases the drawings are copies after earlier models, particularly from drawings by Pirro Ligorio and other archaeological artists of the late sixteenth century, such as the author of the Fulvio Orsini Codex, now in the Vatican, and this fact may account for the difference in style. In certain cases Testa may have been completing the depiction of a particular subject by adding to it drawings of his own invention, in which he is deliberately imitating an earlier manner. The volume also contains two drawings (10200–01) which are by Testa using his normal style and not imitating that of the sixteenth century.

The other volumes contain a certain number of drawings in pen and brown wash which conform exactly to Testa's confirmed drawings after the Antique (9068, 9072, 9094–9095, 9102–05, 9145–46, 9169–71, 9173–76, 9181, 9189).

The water-colours after the Vatican *Virgil* and *Terence* are quite unlike Testa's usual works, and Baldinucci may have been in error about them. However, he is quite explicit, and the pen drawings after the *Virgil* are close in style to the first group of drawings after the Antique discussed above.

A similar problem is presented by two volumes of drawings after mediaeval mosaics and frescoes (Nos. 8928–9221). At first sight these do not seem to have anything to do with Testa, but in those drawings in which there is a good deal of free pen drawing or modelling in brown wash the style is so close to the handling in the group of theatrical and feast drawings that it seems reasonable to attribute them to the same hand, the more so as the use of water-colour is very like what we find in the *Virgil* and *Terence*.

There are also little scribbles of details on the *versos* of some of these drawings (e.g. 8938) which are characteristic of Testa. A few further drawings, apparently after ancient and early Christian manuscripts, are to be found in volumes 196 (Nos. 11390, 11392, 11419–28, 11929–30, 19229) and 166 (19235–42), also in the same style as the *Virgil* and *Terence*.

I must emphasize that these notes are only intended to indicate the problems involved in the attribution of these drawings, about which opinions differ. Miss Karin Hartmann agrees with the attribution to the artist of the drawings listed above, but Mrs. Sheila Rinehart, who has long been working on the whole group of drawings after the Antique made for Pozzo, believes that the problem is much more complicated and that several hands are involved. It is to be hoped that she will complete her study in the near future.

DESIGNS FOR A BED

453. 160 × 280 mm. Pen and brown ink. (*Fig. 35*).
(8526 *verso*)

454. 178 × 354 mm. Pen and brown ink. (*Fig. 37*).
(10890)

No. 8526 *recto* (*Fig. 37*) has a number which indicates that it came from the Pozzo collection, and No. 454 probably comes from the same sourec. Both drawings came with the Albani collection.

Fig. 35 Cat. No. 453 *verso*

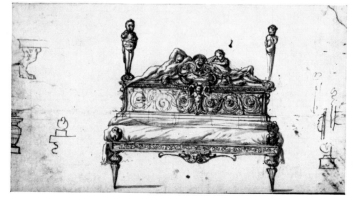

Fig. 36 Cat. No. 454

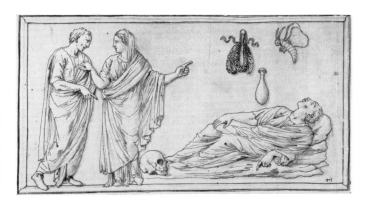

Fig. 37 Cat. No. 453 *recto*

No. 453 is a rough sketch with several alternative versions, whereas No. 454 shows the design brought to a more or less final form. For the significance of the drawings see above.

455. A MAN IN ROMAN ARMOUR (096)
174 × 75 mm. Pen and brown ink, on brown paper.
The figure is close to one in a drawing of *Venus meeting Aeneas* on page 31 of Testa's *Trattato* in Düsseldorf.

THE ASCENSION OF ST. LAMBERT (Blunt and Cooke, No. 980) (5933)
Miss K. Hartmann has identified this drawing as a study for the destroyed fresco in S. Maria dell'Anima, Rome. She believes that the drawing in the Louvre is a copy, but has discovered two further originals, one in Haarlem and one in the Skippe sale, Christie's, 20f.xi.1958, lot 197 E.

BACCHANAL (Blunt and Cooke, No. 982) (5937)
The drawing in Frankfort is, according to Miss Hartmann, a copy after a lost original.

HERCULES AND ANTAEUS (Blunt and Cooke, No. 984) (5936)
Miss Hartmann does not accept the attribution to Testa.

POLYPHEMUS (Blunt and Cooke, No. 985) (5934)
Dr. Vitzthum (p. 518) and Miss Hartmann reject the attribution to Testa.

FIGURE OF A WOMAN (Blunt and Cooke, No. 986) (5935)
Mrs. Harris has pointed out that this figure occurs in a drawing after Testa in the Louvre (1909), which has the Barberini arms.

KNEELING NUDE (Blunt and Cooke, No. 987) (5931)
Dr. Vitzthum (p. 518) confirms the attribution to Testa on the grounds of a similar drawing in Stockholm, but Miss K. Hartmann rejects the connection with the artist.

WAR DRIVING OUT THE ARTS OF PEACE (Blunt and Cooke, No. 999) (5951)

Dr. Vitzthum (p. 518) believes that this drawing, catalogued as a copy, is an original by Testa. Miss Hartmann endorses this view and dates the drawing to Testa's last years.

456. A HERM UNDER A TREE (Blunt, *Castiglione*, No. 9) (11926)
This drawing was catalogued as by Castiglione, but Miss Hartmann believes it to be an original by Testa.
See also: *ROMAN SCHOOL* (No. 706 below).

ALESSANDRO TIARINI
(1577–1668)

457. THE ALMIGHTY (6030)
156 × 139 mm. Grisaille, oil colours, in a feigned roundel.
Inventory A, p. 55: 'Zucharo, Passarotti e Altri Maestri'.
The attribution to Tiarini was suggested by Mr. Philip Pouncey.

PELLEGRINO TIBALDI
(1527–96)

DESIGN FOR THE DECORATION OF A FRIEZE (Popham and Wilde, No. 945) (10908)
Mr. Popham connected the arms with those of the Poggi family of Bologna, but Mr. John Gere has pointed out that they include a wreath as well as the *monti* and must therefore be those of Julius III. In fact a frieze of putti playing with the *monti* of Julius by Tibaldi is recorded in the Vatican Belvedere (cf. J. Ackerman, *The Cortile del Belvedere*, Rome, 1954, p. 69, note 3, and J. Gere, *Taddeo Zuccaro*, London, 1969, p. 75, note 1).
See also: *GIACOMO BERTOJA* (No. 44 above); *POMPEO CESURA DELL'AQUILA* (Popham and Wilde, No. 232); *POLIDORO DA CARAVAGGIO* (No. 372 above), and *FRANCESCO SALVIATI* (No. 430 above).

TITIAN
(1485/88–1576)

ECCE HOMO (Popham and Wilde, No. 961) (4794)
C. L. Ragghianti (p. 596) suggested the name of Paris Bordone for this drawing.

FELICE TORELLI
(1667–1748)

458. THE ADORATION OF THE SHEPHERDS (5505)
281 × 279 mm. Pen and brown ink, brown and grey washes, some body-colour, over black chalk on brown paper.
The attribution was proposed by Mr. Philip Pouncey and Professor Dwight Miller.

FLAMINIO TORRE
(1626–61)

459. THE VIRGIN AND CHILD IN GLORY (Kurz, No. 543) (3250)

The drawing from the Mond collection is now in the Metropolitan Museum, New York.

460. THE CHRIST CHILD APPEARING TO ST. ANTONY OF PADUA (Kurz, No. 622) (0169)

The drawing, catalogued as anonymous, was attributed to Torre first by F. Arcangeli and later, independently, by R. Buscaroli. It is a study for his painting in the Chiesa dell'Osservanza, Imola.

FRANCESCO TREVISANI
(1656–1746)

461. THE FLIGHT INTO EGYPT (Blunt and Cooke, No. 271) (4360)

This drawing was catalogued as by Maratta, but Dr. Eckhard Schaar attributes both it and the related painting at Yale to Trevisani.

See also: *ANDREA CAMASSEI* (No. 71 above).

GIOVANNI BATTISTA TROTTI
(1555–1619)

See *CAMILLO PROCACCINI* (No. 380 above).

ALESSANDRO TURCHI,
called L'ORBETTO
(1578–1649)

462. ST. CATHERINE OF SIENA TOUCHING THE DUMB CHILD'S TONGUE (5503)

224 × 255 mm. Pen and brown wash over black chalk.

Inventory A, p. 53: 'Perino del Vaga, Bald.re Peruzzi, Nico: del Abatte'.

The attribution is due to Mr. Philip Pouncey.

Attributed to ALESSANDRO TURCHI

463. THE RELUCTANT BRIDE (5510)

294 × 249 mm. Pen and brown ink, brown and grey washes, on brown washed paper.

Inventory A, p. 53: 'Perino del Vaga, Bald.re Peruzzi, Nico: del Abatte'.

A tentative attribution to Turchi has been proposed by Mr. Philip Pouncey.

Attributed to PERINO DEL VAGA
(1500/1–47)

Among the decorative drawings in the Royal Library at Windsor is a group of studies, about a hundred in number, which are connected with Perino del Vaga and his immediate circle. The attribution of drawings of this type is at the moment extremely difficult, owing to the small number of firm points from which to work, but on the basis of opinions expressed by a number of experts, particularly Mr. Philip Pouncey, Mr. John Gere, Dr. Konrad Oberhuber and Dr. John Shearman, it has been thought worth while to classify the drawings with tentative attributions to Perino, to Luzio Luzzi, called Luzio Romano (q.v.), and to their followers. It is however important to emphasize that in our present state of knowledge these divisions must be regarded as purely provisional.

In the entries under Perino del Vaga the phrase 'Follower of Perino' has been preferred to 'Studio of Perino', because many of the drawings here catalogued were certainly produced after his death, e.g. those bearing the arms of Julius III and Pius IV.

464. DESIGN FOR THE TOMB OF CARDINAL CRISTOFORO GIACOBACCI (d. 1540) (10895)

235 × 325 mm. Pen and brown wash over black chalk. Watermark: two crossed arrows.

Verso: Angels and other figures, some of which may refer to the design on the *recto*.

The attribution and the identification of the tomb are due to Mr. Philip Pouncey and Mr. John Gere (cf. P. Pouncey and J. Gere, *Italian Drawings in the British Museum, Raphael and his Circle*, London, 1962, p. 95, No. 162).

465. DESIGN FOR THE DECORATION OF A WALL (*Plate 20*) (10894)

323 × 231 mm. Pen and brown wash over black chalk.

The attribution is due to Mr. Philip Pouncey.

467. DESIGN FOR A WALL DECORATION WITH PUTTI AND FRUIT (10935)

169 × 272 mm. Pen and brown wash over black chalk.

STUDIES FOR FRIEZES

468. 89 × 247 mm. Pen and brown ink over black chalk.
(10928)

469. 71 × 370 mm. Pen and brown wash. (10929)

470. 69 × 202 mm. Pen and brown wash. (10930)

471. 100 × 132 mm. Pen and brown wash. (10931)

Very close to Perino himself, but possibly by Luzio Romano.

472. DESIGN FOR A EWER, AND A SMALLER DRAWING OF A SIMILAR SUBJECT (11257)

254 × 158 mm. Black chalk.

Verso: Study for a *Virgin and Child*, and an armless torso. Inscribed in ink: *Amantissimo, Amantiss° Pater*, etc.

The *verso* is discussed by P. Pouncey and J. Gere, *op. cit.*, p. 104, No. 173.

After PERINO DEL VAGA

473. THE HUNTING OF THE CALEDONIAN BOAR
(Popham and Wilde, No. 905) (5098)

Mr. Popham recognized the fact that this drawing was probably a copy, but thought that the original was likely to be by Salviati. It has, however, been suggested by Mr. John Gere that it is more likely to be after Perino and to be connected with similar drawings at Besançon (1398) and in the Witt Collection at the Courtauld Institute (1694).

Follower of PERINO DEL VAGA

DESIGNS FOR THE DECORATIONS OF WALLS
(*Plate 18*) (10847)

474. 367 × 541 mm. Pen and brown ink, with grey wash.

The designs include the arms of Paul III over the central door. Mr. A. E. Popham (*Italian Drawings*, No. 980) has suggested that the drawing is a sketch for the Biblioteca in the Castel S. Angelo, with which it has many features in common, although it does not correspond exactly to the decoration as executed.

475. 64 × 178 mm. Pen and brown ink, with brown wash. Inscribed on *verso: longa p. 59 la stanza.* (11488A)

476. 207 × 222 mm. Pen and brown wash. (10862)

DESIGNS FOR THE DECORATION OF A CEILING
(*Plate 16*)

477. 432 × 293 mm. Cut to a rhomboid shape. Pen and brown wash. (10870)

478. 213 × 280 mm. Cut to a triangular shape. Pen and brown wash. (10879)

479. 209 × 274 mm. Cut to a triangular shape. Pen and brown wash. (10880)

480. 203 × 283 mm. Cut to a triangular shape. Pen and brown wash. (10881)

481. 208 × 273 mm. Cut to a triangular shape. Pen and brown wash. (10882)

Mr. A. E. Popham (*Italian Drawings*, No. 344) has suggested that these drawings are by the same hand as his No. 344, which he tentatively ascribes to Giovanni da Udine, but they appear to belong to the main series of drawings from the circle of Perino.

In No. 478 the initials *A.B.* occur on the base of an ornament supporting Sphinxes, which has hieroglyphs on its front face.

At one time No. 477 has been used to frame a pressed butterfly, of which traces can still be seen in the blank panel in the centre of the drawing. Dr. John Shearman has suggested that this whole series of designs were intended as frames, and it is indeed difficult to see how they could fit into the decoration of a ceiling.

482. DESIGN FOR THE DECORATION OF A CEILING
(*Plate 17*) (10857)

232 × 299 mm. Pen and brown wash.

483. DESIGN FOR THE DECORATION OF A WALL AND A VAULT (10886)

255 × 360 mm. Irregularly cut. Pen and brown wash.

No. 483 has been made up in the lower left-hand corner with what appears to be a part of drawing No. 482.

No. 482 has in the centre arms which appear to be those of the Grimani family, with a canon's hat. The two drawings seem to belong to a single scheme of decoration.

484. DESIGN FOR PART OF A CEILING (11419A)

260 × 370 mm. Pen and brown wash. Ruled lines in black chalk.

The decoration includes the *monti* and papal tiara of Julius III and may therefore be connected with the Villa Giulia.

This group of drawings is discussed by P. Pouncey and J. Gere, *op. cit.*, p. 110, No. 184.

DESIGNS FOR A VAULT

485. 418 × 272 mm. Cut to a rhomboid shape. Pen and brown wash. Dated *1548*. (10872)

486. 400 × 263 mm. Pen and brown ink. (10873)

487. 409 × 260 mm. Pen and brown ink. (10874)

488. 137 × 408 mm. Cut to a triangular shape. Pen and brown ink. (10876)

489. 205 × 270 mm. Cut to a triangular shape. Pen and brown ink. (10877)

490. 212 × 275 mm. Cut to a triangular shape. Pen and brown ink. (10878)

These drawings are connected with Nos. 477–481 in their general design but are much coarser in execution.

DESIGN FOR THE BASE OF A CANDLESTICK

491. 178 × 406 mm. Pen and grey-brown wash. (11340)

DESIGNS FOR CEILINGS

492. 152 × 208 mm. Pen and brown ink over black chalk, with grey wash. (11488B)

493. 256 × 139 mm. Pen and brown ink over black chalk, with brown and grey wash, heightened with body-colour.
 (10868)

DESIGNS FOR FRIEZES

494. 180 × 300 mm. Pen and brown ink, with blue washes.
 (11484A)

495. 202 × 313 mm. Pen and brown ink, with blue washes.
(11484B)

496. DESIGN FOR THE DECORATION OF A SOFFIT
(10858)
226 × 139 mm. On two pieces of paper joined together.
Pen and brown wash over black chalk, with some body-
colour.

497. DESIGN FOR THE DECORATION OF A WALL
AND CEILING (10848)
392 × 281 mm. Pen and brown ink over black chalk, with
grey-green wash.

STUDIES FOR CANDELABRA

498. 235 × 58 mm. overall. Pen and brown ink. (11235)

499. 259 × 50 mm. overall. Pen and brown ink. (11236)

500. 430 × 254 mm. Pen and brown wash. (11266)

STUDIES FOR A PYX

501. 155 × 65 mm. Black chalk. (11260)

502. 196 × 98 mm. Black chalk. (11262)

503. DESIGN FOR AN ORNAMENTAL EWER (11256)
429 × 223 mm. Pen and grey wash over faint chalk
indications.

504. DESIGN FOR A MORSE WITH THE FIGURE OF
ST. LUKE (Fig. 38) (11325)
166 × 149 mm. Pen and brown ink, dark brown wash.

505. DESIGN FOR A PYX (11237)
384 × 139 mm. Black chalk and brown wash.
Similar to two designs for candlesticks attributed to Perino
in the Victoria and Albert Museum.

DESIGNS FOR EWERS

506. 274 × 158 mm. Pen and brown ink, with brown and
grey wash. (11258)

507. 106 × 165 mm. Black chalk. (11259)
The designs on these two drawings are related to those in
No. 472. Similar designs are in the British Museum
(cf. P. Pouncey and J. Gere, op. cit., p. 112, No. 187).

DESIGNS FOR METAL DISHES

508. 121 × 240 mm. Pen and grey wash. (11331)

509. 123 × 234 mm. Pen and grey wash. (11332)

510. 148 × 238 mm. Pen and grey wash. (11333)

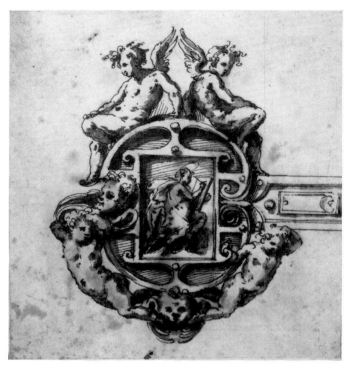

Fig. 38 Cat. No. 504

511. DESIGNS FOR A COVERED TWO-HANDLED JAR
(11328)
256 × 220 mm. overall. Pen, with grey wash.
Probably a copy or adaptation of a design by Perino.
Dr. Konrad Oberhuber has, however, suggested that it is
in certain ways nearer to the style of Pirro Ligorio.

512. DRAWINGS AFTER ANCIENT DECORATIVE
DETAILS (11415A)
210 × 280 mm. Pen and brown ink. Bears three illegible
words, perhaps colour notes.
Verso: Grotesque masks. Pen and brown ink. Probably
off-sets.
See also: GIACOMO BERTOJA (No. 44 above); Attributed
to POLIDORO DA CARAVAGGIO (No. 373 above), and
After TADDEO ZUCCARO (No. 524 below).

FRANCESCO VANNI
(1563/5–1610)

513. PUTTO PLAYING A STRINGED INSTRUMENT
(Fig. 39) (0249)
132 × 91 mm. Pen and brown ink, over black chalk.
A study for the angel in the Vision of St. Francis known
from an etching and from a version, probably after the
etching, in the Miethke sale, Wawra, Vienna, May 6th,
1918 (wrongly ascribed to Sacchi). This drawing is in
the reverse sense from the etching and is probably an
original sketch for it or for the painting.
See also: RUTILIO MANETTI (No. 289 above), and
SIENESE SCHOOL (Nos. 719, 720 below).

ALESSANDRO VAROTARI
(1588–1648)

See *ITALIAN SCHOOL* (No. 632 below).

GIORGIO VASARI
(1511–74)

REBECCA AND ELIEZER (Popham and Wilde, No. 999) (6005)

Mr. John Gere has pointed out that the composition recurs in a ceiling design in the Art Institute, Chicago, formerly ascribed to Prospero Fontana.

GIOVANNI DE' VECCHI
(1536–1615)

514. THE MIRACLE OF ST. CATHERINE OF SIENA (Popham and Wilde, No. 677) (5086)

Mr. Popham attributed this drawing to Giovanni de' Vecchi rather than Passignano, under whose name it was originally catalogued, and Mr. Philip Pouncey has identified it as a study for a fresco in S. Maria Sopra Minerva, Rome.

515. A POPE (?PIUS V) GIVING THE BENEDICTION (Popham and Wilde, No. 679) (5518)

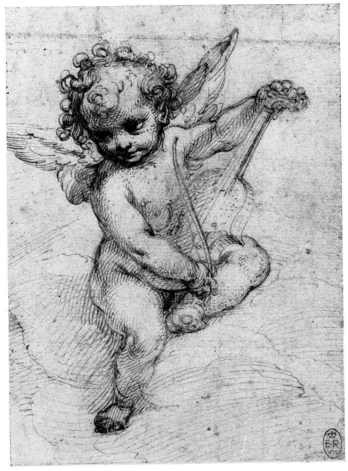

Fig. 39 Cat. No. 513

Mr. Popham agrees with the attribution to Giovanni de' Vecchi proposed by Mr. Philip Pouncey.

See also: *GIACOMO BERTOJA* (No. 43 above).

Studio of PAOLO (CALIARI) VERONESE
(1528–88)

ALLEGORICAL COMPOSITION (Popham and Wilde, No. 1021) (3813)

Antal (p. 35) suggested the name of Andrea Vicentino.

THE BIRTH OF THE VIRGIN (Popham and Wilde, No. 1022) (4785)

Dr. Richard Cocke suggests that this is connected with the painting by Benedetto Caliari in the Accademia, Venice.

THE VIRGIN AND CHILD (Popham and Wilde, No. 1028) (6689)

Dr. Cocke points out that this is related to a school picture in Dresden.

THE ADORATION OF THE SHEPHERDS (Popham and Wilde, No. 1035) (6711)

Dr. Cocke believes that this is a preparatory sketch for a painting by Carletto Caliari in S. Afra, Brescia.

ANDREA VICENTINO
(1539–1614)

See *Studio of PAOLO (CALIARI) VERONESE* (Popham and Wilde, No. 1021).

PIERINO DA VINCI
(1531–54)

See *Attributed to BATTISTA FRANCO* (No. 188 above).

ANTONIO VISENTINI
(1688–1782)

516. ADMIRANDA ARTIS ARCHITECTURAE VARIA (10506–67)

Each sheet 530 × 380 mm. Pen and brown ink.

Sixty-three drawings of the principal buildings of Venice and other parts of Italy.

517. ARCHITECTURAL DRAWINGS (19288–19311)

Each drawing c. 370 × 520 mm, except for No. 19299, which is 424 × 615 mm. Pen and brown ink.

The drawings probably formed a volume similar to the one just mentioned. Three further volumes were taken to the British Museum with the printed books from the library of George III.

DESIGNS FOR VIGNETTES (Blunt and Croft-Murray, Nos. 452–454, 456–459) (7646–8, 7650–3)

Mrs. Frances Vivian has pointed out that these designs were engraved in the Italian edition of Chambers' *Encyclopedia*, published by Pasquali for Consul Smith in 1748–49.

ARMS OF THE GRAND DUKE OF TUSCANY
(Blunt and Croft-Murray, No. 464) (7577)
As Mrs. Frances Vivian has pointed out, the arms are those of Francis of Lorraine, not Francesco de' Medici.

ARCHITECTURAL FANTASIES (Blunt and Croft-Murray, Nos. 518, 546) (7657, 7684)
These designs have been identified by Mrs. Vivian as illustrations to Antonio Conti's *Prose e poesie*, published by Pasquali in 1739.

Attributed to TIMOTEO VITI
(1467–1523)

HEAD OF A MAN (Popham and Wilde, No. 1040) (061)
Antal (p. 32) proposed an attribution to Lo Spagna.

ANTONIO MARIA ZANETTI
(1679/80–1767)

The most complete survey of Zanetti as a caricaturist is to be found in A. Bettagno's catalogue of the exhibition *Caricature di Anton Maria Zanetti*, held at the Fondazione Cini in 1969, in which the author refers to many of the drawings at Windsor.

FEDERICO ZUCCARO
(1542/43–1609)

518. PEACE (Popham and Wilde, No. 50) (4786)
Antal (p. 32) has pointed out that this drawing corresponds fairly closely in reverse to a fresco at Caprarola, almost certainly by Federico Zuccaro.

519. AUGUSTUS AND THE SIBYL (Popham and Wilde, No. 52) (0144)
This drawing was catalogued as by Niccolò dell'Abbate, but Mr. Philip Pouncey has pointed out that it corresponds to a fresco by Federico Zuccaro in the left transept of the SS. Trinità dei Monti, Rome.

520. PIETÀ (Popham and Wilde, No. 238) (5054)
This drawing was catalogued with an attribution to Cigoli, but Mr. Popham now accepts the name of Federico Zuccaro, put forward independently by Mr. Jacob Bean and Mr. John Gere.

A MAN SEATED WITH ANOTHER MAN STANDING ON THE RIGHT (Popham and Wilde, No. 1051) (0220)
Mr. John Gere has pointed out that there is an offset of this drawing in the Louvre, dated 1576, in which names are attached to the figures represented (cf. D. Heikamp, *Paragone*, 205, 1967, p. 58 and Pl. 22).

Follower of FEDERICO ZUCCARO

THE MARTYRDOM OF ST. LAWRENCE (Popham and Wilde, No. 1064) (0380)

THE MASSACRE OF THE INNOCENTS (Popham and Wilde, No. 1065) (0291)
Antal (p. 32) suggested an attribution to Pasquale Cati.
See also: *BOLOGNESE SCHOOL* (No. 570 below); *DENIS CALVAERT* (No. 68 above), and *LORENZO SABBATINI* (Nos. 417–20 above).

TADDEO ZUCCARO
(1529–66)

521. STUDY FOR THE APOSTLES IN THE AGONY IN THE GARDEN (Popham and Wilde, No. 887) (6024)
Antal's attribution to Salviati was accepted by Mr. Popham, but Mr. John Gere later identified the drawing as a study for a painting by Taddeo Zuccaro in the Strassmeyer Gallery, Zagreb (cf. *Burlington Magazine*, cv, 1963, pp. 390 ff.). Another drawing for the same composition was on the London art market in 1963.
See also: *BERNARDO CASTELLO* (No. 108 above); *PROSPERO FONTANA* (No. 170 above); *MARCO MARCHETTI DA FAENZA* (Popham and Wilde, No. 416), and *FRANCESCO SALVIATI* (Popham and Wilde, No. 894).

After TADDEO ZUCCARO

522. ALEXANDER AND BUCEPHALUS (5201)
207 × 345 mm. Oval, cut on all four sides. Red chalk with red wash.
This is a copy of a lost drawing for the fresco in the Palazzo Gaetani, Rome. The original is in the Weld collection at Lulworth, Dorset (cf. catalogue of the exhibition *Italian 16th-century drawings from British Private Collections*, Edinburgh, 1969, No. 100).

523. ALLEGORICAL FIGURE OF TEMPERANCE (Popham and Wilde, No. 754) (4788)
Mr. John Gere has pointed out that this drawing is a copy of one at Ottawa, attributed by Mr. Popham to Taddeo Zuccaro (cf. Popham and Fenwick, p. 31, No. 40).

524. A ROMAN NAVAL ENGAGEMENT (Popham and Wilde, No. 987) (5471)
Mr. Popham originally catalogued this drawing as a copy after Perino del Vaga, but later expressed the view that the composition was more likely to be by Taddeo Zuccaro, a view which Mr. Gere accepts (*Burlington Magazine*, cv, 1963, p. 309).

525. ALEXANDER REFUSING A DRINK OF WATER (Popham and Wilde, No. 1074) (5066)
Mr. John Gere has identified this as a copy after a drawing by Taddeo Zuccaro for a painting in the Palazzo Gaetani, Rome. Another copy is in the Louvre.

526. A GROUP OF WARRIORS (Popham and Wilde, No. 1196) (5065)

This drawing was catalogued without attribution, but Mr. John Gere has suggested that it is a design for a maiolica dish made in the Zuccaro studio.

JACOPO ZUCCHI
(1541–1589/90)

See *ANDREA BOSCOLI* (Popham and Wilde, No. 141).

ANONYMOUS DRAWINGS

BOLOGNESE SCHOOL
(late sixteenth century)

527. DESIGN FOR A STAGE SET (11248)

150 × 241 mm. Pen and brown ink.

Verso: Landscape with figures and goats by a river. Pen and brown ink. Ornamental cartouche, pen and red chalk. The arms on the large stemma above the courtyard entrance are clearly papal, but are so vaguely indicated that they cannot be certainly identified. They appear, however, to be intended for those of Sixtus V.

The landscape and the cartouche on the *verso* are close in style to Agostino Carracci, and the tower, of which the top is just visible in the stage set, is reminiscent of the taller of the two leaning towers at Bologna. The presence of the papal arms would conform to such an origin and, if they are in fact those of Sixtus V (1585–90), the date would fit with the early career of Agostino.

BOLOGNESE SCHOOL
(seventeenth century)

528. THE VIRGIN AND CHILD, ST. JOHN THE BAPTIST AND ST. LAWRENCE (6823)

332 × 214 mm. Black chalk, grey wash.

Inventory A, p. 128: 'Moderna Schuola Romana'.

Bolognese School rather than Roman, early seventeenth century.

529. ST. CATHERINE OF SIENA, SEATED, HOLDING A CROWN OF THORNS (352)

213 × 148 mm. Light brown wash over faint black chalk.

From the Domenichino drawings.

Early seventeenth century.

530. A TRIUMPH (3508)

415 × 592 mm. Black and red chalk, heightened with white, on brown paper.

Inventory A, p. 81: 'Guido &c. Tom. 6: Drawings of inferior Masters of the Bolognese School'.

Early seventeenth century.

531. THE TRIUMPH OF CHRISTIAN FAITH (*Plate 68*) (3568)

348 × 505 mm. Pen and black ink, reddish wash, heightened with white, on pinkish ground, the outlines indented.

Inventory A, p. 20: 'Bolognesi Moderni'.

The architecture in the background is Roman—the Capitol on the left and the Castel S. Angelo on the right—but the style of the drawing is Bolognese.

532. MINERVA AT THE CAVE OF ENVY. ABOVE A BLANK SHIELD SURMOUNTED BY A CARDINAL'S HAT AND SUPPORTED BY PUTTI (*Plate 66*) (5514)

188 × 129 mm. Red washes, heightened with white, on brown paper.

Inventory A, p. 53: 'Perin.° del Vaga, Bald.re Peruzzi, Nico: del Abatte &c.'.

The subject is taken from Ovid, *Metamorphoses*, II, 760 ff. Probably a design for a title-page.
Mr. Philip Pouncey suggests that it is the work of a Bolognese engraver of the early seventeenth century.

533. HEAD OF A BOY, IN PROFILE TO LEFT (0248)

223 × 179 mm. Pen and brown ink, over black chalk.

Early seventeenth century.

534. HEAD OF A MONK (7208)

115 × 88 mm. Pen and black ink. The paper cut and repaired at the bottom.

From Consul Smith's volume of caricatures, as Guercino.

The attribution to Guercino is not convincing, but the drawing is probably by an early seventeenth-century Bolognese artist.

535. THE VIRGIN AND CHILD WITH ANGELS, ST. JOHN THE EVANGELIST, ST. LAWRENCE, ST. PETER, AND POSSIBLY ST. CHARLES BORROMEO (6752)

385 × 230 mm. Pen and black ink, grey and white body-colour, on red paper.

Inventory A, p. 128: 'Moderna Schuola Romana'.

Bolognese School rather than Roman, late seventeenth century.

536. A MAN SEATED, DRAWING (7216)

169 × 137 mm. Red chalk on brown paper.

From Consul Smith's volume of caricatures.

537. HEAD OF A MAN IN COWL, IN PROFILE TO LEFT (7211)

231 × 169 mm. Pen and black ink. A strip added on the right.

From Consul Smith's volume of caricatures.

538. AN ELDERLY WOMAN, IN PROFILE TO LEFT, HALF-LENGTH (7218)

214 × 163 mm. Red chalk on brown paper.
From Consul Smith's volume of caricatures.

539. AN OLD MAN TAKING A CHICKEN TO MARKET
(7220)
265 × 199 mm. Red chalk.
From Consul Smith's volume of caricatures.
This and Nos. 536–538 were ascribed by Smith to Guercino, but are probably by a Bolognese artist of the seventeenth century.

540. HEAD OF A BEARDED MAN (5171)
100 × 85 mm. Pen and brown ink, brown wash. Top left corner cut, cut at right.

541. A HEAD OF A BOY WEARING A CAP (5172)
79 × 65 mm. Pen and brown ink.

542. HEAD OF A WOMAN, WEARING A HEADDRESS, LOOKING UP (5391)
193 × 149 mm. Black chalk, on prepared paper.

543. THREE HEADS: A WOMAN AND TWO CHILDREN
(5431)
210 × 223 mm. Red chalk, a little black chalk.

544. AN INN AMONG TREES, TRAVELLERS ALONG THE ROAD (5731)
201 × 275 mm. Pen and brown ink.
Inventory A, p. 119: 'Paesi diversi . . . four of the Carracci School'.

545. LANDSCAPE WITH ROCKS (5753)
250 × 396 mm. Pen and grey ink.
Inventory A, p. 119: 'Paesi Diversi . . . Five Lombard'.

546. LANDSCAPE: A ROCKY MOUND SURMOUNTED BY TREES, WITH FIGURES (5730)
194 × 288 mm. Pen and brown ink over black chalk.
Inventory A, p. 119: 'Paesi Diversi . . . four of the Carracci School'.

547. A CASTLE IN A LANDSCAPE, A TROOP OF HORSEMEN IN THE DISTANCE (5758)
176 × 253 mm. Pen and brown ink, over black chalk.
Inventory A, p. 119: 'Paesi Diversi . . . Of the Roman and Lombard school'.

548. A FARMHOUSE AMONG TREES ON A HILL (5818)
184 × 242 mm. Pen and brown ink on faded paper.
Inscribed in ink (erased): Campagnola allievo di Titiano.
From the Grimaldi volume.

549. THE UPPER PART OF A CHURCH (5817)
115 × 175 mm. Pen and brown ink.
From the Grimaldi volume.

550. A MAN SKETCHING THE IVY-COVERED TRUNK OF A TREE (5815)
265 × 277 mm. Pen and brown ink over black chalk.
From the Grimaldi volume.
This drawing is probably seventeenth-century Bolognese, but it has some affinity with the work of Pier Francesco Mola.

551. LANDSCAPE WITH TREES, DISTANT CASTLE, BRIDGE AND FIGURES (5807)
205 × 306 mm. Pen and brown ink. Much stained. Inscribed at the top right: L. R.
From the Grimaldi volume.

552. A TREE ON A ROCK OVER A RIVER; DISTANT LANDSCAPE (6137)
202 × 274 mm. Pen and brown ink, brown and grey washes.
Inventory A, p. 115: 'Paesi di N. & G. Poussin e Altri'.

553. A CASTLE BEYOND A LAKE, A TREE IN THE FOREGROUND (0829)
268 × 191 mm. Pen and brown ink, on white paper with brown wash. The top of the drawing is damaged and mounted on a piece of paper washed with a similar shade of brown.

554. A NUDE PUTTO, LEFT LEG RAISED ON A STEP, HOLDING A ROPE (3473)
234 × 200 mm. Black chalk on brown paper.
Inventory A, p. 81: 'Guido &c.'.

DESIGNS FOR CARTOUCHES (Plate 71)
555. 240 × 189 mm. Pen and brown ink over red chalk, yellow wash. (1562)
556. 249 × 180 mm. Pen and brown ink, red chalk, yellow wash. (1563)
557. 231 × 184 mm. Pen and brown ink, over red chalk.
(1564)
From the Domenichino volumes.

558. RAPE OF THE SABINES (3564)
352 × 505 mm. Pen, dark wash, heightened with white oil paint, on dark brown paper.
Inventory A, p. 20: 'Bolognesi Moderni'.

559. UNIDENTIFIED MYTHOLOGICAL LOVE SCENE
(3563)
366 × 489 mm. Pen, dark brown wash, heightened with white, on dark brown paper.
Inventory A, p. 20: 'Of Canuti . . .'.

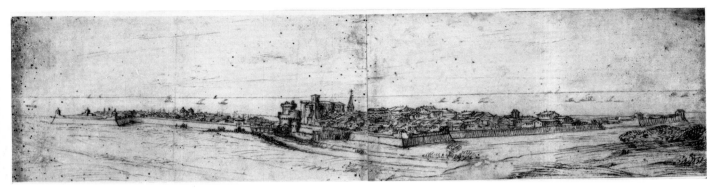

Fig. 40 Cat. No. 561

560. A LANDSCAPE WITH TREES AND DISTANT
HILLS, TWO BUILDINGS (3558)

175 × 232 mm. Pen.

An old attribution 'P. Brilli' on the mount.

561. VIEW OF A FORTIFIED TOWN ON THE
MEDITERRANEAN (*Fig. 40*) (3562)

121 × 494 mm. On two pieces of paper joined together.
Pen and brown ink, on slightly darkened paper. Inscribed
on the *verso*: *del Guercino*.

The right-hand sheet has been at Windsor since the
eighteenth century (Inventory A, p. 116: 'Paesi di Maestri
Bolognesi'); the left-hand sheet was shown at an exhibition
held by Mortimer Brandt in New York in April 1966
(No. 2, without attribution). It was bought by Mrs. Jacob
M. Kaplan of New York, Vice-President of the American
Federation of Art, who later, on learning that it formed
part of a sheet in the Royal Library, presented it to H.M.
The Queen. The two sheets were then joined together.
The drawing has so far defied identification as regards
either site or artist. Both the architecture and the ships
make it clear that the town is on the Mediterranean, but
it might be in northern Italy, France, or Spain.
As regards the attribution, the inscription on the *verso*
giving it to Guercino, and the fact that the drawing was
classed as Bolognese in the eighteenth century, make it
likely that it is by an artist of this school, an identification
which is stylistically convincing.

562. DAY DEFEATING NIGHT: DESIGN FOR A
CEILING WITH FOUR CURVED SIDES (4490)

374 × 253 mm. Black chalk, body-colour, on blue-grey
paper. Inscribed in the 'deceptive' hand: *Cortona*.

Late seventeenth century.

563. TWO MEN SUPPORTING A BODY (Kurz, No. 816)
 (5322)

From the Luti collection.

Professor Kurz catalogued this drawing among the anony-
mous Bolognese. A copy by Altomonte in the Albertina,
Vienna, is inscribed with the name of Guido Reni, but
this attribution is not convincing.

BOLOGNESE SCHOOL
(eighteenth century)

564. SCENE FROM CLASSICAL HISTORY OR LEGEND:
AN OLD MAN OFFERS A COIN AND A PETITION TO A
ROMAN GENERAL, WHO REJECTS HIS OFFER WITH
HORROR (3716)

385 × 525 mm. Pen and black ink, grey wash, over black
chalk, on buff paper.

Inventory A, p. 20: 'Bolognesi Moderni'.

Early eighteenth century.

565. HEAD OF A BEARDED MAN, IN PROFILE TO
RIGHT (01242)

380 × 333 mm. Black chalk, touched with white, on grey
paper.

566. HEAD OF A BEARDED MAN, NEARLY FULL
FACE, LOOKING TO LEFT (01243)

381 × 333 mm. The same technique.

567. HEAD OF A BEARDED MAN, THREE-QUARTERS
TO LEFT (01244)

379 × 339 mm. The same technique.

568. HEAD OF A BEARDED MAN, LOOKING HALF-
RIGHT (01245)

381 × 334 mm. The same technique.

Inventory A, p. 110: 'Passari, Pietro de Petris etc.'.

Early eighteenth century, but Bolognese rather than
Roman.

569. HEAD OF AN OLD MAN (6426)

341 × 259 mm. Black chalk, slightly heightened with white,
on blue paper.

Inventory A, p. 103: 'Of Cor: Vischer'.

Catalogued by Puyvelde as anonymous Flemish (No. 303),
but certainly Italian, perhaps Bolognese, of the early
eighteenth century.

570. THE APPARITION OF THE ARCHANGEL
MICHAEL TO ST. GREGORY (Popham and Wilde,
No. 1081) (5993)

Mr. Popham has called attention to a drawing at Munich attributed to Federico Zuccaro, in which the principal figures correspond (cf. *Münchner Jahrbuch*, 3. Folge, I, 1965, p. 249).

LOT AND HIS DAUGHTERS (Kurz, No. 560) (3287)

A drawing for the same composition is in the Louvre, wrongly attributed to Guido Reni.

See also: *ALESSANDRO ALGARDI* (No. 5 above); *GIOVANNI ANGELO CANINI* (No. 77 above); *LODOVICO CARRACCI* (No. 104 above); *BARTOLOMEO CESI* (Nos. 112, 113 above); *GESSI* (No. 194A above); *ANTONIO GIONIMA* (No. 196 above); *GIOVANNI LANFRANCO* (No. 223 above); *LUCIO MASSARI* (No. 302 above); *GIUSEPPE PORTA (SALVIATI)* (No. 377 above); *GUIDO RENI* (No. 385 above), and *FLAMINIO TORRE* (No. 460 above).

CREMONESE SCHOOL

571. A PUTTO, WALKING TO LEFT (0961)

228 × 170 mm. Red and black chalk, with body-colour, on buff paper. Squared in red chalk.

Mr. Philip Pouncey has suggested that this drawing is by a Cremonese artist working under the influence of Antonio and Bernardino Campi.

572. PUTTI TREADING GRAPES (10910)

109 × 285 mm. Pen and brown wash.

The name of Giulio Campi has been suggested by Mr. John Gere.

See also: *ALTOBELLO MELONI* (No. 304 above).

FLORENTINE SCHOOL

573. DESIGNS FOR EWERS (11311)

202 × 302 mm. Irregularly cut. Pen and brown ink, on brownish paper, apparently oiled for tracing.

Copies after late sixteenth-century designs.

574. DESIGNS FOR A BOWL AND A TAZZA (11296)

198 × 196 mm. Red chalk, strengthened with pen and brown ink. Numbered: *730, 729*.

From the Pozzo and Albani collections.

Probably late sixteenth century.

575. COVERED GLASS GOBLET (11297)

247 × 164 mm. Pen and brown ink. Numbered: *327*.

From the Pozzo and Albani collections.

Mr. R. Charleston has pointed out that a glass of this type, without cover, appears in a painting at Karlsruhe by Judith Leyster, generally dated c. 1627–28. A similar glass, in the Victoria and Albert Museum (C 186–1936), probably dates from the first quarter of the seventeenth century. The ringed cover is a later feature, usually associated with the period after 1660, but in this case it

must be earlier, since the drawing belonged to Cassiano dal Pozzo, who died in 1657. The drawing is by the same hand as No. 574.

576. FRAGMENT OF A DESIGN FOR DECORATION WITH A SEA-MONSTER (11249)

195 × 200 mm. Fine pen and brown wash.

Probably a copy after a design of the later sixteenth century.

577. A PRIEST GIVING COMMUNION (5522)

219 × 169 mm. Pen and brown ink, blue wash. Squared in black chalk.

Inventory A, p. 53: 'Perin.º del Vaga, Bald.ʳᵉ Peruzzi, Nico: del Abatte &c.'.

C. 1600.

578. DESIGN FOR A COVERED DISH, WITH A RECUMBENT SPHINX ON THE LID (*Plate 22*) (11324)

216 × 264 mm. Pen and brown wash.

The design has elements that recall Rosso (1494–1541), but the drawing is probably much later, c. 1600.

579. TWO GADROONED URNS (11315)

381 × 249 mm. Pen and brown ink, brown wash.

Verso: Two narrow amphorae. One of them inscribed: *Questo*.

580. DESIGNS FOR TWO URNS (11323)

358 × 258 mm. Pen and brown wash. One inscribed: *Questo . . . più grande* (second word illegible).

Verso: Designs for two tall jars.

Probably by a Florentine artist working about 1600.

581. DESIGN FOR A EWER (*Plate 23*) (11334)

c. 335 × 180 mm. Cut around the contour of the drawing. Pen and dark brown wash.

Early seventeenth century.

582. THE DAY OF JUDGMENT (5053)

251 × 316 mm. Pen and brown ink, brown washes, on ten pieces of paper of irregular shape and superimposed one on another.

The figure *666*, perhaps referring to the Number of the Beast in the Book of Revelations, is inscribed (in a later hand?) on the book open before the central figure, a prelate.

Late sixteenth century or early seventeenth century.

583. A GIRL, HALF-LENGTH, HER HAND ON HER EXPOSED BREAST (*Plate 58*) (5221)

239 × 220 mm. Black and red chalk.

A drawing of considerable distinction, which has some affinities with French artists of the early eighteenth century, particularly with Watteau, but is probably Florentine of the early seventeenth century.

584. DESIGNS FOR STAGE COSTUMES

214 × 110 mm. Pen and brown ink, grey wash, on faded paper. (4636)

212 × 113 mm. Pen and brown ink, grey wash, on faded paper. (4637)

Inventory A, p. 122: 'Stefanino della Bella'.

Too insensitive for Stefano della Bella, but probably Florentine, early or mid-seventeenth century.

THE VIRGIN AND CHILD WITH ST. APOLLONIA (Popham and Wilde, No. 1099) (5131)

Antal (p. 35) suggested that this drawing was by a member of the school of Verona, perhaps Domenico Brusasorci.

A SAINT CELEBRATING MASS (Popham and Wilde, No. 1103) (6014)

Antal (p. 32) suggested an attribution to Sabbatini.

See also: *PASSIGNANO* (*DOMENICO CRESTI*) (No. 338 above).

GENOESE SCHOOL

585. DESIGN FOR AN ARCH LEADING TO A CLOISTER
(10762)

405 × 249 mm. Pen and brown wash.

The heavy atlantes and the style of the drawing suggest an attribution to a Genoese artist of the mid-seventeenth century.

586. A TITLE-PAGE (3652)

243 × 167 mm. Pen and brown ink, brown washes, over faint black chalk.

The angel's trumpet bears a flag on which is inscribed: *Incoronatione Del Ser^{mo} Stef^{o} Demari DUCE Della Republica di GENOVA.* The scroll among the objects on the sea-bed reads: *Queste del . . . lido . . . mio . . . fonc [?] L'arene.*

Inventory A, p. 20: 'Bolognesi Moderni'.

Two tritons bear the De Mari arms, and a third carries a banner with the insignia of Genoa. Stefano De Mari was one of the Biennial Doges and ruled 1663–65.

ITALIAN SCHOOL
(mid-16th century)

587. SARCOPHAGUS RELIEF: ACHILLES AND PENTHESILEA (8071)

125 × 148 mm. Pen and brown washes over pencil.

From the Pozzo and Albani collections.

Sculpture in the Palazzo Lancelotti, Rome (cf. Vermeule, p. 66).

By the same hand as No. 588.

588. SARCOPHAGUS RELIEF: BATTLE WITH THE AMAZONS (8074)

117 × 132 mm. Pen and brown wash over pencil.

From the Pozzo-Albani drawings.

By the same hand as No. 587 and after the same sarcophagus.

589. A EWER (11293)

124 × 73 mm. Pen and brown wash, heightened with body-colour, on yellow-brown paper.

590. SARCOPHAGUS RELIEF: IMPERIAL LION HUNT
(8041)

130 × 197 mm. Pen and brown wash over pencil.

From the Pozzo-Albani drawings.

Sculpture in the Villa Doria-Pamphili, Rome (cf. Vermeule, p. 64).

591. ITALO-ETRUSCAN FUNERARY URN: THE LID AND FRONT PANEL WITH A COMBAT SCENE (8064)

193 × 201 mm. Pen and brown wash.

From the Pozzo-Albani drawings.

After an urn in the Vatican (cf. Vermeule, p. 66).

592. DESIGNS FOR PART OF A CEILING (10856)

380 × 412 mm. overall. Cut irregularly. Pen and brown ink.

The designs include a representation of Hercules and Antaeus.

Probably a seventeenth-century copy after a mid-sixteenth-century design.

ITALIAN SCHOOL
(late 16th century)

593. GRAECO-ROMAN RELIEF: A SEATED MALE DIVINITY, FLANKED BY A DRAPED AND A HALF-DRAPED FEMALE FIGURE (7994)

163 × 208 mm. Pen and dark brown ink, light brown wash over some black chalk.

Original sculpture at the Louvre (No. 391).

The drawing shows the sculpture before restoration.

594. RELIEF REPRESENTING PAN-SATYRS GATHERING GRAPES AND AN INFANT WITH TWO OXEN (7996)

148 × 225 mm. Brown ink and brown wash. Numbered: *113* (or *118*).

By the same hand as No. 593.

595. LID OF THE LARGE SARCOPHAGUS FROM THE THEATRE OF MARCELLUS (8062)

100 × 205 mm. Pen and brown washes.

From the Pozzo-Albani drawings.

Sculpture in the Museo Torlonia (cf. Vermeule, p. 65).

By the same hand as No. 593.

596. ENRICHED PILASTER CAPITAL (8629)

128 × 177 mm. Pen and black ink. Numbered: *52.*
From the Pozzo and Albani collection.

From the Pozzo and Albani collections.

The present location of the capital is unknown (cf. Vermeule, p. 43).

597. STUDIES OF PART OF A SARCOPHAGUS LID (?): EROTES AND SEA-BEASTS (8600)

97 × 431 mm. Pen and brown ink over pencil indications.

From the Pozzo-Albani drawings.

Similar reliefs are in the Palazzo Massimi alle Colonne and Palazzo Mattei di Giove (cf. Vermeule, p. 40).

598. DESIGN FOR A VASE (11308)

165 × 136 mm. Black chalk.

599. DESIGN FOR A VASE (11309)

206 × 137 mm. Pen and brown ink, light brown wash.

600. CHRIST RISING FROM THE TOMB (Popham and Wilde, No. 1201) (3638)

Antal originally suggested the name of Lilio, but later (p. 35) proposed that of Ferrau Fenzoni (1562–1645).

ITALIAN SCHOOL
(c. 1600)

601. A NARROW-NECKED EWER, EMBOSSED WITH CLASSICAL FIGURES (11304)

219 × 131 mm. Pen, brown washes.

Probably by the same hand as No. 602.

602. A EWER WITH A ROUNDED BASE, TWO ALTERNATIVE DESIGNS FOR THE LIP AND HANDLE (11322)

286 × 220 mm. Pen and brown ink, brown wash.

Probably by the same hand as No. 601.

603. A PUTTO HOLDING A HORN OF PLENTY (0112)

183 × 90 mm. Pen and brown ink, much rubbed.

604. HEAD OF A WOMAN, WEARING A VEIL, IN PROFILE TO RIGHT (0366)

150 × 144 mm. Red chalk on brown paper.

ITALIAN SCHOOL
(17th century)

605. HEAD OF A WOMAN, THREE-QUARTERS TO LEFT (0365)

294 × 212 mm. Red and black chalks.

Early seventeenth century.

606. DESIGN FOR A TITLE-PAGE (*Plate 67*) (5515)

207 × 140 mm. Pen and brown wash, over black chalk.

Inventory A, p. 53: 'Perin.º del Vaga, Baldʳᵉ Peruzzi, Nico: del Abatte &c.'.

The arms could be those of a large number of Italian families, of which the Baglioni, Giustiniani, Morosini, Vendramin, San Severino and Sagredo are the most celebrated. If one could be certain that the hat was that of a cardinal, the only candidates at the right date would be the Venetian Francesco Vendramin (d. 1619) and the Neapolitan San Severino (d. 1623), of whom the latter would have the better claim, since the drawing does not seem to be Venetian.

Early seventeenth century.

607. TWO PUTTI CARRYING A CUIRASS AND SUPPORTING AN ENTABLATURE (10433)

167 × 141 mm. Red chalk.

608. A BLOCK DECORATED WITH AN ACANTHUS AND A PALMETTE (10438)

118 × 168 mm. Red chalk. Numbered: *14*.

From the Pozzo and Albani collections.

Perhaps by the same hand as No. 607.

609. DESIGN FOR A PIECE OF WALL DECORATION (10779)

310 × 168 mm. Top right corner missing; cut on all sides. Pen and brown ink, brown and grey washes, on faded and darkened paper.

The design includes an eagle and a leopard, each supporting a blank escutcheon, one of which is surmounted by a cardinal's hat.

Fragment of a large design. Early seventeenth century.

610. A BISHOP GIVING ALMS AT A CHURCH DOOR (5028)

297 × 196 mm. Pen and brown ink, grey wash, on buff paper.

Mid-seventeenth century.

611. ANGELS ADORING THE CRUCIFIX (5673)

197 × 158 mm. Pen and black ink, grey washes, on dark brown paper.

From the Lanfranco volume.

Late seventeenth century.

612. CHRIST APPEARING TO THE VIRGIN MARY (5523)

342 × 275 mm. Pen and brown ink and water-colour, on buff paper.

The technique is unusual in Italy and the drawing may be by a German artist working in the south.

Late seventeenth century.

613. FIGURES AMONG TREES IN A LANDSCAPE (6150)

248 × 412 mm. Pen and dark brown ink.

Verso: Design for an over-door, a panel with rounded ends: landscape, with a lake amidst rocks. Brown ink, reddish wash. Inscribed: *Soprᵃ La porta del Camer:*

Inventory A, p. 115: 'Paesi di N. & G. Poussin e Altri'.

614. THE ENTRANCE TO A HOUSE IN A WOOD:
HUNTSMEN AND A DOG (6143)
209 × 275 mm. Pen and grey ink.
Verso: Mountebanks acting on a stage among trees, horse-
men and carriage. Pen, brown ink and black chalk.
Inventory A, p. 115: 'Paesi di N. & G. Poussin e Altri'.

615. TREES AND ROCKS OVER A LAKE, A ROAD IN
THE FOREGROUND (6160)
218 × 185 mm. Pen and brown ink.
Inventory A, p. 115: 'Paesi di N. & G. Poussin e Altri'.

616. LANDSCAPE: A STREAM AMONG WOODED HILLS
 (6158)
190 × 248 mm. Pen and brown ink. An old ascription to
I. Salviati on the mount.
Inventory A, p. 115: 'Paesi di N. & G. Poussin e Altri'.

617. VENUS AND ADONIS (6174)
185 × 212 mm. Black chalk.
Inventory A, p. 103: 'N. Poussin, Le Seur &c: Tom. III:
"Venus and Adonis" . . . These by Le Seur.'

618. CLORINDA SAVES OLINDO AND SOPHRONIA
FROM THE PYRE (6654)
386 × 547 mm. Pen and brown wash, heightened with
body-colour, on prepared paper.
The drawing illustrates a passage from Tasso, *Gerusalemme
liberata*, Canto II.

619. HEAD OF A BOY, FULL FACE, LOOKING DOWN
 (5382)
207 × 160 mm. Black chalk.
By the same hand as No. 620.

620. HEAD OF A WOMAN, NEARLY FULL FACE (5381)
207 × 159 mm. Black chalk.

621. HEAD OF A GIRL (5419)
289 × 216 mm. Black chalk, touches of white, on dark grey
paper.
Inventory A, p. 19: '10 School of the Carracci'.

622. HUNTSMEN AND DOGS BY A RIVER (5757)
181 × 255 mm. Pen and brown ink, over black chalk.

623. A WILLOW TREE LEANING OVER A STREAM
 (5767)
181 × 257 mm. Pen and brown ink.
Inventory A, p. 119: 'Paesi Diversi . . . By Fratti and
Donato Creti of Bolognese.'

624. STUDY OF TREES (6138)
285 × 205 mm. Pen and grey ink, cut all round.
Inventory A, p. 115: 'Paesi di N. & G. Poussin e Altri'.

625. HEAD OF A ROMAN MATRON (090)
147 × 101 mm. Pen and brown ink.

626. A NUDE MAN SEATED, BACK TO SPECTATOR,
TALKING TO ANOTHER OF WHOM ONLY THE HEAD
AND SHOULDERS ARE VISIBLE (0358)
186 × 213 mm. Red chalk on faded paper.

627. HEAD OF A MAN, LOOKING DOWN, THREE
QUARTERS TO LEFT (0252)
144 × 97 mm. Red and black chalk, brown wash. Two pen
inscriptions are illegible.
It seems to have had an old attribution to Pier Francesco
Mola, but is certainly not by him.

628. AN ANGEL ROUSING A YOUNG MAN (0250)
120 × 195 mm. Within a ruled border. Pen and brown
wash.

629. ST. CECILIA (727)
177 × 138 mm. Pen and brown ink on buff paper.
From the Domenichino volumes.

630. THE INFANT CHRIST CONTEMPLATING THE
CROSS (10937b)
91 × 135 mm. Irregularly cut. Pen and brown ink, with
grey wash.
Stuck on to the blank panel of a design for a dome, No.
10937a, but not connected with it.
Late seventeenth century.

631. THE AGONY IN THE GARDEN (0824)
108 × 87 mm. Pen and brown wash over black chalk.
A drawing of such poor quality that any positive attribution
is impossible. Probably late seventeenth century.

ITALIAN SCHOOL
(18th century)

632. THE REPENTANT MAGDALEN, HOLDING A
SKULL AND A BOOK (0125)
320 × 241 mm. Black and white chalk on grey-green paper.
An old attribution to Alessandro Varotari is on the mount,
but there seems no reason to accept it.
Early eighteenth century.

633. MINERVA GARLANDED BY PUTTI: DESIGN FOR
A CEILING OR OVER-DOOR (4498)
199 × 257 mm. Black chalk, grey wash, body-colour, on
blue-grey paper. Inscribed in the 'deceptive' hand:
Cortona.
Probably Roman or Bolognese School, early eighteenth
century.

634. ST. LUKE (4496)
256 × 285 mm. Black and white chalk, in a feigned oval,
on blue paper.

635. ST. MARK (4497)

249 × 291 mm. Black and white chalk, in a feigned oval, on blue paper.

Both drawings are inscribed in the 'deceptive' hand: *Cortona*.

Inventory A, p. 113: 'P. Cortona, Ciro Ferri, Romanelli, Salvator Rosa &c: "Two Evangelists St. Luke and St. Mark"'.

Early eighteenth century.

636. DESIGN FOR A FRESCO IN AN ORNAMENTAL STUCCO FRAME (4491)

420 × 288 mm. Grey washes over faint black chalk. Inscribed in the 'deceptive' hand: *Cortona*.

Inventory A, p. 113: 'Cortona, Ciro Ferri, Romanelli, Salvator Rosa: "A Battle"'.

Probably a scene from *Gerusalemme liberata*.

Early eighteenth century. Mr. Philip Pouncey has suggested that it is by an artist near Carlo Carlone.

637. CHRIST PREACHING BY A LAKE (5507)

364 × 258 mm. Pen and dark ink, light brown wash over black chalk.

Inventory A, p. 53: 'Perin.º del Vaga, Bald.ʳᵉ Peruzzi, Nico: del Abatte &c.'.

Early eighteenth century.

638. HEAD OF A GIRL, IN PROFILE TO LEFT (5424)

Circular. 203 mm. diameter. Black, white and red chalks on grey-green paper.

Inventory A, p. 19: 'Two after Correggio'.

Probably Florentine or Roman School, early eighteenth century.

639. PORTRAIT OF A YOUNG WOMAN, HEAD AND SHOULDERS (5183)

201 × 143 mm. Black and red chalks, touches of white, on grey-green paper.

Early eighteenth century.

640. DEATH OF CATO (6837)

525 × 430 mm. Grey wash over black chalk.

Probably early eighteenth century.

641. ST. CATHERINE OF SIENA (6740)

196 × 260 mm. Black, red and white chalks, on dark grey paper. In a feigned oval.

Inventory A, p. 128: '30 Of Bacicia Galli, Lazzaro Baldi, Baglione etc.'.

642. A YOUNG MAN, HEAD AND SHOULDERS, LOOKING UP (5420)

273 × 190 mm. Black chalk, touches of white, on dark brown paper.

643. PUTTI PLAYING, IN PAIRS: SIX DESIGNS (0214)

193 × 285 mm. Pen and brown ink, grey wash.

See also: *LODOVICO CARRACCI* (No. 99 above).

MILANESE SCHOOL

644. THE TRIUMPH OF FAITH (*Fig. 41*) (6850)

392 × 490 mm. Pen, brown and yellow washes, heightened with white, on prepared paper. Inscribed *Piola* in ink in two writings, one being the 'deceptive' hand.

Inventory A, p. 126: '1 Emblematical with Architecture, of the Triumph of Faith'.

Faith, holding the Cross and the Papal Tiara, stands on a cloud, accompanied by two putti holding the Keys and the Tables of the Law. Above her is the dove and below on the left three allegorical figures, of which the middle one is probably Fortitude, further down Envy and Discord. On the right Prudence and two other female allegorical figures.

The architecture shows quite precisely the two courts of the Collegio Elvetico, Milan, founded by S. Charles Borromeo and built by his nephew, Cardinal Federico, whose arms appear at the top of the drawing on a separate piece of paper.

Professor Anna Maria Brizio has suggested that the drawing is for the decoration of a thesis and pointed out its similarity to an engraving for such a thesis (Fig. 48), inscribed *Bartholomaeus Cremonensis delin*, and *Cesar Bastanus Sculpsit Mlni 1624*. The drawing must date from almost the same period.

645. DESIGN FOR A CEILING WITH MUSIC-MAKING ANGELS (10901)

230 × 577 mm. Pen and brown ink, brown and blue washes, on faded paper. Inscribed in pencil on the mount, probably repeating an inscription on the *verso: fra.ᶜᵒ Milanese*.

The identity of the Milanese artist indicated in the inscription cannot at present be established, but he must have worked in the first half of the eighteenth century.

THE ASCENSION (Popham and Wilde, No. 1114)

 (0181)

C. L. Ragghianti (p. 596) has suggested an attribution to Peterzano.

A CHILD BLESSED BY A BISHOP (Popham and Wilde, No. 1121) (5124)

Mr. Philip Pouncey has pointed out that this drawing corresponds to a picture on the west wall of S. Abbondio, Como, the author of which is not known.

See also: *GIOVANNI GIROLAMO SAVOLDO* (No. 435 above), and *ROMAN SCHOOL* (Popham and Wilde, No. 1132).

NEAPOLITAN SCHOOL

646. HEAD OF AN OLD MAN (*Plate 59*) (5161)

273 × 210 mm. Black and white chalk, on blue paper.

Fig. 41 Cat. No. 644

The drawing is traditionally attributed to Jordaens and catalogued as such by Puyvelde (*Flemish Drawings*, No. 248), but it is clearly Italian. The type of head is common in works by Ribera and his followers (e.g. Stanzione, *Susanna*, Städelsches Kunstinstitut, Frankfort), but drawings by this group of artists are so rare that a definite attribution is difficult. The head has also affinities with the work of Langetti, who evolved a Venetian form of the naturalism which was indigenous to Naples; but here again the evidence is too sparse to allow of any definite attribution.

647. SHIPS ARRIVING ON A COAST, A CASTLE AND
A HOUSE IN THE DISTANCE (3526)

175 × 286 mm. Pen and black ink, brown washes, over black chalk.

Inventory A, p. 116: 'Paesi di Maestri Bolognese'.

Eighteenth century, probably Neapolitan.

648. THE VIRGIN WITH ST. LUKE AND ST. JOHN
THE EVANGELIST (5315)

319 × 179 mm. Black chalk, touches of white, on brown paper. Cut on both sides.

Inventory A, p. 82: 'Francesco Albano, C. Cignani etc.'.

Design for a round-headed altarpiece.

Perhaps Neapolitan School, probably early eighteenth century.

NORTH ITALIAN SCHOOL

649. STUDIES OF AN OLD MAN KNEELING, AND
DRAPERY (098)

132 × 203 mm. Red chalk.

Verso: Studies of an old man, a young man kneeling in adoration, and a cart. Red chalk. An inscription in brown ink in a sixteenth-century German hand, which appears to read: *Johans von ach* . . . Below in pencil in a much later hand: *Georgeon.*

The presence of a German inscription has led to the suggestion that this drawing is by a German artist, but it

is clearly Italian. The attribution to Giorgione, indicated in the later inscription, points in the right direction, and the drawing is probably by an artist working on the Venetian *terra firma*, perhaps at Brescia, in the early part of the sixteenth century.

650. TWO STUDIES OF A SANDALLED FOOT (11225)

120 × 112 mm. Pen and brown ink.

Presumably after the Antique.

From the first half of the seventeenth century.

651. SARCOPHAGUS RELIEF: THE BIRTH OF VENUS, TRITONS, NEREIDS (8601)

208 × 772 mm. Pen and dark ink, brown and grey wash, heightened with white (oxydised).

From the Pozzo-Albani drawings.

The original relief was formerly in the Palazzo Lancellotti and is now in the Museo Profano Lateranense (cf. Vermeule, p. 41).

Late sixteenth century.

652. DESIGN FOR A FOUNTAIN (10776)

309 × 229 mm. Black chalk, pen and brown wash. Inscribed: *tutte queste ficure se non si vogliano far di bronzo gli poso far di terra cotta fortisimi et coloriti a modo di bronzo.*

The swans which occur prominently in the design may have a heraldic significance.

Very late sixteenth century.

653. BATTLE OF THE PARTHIANS (8145)

183 × 370 mm. Pen and brown wash, heightened with white. Numbered in the bottom right-hand corner: 77.

From the Pozzo and Albani collections.

After the Ludovisi Battle Sarcophagus in the Museo Nazionale, Rome (cf. Vermeule, p. 8).

Sixteenth century.

656. DESIGNS FOR A DORIC CORNICE (10774)

126 × 424 mm. Pen and brown wash.

657. DESIGN FOR A CORNICE WITH BUSTS OF ROMAN EMPERORS (10775)

133 × 396 mm. Pen and Brown wash, with black chalk.

The second drawing includes eagles between the busts, no doubt with a heraldic significance.

C. 1600.

658. TRAVELLERS BY A RIVER, RESTING UNDER TREES (5727)

178 × 265 mm. Pen and brown ink. Damaged and stained. C. 1600.

659. THE THREE MARYS (0161)

294 × 246 mm. Pen and brown ink.

660. THE ENTOMBMENT (12171)

233 × 196 mm. Pen and brown ink.

661. HEAD OF A BEARDED MAN (7207)

115 × 89 mm. Pen and brown ink.

From Consul Smith's volume of caricatures.

662. HEAD OF A MAN IN A POINTED CAP (7209)

116 × 88 mm. Pen and brown ink over red chalk.

From Consul Smith's volume of caricatures.

These two drawings are imitations of German works of the early sixteenth century, but the actual execution suggests that they are by North Italian rather than German artists, probably of the early seventeenth century.

663. HEAD OF A BEARDED MAN IN A TURBAN (5146)

149 × 182 mm. Red chalk, heightened with body-colour.

Mid-seventeenth century.

664. CARICATURE OF A MAN, FULL-LENGTH, STANDING HOLDING A PAPER WINDMILL BEHIND HIS BACK (7202)

297 × 179 mm. Pen and brown ink.

From Consul Smith's volume of caricatures.

According to Smith's list, this should be one of four drawings attributed to Annibale Carracci, but it appears to be later, dating probably from the middle of the seventeenth century.

665. THE VIRGIN INTERCEDING WITH THE TRINITY FOR A PLAGUE-STRICKEN COUNTRY (6780)

296 × 168 mm., arched top. Pen and brown ink, brown washes.

Inventory A, p. 128: 'Moderna Schuola Romana'.

The theme is not uncommon, but usually shows Christ rather than the Trinity (cf. drawing by Castiglione in the Royal Collection (Blunt, *Castiglione*, No. 193, reproduced p. 20), which is derived from a lost ceiling painting by Strozzi at Genoa).

Late seventeenth century.

666. A MARINE TRIUMPH (5123)

292 × 259 mm. Black chalk and brown wash.

Probably a seventeenth-century copy after a painting of the same period.

667. ADORATION OF THE SHEPHERDS (3808)

158 × 225 mm. Brown and grey washes, heightened with white, on grey-green paper. Inscribed in the 'deceptive' hand: *Paolo.*

Inventory A, p. 21: 'Bolognesi Moderni'.

The technique is Venetian, the types recall Parmigianino, and the composition seems to reflect the influence of Poussin.

668. ALLEGORICAL STUDY: A FEMALE FIGURE SUPPORTED BY A LION AND HOLDING A SCEPTRE AND A CORNUCOPIA, AND A MAN HOLDING A SCEPTRE AND A LANCE(?), SEATED ON CLOUDS (5202)

169 × 263 mm. Red chalk, brown washes, over black chalk. Squared.

Seventeenth century.

669. HEAD OF A MAN, IN PROFILE TO RIGHT (5413)

267 × 176 mm. Black and white chalks, on dark brown paper.

Inventory A, p. 19: '10 School of the Carracci'.

Seventeenth century.

670. DESIGN FOR A CEILING DECORATION (10916)

383 × 237 mm. Pen and brown ink, blue and brown washes, a little gold.

The design comprises four wide panels, separated by scrolled borders. One of the panels shows a balustrade open to the sky, one a cornice with swags, and the other two decorative panels.

First half of the eighteenth century.

671. DESIGNS FOR THE DECORATION OF A WALL AND VAULT

308 × 194 mm. Pen and brown wash, heightened with white, on buff tinted paper. (10938)

332 × 191 mm. Same technique. (10939)

No. 10939 shows a section of the wall with a niche, in which stands the figure of a turbaned man beside a brazier, probably symbolizing Winter. The vault (No. 10938) is decorated with putti and decorative panels, with an opening in false perspective in the middle. Dr. Arnold Noach has proposed the name of Giacomo Pavia (1699–1750) for these drawings.

672. DESIGN FOR A COACH (13998)

394 × 293 mm. Black chalk, purple wash, on grey paper. Inscribed in ink at the foot: *Design for a State Coach.*

Acquired with the two designs for a state coach by Cipriani and Sir William Chambers (*English Drawings*, Nos. 116, 117) from the Librarian of the Guildhall in November 1937.
The presence of an eagle and a lily among the decorative motifs would connect the coach with the Este family of Modena.

Mid-eighteenth century.

673. AN ITINERANT SINGER HOLDING OUT A PLATE (7203)

205 × 162 mm. Pen and grey ink over black chalk.

From Consul Smith's volume of caricatures.

One of the four caricatures attributed by Smith to Annibale Carracci, but certainly early eighteenth century.

674. THE FLAGELLATION (Popham and Wilde, No. 38) (12814)

This drawing, originally ascribed to Altichiero, was catalogued as late fourteenth-century Bolognese. C. L. Ragghianti (p. 596) suggests that it is Lombard, about 1450. This date is probably a little too late and the drawing is probably from about 1410–20.

See also: *MARCO CARDISCO* (Popham and Wilde, Nos. 87, 88); *PIETRO NEGRONI* (No. 316 above), and *MATTEO ROSSELLI* (Nos. 411, 412 above).

PARMESE SCHOOL

675. COMPOSITION SKETCH FOR A SCENE IN A CHURCH (*Plate 7*) (0532)

164 × 123 mm. Cut irregularly on right. Pen and ink over black chalk, on blue paper, heightened with white.

Below the study of a woman's hands in metal point.

676. THE FIGURE OF A BISHOP STANDING IN A NICHE (*Plate 6*) (6430)

133 × 81 mm. Pen and brown ink on grey-green paper, heightened with body-colour.

Inventory A, p. 105, as Flemish.

Catalogued by Puyvelde as by Bloemaert (*Dutch Drawings*, No. 89), but certainly by a follower of Parmigianino.

677. THE HOLY FAMILY WITH ST. JOHN, ST. ELIZABETH AND AN ANGEL (6431)

139 × 111 mm. Pen and brown ink, on faded yellow-brown paper, heightened with body-colour.

Catalogued by Puyvelde as by Bloemaert (*Dutch Drawings*, No. 90), but certainly Italian and probably Parmese.

See also: *MICHELANGELO ANSELMI* (Nos. 14, 15 above), and *GIULIO CAMPI* (Nos. 75, 76 above).

PIEDMONTESE SCHOOL

678. DESIGN FOR AN ALTAR WITH FIGURES OF ST. JOHN THE BAPTIST AND ST. JOHN THE EVANGELIST (*Fig. 42*) (5494)

369 × 268 mm. Pen and brown wash. Inscribed: *Baldassare* and *Di Baldassare*, with measurements, one of which is given as: *onsi 1 1/2*.

Inventory A, p. 53 : 'Perino del Vaga, Peruzzi, Nicolo del Abbate, etc.'.

The inscription is probably intended to refer to Baldassare Peruzzi, but the drawing is evidently much later. The exact dating is difficult, because the central tabernacle is Vignolesque, the panel below the figure of St. John the Baptist is composed of Fontainebleau strap-work, whereas the figure of God the Father at the top suggests the incipient Baroque. The most plausible date appears to be c. 1610–20.

Fig. 42 Cat. No. 678

Mr. Howard Burns has pointed out that the spelling *onsi* for *oncie* suggests that the artist was Piedmontese, and this would be supported by the presence of French strap-work.

ROMAN SCHOOL

679. FIGURES FROM A BACCHIC SARCOPHAGUS
RELIEF (8331)
120 × 227 mm. Top corners cut. Pen and grey ink, brown wash.

From the Pozzo-Albani drawings.

Probably after a sarcophagus at Pisa, Campo Santo, but only copying certain parts of the original (cf. Vermeule, p. 21).

From the first half of the sixteenth century.

COPIES AFTER ANCIENT ROMAN FRESCOES

680. 208 × 278 mm. Brown ink. (9567)

681. 243 × 340 mm. Same technique. (9568)

682. 183 × 277 mm. Brown ink on tracing paper. (9569)

683. 125 × 190 mm. Same technique. (9570)

684. 244 × 230 mm. Same technique. (9571)

685. 124 × 234 mm. Same technique. (9572)

After drawings of the early sixteenth century.

686. STUDIES AFTER AN ARCHITECTURAL RELIEF:
TRITONS AND SEA-MONSTERS (8599)
248 × 420 mm. Pen and brown wash over pencil. Some figures in pen only.

From the Pozzo-Albani drawings.

The middle and bottom rows of the drawing were made from a frieze in the Museo delle Terme, Rome (cf. Vermeule, p. 40).

Sixteenth century.

687. THE LEFT PORTION OF A BACCHIC
SARCOPHAGUS RELIEF: DIONYSUS IN PROCESSION
 (8638)
226 × 352 mm. Pen and brown wash over pencil.

From the Pozzo-Albani drawings.

After a sarcophagus at Woburn Abbey (cf. Vermeule, p. 44).

Late sixteenth century.

688. DESIGN FOR THE DECORATION OF A CHAPEL:
THE BURIAL OF THE VIRGIN (10913)
166 × 320 mm. Cut on all sides. Pen and brown wash, over slight black chalk.

Late sixteenth century.

689. SARCOPHAGUS RELIEF: DIONYSUS RIDING IN
PROCESSION (8637)
172 × 434 mm. Pen and brown wash over black chalk.

The original is in the Villa Medici, Rome (cf. Vermeule, p. 43).

Verso: A sea-creature and a rhinoceros, etc. Red chalk. After a relief in Naples.

Late sixteenth century.

690. DESIGN FOR A COFFERED CEILING, WITH
SCENES FROM THE OLD TESTAMENT (*Fig. 43*) (10493)
510 × 520 mm. Pen and black ink with water-colour.

Verso: A landscape and three studies of heads. Red chalk.

The central panel shows David and the dead Goliath. In the four corners are: Judith and Holofernes, David and Jonathan, David stealing the arms of Saul, and a scene which is difficult to identify, showing a king turning away from a man standing in the mouth of a cave and holding out an unidentifiable object. Two other panels contain the coat of arms of an ecclesiastic which cannot, unfortunately, be identified.

691. FRONT OF A BACCHIC SARCOPHAGUS WITH
PROTRUDING LION MASKS (8631)

Fig. 43 Cat. No. 690

150 × 412 mm. Brown ink over black chalk. Watermark: Tree in circle, star above.

From the Pozzo-Albani drawings.

After a sarcophagus of which the present location is unknown (cf. Vermeule, p. 43).

Late sixteenth century.

692. DESIGN FOR THE DECORATION OF AN APSE
(10907)

205 × 348 mm. Semi-circular. Pen and brown wash, over black chalk.

The design contains a central roundel showing the Almighty and putti.

Mr. John Gere has suggested that the drawing is by the same hand as a drawing for a decoration of a chapel in the Victoria and Albert Museum by a Roman artist in the last quarter of the sixteenth century.

693. HEAD AND SHOULDERS OF A YOUNG MAN,
LOOKING UP TO RIGHT (5400)

370 × 250 mm. Brown washes and body-colour.

Inventory A, p. 19: 'A Boy's Head Arpino'.

Based on the head of the left-hand of the two sons in the *Laocoon*.

Probably c. 1600.

Fig. 44 Cat. No. 694

Fig. 45 cf. Cat. No. 694

**694. DESIGN FOR THE TOMB OF CARDINAL
GIOVANNI BATTISTA CICADA (*Fig. 44*) (11899A)
297 × 223 mm. Black chalk.**

This drawing is in a volume of interesting but very inferior
drawings of late mediaeval and Renaissance tombs in
Rome which may possibly have been brought together by
Cassiano dal Pozzo. It is, however, entirely different in
style from the main series and is clearly an original design
for a tomb and not, like the others, a drawing after an
existing monument.

It is inscribed on the verso: *Card*le *Rebiba in S. Silvestro si
vede*. This must, however, simply be a mistake, since it
bears no resemblance to the Rebiba tomb which still
exists in S. Silvestro al Quirinale, and the arms are not his.
It is in fact for the tomb-slab of Cardinal Giovanni Battista
Cicada in S. Maria del Popolo, Rome. This still exists in
the chapel of S. Rita da Cascia (off the south transept),
which was previously dedicated to S. Lorenzo and then to
S. Lucia. The inscription is recorded by Forcella (*Inscrip-
tiones*, I, p. 350, No. 1349). The tomb was originally in the
Cappella Cybo, the second on the right of the nave, but
it was removed when this chapel was restored by Carlo
Fontana for Cardinal Alderamo Cybo between 1682 and
1687 (cf. R. Colantuoni, *La chiesa di S. Maria del Popolo*,
Rome, 1899, pp. 89, 114). It seems to have been badly
damaged when it was removed to its new location, as
can be seen by comparing its present state (Fig. 46) with

a drawing in the same volume at Windsor which records
its appearance in the seventeenth century (Fig. 45). As it
stands today it consists of a bronze coat-of-arms surrounded
by two cartouches enclosed in ribbons, while above and
below are long Latin inscriptions. The border which
originally surrounded it has disappeared and has been
replaced by a band of black marble. In this way the unusual
decorative features of eagles and cross-bones have dis-
appeared. In the drawing after the tomb these elements
are shaded like the coat-of-arms, which seems to indicate
that they, too, were to be in bronze.

The original drawing contains two alternative schemes.
The artist first drew in faint black chalk a smaller design,
with the eagles and cross-bones immediately surrounding
the coat-of-arms, but over this he has drawn, in a much
blacker and softer chalk, an alternative with the coat a
little lower down and a broad area between it and the
surrounding border. In the execution the second scheme
was followed, though it was modified by the addition of the
ribbon-cartouches.

The inscription states that the tomb was set up by Carlo
Cicada, Bishop of Albenga, who was the Cardinal's
nephew and heir, and that it was made according to
instructions left in his will. The Cardinal died in 1570,
and it seems reasonable to assume that the tomb was
made soon after. The combination of marble and bronze
is unusual at this time in Rome, but other tomb-slabs in
exactly the same style are to be found in S. Maria del

IO·BAPTISTÆ CICADÆ GENVEN·
EPISCOPO SABINEN·S·R·E·
CARDINALIS·S·CLEMENTIS
VIRO INGENII ACVMINE
ET VBERTATE CONSILII
ADMIRABILI OMNIVM
OFFICIOSISS·IVR·RERVMQVE
VRBANARVM ET FORENSIVM
VSV AC INTELLIGENTIA
PERITISS·
LIBERTATIS ECCLESIASTICAE
DEFENSORI STVDIOSISS·

CAROLVS CICADA EPISC·
ALBINGANEN·
HAERES EX TESTAMENTO
PATRVO B·M·P·
VIX·ANN·LX·OBIIT DIE VIII
APRIL·M·D·LXX·

Fig. 46 cf. Cat. No. 694

Popolo. In the middle of the nave is that of Paolo Montori of Narni, nephew of Cardinals Paolo and Federico Cesi, who died in 1581. The tomb was commissioned by his heirs (cf. Forcella, *op. cit.*, I, p. 361, No. 1392). Fragments of another survive just inside the west door of the church. This was to commemorate Inico Piccolomini, Duke of Amalfi, who died in 1566. Only the inscription, the skull and the bones survive, but the middle section probably contained the arms of Piccolomini in bronze.

695. HEAD OF A MAN (8020 *verso*)
The whole sheet 82 × 202 mm. The head, c. 100 mm high, cut off by the edge of the paper. Red and black chalk.
Recto: Drawing after the Antique.
From the Pozzo and Albani collections.
In technique the head is close to Federico Zuccaro, but the style does not seem to be exactly his. The drawing on the *recto* belongs to a series which all seem to date from the very end of the sixteenth century.

Fig. 47 Cat. No. 696

696. DESIGN FOR A CEILING WITH THE ARMS OF PAUL V (*Fig. 47*) (10914)

240 × 524 mm. Pen and brown ink, with brown, grey and yellowish wash. The group of putti supporting the tiara on a separate piece of paper stuck down over an earlier version.

The drawing has not so far been identified as a study for any known fresco commissioned by Paul V (1605–21).

697. DESIGN FOR A FRIEZE (10896)

112 × 394 mm. Pen and brown wash over some black chalk.

The frieze includes two blank coats of arms, one with a papal tiara, the other with a canon's hat. In the middle panel are two doves, an olive branch and a palm branch. The first two point to the Pamphili family. The design must have been made either for Giovanni Battista Pamphili (1574–1655), later Pope Innocent X, before he became a cardinal in 1627, or for a relative of his who was a canon. The style of the drawing points to a date relatively early in the seventeenth century and supports the former hypothesis.

698. DESIGN FOR A DEEP FOUR-LOBED WINE GLASS (11301)

91 × 74 mm. Pen and brown ink, with brown and blue wash, over chalk indications.

Mr. Robert Charleston dates this glass, which is clearly of Venetian manufacture, to the early seventeenth century and points out that a group of drawings by Ligozzi in Florence includes some of similar glasses (cf. L. Zecchin, 'Disegni vetrari del Seicento', in *Sulla storia dell'arte vetraria*, Venice, 1961, p. 63). For the handles parallels may be found in a set of drawings known as the *Libro del Serenissimo Principe d'Este*, which dates from the second quarter of the seventeenth century (cf. A. Gasparetto,

'Quattro "Zuccarini" al Museo di Murano', *Bollettino dei Musei Civici Veneziani*, 1959, Figs. 13–14).

Although the glass is Venetian, the drawing, which appears to have been made for Cassiano dal Pozzo, is probably Roman. It must date from before Pozzo's death in 1657 and was probably made in the first quarter of the seventeenth century.

699. DESIGN FOR A SCREEN ACROSS THE WESTERN APSE OF ST. PETER'S (5590)

371 × 422 mm. Pen and brown ink, on darkened paper. From the Bernini volume.

The drawing was published by Dr. H. Thelen, *Francesco Borromini. Die Handzeichnungen*, Vienna, 1967, p. 14 and Fig. 24. It shows a scheme, otherwise unrecorded, for building across the extreme western bay of St. Peter's a screen, which would have cut off the apse containing the papal throne. A drawing by Borromini after a design by Maderno for a similarly placed screen, quite different in its details, is in the Albertina (reproduced Thelen, *op cit.*, No. 8).

C. 1605–6.

700. FAÇADE OF A CHURCH (10739)

471 × 326 mm. Pen and brown ink, on much darkened paper. Inscribed: *Disegno della Facciata della Vittoria . . . di Gio. Batt.ª Soria Romano A.º 1606.*

The inscription is clearly based on a series of confusions. Soria was only concerned with the building of the façade of S. Maria della Vittoria at a much later date than 1606 —he was only born in 1581—when, incidentally, the church was still called S. Paolo. Moreover, the drawing has no connection with any recorded design for the façade. It is probably a copy of a lost drawing by one of the

classicizing group round Soria, dating from about 1630. The fact that the double-cross of Lorraine is so prominently displayed on the point of the pediment must have a significance, but this cannot at present be interpreted. It might suggest that it is a design for S. Nicola dei Lorenesi, but it does not fit the site or the known facts about the building of the church.

701. A HEAD (8946 verso)

406 × 225 mm. Red chalk.

From the Pozzo and Albani collections.

On the verso of one of the drawings after mediaeval mosaics made for Pozzo.

702. VIEW OF THE CASCADE AT THE VILLA ALDOBRANDINI (1553)

288 × 328 mm. Pen and brown ink. With notes of materials (Granita bianca, granita rossa, piperino, etc.).

From the Domenichino volumes.

The drawing is cut on the left and was no doubt originally symmetrical about the line down the middle of the cascade. It has been folded over at this point, and the design has been pricked through from the right to the left side, a feature which suggests that it may be a preparation for an engraving. It cannot, however, be connected with any of the known engravings of the Villa by Barrière or Falda. The drawing has been published and discussed by K. Schwager, 'Kardinal Pietro Aldobrandinis Villa di Belvedere in Frascati', Römisches Jahrbuch für Kunstgeschichte, IX–X, 1961–62, pp. 356 f. Schwager points out that, though the drawing shows details such as the statues in the smaller niches with great precision, the big niches are empty, and concludes that it must have been made before the statues which now fill these niches were executed. This would suggest a date of slightly before 1621, when Jacques Sarrazin was paid for the Hercules in the central niche (cf. Cesare d'Onofrio, La Villa Aldobrandini di Frascati, Rome, 1963, p. 141).

703. ELEVATION OF A CHURCH (10381)

597 × 549 mm. Pen and brown ink.

The drawing shows a church with a tetrastyle Corinthian portico and a low dome supported on a drum articulated with an order of low Corinthian pilasters. It does not appear to be related to any known building.

Early seventeenth century.

704. HEAD OF A BEARDED MAN (? BACCHUS) (8495 verso)

130 × 287 mm. Black chalk.

From the Pozzo and Albani collections.

On the verso of one of Pozzo's drawings after the Antique.

705. FIGURE STUDIES (8276 verso)

(a) GOD THE FATHER. On a separate piece of paper (188 × 193 mm.), joined to two others to make a sheet large enough to contain the drawing after the Antique on the recto. Red chalk.

(b) HEAD OF A WOMAN. On a separate piece of paper. 185 × 193 mm. Black chalk.

From the Pozzo and Albani collections.

706. STUDIES OF A MALE NUDE AND A WOLF'S HEAD (8252 verso)

503 × 338 mm. Black chalk on grey paper.

Recto: Drawing of a trophy after the Antique.

The drawing belongs to a group of drawings which are close to Testa in style, and the verso drawing may also possibly be by him.

Mid-seventeenth century.

707. DESIGN FOR A MOULDING (10749)

190 × 243 mm. Pen and brown ink. Lines ruled in black chalk.

Perhaps by an artist working in the circle of Pietro da Cortona.

708. STUDIES FOR DOUBLE-HANDLED URNS (11269–71)

120 × 229 mm. Pen, grey and brown wash.

Further designs for similar urns are shown on the verso of each sheet.

Early seventeenth century.

709. DESIGN FOR A TWO-HANDLED URN (11314)

333 × 207 mm. Pen and brown ink, grey wash.

First half of the seventeenth century.

710. FORTITUDE IN A CHARIOT, ACCOMPANIED BY TWO RIVER-GODS, POINTS TO THE SYMBOL OF THE HOLY TRINITY (6788)

235 × 469 mm. Brown and grey washes, some body-colour, over black chalk.

Inventory A, p. 128: 'Moderna Schuola Romana'.

Late seventeenth century.

711. STUDY OF A HEAD (11220)

84 × 97 mm. Pen and brown ink.

Late seventeenth century.

712. THREE WOMEN DANCING (11386)

157 × 213 mm. Pen and brown wash.

Seventeenth century.

713. GROTESQUE HEAD (11310)

84 × 97 mm. Red chalk.

Seventeenth century.

714. STUDIES OF THREE EWERS AND AN URN (11263)

164 × 211 mm. Black and white chalk, on grey-blue paper.

Verso: Hasty sketch of a jug.

Seventeenth century.

715. DESIGNS FOR ORNAMENTAL URNS ON
PEDESTALS (11279–11282)
220 × 145 mm. each. Red chalk.
11279 verso: Study of a man, half-length.

716. TWO VASES (11283)
111 × 158 mm. Red chalk.

717. FOUR DESIGNS FOR URNS (11284)
111 × 260 mm. Red chalk.

These six drawings, by the same hand, are probably by
an artist working in Rome in the mid-eighteenth century.

DESIGN FOR SCULPTURED ALTAR (Popham and
Wilde, No. 1132) (0208)
C. L. Ragghianti (p. 595) has suggested that this drawing
is by a Milanese artist between Cristoforo Solari and
Bambaja.

HEAD OF A WOMAN (Popham and Wilde, No. 1133)
 (066)
C. L. Ragghianti (p. 596) ascribes this drawing to Antonio
Solario or Boltraffio, an attribution with which Mr.
Popham does not agree.

A FRAME CONTAINING A PICTURE OF ST. JEROME
(Popham and Wilde, No. 1152) (0207)
Antal (p. 31) suggested that this drawing was by a follower
of Girolamo Muziano.

STUDY FOR ST. JEROME (Blunt and Cooke, No. 1006)
 (4873)

DONNA OLIMPIA MUTI CAFFARELLI (Blunt and
Cooke, No. 1007) (6350)
In the catalogue it was suggested that the nearest stylistic
analogy was with paintings by Orazio Gentileschi, and it
is perhaps worth pointing out that Van der Doort (ed.
Oliver Millar, *Walpole Society*, XXXVII, 1960, p. 126)
records that Charles I owned a volume of drawings by
Gentileschi.

A SATYR TIED TO A TREE (Blunt and Cooke,
No. 1055) (6792)
Miss Jennifer Montagu has identified a drawing in the
Berlin Print Room which has the same group set in a
landscape. The Berlin drawing is inscribed *Io. Pectoralinus
fec . et inv. Rome* (or *Roma*) 1679, but it has so far not been
possible to identify this artist. The Berlin drawing is cer-
tainly not Roman in style and seems to be by a North
Italian or possibly even a Flemish artist working in Rome.

FOUR VIRTUES (Blunt and Cooke, No. 1057) (5555)
Miss Jennifer Montagu has pointed out that the fourth
Virtue is Justice and not Fortitude.

JUDAH AND TAMAR (Blunt and Cooke, No. 1061) (4157)
The subject has been identified by Miss Jennifer Montagu
as Judah and Tamar.

See also: *DOMENICO MARIA CANUTI* (Nos. 85, 86
above); *Attributed to LODOVICO CARRACCI* (No. 102
above); *NICOLO CIRCIGNANI* (No. 118 above); *MARC
ANTONIO FRANCESCHINI* (No. 178 above); *FRAN-
CESCO FURINI* (No. 190 above); *GIOVANNI BATTISTA
LENARDI* (Blunt and Cooke, Nos. 1011–1016); *FRAN-
CESCO MAZZOLA, IL PARMIGIANINO* (No. 334
above); *BALDASSARE PERUZZI* (Nos. 341, 342 above);
Attributed to PIETRO DA CORTONA (No. 361 above);
Studio of PIETRO DI PIETRI (No. 363 above);
DOMENICO PIOLA (No. 367 above), and *DANIEL
SAITER* (No. 426 above).

SIENESE SCHOOL

718. ST. CATHERINE OF SIENA TAKING THE VEIL
 (6667)
256 × 224 mm. Pen and brown wash over black chalk, on
prepared paper. The top right-hand corner made up with
part of a different drawing.
Probably c. 1600.

TWO SEATED BISHOPS

719. 278 × 384 mm. Black chalk on grey-blue paper.
 (0246)

720. 280 × 354 mm. Black chalk on grey-blue paper.
 (0247)

Probably copies after Sienese works of about 1600. Mr.
E. G. Troche has suggested an attribution to Vanni.

VENETIAN SCHOOL

721. DESIGN FOR THE DECORATION OF PART OF A
DOME (10937A)
278 × 240 mm. Pen and brown wash, on grey-blue paper,
heightened with body-colour.

The drawing represents one quarter of a dome decorated in
the manner usual in Venice in the later sixteenth century,
with stucco figures and cartouches. The style is close to
that of Paolo Farinato, but is even more insensitive.
Possibly by the same hand as No. 10905.

722. DESIGN FOR A DECORATIVE PANEL ON A
STAIRCASE (*Plate 19*) (10905)
416 × 263 mm. Pen and brown wash, on grey-green paper,
heightened with body-colour.

Close in technique and style to No. 721. Possibly by the
same hand and for part of the same scheme of decoration.

723. CHRIST MOCKED (5018)
213 × 141 mm. Pen and brown wash over black chalk, on
grey paper.

724. THE FLAGELLATION (5019)
211 × 143 mm. Same technique.

725. THE CRUCIFIXION (5020)
211 × 137 mm. Same technique.

726. THE RESURRECTION (5021)

211 × 139 mm. Same technique.

Inventory A, p. 117, as Paolo Farinati.

The technique of these drawings is that of the Venetian School about 1600, but some of the types suggest that the author may have been a northerner, either German or Flemish, working in Venice.

SCENES FROM THE COMMEDIA DELL'ARTE

727. 162 × 256 mm. Pen and brown ink, brown wash, on tracing paper. (7420)

728. 160 × 270 mm. Cut irregularly. Pen and brown ink, brown wash, on tracing paper. (7421)

Probably c. 1600. The dress suggests Venice.

729. A CHARACTER IN THE COMMEDIA DELL'ARTE
(*Plate 77*) (7217)

213 × 138 mm. Pen and brown ink, grey wash.

From Consul Smith's volume of caricatures.

Ascribed by Smith to Guercino, but probably Venetian School, early eighteenth century.

730. A FAT MAN, STANDING (*Plate 76*) (7219)

255 × 162 mm. Black chalk.

From Consul Smith's volume of caricatures.

Ascribed by Smith to Guercino, but probably early eighteenth century, and possibly Venetian.

731. CARICATURE OF AN ORATOR OR A PREACHER
 (7204)

229 × 190 mm. Red chalk on brown paper.

From Consul Smith's volume of caricatures.

One of the four caricatures attributed by Smith to Annibale Carracci, but probably eighteenth century.

732. A CONCERT (6443)

312 × 374 mm. Black chalk, with touches of body-colour.

Inventory A, p. 105: 'Rubens, Vandyke, Vischer &c. . . .'. Certainly Italian, mid-eighteenth century, and perhaps Venetian, owing to the mixture of contemporary fashions with dress taken from sixteenth-century models.

733. A GOTHIC CASTLE (01413)

Circular. Diameter 420 mm. Pen and dark brown ink.

The outlines have been pricked through from another drawing and then gone over rather roughly with a pen.

C. 1800.

VERONESE SCHOOL

THE MYSTIC MARRIAGE OF ST. CATHERINE
(Popham and Wilde, No. 232) (6025)

This drawing was catalogued as by Pompeo Cesura dell'Aquila, but Mr. Popham is now inclined to accept the suggestion of Antal (p. 32) that it is by a member of the School of Verona.

See also: *CAMILLO BOCCACCINO* (No. 47 above).

ADDENDA

FRANCESCO ALBANI

2A. *Circe* (Wittkower, No. 35) (2122)

This drawing was catalogued by Professor Wittkower as by Ludovico Carracci, but it has been published by R. Rolli (*I disegni italiani del seicento*, 1969, No. 25) with an attribution to Albani.

FRANCESCO GESSI

194A. *The Martyrdom of St. Catherine* (Kurz, No. 437)
 (3231)

This drawing has been identified by Miss Johnston as a study for Gessi's painting of the same subject in the Church of S. Caterina in Strada Maggiore.

ACADEMIA HERMATHENAICORVM SEMINARII MEDIOLANENSIS.

Fig. 48

PLATES

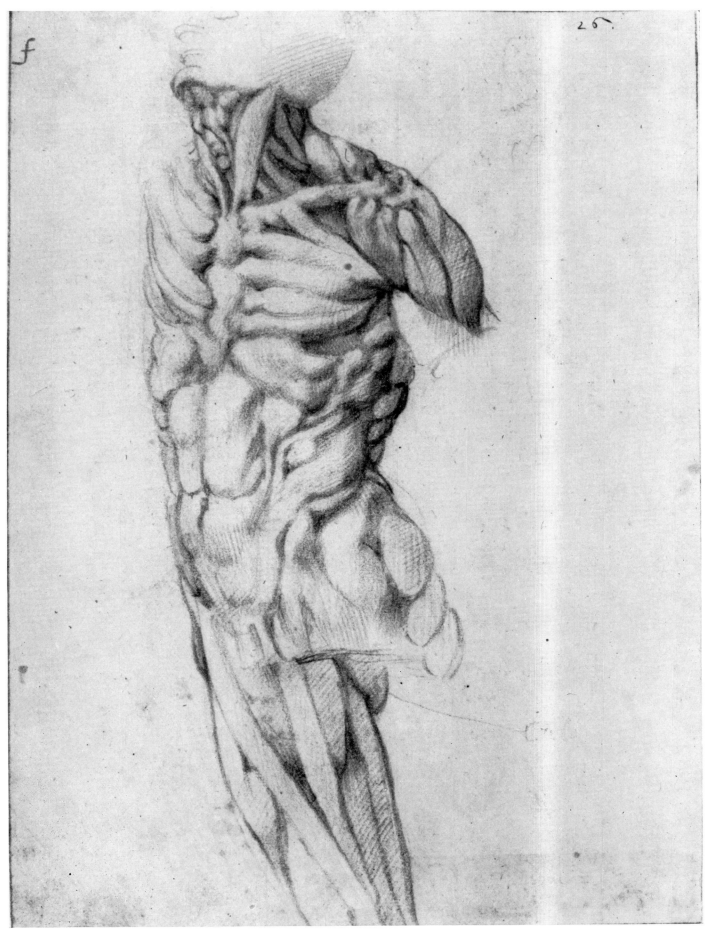

1. Michelangelo: *Ecorché* (Cat. p. 99)

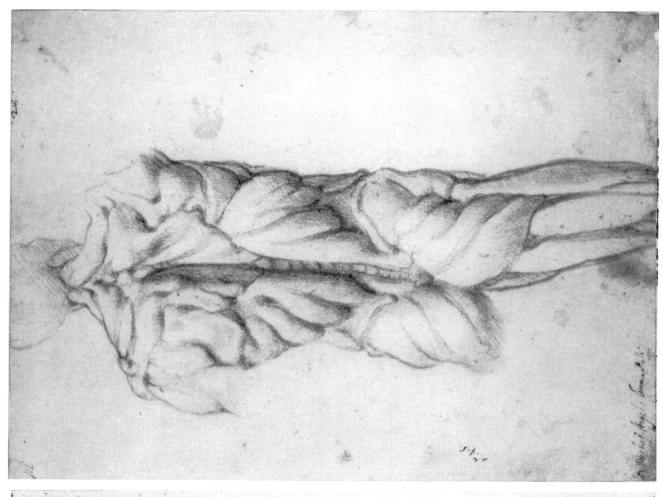

3. Michelangelo: *Ecorché of a male torso* (Cat. p. 99)

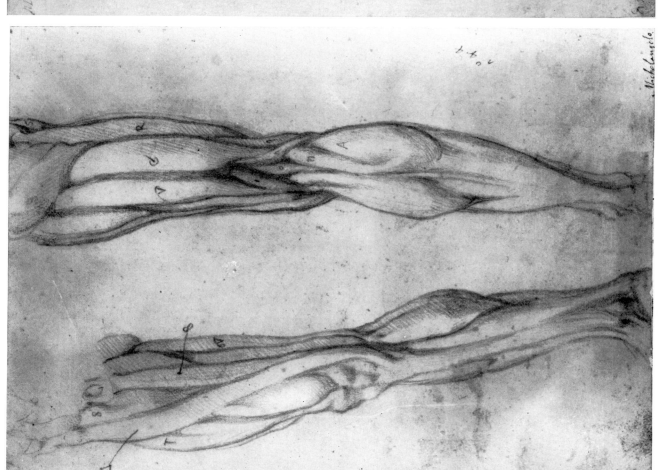

2. Michelangelo: *Ecorché of two legs* (Cat. p. 99)

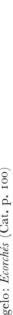

5. Michelangelo: *Ecorchés* (Cat. p. 100)

4. Michelangelo: *Ecorchés* (Cat. p. 100)

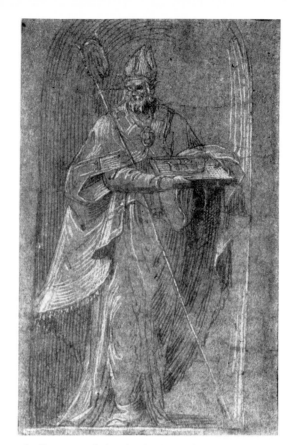

6. Parmese School: *A Bishop* (Cat. No. 676)

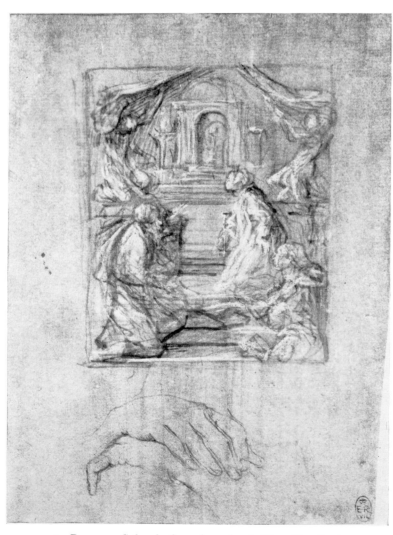

7. Parmese School: *Scene in a church* (Cat. No. 675)

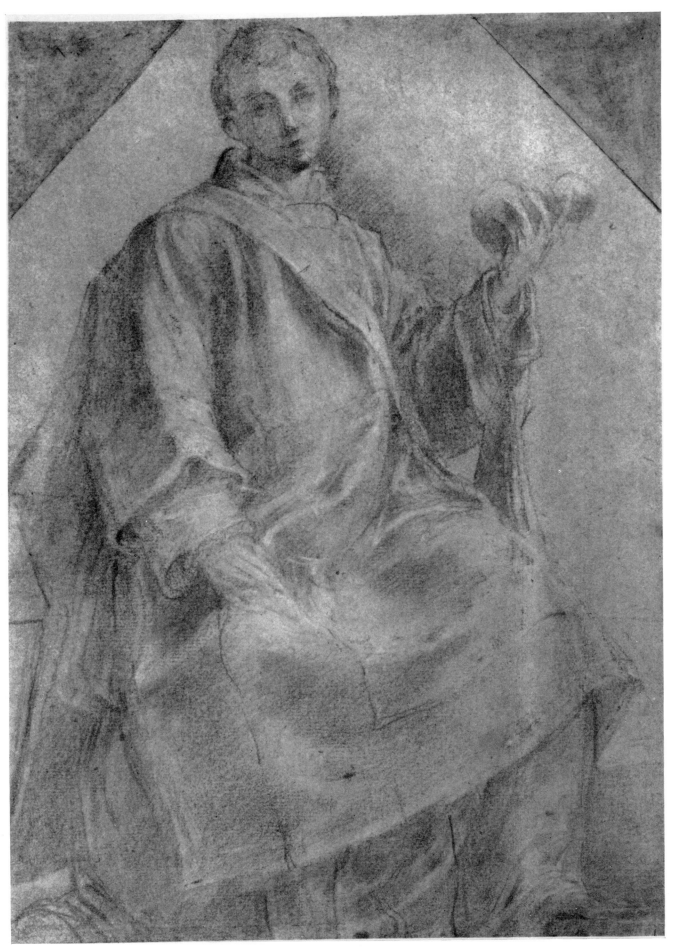

8. Parmigianino: *St. Stephen* (Cat. No. 333)

9. Manner of Romanino: *Two Landsknechte* (Cat. No. 399)

10. Manner of Romanino: *A group of figures singing* (Cat. No. 398)

11. Attributed to Battista Franco: *Design for a dish* (Cat. No. 181)

12. Attributed to Battista Franco: *Ancient relief* (Cat. No. 179)

13. Luzio Romano: *Design for the Palazzo dei Conservatori* (Cat. No. 234)

14. Luzio Romano: *Design for the Palazzo dei Conservatori* (Cat. No. 233)

15. Luzio Romano: *Design for the Palazzo dei Conservatori* (Cat. No. 238)

16. Follower of Perino del Vaga: *Design for a ceiling* (Cat. No. 480)

18. Follower of Perino del Vaga: *Design for wall decoration* (Cat. No. 474)

19. Venetian School, late 16th century: *Design for the decoration of a staircase* (Cat. No. 722)

20. Perino del Vaga: *Design for the decoration of a wall* (Cat. No. 465)

21. Attributed to Pietro da Cortona: *Design for a sauce-boat* (Cat. No. 352)

22. Florentine School, late 16th century: *Design for a dish* (Cat. No. 578)

23. Florentine School, early 17th century: *Design for a ewer* (Cat. No. 581)

24. Pirro Ligorio: *Design for a ceiling* (Cat. No. 225)

25. Circle of Francesco Salviati: *Design for a cassone* (Cat. No. 431)

26. Denis Calvaert: *Paradise* (Cat. No. 65)

27. Denis Calvaert: *The Virgin and Child adored by two Saints* (Cat. No. 66)

28. Lodovico Carracci: *Portrait of a Cardinal* (Cat. No. 99)

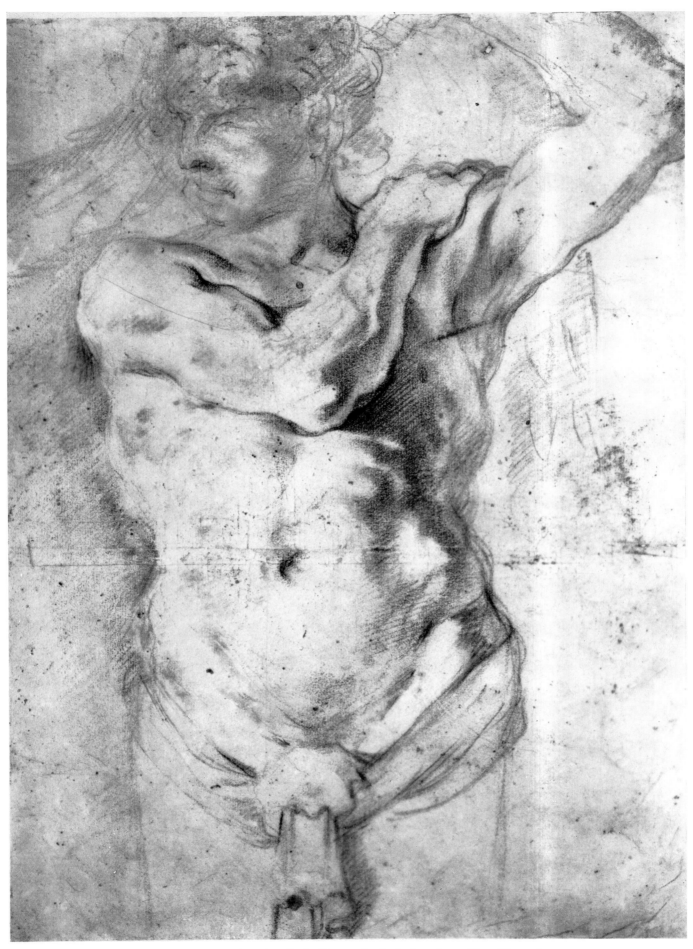

29. Attributed to Annibale Carracci: *Study for a herm* (Cat. No. 94)

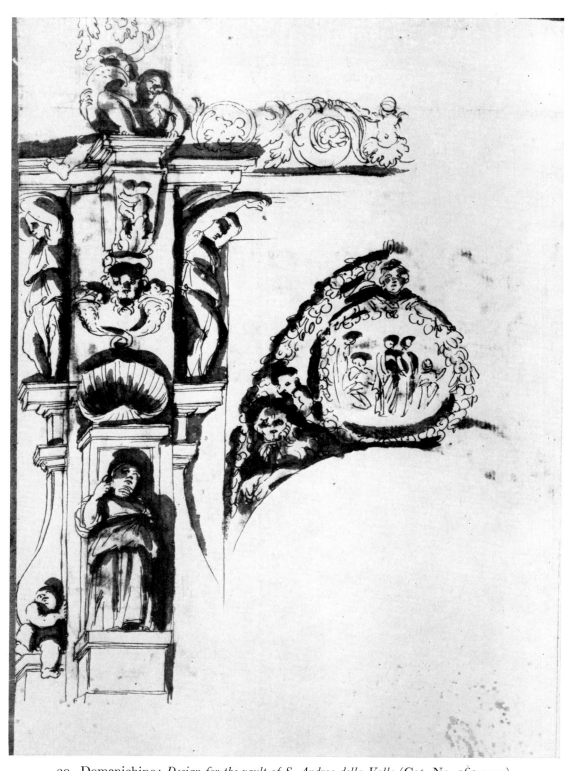

30. Domenichino: *Design for the vault of S. Andrea della Valle* (Cat. No. 160 *verso*)

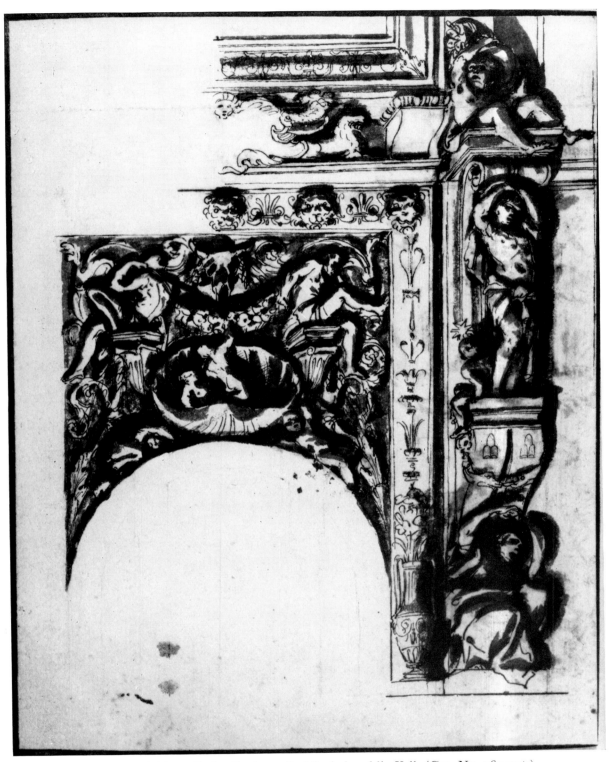

31. Domenichino: *Design for the vault of S. Andrea della Valle* (Cat. No. 160 *recto*)

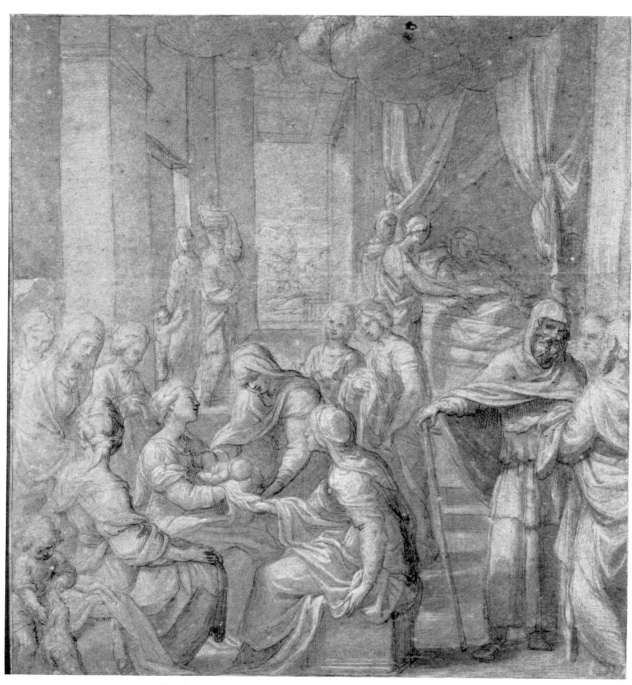

32. Guido Reni: *The Birth of St. John the Baptist* (Cat. No. 386)

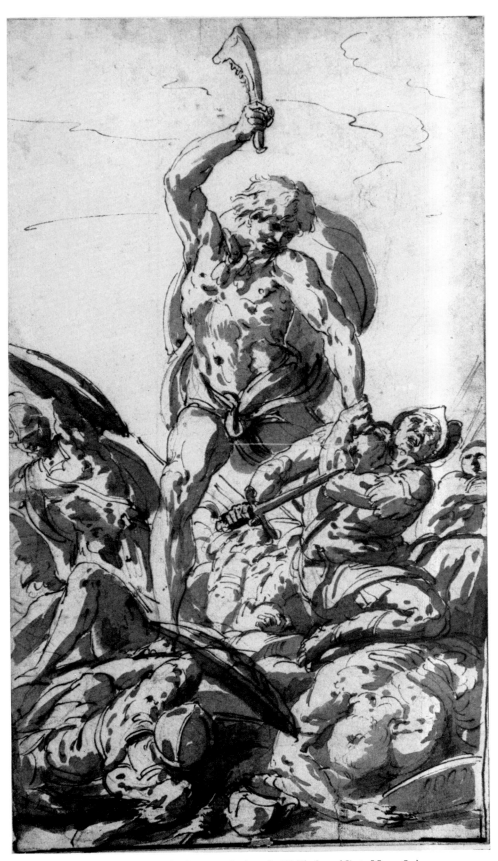

33. Guido Reni: *Samson slaying the Philistines* (Cat. No. 383)

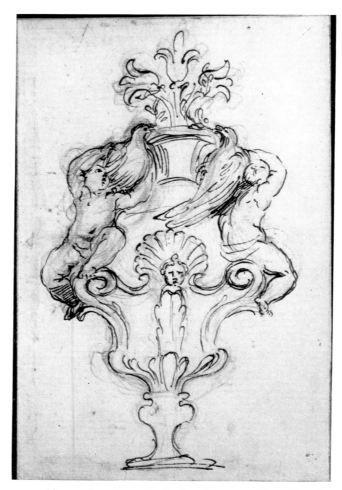

34. Alessandro Algardi: *Design for an urn* (Cat. No. 6)

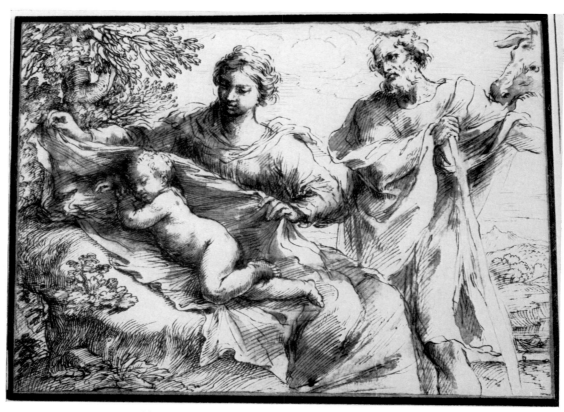

35. Alessandro Algardi: *The Rest on the Flight* (Cat. No. 4)

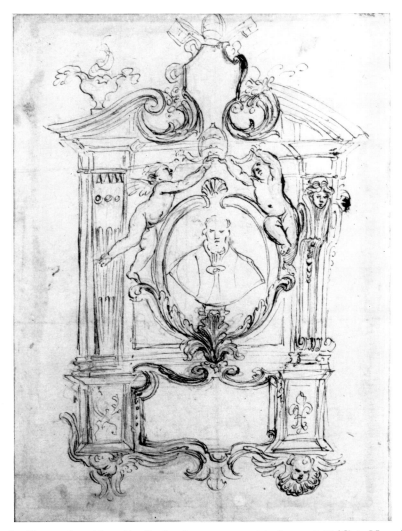

36. Alessandro Algardi: *Design for a monument to Innocent X* (Cat. No. 7)

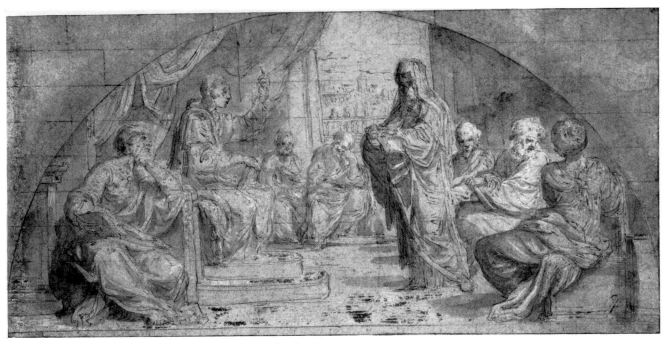

37. Guido Reni: *St. Stephen and the Rabbis* (Cat. No. 385)

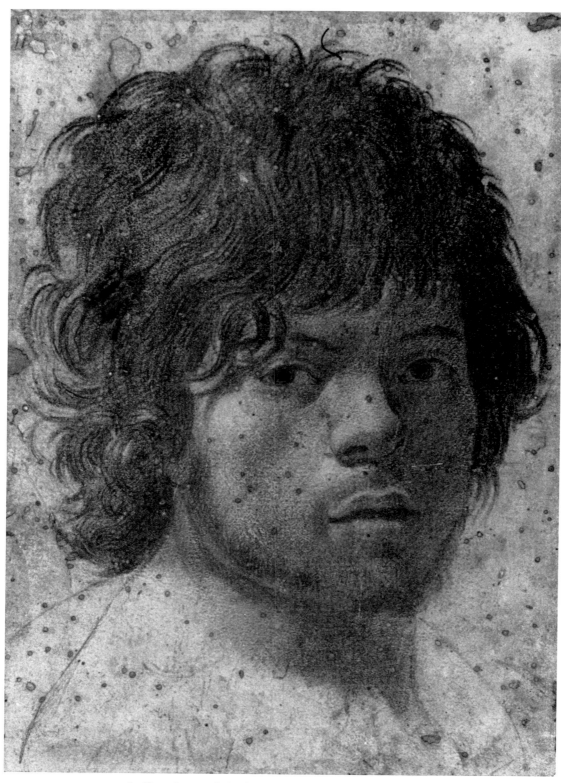

38. Bartolomeo Schedone: *Head of a man* (Cat. No. 437)

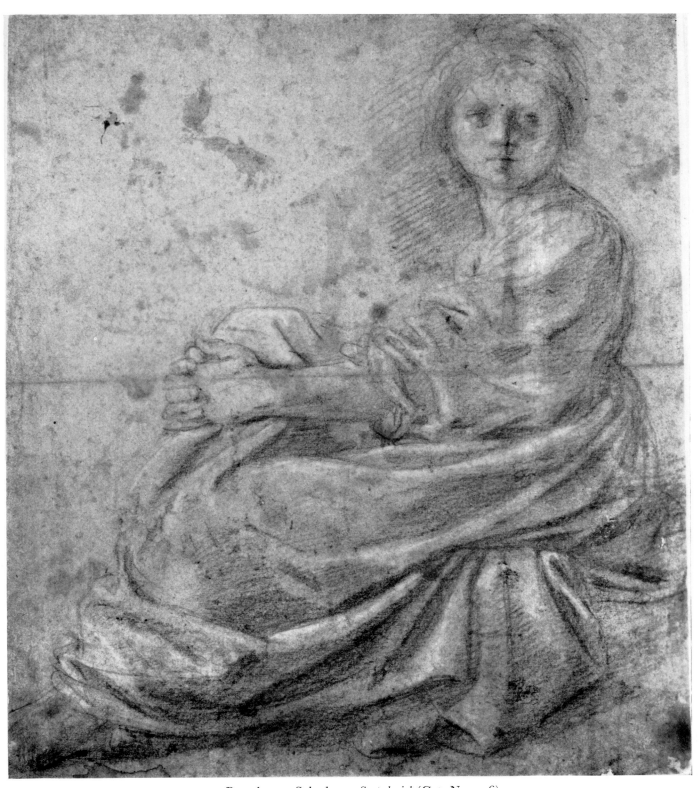

39. Bartolomeo Schedone: *Seated girl* (Cat. No. 436)

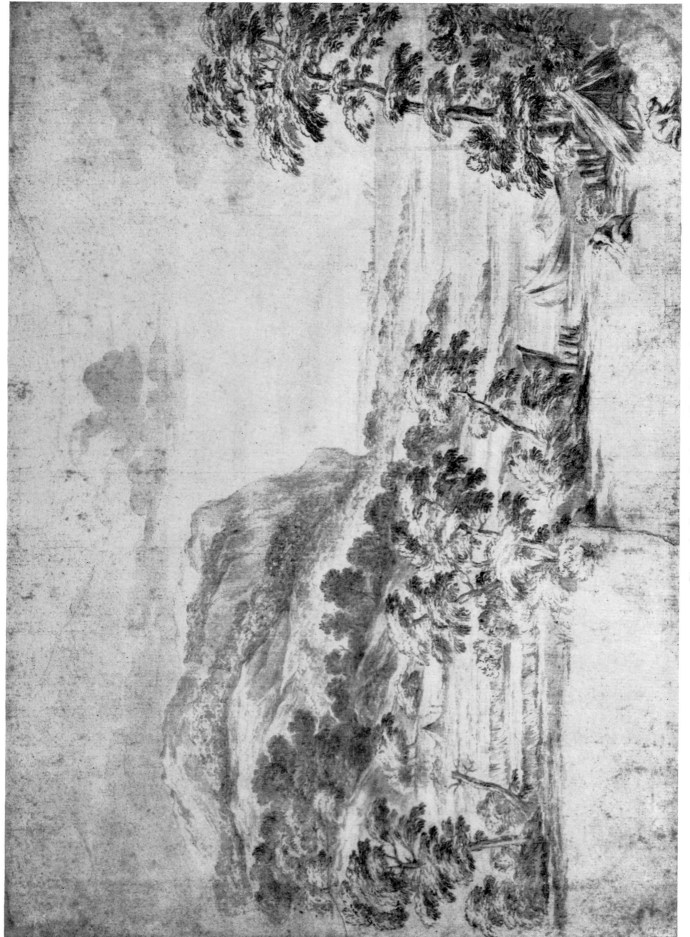

40. Pietro da Cortona: *Landscape* (Cat. No. 347)

42. Attributed to Domenico Campagnola: *Turbaned men near a tree* (Cat. No. 73)

41. Attributed to Giovanni Francesco Romanelli: *Jacob and Laban* (Cat. No. 393)

43. Salvator Rosa: *Allegory of Painting* (Cat. No. 401)

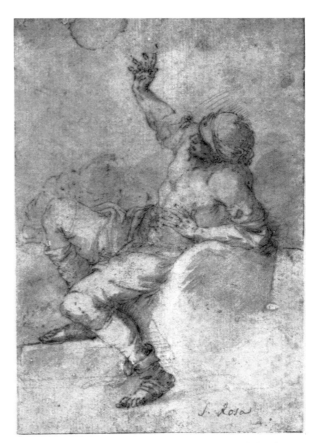

44. Salvator Rosa: *A Man seated on a rock* (Cat. No. 404)

45. Salvator Rosa: *A Man seated on a rock looking up* (Cat. No. 402)

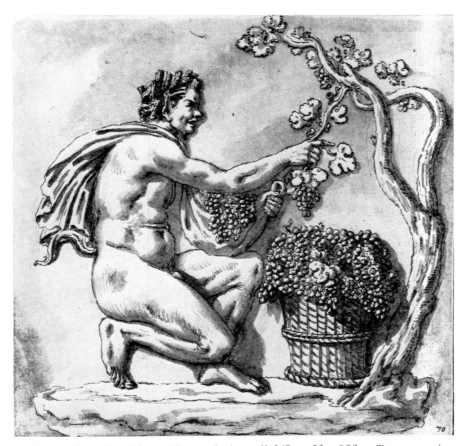

46. Attributed to Pietro Testa: *Ancient relief* (Inv. No. 8664; Cat. p. 121)

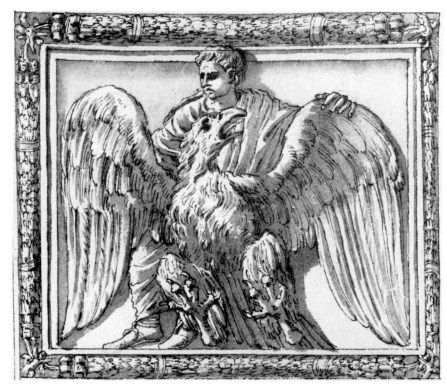

47. Attributed to Pietro Testa: *Relief from the Arch of Titus* (Inv. No. 8181; Cat. p. 121)

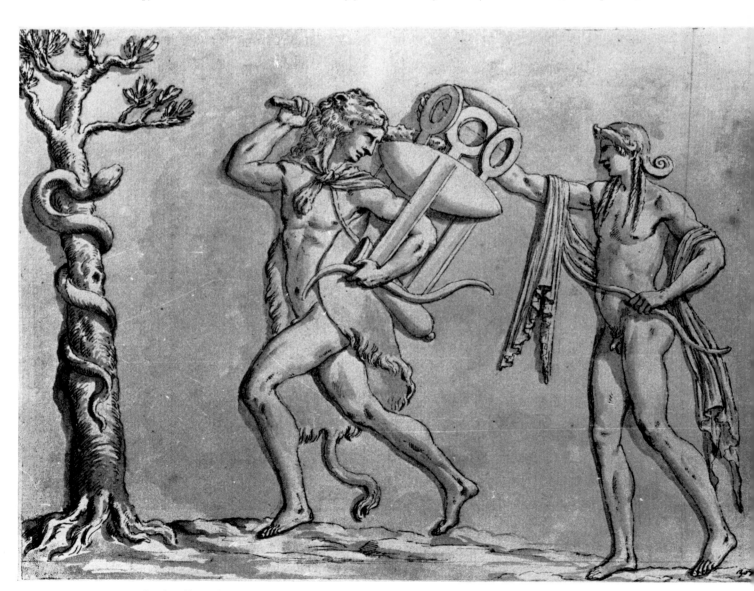

48. Attributed to Pietro Testa: *Relief of Hercules and Apollo.* (Inv. No. 8350; Cat. p. 121)

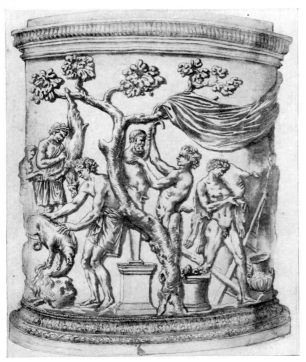

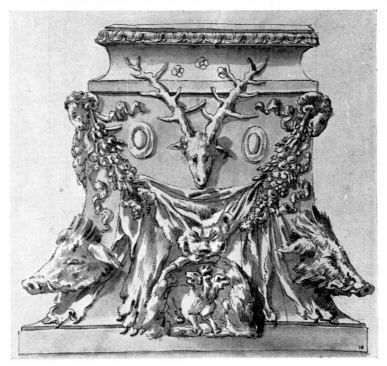

49. Attributed to Pietro Testa: *Ancient puteal* (Inv. No. 8643; Cat. p. 121)

50. Attributed to Pietro Testa: *Ancient altar* (Inv. No. 8310; Cat. p. 121)

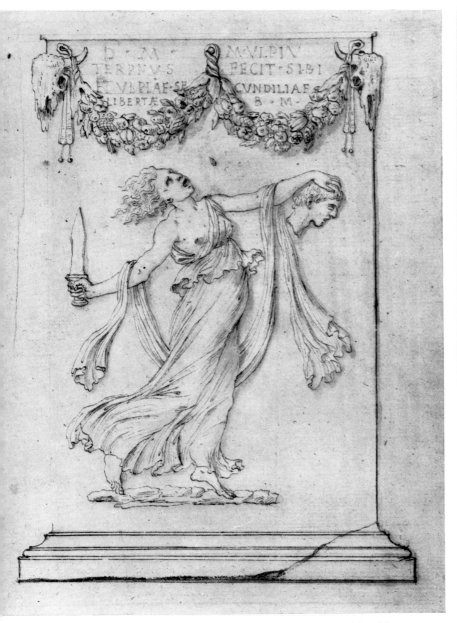

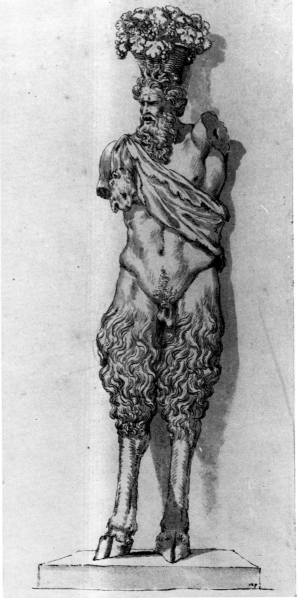

51. Attributed to Pietro Testa: *Relief of a Maenad* (Inv. No. 8692; Cat. p. 121)

52. Attributed to Pietro Testa: *Statue of a Satyr* (Inv. No. 8816; Cat. p. 121)

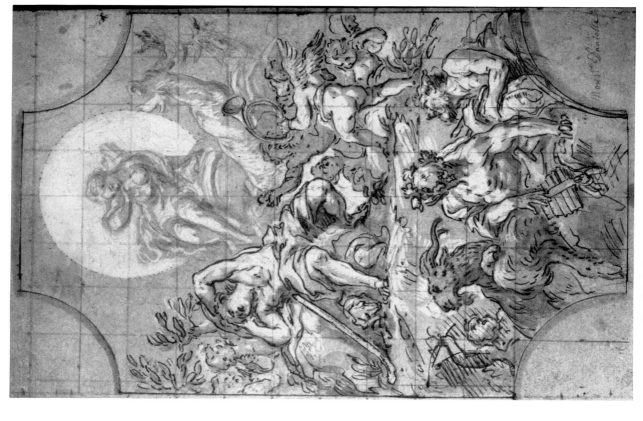

54. Daniel Saiter: *Diana and Endymion* (Cat. No. 422)

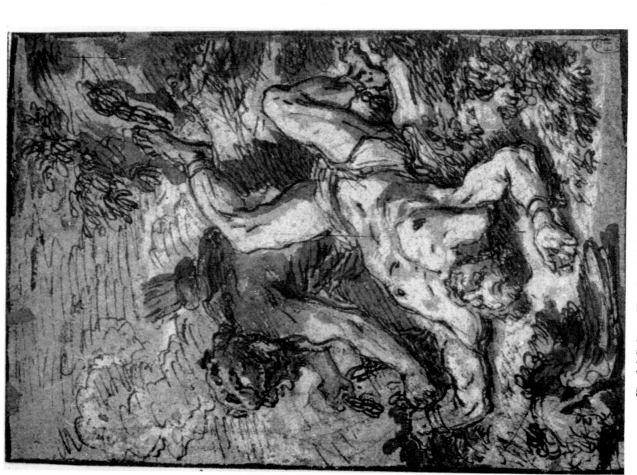

53. Daniel Saiter: *Hercules chaining Prometheus* (Cat. No. 423)

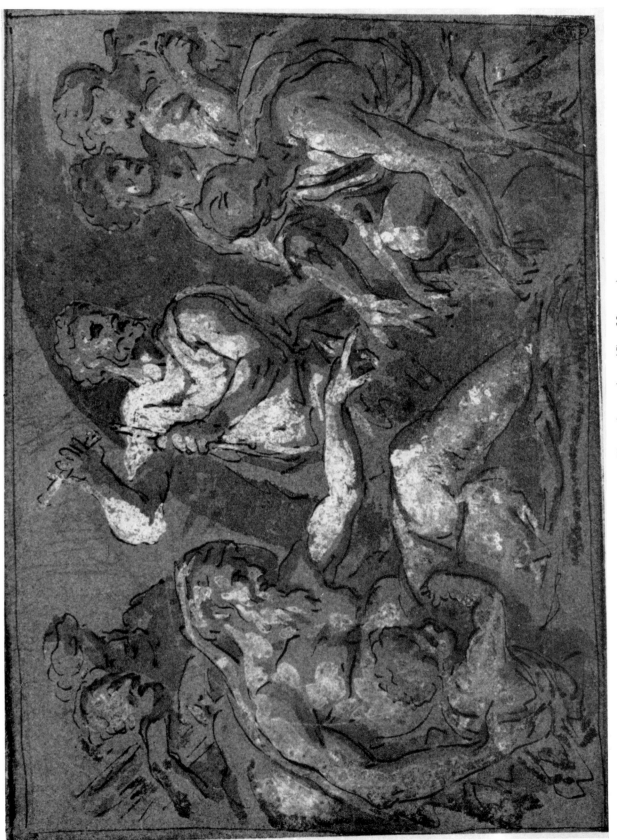

55. Daniel Saiter: *Illustration to Aesop* (Cat. No. 425)

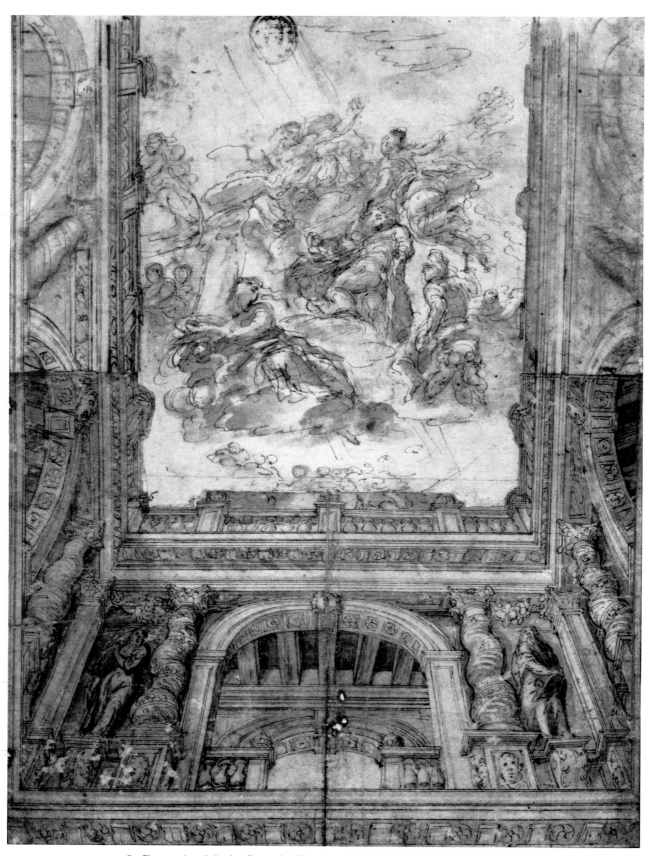

56. Domenico Maria Canuti: *Hercules received into Olympus* (Cat. No. 80)

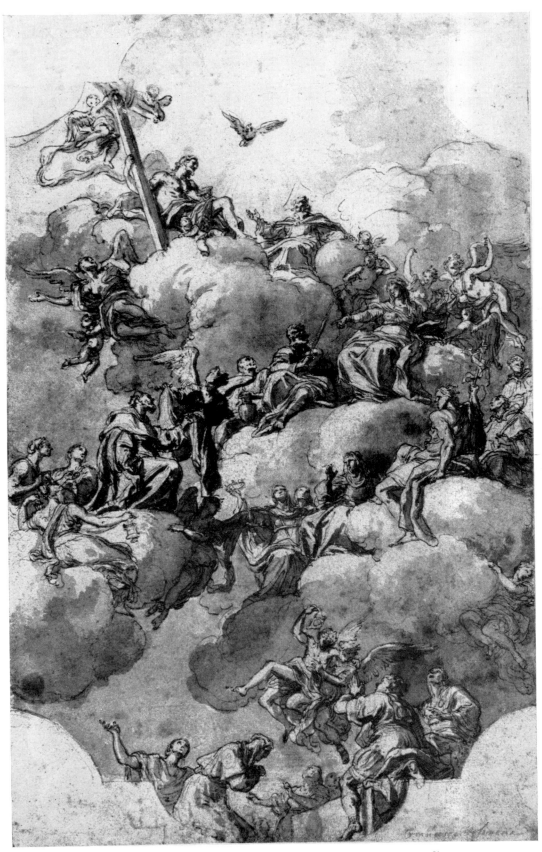

57. Francesco Solimena: *A vision of Paradise* (Cat. No. 446)

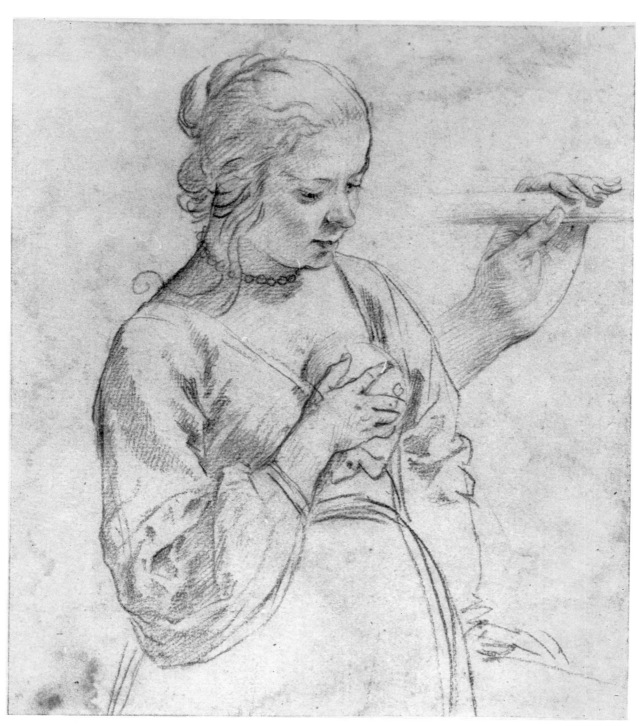

58. Florentine School, early 17th century: *Figure of a girl* (Cat. No. 583)

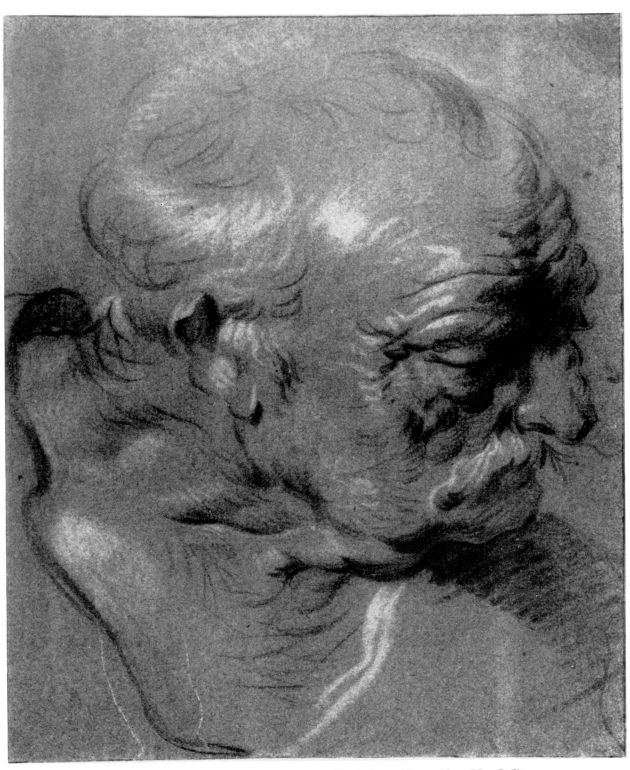

59. Neapolitan School, 17th century: *Head of an old man* (Cat. No. 646)

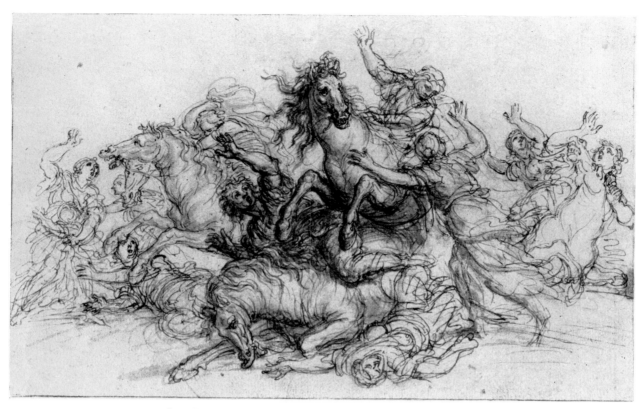

60. Giovanni Battista Foggini: *A battle* (Cat. No. 174)

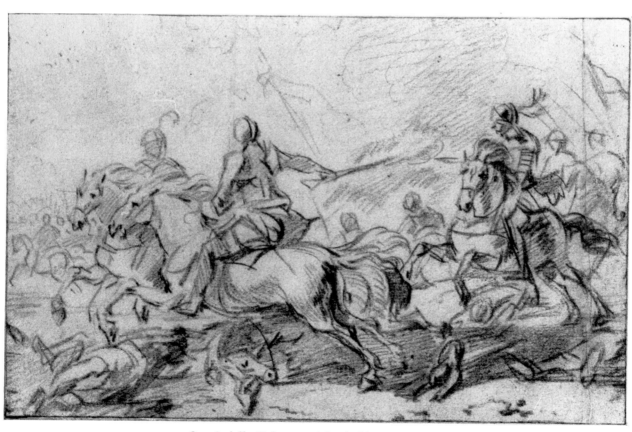

61. Aniello Falcone: *A battle* (Cat. No. 168)

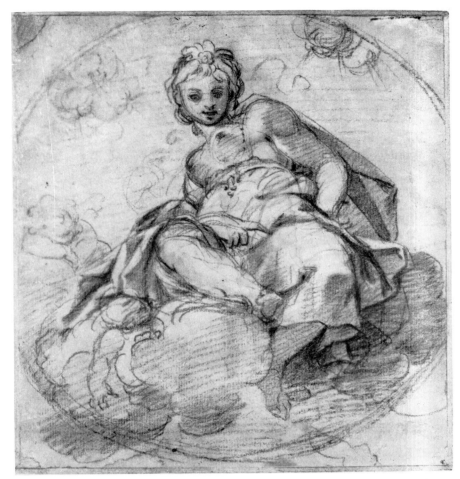

62. Giovanni da San Giovanni: *A figure seated on clouds* (Cat. No. 284)

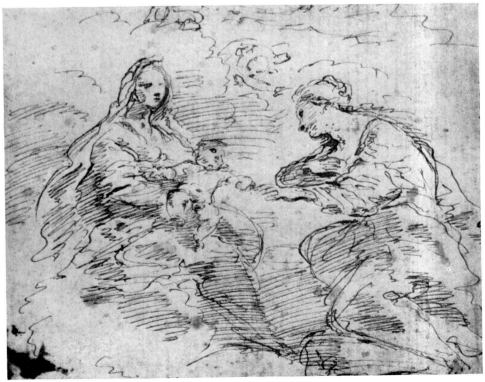

63. Attributed to Valerio Castello: *The Mystic Marriage of St. Catherine* (Cat. No. 109)

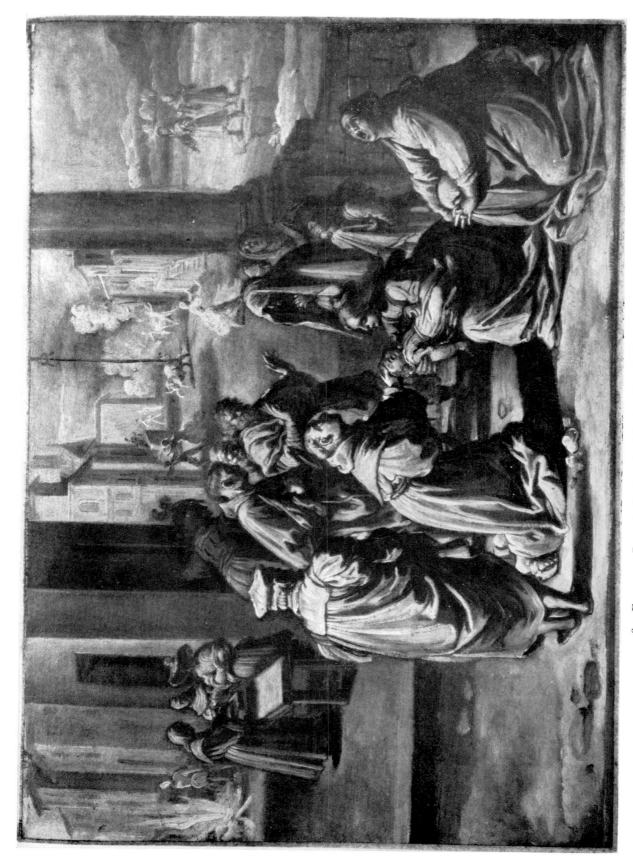

64. Francesco Pagani: *St. Francis of Paola with a dead child* (Cat. No. 328)

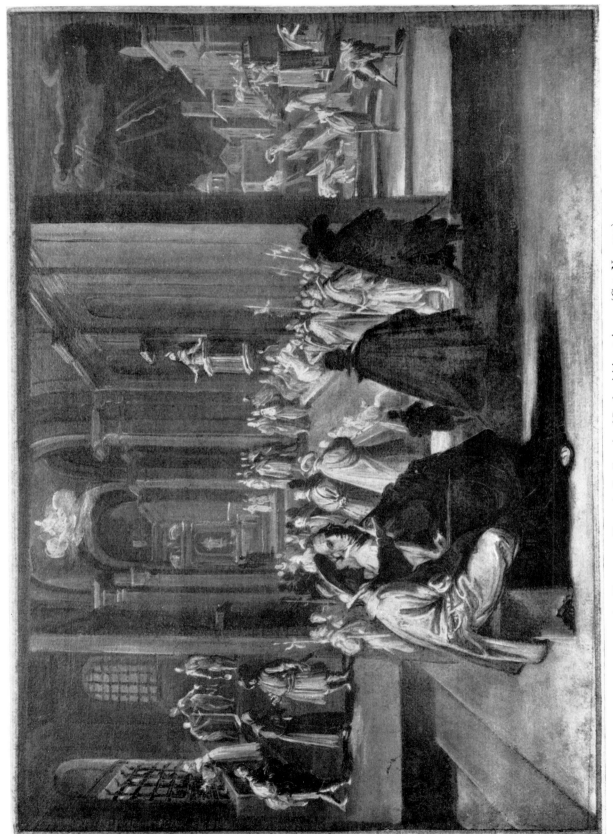

65. Francesco Pagani: *St. Francis of Paola visiting prisoners* (Cat. No. 327)

67. Italian School, early 17th century: *Design for a title-page*
(Cat. No. 606)

66. Bolognese School, early 17th century: *Minerva at the cave of Envy*
(Cat. No. 532)

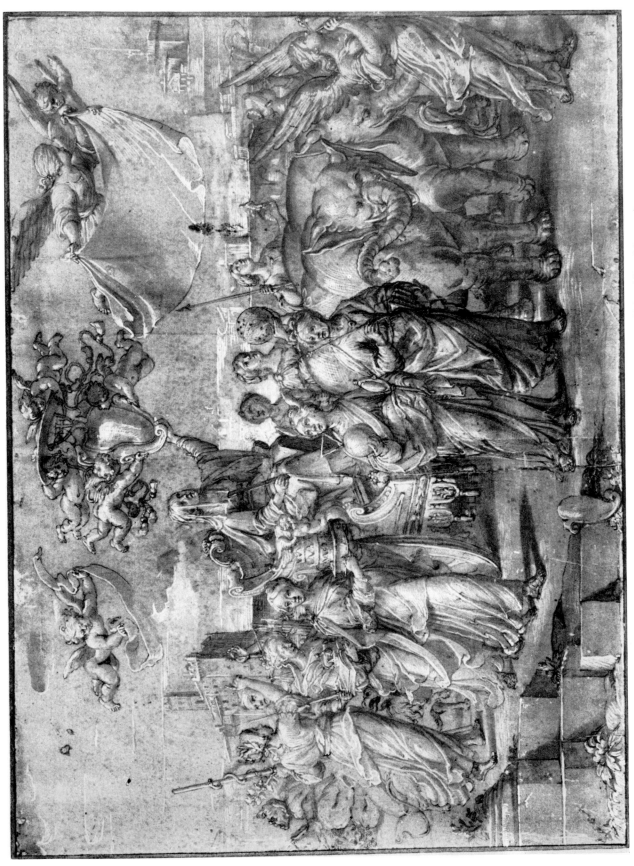

68. Bolognese School, early 17th century: *The Triumph of Religion* (Cat. No. 531)

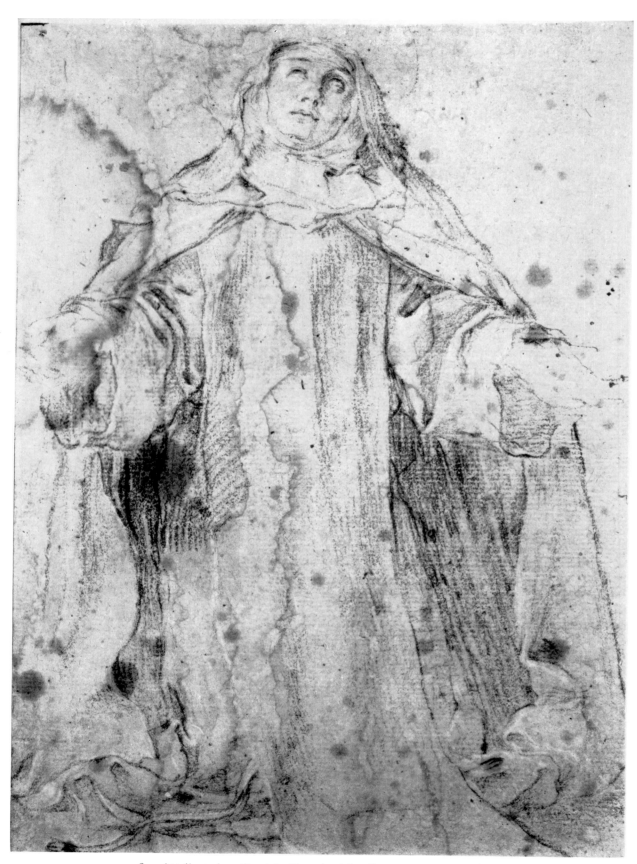

69. Attributed to Daniele Crespi: *A kneeling nun* (Cat. No. 150)

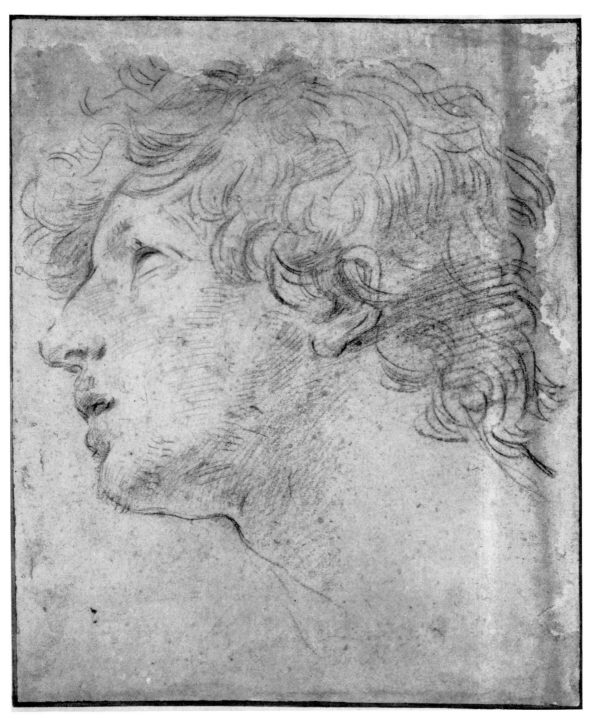

70. Guido Reni: *Head of St. John* (Cat. p. 112)

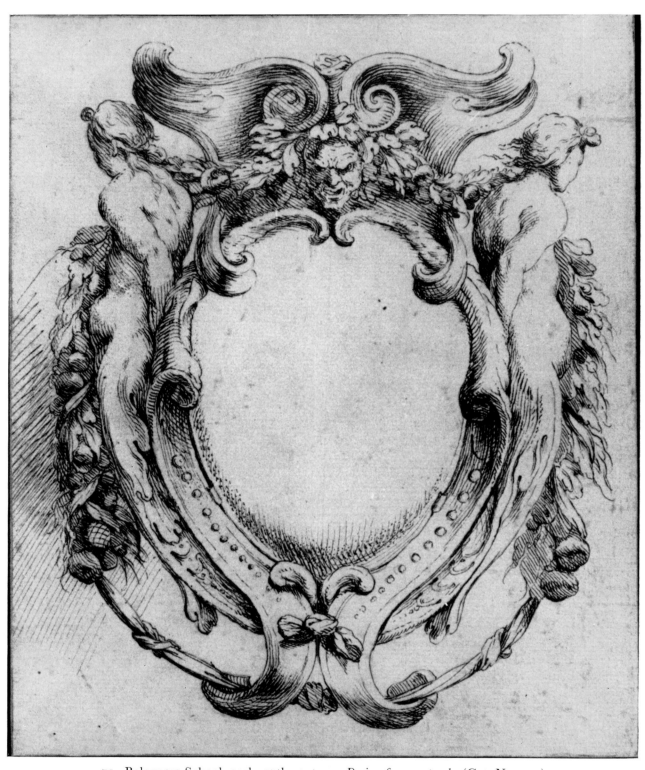

71. Bolognese School, early 17th century: *Design for a cartouche* (Cat. No. 557)

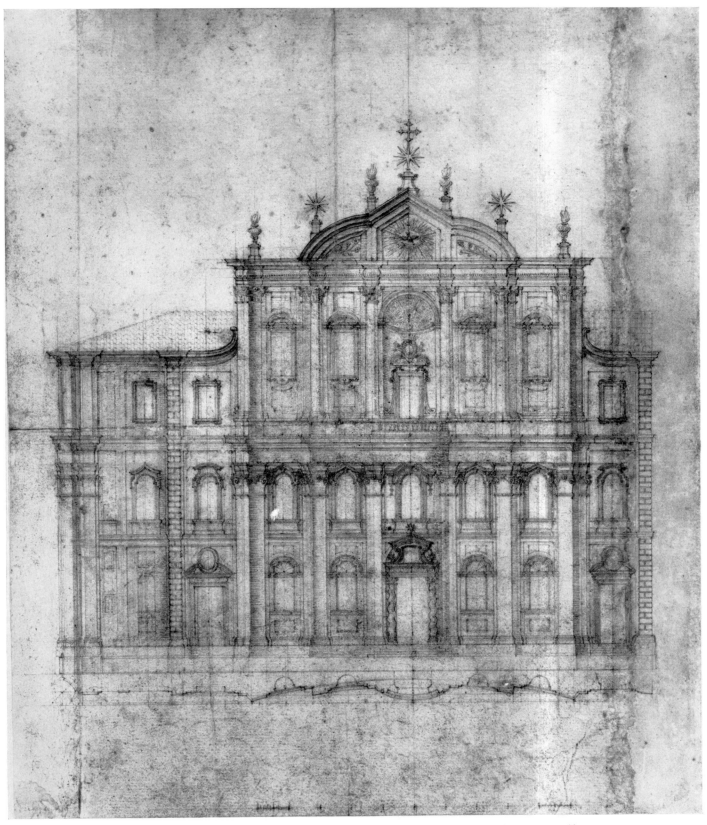

72. Francesco Borromini: *Design for the Oratory of S. Filippo Neri* (Cat. No. 48)

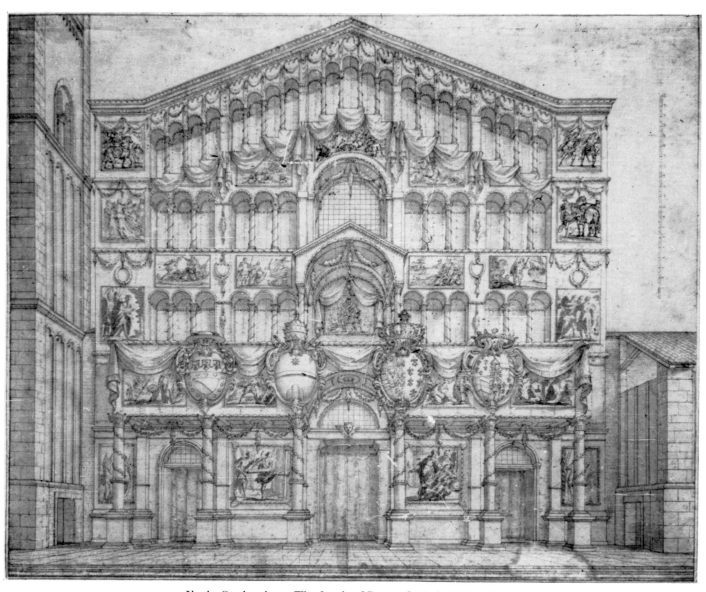

73. Ilario Spolverino: *The façade of Parma Cathedral* (Cat. No. 449)

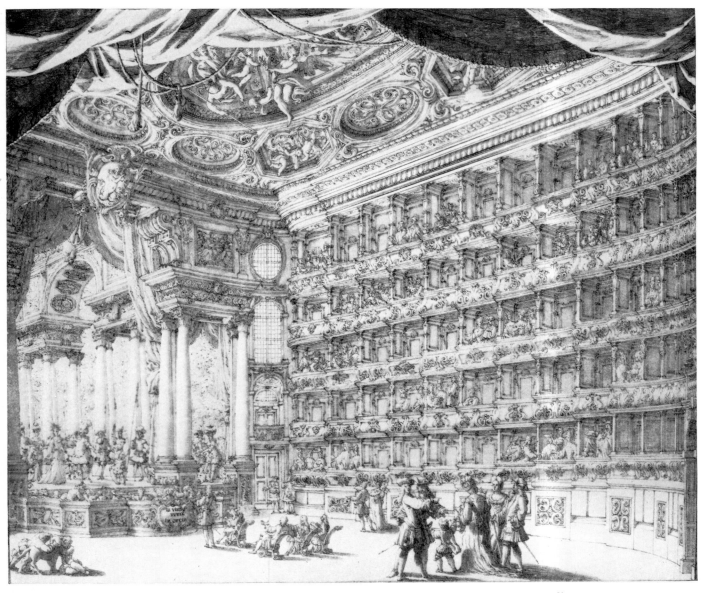

74. Francesco Galli Bibiena: *The Teatro Filarmonico at Verona* (Cat. No. 46)

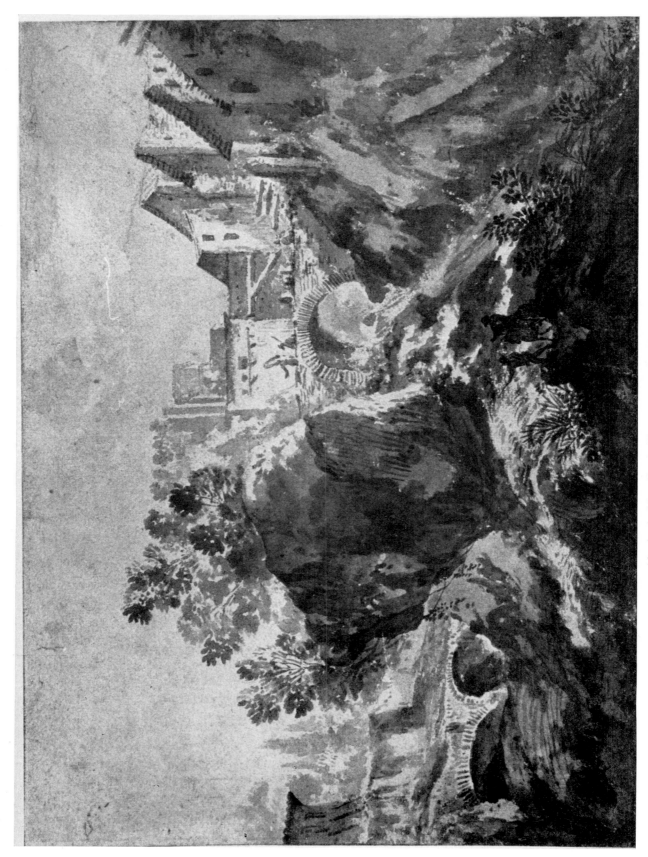

75. Alessio da Napoli: *A village over a ravine* (Cat. No. 301)

77. Venetian School, 18th century: *A character from the* COMMEDIA DELL'ARTE (Cat. No. 729)

76. Venetian School, early 18th century: *Caricature of a fat man* (Cat. No. 730)

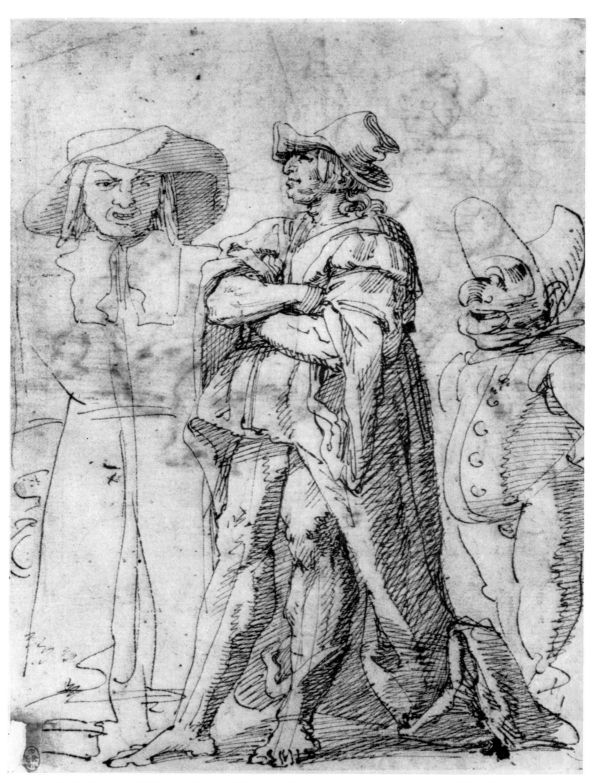

78. Imitator of Salvator Rosa: *Characters from the* COMMEDIA DELL'ARTE (Cat. No. 409)

FRENCH DRAWINGS

CATALOGUE

JACQUES ANDROUET DU CERCEAU
(c. 1520–after 1584)

1. DESIGN FOR AN ARCADED LOGGIA (*Fig. 1*) (10491)
260 × 346 mm. Pen and brown ink with grey-brown wash.

The rustication and the unusually elongated proportions of the pilasters point to a French architect of the later sixteenth century, probably the elder Jacques Androuet du Cerceau. The drawing of the figure in armour is also like his work. The design cannot at present be connected with any known project, but it has certain features in common with both Verneuil and Charleval.

See also: *PHILIBERT DE L'ORME* (Nos. 17, 18 below).

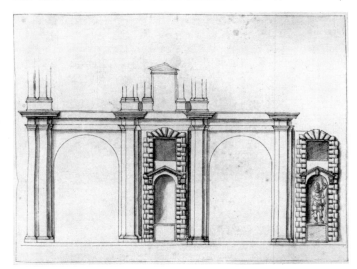

Fig. 1 Cat. No. 1

HYACINTHE BASSINET
(active c. 1762)

A VIEW OF WINCHESTER PALACE (Blunt, *French Drawings*, No. 308) (17168)

An invoice in the Royal Archives (27667), dated 12 December 1811 (mistakenly 1813), shows a payment to Colnaghi for 'A drawing view of the Kings house at Winton . . . 5/–'.

The drawing is taken from exactly the same point of view as an engraving of the palace by S. and H. Buck, dated 1733 (cf. Wren Society, VII, 1930, Pl. III) and may actually be based on it.

LOUIS BELANGER
(1736–1816)

VIEW OF THE MALL WITH THE BACK ENTRANCE TO CARLTON HOUSE (Blunt, *French Drawings*, No. 309) (17167)

An invoice in the Royal Archives (A.1.27743) of October 31, 1808, shows a payment to Colnaghi for 'A drawing View of the Lodge of Carlton House from St. James Park by Belanger £2-2-0'.

The drawing is reproduced in the *Survey of London*, XX, 1940, *The Parish of St. Martin-in-the-Fields*, part III, plate 54. A similar view was drawn by Rowlandson (cf. P. Oppé, *Thomas Rowlandson*, London, 1923, Pl. 10).

A CRICKET MATCH (Blunt, *French Drawings*, No. 310) (13224)

Reproduced in *Cricket*, edited by Horace G. Hutchinson, London, 1903, p. 361.

An invoice in the Royal Archives (27145) shows a payment to Colnaghi, 16th April 1800, for 'A Drawing by Belanger, a View at Cricket, £4-4-0'.

An old label had the inscription: 'Painted by Louis Bellanger a Swedish artist. Cricket match played at Victoria Inn, Banstead (F.WB.).'

JEAN BERAIN THE ELDER
(c. 1637–1711)

See *Attributed to HENRI GISSEY* (Blunt, *French Drawings*, No. 72).

ABRAHAM BOSSE
(1602–76)

See *JACQUES CALLOT* (Blunt, *French Drawings*, Nos. 24, 25).

JACQUES CALLOT
(1592–1635)

LA RUE NEUVE DE NANCY (Blunt, *French Drawings*, No. 23) (4615)

Rejected as a copy by D. Ternois (*Jacques Callot, Catalogue complet de son œuvre dessinée*, Paris, 1962, p. 176 E).

STUDIES OF A MAN (Blunt, *French Drawings*, Nos. 24, 25) (4634–5)

As was pointed out by Mr. A. E. Popham (*Burlington Magazine*, LXXXVIII, 1946, p. 284), these two drawings are too clumsy to be by Callot. An alternative attribution is not easy to propose, but they might be by an imitator of Callot such as Jean de Saint-Igny, or possibly early works by Abraham Bosse.

See also: *STEFANO DELLA BELLA* (p. 77, No. 154).

LOUIS CARROGIS DE CARMONTELLE
(1717–1806)

LE COMTE DE GENLIS (Blunt, *French Drawings*, No. 315)
(13119)

An invoice in the Royal Archives (28376) shows a payment to Colnaghi, 20 September 1821, for 'Le Comte de Genlis Col'd, Drawing £1-11-6'.

CHARLES LOUIS CLÉRISSEAU
(1722–1820)

2. THE RUINS OF A ROMAN BATH (13027)
483 × 351 mm. Gouache. Signed: *Clerisseau f. Roma 1763*.

2a. ROMAN RUINS (13028)
487 × 378 mm. Gouache.

Other gouaches by Clérisseau are attached as decorations to the interior of a French seventeenth-century cabinet in the Corridor at Windsor Castle, in a drawer of which these gouaches were found.

After FRANÇOIS CLOUET
(before 1522–72)

PORTRAIT OF A LADY IN MOURNING (Blunt, *French Drawings*, No. 2) (13068)

The original in the British Museum, of which this is a copy, is a study for a painting of Marguerite de Valois, wife of Philibert Emmanuel of Savoy, in Turin (cf. G. Pacchioni, *La Regia Pinacoteca di Torino*, Rome, 1932, p. 38).

SCENE FROM A FRENCH FARCE (Blunt, *French Drawings*, No. 3) (6445)

A. Beiger (*Revue d'histoire du théâtre*, 1957) has shown that this drawing represents the *farceur* Agnan, who was still alive in Paris in 1609.

REMY COLLIN
(active 1601–9)

3. THE FONTAINE BELLE EAU AT FONTAINEBLEAU (*Fig. 2*) (10492)
286 × 273 mm. Pen and brown wash, with a little blue wash. Numbered: *16*

From the Pozzo and Albani collections

The monogram of Henry IV and Marie de' Medici under a French royal crown appears above the central arch. The drawing shows the setting of the fountain, built by Henry IV and destroyed in the eighteenth century, but recorded in an etching by Silvestre (Faucheux, 216,11).

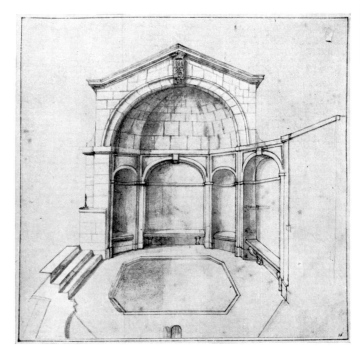

Fig. 2 Cat. No. 3

The design is almost certainly due to Remy Collin, who was in charge of building at Fontainebleau under Henry IV (an article on this subject will be published in the *Revue de l'Art* by Mrs. P. Coope, who kindly supplied me with the identification of the author of this drawing).

The drawing was presumably acquired by Cassiano del Pozzo on his visit to Fountainebleau in 1625.

JACQUES COURTOIS
(1621–75)

See p. 76.

Manner of
JEAN COUSIN THE ELDER
(c. 1500–60/61)

4. THE DEATH OF THE VIRGIN (*Plate 2*) (5994)
166 × 327 mm. Pen and brown ink.

Inventory A, p. 127: 'Pietro Testa, Solimeni etc.'.

The style of the drawing recalls that of the elder and the younger Jean Cousin, whose work cannot at present be satisfactorily separated. The kneeling figure in the foreground is no doubt the donor.

Manner of
JEAN COUSIN THE YOUNGER
(1522–c. 1594)

5. A BATTLE AT A RIVER (*Plate 1*) (0115)
184 × 322 mm. Pen and light-brown ink.

The subject may possibly be the Battle of the Milvian Bridge. The drawing is certainly late sixteenth-century French and seems to come nearest to the manner of the younger Jean Cousin.

Manner of ÉTIENNE DELAUNE
(1519–84)

6. ORNAMENTAL SIX-SIDED CUP (11299)
55 × 74 mm. Pen and brown wash.

7. A NARROW-NECKED VASE: A CROUCHING DOG
 (11302)
95 × 62 mm. Pen and black ink, over chalk indications.

GASPARD DUGHET, called GASPARD POUSSIN
(1615–75)

LANDSCAPE WITH A ROAD AND A STREAM (Blunt, *French Drawings*, No. 39) (6131)
Catalogued as 'School of Dughet', but probably an original, since it is closely connected with one of the early landscapes in the Doria Gallery.

8. VIEW OF A HILL-TOWN NEAR ROME (Blunt, *French Drawings*, No. 222) (6140)
This drawing was catalogued with a tentative attribution to Poussin, but Dr. John Shearman ascribes it convincingly to Gaspard Dughet (cf. Friedlaender and Blunt, IV, p. 64, G 42).

Manner of DANIEL DUMONSTIER
(1574–1640)

9. PORTRAIT OF A WOMAN WEARING A VEILED HEADDRESS (5181)
494 × 377 mm. Black, red, white and brown chalks, on grey paper. Inscribed in pencil at foot right: *Paduanino*.
The style is related to that of Daniel Dumonstier and, although the costume is certainly not French, the sitter may have been a foreigner visiting Paris.

CLAUDE GELLÉE, LE LORRAIN
(1600–82)

All the drawings by Claude at Windsor are discussed by Marcel Roethlisberger in *Claude Lorrain, The Drawings*, Berkeley and Los Angeles, 1968.

THE MARRIAGE OF ISAAC AND REBECCA (Blunt, *French Drawings*, No. 41) (13076)
This drawing is dated 1663.

THE TEMPLE OF APOLLO AT DELPHI (Blunt, *French Drawings*, No. 47) (13079)
The painting is now in the Art Institute, Chicago.

S. GIORGIO IN VELABRO (Blunt, *French Drawings*, No. 56) (13090)
The *verso* is probably by Claude himself.

THE BANKS OF THE TIBER (Blunt, *French Drawings*, No. 61) (13094)
A drawing, almost identical in composition, is in the Albertina.

A STUDY OF TREES (Blunt, *French Drawings*, No. 63)
 (11927)
Roethlisberger (*op. cit.*, p. 156, No. 307) states that this drawing was ascribed to Poussin till the exhibition of 1949. In fact it was attributed to Claude in the 1945 catalogue of the French Drawings.
See also: *ISRAEL SILVESTRE* (No. 21a below).

Manner of CLAUDE GILLOT
(1673–1722)

THREE SCENES FROM A CHILDREN'S STORY (Blunt, *French Drawings*, Nos. 322–324) (13125–7)
An invoice in the Royal Archives (27423) shows a payment to Colnaghi on 25 November 1807 for 'Three Drawings of a Prince and Ambassadors. £3-3-0'.

Attributed to HENRI GISSEY
(1621(?)–73)

LOUIS XIV AS APOLLO (Blunt, *French Drawings*, No. 72)
 (13071)
Almost identical with a drawing attributed to Bérain in the collection of Baron Vitta (reproduced *Le Gaulois artistique*, 31.iii.1928, p. 208).

JEAN BAPTISTE ISABEY
(1767–1855)

10. THE CONGRESS OF VIENNA (Fig. 24) (13025)
635 × 914 mm. Pencil. Signed and dated *1815*.
Acquired with number 11 by George IV for £600 from the exhibition which the artist arranged in London in 1820. The two drawings arrived at Carlton House on 31.vii.1820.
In 1815 Isabey was invited by Talleyrand to paint an official picture of the Congress of Vienna. He chose to illustrate the delegates in an informal mood, which he later adapted to the moment when Wellington was introduced to the Congress. The Duke arrived at Vienna on 3 February 1815 to succeed Castlereagh as first British Plenipotentiary; Castlereagh, who is seen seated at the table, introduced Wellington to the Congress and left Vienna on 14 February. The scene is taking place in the conference room in Metternich's house on the Ballplatz. A portrait of the Emperor Francis I hangs on the wall. Isabey found great difficulty in giving life to what was an inevitably monotonous subject and the sitters could not always find time to sit to him. The drawing is presumably the finished design for the print published by John Godefroy in 1819. By January 1815 Isabey was able to advertise the publication of the print and hoped to have finished the picture by the beginning of March. The print was, however, delayed by

Fig. 2A

Cat. No. 10

Fig. 3

Cat. No. 11

events and has always been a rarity. There are related drawings in the Louvre, which are studies for individual figures in the design. The finished work was exhibited at the Salon in 1817.

In the corners of the borders are the symbols of Truth, Prudence, Wisdom and Knowledge; in the centre at the top is the symbol of Justice. In the upper border are the heads, conceived as medals, of the rulers of England, Austria, Spain, France, Portugal, Prussia, Russia and Sweden. Their arms are in the lower border. Down the sides are the arms of the delegates (cf. particularly Sir Harold Nicolson, *The Congress of Vienna*, 1946, and the catalogue of the exhibition *Der Wiener Kongress*, Vienna, 1965, especially pp. 169–71).

JEAN BAPTISTE ISABEY
and CARLE VERNET
(1758–1836)

11. THE REVIEW AT THE TUILERIES (*Fig. 3*) (13026)

1232 × 1734 mm. Pencil. Signed by both artists and dated *1799*.

Acquired by George IV with number 10.

The drawing records Bonaparte's arrival at the Tuileries on the morning of 9 November (18 Brumaire) 1799 during his *coup d'état*; he was accompanied by the officers who had joined him and supported by three regiments of dragoons. This drawing was probably commissioned by Bonaparte, who told the artist whom to include in the scene. Carle Vernet was summoned to assist with the horses. Bonaparte criticized Isabey's presentation of himself, with humped, bent shoulders, but did not insist on their being corrected. The likenesses were warmly praised when the drawing was exhibited at the Salon in 1804. It was engraved by Paquet. A preparatory drawing is in the Louvre.

These two drawings were exhibited in the exhibition of *George IV and the Arts of France* at The Queen's Gallery, 1966, Nos. 116, 129.

ÉTIENNE JEAURAT
(1699–1789)

See *FRENCH SCHOOL* (No. 30 below).

RAYMOND LA FAGE
(1656–84)

12. GOD APPEARING TO JACOB (6747)

128 × 200 mm. Pen and light brown wash. Inscribed: *La Fage.*

EURYDICE (Blunt, *French Drawings*, No. 103)
The inventory number should be 6222, not 2622.

'LAGNEAU'
(late 16th century)

See *FRENCH SCHOOL* (No. 33 below).

LOUIS FÉLIX DE LA RUE
(1731–65)

13. STREET SCENE (Blunt, *French Drawings*, No. 363)
 (13112)

This drawing was catalogued as anonymous, but it must be the drawing recorded (Royal Archives, Invoice 27418) as bought on 7 November 1807: 'A drawing View in Paris by La Rue. £2-2-0 (Colnaghi).'

Attributed to
PHILIBERT BENOÎT DE LA RUE
(c. 1735–80)

14. AN OFFICER ON HORSEBACK (12841)

225 × 291 mm. Pen, Indian ink and water-colour.

Formerly ascribed to Dirk Maes (1659–1717), but the uniform is of a much later date, and the drawing is clearly by a French artist of the mid-eighteenth century.

SÉBASTIEN LECLERC
(1637–1714)

THE SIEGE OF ORSOY (16593)
(Blunt, *French Drawings*, No. 137a)

THE SIEGE OF BURICK (16954)
(Blunt, *French Drawings*, No. 137b)

An invoice in the Royal Archives (27142) refers to the purchase of these drawings: 'March 10, 1800, Colnaghi. Two drawings of Orsoy and Burick by Leclerk, £4-4-0.'

I. (or J.) LEROUX
(mid-18th century)

15. SECTION OF THE ESCORIAL SHOWING THE FAÇADE OF THE CHURCH (0801)

242 × 456 mm. Cut at upper corners. Pen and brown ink. Inscribed on *verso: Schizzo di Michel Angelo Buonarotti primo disegno del Tempio di S. Pietro che p. Bramante, Raffaelli, Bernini. . . .*

16. SECTION OF THE ESCORIAL THROUGH THE LENGTH OF THE CHURCH (0800)

257 × 513 mm. Irregularly cut. Pen and brown ink, with blue wash.

The drawings are in all essentials identical with two engravings in George Thompson's *A Description of the Royal Palace and Monastery of St. Lawrence called the Escurial*, London, 1760, opposite pp. 24 and 36. The book was a translation of the description of the Escorial by Francisco de los Santos, published in Spanish in 1667, but in this edition there are no engravings corresponding with the drawings, which appear to have been made specially for Thompson's edition. The engravings are inscribed *I* (or *J*) *Leroux Arch*ᵗ *Delin*, but the artist does not seem to be otherwise recorded.

EUSTACHE LE SUEUR
(1617–55)

THE GODS OF OLYMPUS (Blunt, *French Drawings*,
No. 144) (6176)

M. Jacques Dupont has pointed out that this is a study for
a ceiling painting in a room on the first floor of the east
wing of the Hôtel Lambert, Paris.

J. LEVERGNE
(?–?)

PORTRAIT OF LOUIS XV (Blunt, *French Drawings*,
No. 330) (13175)

Bought from Colnaghi, 11 April 1808.

PHILIBERT DE L'ORME
(1512/15–70)

17. DESIGNS OF ANCIENT MOULDINGS (*Fig. 4*) (10439)

257 × 204 mm. Pen and brown ink.

A preparatory drawing for an engraving in the *Architecture*
(1567, p. 213; cf. A. Blunt, *Philibert de l'Orme*, London 1958,
p. 15 and Pl. 2b).

18. AN IONIC CAPITAL (*Plate 12*) (10757)

379 × 274 mm. Pen and brown ink.

Cf. A. Blunt, *op. cit.*, p. 118 note, and Pl. 63a.

Fig. 4 Cat. No. 17

19. DRAWINGS OF ROMAN BUILDINGS (*Plate 12*)
 (10495–6)

The drawings, attributed to Jacques Androuet du Cerceau
the Elder in Blunt, *French Drawings*, p. 15, are almost
certainly by de l'Orme (cf. Blunt, *Philibert de l'Orme*, p. 16).
The attribution to de l'Orme is due to Dr. Arnold Noach.

DIRK MAES
(1659–1717)

See *Attributed to* PHILIBERT BENOÎT DE LA RUE
(No. 14 above).

BENOÎT PÉCHEUX
(1779–after 1831)

LOUIS XVIII ENTERING PARIS BY THE PORTE
ST. DENIS (Blunt, *French Drawings*, Nos. 507, 508)
 (13141–2)

These two drawings were bought by the Prince Regent
from Colnaghi's in 1814 and 1815 (cf. Royal Archives,
invoices 28000, 28037). A third drawing of the same
subject bought with these is no longer traceable.

BERNARD PICART
(1673–1733)

THE SENSES OF TASTE, SMELL, TOUCH, AND
HEARING (Blunt, *French Drawings*, Nos. 346–349)
 (13108–11)

These drawings are identical in composition with engravings
by Picart, apparently made after his own designs. *Hearing*
is reproduced in E. Michel, R. Aulanier, H. de Vallée,
L'Embarquement pour Cythère, Paris, n.d., Fig. 10. A much
finer version of this subject in the Ashmolean (cf. K.
Parker, *Ashmolean Drawings*, Oxford, 1938, I, p. 263, No.
544) was engraved by Picart in reverse (cf. M. Leloir,
Histoire du costume, 1933–, x, Pl. 33) and was also used
for a group in his *Grand Concert dans un jardin*. A similar
composition, representing *Sight*, was also engraved by
Picart, but in the only print of it known to me (in the
British Museum) is made into an oval.

The Oxford drawing is dated 1708, and this is probably
the approximate date of the other designs; but the quality
of the Windsor series is so poor in comparison, and the
technique is so unusual, that they are probably copies
after the engravings, which are in the same sense as the
drawings, whereas the engraving after the Oxford study is
reversed.

NICOLAS POUSSIN
(1594–1665)

The mythological, landscape and miscellaneous drawings
by or after Poussin in the Royal Collection have been
discussed at some length in Friedlaender and Blunt, vols.
III and IV, which appeared since the French volume of the
Windsor catalogue was published. Further comments will
be found in volume V, which is in the press.
The Marino drawings have been the subject of an important

article by Miss Jane Costello (cf. *Journal of the Warburg and Courtauld Institutes*, XVIII, 1955, pp. 296 ff.).

Some amendments must be made to the history of the Massimi volume. It has been pointed out by Professor E. K. Waterhouse (*Actes du Colloque International Nicolas Poussin*, 1960, I, p. 287) that Mead is unlikely to have bought the drawings in Rome in 1695–96, since he was at that time a relatively poor medical student. There is, however, no reason to doubt the tradition that he owned them and sold them to Frederick, Prince of Wales, in whose possession Vertue saw them, probably in 1750 (British Museum MS. 19027, fol. 25, kindly brought to my attention by Mr. Oliver Millar). Vertue's account also makes it clear that the inscription at the beginning of the catalogue volume was written for the Prince, in the presence of Vertue, by 'Mr. Shraders Servant'.

20. RECTO: THE ARCUS ARGENTARIORUM (*Plate 7*)
(8237)
358 × 277 mm. Pen and brown wash.

The drawing is without traditional attribution, but is clearly from the hand of Poussin. The nearest analogies are with drawings of the 1640's, particularly the *View with an arch* (Friedlaender and Blunt, IV, No. 272), now known to represent Villeneuve-lès-Avignon and to date from 1642, and the *View of the Aventine* (*ibid.*, No. 277) of the mid-1640's.

Verso: Outline drawing of two figures. Black chalk.

This sketch, though very faint, follows exactly the group in the bottom right-hand corner of Poussin's *Kingdom of Flora* at Dresden. It shows the head, body and legs of Smilax and the head and shoulders of Crocus. The legs of Smilax differ slightly from the painting in pose and are less fully draped. The drawing is so faint that it is impossible to make a definite pronouncement on its status, but it may well be from Poussin's hand. If so, it must date from c. 1630, that is to say, a good deal earlier than the drawing on the *recto*.

APOLLO GUARDING THE HERDS OF ADMETUS (Blunt, *French Drawings*, No. 155) (11947)
A copy of this drawing, said to be dated *Rome 1630*, was sold at the Hôtel Drouot, Paris, 28.x.1927, lot 116; 195 × 305 mm.

MARS AND VENUS (Blunt, *French Drawings*, No. 175)
(11975)
A copy of an original drawing acquired by the Louvre during the second world war (cf. Friedlaender and Blunt, III, p. 30, No. 206).

DIANA HUNTING (Blunt, *French Drawings*, No. 178)
(11985)
A copy of this drawing (165 × 247 mm.) appeared as lot 150 in the Randall Davies sale, Sotheby, 10.ii.1947.

THE ENTOMBMENT (Blunt, *French Drawings*, No. 183a)
(*Plate 6*) (0748)
This drawing was catalogued in the 1945 catalogue, but was not reproduced.

ST. MARY OF EGYPT (Blunt, *French Drawings*, No. 195)
(11925)
Perhaps connected with a painting of the *Magdalen in the desert* mentioned by Sandrart (*Teutsche Academie . . .*, ed. A. R. Peltzer, Munich, 1925, p. 258).

TWO ANCIENT STATUES (Blunt, *French Drawings*, No. 197) (11916)
After the right half of a relief of the *Hours* in the Villa Albani (cf. Vermeule, p. 35).

SCIPIO AFRICANUS AND THE PIRATES (Blunt, *French Drawings*, No. 211) (11886)
The reference to Valerius Maximus should be ii. 10. 2.

CUPID ON HORSEBACK (Blunt, *French Drawings*, Nos. 212, 212a) (11967–8)
A further drawing connected with this composition was published by Dr. Walter Vitzthum (*Art de France*, II, 1962, pp. 262 f.). There does not seem to be any reason to doubt that both the Windsor drawings are from Poussin's own hand.

HOLY FAMILY (Blunt, *French Drawings*, No. 213) (11988)
Closer examination of the Chantilly painting has shown it to be an original by Poussin, so the name of Le Sueur need no longer be connected with the composition. On stylistic grounds the drawing should be placed a short time after the artist's return to Rome, c. 1643–44.

THREE SATYRS (Blunt, *French Drawings*, No. 227)
(*Plate 4*) (11992)
Probably an original by Poussin. Based on a gem in the collection of Pietro Stefanoni in Rome, engraved in *Gemmae antiquitus sculptae a Ptro Stefanonio Vicentino collectae*, Rome, 1627.
For a discussion of the subject of the drawing see E. Panofsky, *A Mythological Painting by Poussin in the National-museum Stockholm*, Stockholm, 1959, p. 43, and Blunt, *Burlington Magazine*, CII, p. 402.

TWO PHILOSOPHERS DISPUTING (Blunt, *French Drawings*, No. 228) (038)
This and not *French Drawings*, No. 229, is Massimi 57. It was catalogued as a studio drawing, but may well be an original.

TWO APOSTLES (Blunt, *French Drawings*, No. 229 *recto*)
(039)
This was catalogued as by a studio hand, but it is probably an original.

SCIPIO AFRICANUS AND THE PIRATES (Blunt, *French Drawings*, No. 251) (0698)
A good copy of this drawing, formerly in the Resta and Lawrence collection, is in the Orléans museum (cf. *The Age of Louis XIV*, Royal Academy, London, 1958, No. 272).

CONFIRMATION (Blunt, *French Drawings*, No. 261)
(11898)

MOSES TRAMPLING ON PHARAOH'S CROWN
(Blunt, *French Drawings*, No. 262) (11885)

These drawings were catalogued as being probably by a good studio hand, but No. 261 is certainly an original, and No. 262 seems also to be by Poussin himself.

A ROMAN RELIEF (Blunt, *French Drawings*, No. 263)
(*Plate 5*) (11880)

This drawing was catalogued as a studio work, but it is certainly an original from Poussin's own hand.

THE VIRGIN AND HER COMPANIONS (Blunt, *French Drawings*, No. 272) (*Plate 3*) (11883)

In the catalogue of French drawings this was classified as by an Italian imitator of Poussin, but this scepticism does not appear to be justified, and the drawing is probably an original of the mid-1630's, made as a conscious variation on Guido's version of the subject.

Studio of NICOLAS POUSSIN

DRAWINGS FOR LEONARDO DA VINCI (Blunt, *French Drawings*, Nos. 230–245) (11951–66)

For a fuller discussion of these drawings see K. T. Steinitz, *Leonardo da Vinci's Trattato della pittura*, Copenhagen, 1958, p. 90, and Friedlaender and Blunt, IV, pp. 26 ff. In the latter reference it is pointed out that the Windsor drawings very probably come from the Duke of Argyll sale, Phillips, 25.v.1798, lot 280. If so, they were probably bought by his brother, Lord Frederick Campbell, because H. Reveley (*Notices illustrative of the drawings and sketches of some of the most Distinguished Masters*, London, 1820, p. 112) says: 'Lord Frederick Campbell has the original Figures which he inserted in Lionardo da Vinci's Drawing-Book, penned and washed'. How they came to the Royal Library is not known.

STUDIES FOR THE DECORATION OF THE LONG GALLERY IN THE LOUVRE (Blunt, *French Drawings*, Nos. 252–256) (11969–73)

For a fuller discussion of these drawings see Friedlaender and Blunt, IV, pp. 11 ff.

VIEW OF ITALIAN FARM BUILDINGS, (Blunt, *French Drawings*, No. 274) (6141)

Discussed in Friedlaender and Blunt, IV, p. 59, No. B 41.

Manner of NICOLAS POUSSIN

21. THE FOUR SIDES OF A QUADRANGULAR ROMAN ALTAR (7997)

79 × 39 mm. On four pieces of paper joined together. Pen and brown ink. Inscribed in pen on the *verso*: *Aldobrandini.*

The Roman Divinities represented in the reliefs are: (A) Fortuna and Spes; (B) Diana and Apollo; (C) Mars and Mercury; (D) Hercules and Sylvanus.
See also: *PIETRO DA CORTONA* (p. 106, No. 351).

Attributed to NICOLAS POUSSIN
See *GASPARD DUGHET* (No. 8 above).

R. DE QUERELLES

UNE CARRIÈRE CONTEMPORAINE (Blunt, *French Drawings*, p. 79) (16875–87)

The artist is still unidentified, but may be connected with a Vicomtesse Hortense de Querelles, who was an aunt of Delacroix' mistress, Mme de Forget (cf. Delacroix, *Correspondance générale*, ed. Joubin, Paris, 1935–38, II, pp. 179, 245).

After HYACINTHE RIGAUD
(1659–1743)

PORTRAIT OF LOUIS XV AS A CHILD (Blunt, *French Drawings*, No. 351) (13070)
Bought from Colnaghi, 11 April 1808.

JEAN DE SAINT-IGNY
(c. 1600–c. 1649)

See *JACQUES CALLOT* (Blunt, *French Drawings*, Nos. 24, 25).

ISRAEL SILVESTRE
(1621–91)

21a. THE TOMB OF CECILIA METELLA (Blunt, *French Drawings*, No. 62) (13078)

In the catalogue of the French drawings I mentioned the similarity of this drawing in style to the work of Silvestre, but maintained that it was more likely to be by Claude. This attribution was rejected by M. Roethlisberger (*op. cit.*, p. 148, No. 283). I now believe that the drawing is in fact by Silvestre.

FRANÇOIS SPIERRE
(1639–81)

See *CIRO FERRI* (p. 84, No. 173).

JOSEPH SUBLEYRAS
(1745–after 1810)

22. THE INTERIOR OF THE PANTHEON (19313)
783 × 593 mm. Water-colour. Signed: *J. Subleyras f.*

JACQUES FRANÇOIS JOSÉ SWEBACH, called DES FONTAINES
(1769–1823)

DEATH OF GENERAL DESAIX
 (*Military Costumes*, IV, p. 89)
(Blunt, *French Drawings*, No. 525)

An invoice in the Royal Archives (A.I. 27763) of 30 November 1808 shows a payment to Colnaghi for 'A Drawing of Death of Gen Desaix at the Battle of Marengo by Swebach £26-5-0'.

ANTOINE CHARLES HORACE, called CARLE VERNET
(1758–1836)

DÉPART DE LA DILIGENCE (Blunt, *French Drawings*, No. 529) (13144)

An invoice in the Royal Archives (A.I. 28310) for 20 December 1819 shows a payment of £12-12-0 to Colnaghi's for this drawing.

LA CHASSE AU RENARD (Blunt, *French Drawings*, Nos. 530, 531) (13145–6)

An invoice in the Royal Archives (A.I. 28005) for 15 June 1814 shows a payment to Colnaghi for 'Two drawings of huntings by Vernet £12-12-0'.

ÉLIZABETH VIGÉE-LEBRUN
(1755–1842)

PORTRAIT OF THE COMTE DE PROVENCE (Blunt, *French Drawings*, No. 353) (13122)

PORTRAIT OF THE COMTESSE DE PROVENCE (Blunt, *French Drawings*, No. 354) (13123)

An invoice in the Royal Archives (A.I. 27964) shows a payment of 10/6d. each for these drawings on 20 December, 1813, to Colnaghi.

Attributed to SIMON VOUET
(1590–1649)

23. PORTRAIT OF A MAN, FACING HALF LEFT (6786)

Circular, diameter 92 mm. Red and black chalk, on light brown paper. Inscribed in pencil: *Domenichino*.

The attribution is based on the similarity of the drawing to one in the British Museum with a seventeenth-century attribution to Vouet (cf. Blunt, 'Some portraits by Simon Vouet', *Burlington Magazine*, LXXXVI, 1946, p. 271).

Attributed to ANTOINE WATTEAU
(1684–1721)

24. A CASTLE BY A RIVER WITH A BRIDGE (*Plate 9*) (3549)

141 × 205 mm. Red chalk, slight grey wash.

Inventory A, p. 116: 'Paesi di Maestri Bolognese'.

The attribution to Watteau is based on K. Parker and J. Mathey, *Antoine Watteau*, 1957, where it is reproduced as No. 408. There appears to be another similar drawing on the *verso* of the sheet, which is laid down.

25. A TOWN ON THE SLOPES OF A MOUNTAIN (*Plate 8*) (6129)

281 × 404 mm. Red chalk and brown wash.

Inventory A, p. 115: 'Paesi di N. & G. Poussin e Altri'.

Catalogued as by Watteau by Parker and Mathey (*op. cit.*, I, No. 423), who, however, incorrectly state that the drawing was in the collection of Sir Bruce Ingram. Possibly a copy after Marco Ricci.

26. HEAD OF AN OLD WOMAN, WITH WILD HAIR AND OPEN MOUTH (*Plate 10*) (5396)

110 × 117 mm. Red chalk.

Inventory A, p. 19: 'Teste di Diversi Maestri, Tom. II'. This may be the drawing there described as 'A Fury Ditto [Carracci]'.

Attributed to Watteau by both Paul Oppé and Sir Karl Parker.

See also: *Attributed to DONATO CRETI* (p. 77, No. 152).

ANONYMOUS

27. THE LEAVE-TAKING (*Fig. 5*) (6434)

141 × 207 mm. Pen and brown ink. Dated on the lintel of the door: MDCXXXXII.

28. A FAMILY AT DINNER (*Fig. 6*) (6435)

142 × 209 mm. Pen and brown ink.

Fig. 5 Cat. No. 27

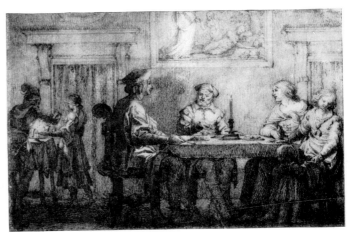

Fig. 6 Cat. No. 28

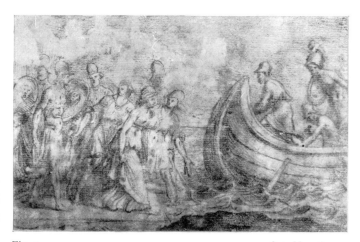

Fig. 7 Cat. No. 28 *verso*

Verso: The Rape of Helen. Black chalk. (*Fig. 7*).

Inventory A, p. 108, as Flemish.

Catalogued by Puyvelde as by an anonymous Dutch artist (*Dutch Drawings*, Nos. 763–764).

The attribution of these drawings presents difficult problems. The dress, the furniture, and the architecture of the room appear to be Italian and suggest the sixteenth century rather than the seventeenth. The technique suggests that the artist knew the engravings of Callot, and the severely classical compositions recall the style of Bosse. The chalk drawing on the *verso* of No. 28 appears to be a copy after a painting of the School of Fontainebleau.

This evidence points to a French artist who had spent some time in Italy.

29. DESIGN FOR THE FRENCH ORDER (*Fig. 8*) (5638)

288 × 172 mm. Pen and black ink, with brown wash.

The capital has the monogram of Louis XIV with interaced L's, and the architrave includes fleurs-de-lys and radiant suns, the latter being repeated in the frieze.

The drawing must be connected with the competition for a French Order organised by Colbert in 1671 (cf. Hautecœur, *Le Louvre et les Tuileries sous Louis XIV*, Paris, 1927, p. 184), but it is not related to any of the recorded designs.

30. A YOUTH, WEARING A CAP, SEATED IN A LOW CHAIR (*Plate 11*) (0149)

192 × 260 mm. Red chalk.

The watermark (a crowned shield of six roundels) would appear to be Italian, but the style of the drawing seems to be French, of the mid-eighteenth century, approaching perhaps most closely to that of Étienne Jeaurat.

31. PORTRAIT OF A MAN, LOOKING HALF LEFT, HEAD AND SHOULDERS (5422)

419 × 217 mm. Red chalk.

Inventory A, p. 19: 'Teste di Diversi Maestri, Tom. II., probably as one of 10 School of Carracci'.

C. 1760-70.

32. PLACE D'ARMES DE FONTAINEBLEAU (13032)

246 × 563 mm. On two pieces of paper joined vertically. Pen, grey and brown washes over pencil. Squared in pencil.

Probably the drawing acquired by the Prince Regent from Colnaghi 25.vii.1814: 'A Drawing Place d'Arme de Fontainebleau for 7/6d.' (Royal Archives, Invoice 28016). On the left are the stables built for Henry IV; in the centre the east wing of the palace.

Early nineteenth century.

33. PORTRAIT OF VILLEROY (Blunt, *French Drawings*, No. 6) (13069)

The portrait is not connected with the engraving of Nicolas de Neuville, Marquis de Villeroy, by Thomas de Leu mentioned in the catalogue entry. Indeed from the costume it can hardly represent him, since he died in 1617. It is much more likely to be of his son Charles (1560–1642), who was, as the inscription says, Governor of Lyons.

The sitter's apparent age would mean that the drawing could hardly date from before about 1630, which is

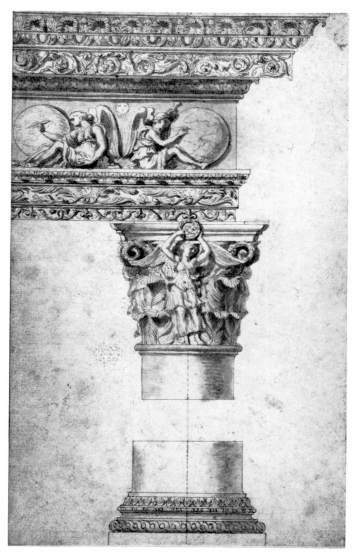

Fig. 8 Cat. No. 29

considerably later than most of the drawings associated with the name of Lagneau. Although it resembles them in technique, it seems safer to ascribe it to an anonymous French artist of c. 1630.

A CHINESE ROOM (Blunt, *French Drawings*, No. 358)
(17184)

An invoice in the Royal Archives (A.I. 27638) shows a payment to Colnaghi on 12 June 1811 for 'A drawing Salon à la Chinoise. 7/6'.

'MONSIEUR LA GOBE' (Blunt, *French Drawings*, No. 536)
(13241)

An invoice in the Royal Archives (A.I. 28131) of 18 November 1816 shows a payment to Colnaghi for a 'Drawing Mons. La Gobe'.

34. MERCURY FLYING DOWN FROM OLYMPUS (Popham and Wilde, No. 767) (5971)

This drawing was described by Mr. Popham as a copy after Primaticcio, perhaps by Tibaldi. Mme Béguin ('L'Hôtel du Faur dit Torpaune', *Revue de l'Art*, 1, 1968, p. 56, note 103) sees in it the influence of both Primaticcio and Niccolò dell'Abbate, and believes that it may be by the artist who painted the decorations in the Hôtel du Faur in Paris, now lost but known from drawings and engravings, which are reproduced in the article quoted above.

35. SOPHONISBA BEFORE SALADIN (Popham and Wilde, No. 1082) (5959)

The subject is from Tasso. The drawing was catalogued as Bolognese, but is probably by a member of the Second School of Fontainebleau.

36. DESIGN FOR A CEILING (Popham and Wilde, No. 1104) (6003, 6004)

Like Popham and Wilde, No. 1105, this drawing was catalogued among the sixteenth-century Italian drawings. In the entry it was stated that the arms—a cross engrailed—were probably those of the Birague family, but they are more likely to be those of the Lenoncourts.

The drawing is certainly later than Primaticcio, whose name appears on an old inscription, and it may date from the very end of the century and be by a member of the Second School of Fontainebleau.

37. DESIGN FOR A BENCH (Popham and Wilde, No. 1105) (6852)

This drawing was identified after the publication of the catalogue of French drawings and was therefore included among the Italian drawings of the sixteenth century. It was tentatively connected with the name of Étienne Delaune or Androuet du Cerceau, but it appears to be earlier and to be by an artist—probably Italian, possibly French, but certainly not Flemish—working at Fontainebleau in the first phase of the decoration of the château, possibly even before the death of Rosso (1540), with whose style it is closely related. The caryatids are based on a type which appears in the stuccoes of the Galerie François I (reproduced P. Barocchi, *Il Rosso fiorentino*, Rome, 1950, Pl. 152) and is repeated in an early engraving by Boyvin (cf. R. Berliner, *Ornamentale Vorlageblätter*, Leipzig, 1926, Pl. 111, 2), though in both the stucco and the engraving the figures are grouped in threes supporting a single basket. The roundel in the right-hand panel of the drawing is also close to an engraving by Boyvin (Berliner, *op. cit.*, Pl. 119, 2).

See also: *LOUIS FÉLIX DE LA RUE* (No. 13 above).

VARIOUS SCHOOLS

RUSSIAN SCHOOL

FRANX XAVIER HOFFERT
(early 19th century)

1. ELEVATION OF AN OBELISK (12047)
603 × 241 mm. Water-colour over pencil.

2. STATUE OF RELIGION (12048)
301 × 243 mm. Water-colour over pencil.

3. MEDALLIONS OF FOUR SOVEREIGNS (12049)
301 × 243 mm. Yellow and grey wash over pencil.
The medallions bear the names of the Emperors of Austria and Russia and the Kings of England and Prussia.

4. ENGLAND CREATING THE ALLIANCE AGAINST
NAPOLEON (12050)

5. THE UNION OF THE SOVEREIGNS OF EUROPE
 (12051)

6. EUROPE RETURNING TO ROME THE MEDALLION
OF PIUS VII (12052)

7. THE RESTORATION OF THE BOURBONS (12053)

8. PLAN OF AN OBELISK (12054)
All five drawings 301 × 243 mm. Pen and black ink, with yellow wash.
The obelisk was designed to be erected in Rome. The drawings are accompanied by an explanatory text and a dedication to 'Altesse Royale', and dated from St. Peters-

burg 5.ix.1814. The artist does not seem to be otherwise recorded, though two artists of the same surname are recorded as working in St. Petersburg later in the nineteenth century.

SPANISH SCHOOL
(17th century)

1. PLAN OF THE PLAZA MAIOR, MADRID (10503)
456 × 555 mm. Pen and brown ink.

2. ELEVATION OF HOUSES ON THE PLAZA MAIOR,
MADRID (10504)
295 × 960 mm. Pen and brown ink, with water-colour.

UNIDENTIFIED SCHOOL

1. SATURN IN A CHARIOT DRAWN BY REINDEER
 (11295)
192 × 280 mm. Pen and brown wash.
Probably a copy after a northern design, perhaps an engraving, of the first half of the sixteenth century. The German, French and Flemish Schools have been suggested, but the drawing is of such poor quality that a decision is difficult to make.

2. A HERMIT AND A MONK IN A MOUNTAINOUS
MOONLIT LANDSCAPE (5754)
425 × 296 mm. Black and white chalk, touches of water-colour, on grey prepared paper.
Probably eighteenth century.

PLATES

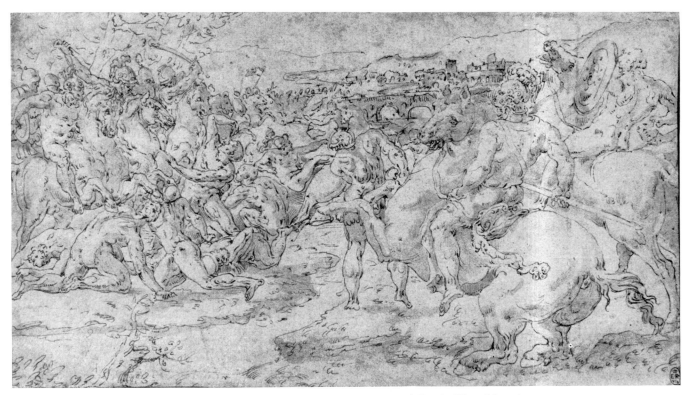

1. Manner of Jean Cousin the Younger: *A Battle* (Cat. No. 5)

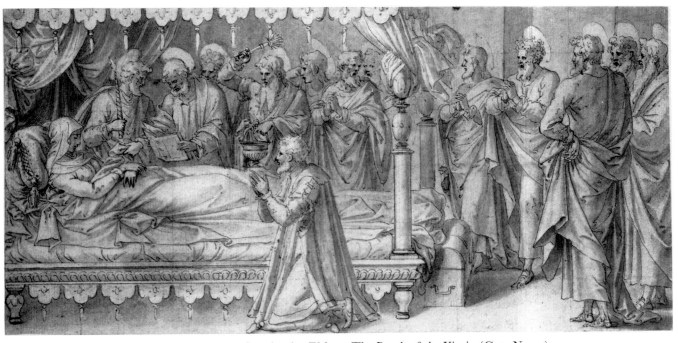

2. Manner of Jean Cousin the Elder: *The Death of the Virgin* (Cat. No. 4)

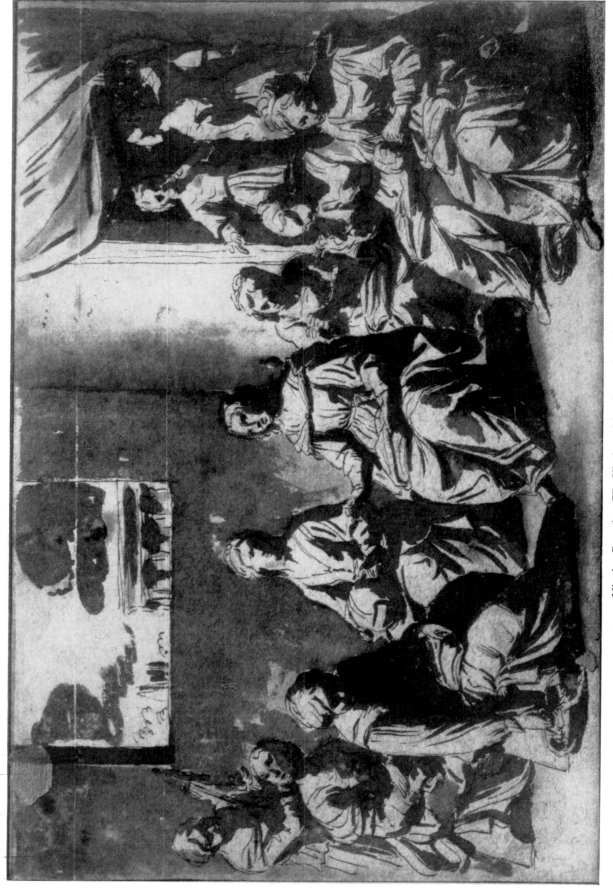

3. Nicolas Poussin: *The Virgin and her Companions* (Cat. p. 216)

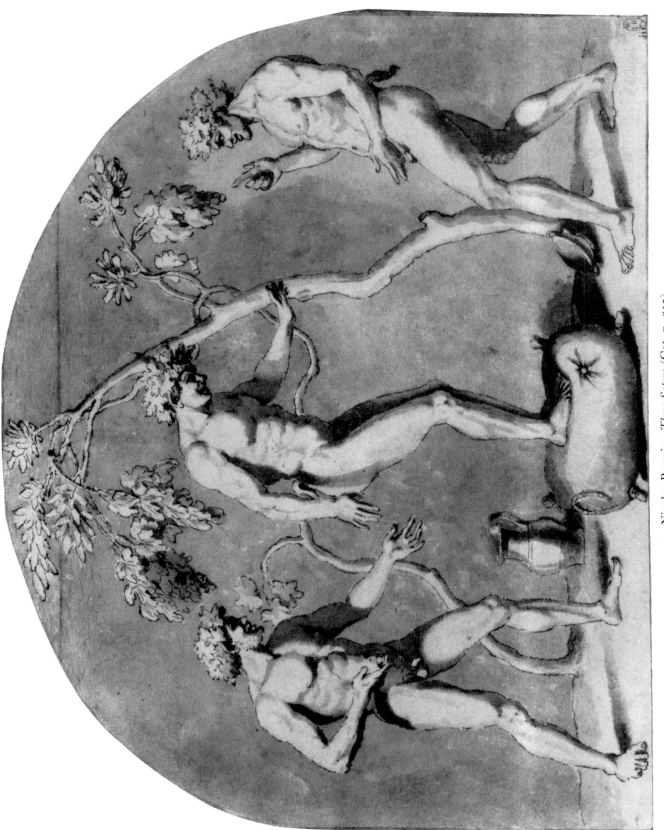

4. Nicolas Poussin: *Three Satyrs* (Cat. p. 215)

5. Nicolas Poussin: *A Roman relief* (Cat. p. 216)

6. Nicolas Poussin: *The Entombment* (Cat. p. 215)

7. Nicolas Poussin: *The Arcus Argentariorum* (Cat. No. 20)

8. Attributed to Antoine Watteau: *A Town below a mountain* (Cat. No. 25)

9. Attributed to Antoine Watteau: *A Castle by a river* (Cat. No. 24)

10. Attributed to Antoine Watteau: *Head of an old woman* (Cat. No. 26)

11. French School, mid-eighteenth century: *A Youth seated in a chair* (Cat. No. 30)

12. Philibert de l'Orme: *An Ionic capital* (Cat. No. 19)

INDEX OF ADDENDA AND CORRIGENDA

CONCORDANCES

INDEX OF ADDENDA AND CORRIGENDA

The following lists contain all those drawings catalogued in previous volumes about which new information is supplied in the present volume (referred to as 'Misc. Cat.').

Blunt and Croft-Murray: Venetian Drawings

New attribution: Croft Murray 195: D. A. Fossati see Misc. Cat. No. 177, C. G. Fossati

New information on Blunt No. 71, see Misc. Cat. under Marco Ricci
,, ,, ,, ,, Nos. 452–4, 456–9, 464, 518 and 546 under Visentini

Blunt: Castiglione and Stefano della Bella

Castiglione catalogue No. 9 attributed to Testa, No. 456 in Misc. Cat.

Additional information on the following entries in the Castigilione catalogue:

19	61	105	141	175	200	226	245
22	67	124	142	190	220	227	251
31	79	131	150	191	221	231	253
54	102	132	151	194	223	235	257
57	103	135	163	197	224	244	261

Additional information on entries in the Della Bella catalogue: 2, 21, 124, 151, 152.

Blunt: French Drawings

New attributions:

Blunt No. 6: Lagneau, (attrib) New attribution: Anonymous, c. 1630, Misc. Cat. No. 33 (French)
,, 22: Callot ,, ,, S. della Bella No. 154
,, 222: Poussin (attrib) ,, ,, Gaspard Dughet No. 8 (French)
,, 275: Sch. of Poussin ,, ,, P. da Cortona No. 351
,, 300: Spierre ,, ,, Ciro Ferri No. 173

Additional information on the following catalogue entries in the French catalogue:

Blunt, No.	2, 3: Clouet		Blunt, No.	300: Spierre
,,	23–25: Callot		,,	309–10: Belanger
,,	33, 34: Courtois		,,	315: Carmontelle
,,	39: School of Dughet		,,	322–24: Gillot
,,	41, 47, 56, 61, 63: Claude Gellée		,,	330: Moreau
,,	72: Gissey		,,	346–49: Picart
,,	103: La Fage		,,	351: Rigaud
,,	137: Lebrun		,,	353–54: Vigée-Lebrun
,,	144: Le Sueur		,,	363: Anonymous (c. 1780)
,,	155, 175, 178, 183a, 195, 197, 211, 212, 212a, 213, 227, 228, 229, 230–45, 251–56, 260–63, 272, 274, 275: Poussin		,,	507–08: Pêcheux
			,,	529–30: Vernet
			,,	536: Anonymous (c. 1815)

See also Querelles and Swebach–des Fontaines.

Pope-Hennessy: Domenichino

Nos. 1176 and 1177 attributed to Lodovico Carracci: See Misc. Cat. No. 100
Nos. 1734 and 1743 attributed to Algardi: See Misc. Cat. Nos. 6 and 7
Additional information to the following entries in the Domenichino Catalogue:

50	184	553–5	1173	1308	1663
90	189	727	1175	1363	1692
100V	195	753–5	1195	1431	1706
113	199	885	1220	1442	1727
118V	255	1006	1261	1515	1728
120	256	1016	1273	1542	1735–9
137V	257	1059	1279	1544	1756
142	393	1172	1292	1556	

Popham and Wilde: Italian Drawings of the XV and XVI centuries:

(a) *New attributions*

P. & W. No.	Attribution	New attribution	Misc. Cat. No.
5	Lorenzo Costa	Aspertini	17
38	Altichiero	Anon. North Italian	674
50	N. dell'Abbate	F. Zuccaro	518
52	N. dell'Abbate	F. Zuccaro	519
64	Anselmi	[New information]	13
201	Girolamo da Carpi	N. dell'Abbate	1
202	Girolamo da Carpi	B. Peruzzi	340
205, 206	Castello	Bertoja	42, 43
215	Cavaliere d'Arpino	Allegrini	11
236	Cigoli	Mytens	315
238	Cigoli	F. Zuccaro	520
264	Daniele da Volterra	Andrea del Sarto	434
516	Morazzone	Caccia	58
556	Palma Giovane	Passignano	337
677, 679	Passignano	Giovanni de' Vecchi	514, 515
754	Giuseppe Porta	T. Zuccaro	523
756	Primaticcio	Salviati	429
767	Sch. of Primaticcio	French School	French, 34
772	Procaccini	Studio of Roncalli	400
783	Pupini	[New information]	381
862–868	Ricci da Novara	G. B. della Rovere	415
877	Rosso	Bandinelli	25
887	Salviati	T. Zuccaro	521
895	Salviati	Bronzino	56
905	Salviati	After Perino del Vaga	473
944	Tibaldi	After Polidoro	372
949	Tibaldi	Salviati	430
971	After G. B. Trotti	Procaccini	380
972	Perino del Vaga	Polidoro, attrib.	373
981	Perino del Vaga	Bertoja	44
987	After Perino del Vaga	T. Zuccaro	524
995	Vanni	Manetti	281
1038	Pierino da Vinci	Battista Franco	188
1057, 1058	Follower of Zuccaro	Sabbatini	417, 418
1060, 1063	Follower of Zuccaro	,,	419, 420
1062	Follower of Zuccaro	Calvaert	68
1066	Taddeo Zuccaro	Prospero Fontana	176
1074	Taddeo Zuccaro	After T. Zuccaro	525
1075	Taddeo Zuccaro	Bernardo Castello	108
1080	Anon. School of Bologna	Giuseppe Porta	377
1081	,, ,, ,,	Bolognese, 18th cent.	570
1082	,, ,, ,,	French School	French, 35
1087	,, ,, ,,	Meloni	304
1100	,, ,, Florence	Passignano	338
1104	,, ,, Fontainebleau	French School	French, 36
1105	,, ,, ,,	,, ,,	French, 37
1112	,, ,, Milan	Savoldo	435
1123, 1124	,, ,, Parma	Anselmi	14, 15
1125, 1126	,, ,, ,,	Campi	75, 76
1134, 1135	,, ,, Rome	Peruzzi	341, 342
1151	,, ,, ,,	Circignani	118
1177	,, ,, Verona	Boccaccino	47
1180, 1181	,, North Italian School	Cardisco	87, 88
1183	,, ,, ,, ,,	Negroni	316
1187, 1188	,, ,, ,, ,,	Rosselli	411, 412
1196	,, Uncertain School	After T. Zuccaro	526
1198	,, ,, ,,	Lodovico Carracci	99

(b) *Additional information on the following entries in the 15th and 16th century catalogue:*

27 Pollaiuolo

61 Allori

88, 89, 94, 96, 97, 100, 107 Barrocci

136 Beccafumi

141 Boscoli

197, 201, Girolamo da Carpi

213, 214, 216 Cesari d'Arpino

232 Cesura dell'Aquila

245 Clovio

246–249 Correggio

337, 340 Gatti
349, 350 Giulio Romano
396 Ligorio
439–443 Michelangelo
521 Naldini
534, 540 Orsi
572, 585, 599, 610 Parmegianino
690, 702 Polidoro da Caravaggio
768, 778 Procaccini
793, 798, 799, 801–8, 812, 856 Raphael
872, 873 Romanino
875 Rosso
888–891, 893–895, 900, 903 Salviati
906, 909, 910 Sammachini

939–941 Tempesta
945 Tibaldi
961 Titian
999 Vasari
1021 Veronese
1022 ,,
1028 ,,
1035 ,,
1040 Viti
1051, 1064, 1065 Zuccaro
1099, 1103, Anon. School of Florence
1114, 1121 Anon. School of Milan
1132, 1133, 1152 Anon., School of Rome
1183 Anon., North Italian

Wittkower: Drawings of the Carracci

(a) *New attributions*

Wittkower Cat.	New attribution	Misc. Cat. No.
11	Guido Reni	386
28	Guido Reni	387
35	Albani	2A
93	Annibale Carracci	93A
375	Domenichino	162
378	Salimbeni	427
502	Domenichino	163
527	Algardi	4

Additional information to the following entries in the Carracci Catalogue:

1	89	158	283	302	329	353	407	502
2	93	164	284	303	330	355	411	506
5	94	170	285	304	331	356	412	507
13	95	171	286	305	332	357	414	511
35	98	186	287	305A	334	358	415	513
38	100	270–72	288	307	337	359	426	538
39	101	275	289	308	338	360	431	540
44	102	278	290	309	343	365	444	579
65	133	279	291	310	344	370	476	
75	134	280	292	312	345	381	477	
76	155	281	293	313	351	386	480	
88	157	282	294–301	315–28	352	390	484	

Kurz: Bolognese Drawings

(a) *New attributions*

Kurz No.	Old attribution	New attribution	Misc. Cat. No.
9	Badalocchio	J. da Empoli	166
72	Cavedone	Guido Reni	384
203	Creti	Giacomo Rolli	391
224	Franceschini	Piola	365
240–42	,, (after)	Piola	366
437	Anon.	Gessi	194A
575	,,	Guido Reni	385
576	,,	Maratta	293
622	,,	Torre	460
629	,,	Gionima	196
646	,,	Canini	77
660	,,	Lanfranco	223
670	,,	Cesi	113
704	,,	Lod. Carracci (manner)	104
715	,,	Algardi	5
720	,,	Massari	302

(b) *Additional information to the following entries in the Bolognese catalogue:*

2–3 Albani
14 Brizio
16, 18 Burrini
30, 31, 36, 41 Cantarini
139 Cignani
155 Cittadini
212, 213, 217, 219, 226, 230, 231, 239 Franceschini
273 Gandolfi

282 Gionima
298 Grimaldi
323–31 Monti
334, 336 Quaini
340, 344, 374, 377, 421, 449 Ren
538 Spada
543 Torre
560, 816 Anonymous

Blunt and Cooke: Roman Drawings

(a) *New attributions:*

Blunt and Cook No.	Old attribution	New attribution	Misc. Cat. No.
23–25, 33	Bernini	Borromini	52, 53
81	Bonatti	Loth	228
86	Calandrucci	Maratta	288
118, 119	Courtois	Allegrini	9, 10
129	Ferri	Pietro da Cortona	350
158	Gaulli	Maratta	289
160	,,	Cristofani	153
161	,,	Passeri	336
167	,,	Maratta	290
169	,,	Canuti	84
186	Lanfranco	Chiari	114
202	,,	Sacchi	421
246–49	Lauri	Ricciolini	390
271	Maratta	Trevisani	461
391	,,	Battoni	31
502	,, (attrib.)	Guido Reni	389
533–34	Masucci	Pietro de Pietri	362
543	Mola	Gabbiani	191
577	Passeri	Baldi	21
611	Pietro da Cortona (follower)	Romanelli	392
616, 622	,, ,, (attrib.)	Ferri	170a, 171
641–49	,, ,, (follower)	Baldi	22
657	,, ,, ,,	Ferri	172
662	,, ,, ,,	Algardi	8
680	Pietro de Pietri	Chiari	115
735–36	Romanelli	Gimignani	195A
737	Rusconi	Maratta (Studio)	292
775	Sacchi	A. di Lione	226
853	,,	Pietro da Cortona	361
854	,,	Falcone	169
855–57	,,	Camassei	69, 70
1002	Trevisani	,,	71
1011–16	Anon.	Lenardi	224A
1035	,,	Franceschini	178
1039	,,	Pietro de Pietri (Studio)	363
1040	,,	Canuti	85
1042	,,	Piola	367
1045	,,	Lod. Carracci	102
1046	,,	Canuti	86
1050	,,	Saiter	426
1065	,,	Parmigianino	334
1073	,,	Maratta	291
1074	,,	Furini	190

(b) *Additional information to the following entries in the Roman Catalogue:*

1 Allegrini
3 Baldi
7, 9, 11 Batoni
82, 83 Bonatti
99 Canini
109 Conca
125, 127, 128, 130–31, 133, 135 Ferri
137 Garzi
150, 155, 159 Gaulli
170 Gherardi
184–85, 194–95, 203–5, 211–12, 215, 218, 220, 231–32 Lanfranco
243–44 Lauri
255–56, 258, 260, 263–64, 266, 269, 272–73, 276–77, 280, 283, 287–88,

293–98, 300–02, 307, 315, 317, 340, 359–60, 363, 366, 506–08, 510–11 Maratta
538–42, 544–46, 548–50 Mola
568, 578, 584 Passeri
588, 592, 595, 602, 608–10, 613, 638, 661 Pietro da Cortona
668–71, 683–84 Pietro de Pietri
738, 740–45, 757–59, 761–68, 773–74, 776–78, 781–82, 786, 789–820, 854, 862 Sacchi
903 Sassoferrato
937, 949, 951–52 Schor
980, 982, 984–87, 999 Testa
1006–7, 1057, 1061 Anonymous

CONCORDANCES

ITALIAN DRAWINGS

Inv.	Cat.	Inv.	Cat.	Inv.	Cat.	Inv.	Cat.	Inv.	Cat.
044	381	01192	57	3636	284	5019	724	5420	642
088	435	01196	43	3638	600	5020	725	5424	638
089	105	01221	315	3639	338	5021	726	5427	231
090	625	01242	565	3652	586	5027	47	5429	193
096	455	01243	566	3656	116	5028	610	5431	543
098	649	01244	567	3668	196	5036	397	5439	372
0112	603	01245	568	3672	112	5047	420	5471	524
0121	368	01248	19	3696	113	5053	582	5494	678
0125	632	01360	373	3704	391	5054	520	5503	462
0130	425	01413	733	3716	564	5056	316	5505	458
0131	423	352	529	3743	339	5057	88	5506	66
0144	519	354	190	3744	23	5058	415	5507	637
0159	67	637B	95	3753	71	5065	526	5510	463
0161	659	727	629	3756) 3757)	366	5066	525	5513	106
0168	188	782	100	3763	365	5085	87	5514	532
0169	460	883	334	3766	366	5086	514	5515	606
0175	9	1220B	100	3802	24	5096	65	5516	84
0179	10	1553	702	3808	667	5098	473	5517	102
0180	59	1561	6	3816	379	5099	417	5518	515
0214	643	1562	555	3824	224	5107	20	5519	73
0228-30	415	1563	556	4168	292	5113	58	5522	577
0233	415	1564	557	4177	114	5119	108	5523	612
0234	13	1576	158	4178	115	5123	666	5525	317
0236	60	1577	159	4179	290	5129	303	5558	420a
0237	61	1584	7	4207	389	5130	377	5563	336
0238	62	1757	198	4222	147	5146	663	5590	699
0239	63	1776	85	4279	226	5158	434	5591	49
0243	359	1805	427	4334	285	5161	646	5593	37
0246	719	1818	107	4335	286	5171	540	5594	48
0247	720	1886	302	4336	287	5172	541	5595	51
0248	533	2037	163	4343	94	5183	639	5602	53
0249	513	2094	162	4348	11	5188	291	5622	54
0250	628	2122	2a	4360	461	5192	442	5635-7	52
0252	627	2157	170	4389	31	5198	199	5639	438
0258	289	2189	387	4403	362	5201	522	5640	439
0265	21	2207	12	4404	362	5202	668	5641	440
0293	68	2328	386	4421	288	5203	361	5654	363
0310	64	2348	4	4482	172	5205	444	5673	611
0327	340	3231	194a	4483	170a	5206	445	5684	421
0333	344	3250	459	4489	426	5209	99	5699	436
0335	56	3363	223	4490	562	5218	111	5727	658
0358	626	3365	333	4491	636	5221	583	5730	546
0360	305	3384	1	4494	83	5239	411	5731	544
0363	86	3407	385	4496	634	5240	412	5752	408
0365	605	3410	383	4497	635	5283	384	5753	545
0366	604	3451	5	4498	633	5294	293	5757	622
0370	25	3453	151	4500	173	5312	8	5758	547
0498	44	3473	554	4505	82	5314	117	5761	97
0510	342	3498	280	4517	171	5315	648	5765	219
0532	675	3499	281	4520	175	5322	563	5767	623
0598	98	3500	332	4525	153	5336	103	5774	93a
0600	15	3508	530	4540	392	5348	194	5793	78
0601	14	3526	647	4541	393	5368	192	5797	347
0747	398	3537	378	4544-7	390	5381	620	5807	551
0791	429	3540	79	4614	154	5382	619	5815	550
0824	631	3554	32	4636-7	584	5384	335	5817	549
0828	157	3556	155	4776	304	5385	437	5818	548
0829	553	3558	560	4786	518	5389	166	5906	222
0961	571	3561	152	4788	523	5391	542	5955	174
01113	443	3562	561	4847	169	5398	41	5956	229
01114	156	3563	559	4882	69	5400	693	5957	230
01115	350	3564	558	4883	150	5408	72	5958	430
01118	76	3568	531	4905	70	5413	669	5969	419
01119	75	3612	77	5018	723	5416	27	5970	400
01125	218	3618	104			5419	621	5987	415

Inv.	Cat.	Inv.	Cat.	Inv.	Cat.	Inv.	Cat.	Inv.	Cat.
5990	176	7207	661	9233	136	10855	261	10937A	721
5993	570	7208	534	9234	137	10856	592	10937B	630
5999	380	7209	662	9235	138	10857	482	10938	671
6013	118	7211	537	9236	139	10858	496	10939	671
6022	415	7216	536	9237	140	10859	239	10944–59	282
6024	521	7217	729	9238	124	10860	201	10960–65	294
6030	457	7218	538	9239	125	10861	240	10966	297
6032	418	7219	730	9240	126	10862	476	10967–11019	294
6036	410	7220	539	9241	128	10863	241	11020	296a
6113	33	7222	16	9242	127	10864	242	11021	294
6114	34	7416	177	9243	123	10865	243	11022a	296
6116	35	7420	727	9244	122	10866	248	11022b	298
6117	36	7421	728	9245	121	10867	235	11023	295
6118	446	7751	319	9246	120	10868	493	11060–11119	89
6119	447	7752	330	9247	143	10869	244	11123	164
6121	405	7753	325	9248	129	10870	477	11173	360
6124	401	7754	324	9249	130	10871	255	11220	711
6125	403	7755	322	9250	119	10872	485	11225	650
6126	406	7756	320	9251	433	10873	486	11235	498
6127	402	7757	326	9254	133	10874	487	11236	499
6128	404	7758	327	9255	134	10875	256	11237	505
6137	552	7759	321	9256	142	10876	488	11246	276
6138	624	7760	323	9257	283	10877	489	11247	275
6143	614	7761	328	9566	30	10878	490	11248	527
6147	369	7762	331	9567	680	10879	478	11249	576
6150	613	7763	329	9568	681	10880	479	11256	503
6153	96	7786B–917	74	9569	682	10881	480	11257	472
6158	616	7918–93	29	9570	683	10882	481	11258	506
6160	615	7994	593	9571	684	10883	250	11259	507
6162	191	7996	594	9572	685	10884	267	11260	501
6174	617	8020V	695	9574	93	10885	252	11261	209
6300	165	8026	394	10381	703	10886	483	11262	502
6332	148	8041	590	10389	146	10887	245	11263	714
6333	407	8060V	55	10431	354	10888	181	11266	500
6337	42	8062	595	10433	607	10889	265	11267	277
6346	168	8064	591	10435	307	10890	454	11269–71	708
6347	149	8071	587	10436	308	10891	266	11272	274
6426	569	8074	588	10437	309	10892	273	11273	278
6430	676	8100	396	10438	608	10894	465	11279–82	715
6431	677	8104	395	10449	38	10895	464	11283	716
6440	197	8145	653	10450	39	10896	697	11284	717
6443	732	8184	26	10451	40	10901	645	11293	589
6450	92	8252V	706	10493	690	10903	374	11296	574
6464	399	8276V	705	10494	225	10904	375	11297	575
6638	301	8331	679	10497	2	10905	722	11300	18
6651	189	8488	179	10498	448	10906	413	11301	698
6654	618	8495V	704	10506–67	516	10907	692	11303	205
6667	718	8503	180	10738	449	10909	370	11304	601
6674	337	8526V	453	10739	700	10910	572	11305	206
6720	422	8548V	356	10743	212	10912	345	11306	207
6722	424	8598	187	10744	211	10913	688	11307	208
6740	641	8599	686	10746	431	10914	696	11308	598
6742	178	8600	597	10749	707	10915	80	11309	599
6743	306	8601	651	10750	355	10916	670	11310	713
6752	535	8629	596	10759	432	10917	253	11311	573
6756	81	8630	182	10760	210	10918	254	11312	310
6758	228	8631	691	10762	585	10919	257	11313	311
6769–74	22	8632	186	10766	46	10920	246	11314	709
6779	441	8633	183	10767	299	10921	268	11315	579
6780	665	8634	184	10768	300	10922	247	11316	312
6784	109	8635	185	10774	656	10923	264	11317	313
6788	710	8636	217	10775	657	10924	269	11318	213
6791	367	8637	689	10776	652	10925	270	11319	214
6794	195	8638	687	10777	101	10926	271	11320	215
6797	232	8639	202	10778	3	10927	272	11321	216
6800	227	8640	348	10779	609	10928	468	11322	602
6801	28	8725	357	10847	474	10929	469	11323	580
6823	528	8946V	701	10848	497	10930	470	11324	578
6837	640	9191V	167	10849	260	10931	471	11325	504
6843	45	9228	294	10850	236	10932	262	11326	279
6850	644	9229	135	10851	233	10933	145	11327	352
7202	664	9230	141	10852	237	10934	160	11328	511
7203	673	9231	131	10853	238	10935	467	11329	353
7204	731	9232	132	10854	234	10936	371	11330	161

Inv.	Cat.	Inv.	Cat.	Inv.	Cat.	Inv.	Cat.	Inv.	Cat.
11331	508	11341	318	11484C	251	11607	91	12959	341
11332	509	11345A	358	11484D	258	11610–11	450	13039	382
11333	510	11346	343	11484E	259	11899A	694	13074	409
11334	581	11386	712	11488A	475	11918	110	13998	672
11335	203	11387	451	11488B	492	11926	456	19228	349
11336	204	11388	452	11488C	263	11959A–12046	346	19288–311	517
11337	416	11415A	512	11522–6	144	11991	351	19314–17	414
11337A	314	11418A	200	11527–73	450	12055	376	19318	90
11338	220	11419A	484	11579–90	450	12171	660		
11339	221	11484A	494	11591	50	12790	17		
11340	491	11484B	495	11596–609	283	12814	674		

FRENCH DRAWINGS

Inv.	Cat.	Inv.	Cat.	Inv.	Cat.	Inv.	Cat.	Inv.	Cat.
0115	5	5638	29	6434	27	10491	1	13026	11
0149	30	5959	35	6435	28	10492	3	13027	2
0800	16	5971	34	6747	12	10495–6	19	13028	2A
0801	15	5994	4	6786	23	10757	18	13032	32
3549	24	6003 }	36	6852	37	11299	6	13069	33
5181	9	6004 }		7997	21	11302	7	13078	21a
5396	26	6129	25	8237	20	12841	14	13112	13
5422	31	6140	8	10439	17	13025	10	19313	22

GERMAN DRAWINGS

Inv.	Cat.	Inv.	Cat.	Inv.	Cat.	Inv.	Cat.	Inv.	Cat.
3544	32	12151	61	12164	17	12178	24	12888	59
3693	29	12152	43	12165	18	12179	52	12889	37
5068	44	12153	40	12166	55	12180	22	12958	10
5724 }	58	12154	41	12167	57	12181	25	12960	19
5725 }		12155	42	12169	51	12182	26	12963	56
6327	27	12156	15	12170	9	12183	30	13008	47
6462	7	12157	54	12172	31	12184	1	13009	48
6642	34	12158	12	12173	53	12185	6	13010	49
6653	33	12159	16	12174	28	12186	3	13011	50
12145	35	12160	14	12175	23	12187	4	13104	8
12146	36	12161	11	12176	21	12853	45	13278	5
12149	38	12162	60	12177	20	12854	46	19312	2
12150	39	12163	13						

RUSSIAN DRAWINGS

Inv.	Cat.
12047–54	1–8

SPANISH DRAWINGS

Inv.	Cat.
10503–10504	1–2

UNIDENTIFIED SCHOOL

Inv.	Cat.
11295	1
5754	2